THE AESTHETICS OF DISENGAGEMENT

THE AESTHETICS OF DISENGAGEMENT
Contemporary Art and Depression

Christine Ross

University of Minnesota Press
Minneapolis • London

A portion of chapter 3 previously appeared in "L'écran en voie de disparition (toujours inachevée)/The Disappearing Screen: An Incomplete Matter," *Parachute* 113 (January/February/March 2004): 15–29. Portions of chapter 4 previously appeared in two other publications: "Inhibitions perceptives: Ce que l'art contemporain a à dire aux sciences cognitives," in *Penser l'indiscipline: Recherches interdisciplinaires en art contemporain/Creative Con/Fusions: Interdisciplinary Practices in Contemporary Art,* ed. Lynn Hughes and Marie-Josée Lafortune (Montreal: Optica, 2001), 178–87; copyright 2001 Optica, un centre d'art contemporain; and "Vision and Insufficiency at the Turn of the Millennium: Rosemary Trockel's Distracted Eye," *October* 96 (Spring 2001): 87–110; copyright 2001 by October Magazine, Ltd., and The Massachusetts Institute of Technology.

Published by the University of Minnesota Press
111 Third Avenue South, Suite 290
Minneapolis, MN 55401-2520
http://www.upress.umn.edu

Library of Congress Cataloging-in-Publication Data

Ross, Christine, 1958–
 The aesthetics of disengagement : contemporary art and depression / Christine Ross.
 p. cm.
 Includes bibliographical references and index.
 ISBN 0-8166-4538-8 (hc : alk. paper) — ISBN 0-8166-4539-6 (pb : alk. paper)
 1. Art, Modern—21st century—Psychological aspects. 2. Melancholy in art. 3. Alienation (Philosophy).
 I. Title.
 N6497.R67 2006
 701'.1709051—dc22

 2005025339

Printed in the United States of America on acid-free paper

The University of Minnesota is an equal-opportunity educator and employer.

12 11 10 09 08 07 06 10 9 8 7 6 5 4 3 2 1

*To my parents,
Armand and Lucille*

CONTENTS

Illustrations

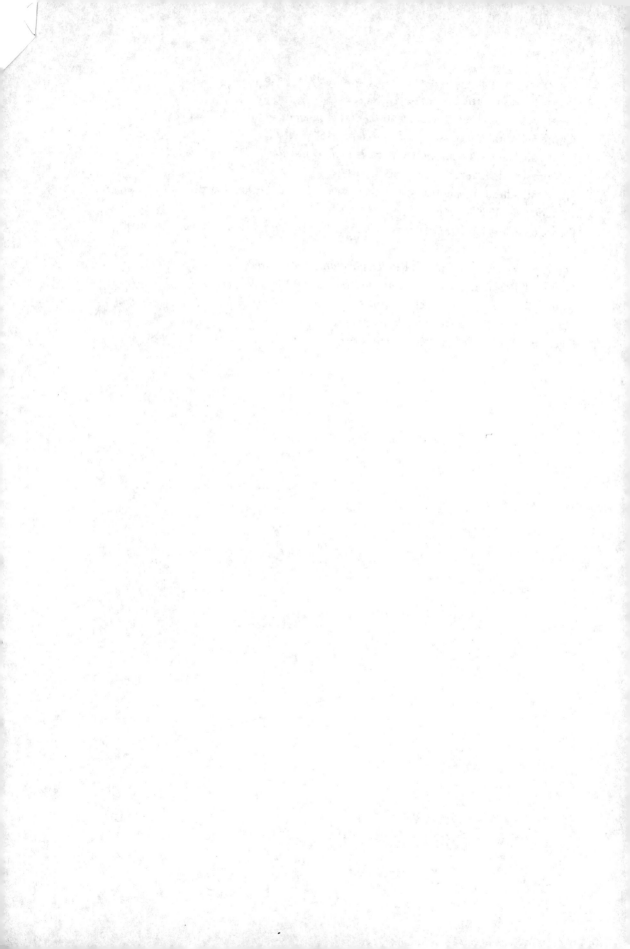

ACKNOWLEDGMENTS

I am grateful to the Social Sciences and Humanities Research Council of Canada, the Fonds québécois de la recherche sur la société et la culture, and McGill University for generous research and travel grants. These have enabled me to secure the necessary funding for the research underlying this book, together with its material (photographic) consolidation. Although I take full responsibility for the final version of *The Aesthetics of Disengagement,* many individuals provided me indispensable and much-appreciated feedback at different stages of the manuscript preparation: I thank Amelia Jones, Elisabeth Bronfen, John Hall, Johanne Lamoureux, Olivier Asselin, Rose Marie Arbour, Mignon Nihon, and Mieke Bal. My thanks also go to the graduate students in art history and communication studies at McGill University: for the past three years, my seminars have been related in one way or another to the book's project and have required intellectual investment from very bright and dedicated students. I especially acknowledge the help of my two research assistants, Julie Lavigne and Claudette Lauzon, who have assisted me in the bibliographic, photographic, quotation, and reproduction rights research. I have come to admire their sense of scholarship and care. I am grateful to the art gallery directors, curators, and assistants who have taken the time to respond to my many requests and questions, in particular Monika Sprüth (Monika Sprüth Galerie), Tania Scartazzini (Galerie Eva Presenhuber), Zach Miner (Gagosian Gallery, New York–Chelsea), and Ruth Phaneuf (Nicole Klagsbrun Gallery). Without their collaboration and interest, I simply could not have accessed the archives, documents, artworks, and publications that have shaped, unshaped, and reshaped my research. I extend my gratefulness to those who have helped in the long but crucial process of getting the right images and reproduction permissions, especially Vivien Adams, Rebecca Akan, John Benicewicz, Stacy Bomento, Allison Card, Ian Davies, Rebecca Donelson, Erika Barahona Ede, Eva Maria Gertung, Bruce Hackney, Bradley Kaye, David L. Kencik, Kelly Kyst, Marie-Josée Lafortune, Melanie Oelgeschläger, Eva Panek, Anita Raymond, Renee Reyes, Markus Rischgasser, Julia Schleyerbach, Carolee Schneemann, Emily Shingler, Jen Stamps, and Nancy Stanfield.

I must also thank my editor at the University of Minnesota Press, Andrea Kleinhuber: her enthusiasm and faith in this book have been inspiring throughout. I feel very lucky that my manuscript, still at a very early stage, fell onto her desk. Finally, many thanks to Tammy Zambo for her excellent copyediting work and to Laura Bevir for the much-valued index.

Introduction

This book is an attempt to understand a certain trajectory of contemporary art, one that has brought into the forefront of aesthetics what must be called a series of depressive enactments—an acting out of states of depression encompassing boredom, stillness, communicational rupture, loss of pleasure, withdrawal, the withering of one's capacity to remember and project, to dream, desire, and fantasize. Especially in the temporal practices of performance and media arts, these traits not only define the subjects (characters, individuals, performers) being staged in the artwork but also are retraceable in the formal structure of the work—in the slowing down, near immobility, opacity, and looped repetition of the image, by which a loss of sense of time and relation to the other endows the relationship between the viewer and representation. Such traits both represent a subject and anticipate a viewing subject whose memory and perceptual, attentional, and relational faculties are considerably devitalized.

But let us push this observation a bit further. I argue that depression is more than just a feature of art at the turn of the twenty-first century or a scientifically defined set of symptoms transposed into art. It is both a question brought *to* art and a paradigm in which art actively participates. As such, it is a means by which contemporary art has redefined itself through the deployment of new subjects (both in and before the image) whose subjectivity is shaped not so much by laws of desire as by rules of disengagement, subjects mobilized by the repeated task yet concomitant fatigue of being a self without others. Let us think of the following artworks. First, Heimo Zobernig's video installation *Nr. 18* (2000) simply but insistently projects the image of a man arranging and rearranging blankets on a flat surface, as though in the process of making his bed while staying in bed, whose task thus remains endless: the repeated action is shown to literally lose the self when the protagonist eventually disappears under the blankets, swallowed up by the electronic red, only to reemerge a few seconds later to repeat his insomniac ritual. Second is Lars Siltberg's *Man with Balls on Hands and Feet* (1998–2001), a three-screen video installation: each screen stages a man in a state of bored imperturbability who attempts to stand on different surfaces (water, ice, and air) with four balls attached to his hands and feet but, from the start and always, either falls and falls again at each trial or begins to fly but is constantly blocked in his movement forward. A third work, Heike

Baranowsky's video projection *Schwimmerin* (2000), shows a female swimmer who repeats the same crawl stroke but whose movement has been edited so as to remain cut off from the moments when the mouth normally resurfaces for new air. Finally, Geneviève Cadieux's large luminous box photograph *La voie lactée* (1992), located on the roof of the Musée d'art contemporain de Montréal, displays the mouth of a woman covered with red lipstick, mimicking a Cover Girl ad but with a discrepancy. The mouth is slightly open, a bit older, and somehow too tightly framed, photographed at the very moment it is about to talk or has just finished talking, sufficiently frozen and stilled by the camera to convey the sense of effort it takes to keep it precisely there, between talk and silence, without being heard.[1] It has been frozen in its failed effort (or nondesire?) to communicate. In all these works—and I follow here P.S. 1 curator Klaus Biesenbach's description of recent media arts—time is "caught in a loop by constant repetition of the same action."[2] The subjects are imprisoned in time; unable to learn from their failures, self-absorbed, and disengaged from the other, they are amnesiacs reenacting the mythic figure Sisyphus, who repeatedly pushes a stone up a hill only to see it fall down again under its own weight. But the works also systematically stage individuals putting a huge effort into actions that don't produce anything other than predictable repetition. This contrast is important: the effort is both huge and unproductive, and it is the very unproductivity of the repeated effort that condemns the individuals to isolation. The loop structure or cramped framing of the image contributes to this remoteness. From the perspective of the represented subject, it is as though nothing is lost or will be lost in the actions he or she persistently seeks to repeat. It is more up to the neglected viewer to feel impoverishment—the loss of breath of Baranowsky's swimmer, the loss of voice in Cadieux's photograph, Siltberg's falling man, *Nr. 18*'s fatigue, the viewer's own lack of recognition by the image.

Statistics are quite overwhelming as to the current rate of depression. The World Health Organization has established that psychiatric disorders are now the third most common type of disease and that the leading mental disorder is depression, followed closely by alcoholism, bipolar disorders, schizophrenia, and obsessive-compulsive disorders.[3] According to the National Institute of Mental Health, major depression is the leading cause of disability worldwide.[4] The one-year prevalence of major depression—the proportion of individuals in a given population affected by depression in a given year—oscillates between 0.8 percent (Taiwan) and 9.5 percent (United States) to 9.9 percent (United Kingdom) of the adult population, and lifetime prevalence—the number of people who will experience a depressive episode at some point in their lives—varies between 4.4 percent and 19 percent.[5] Prognostic studies, however, show that these rates are already too conservative, because the occurrence of depressive disorders is on the rise. They speak of a one-year prevalence of 10–15 percent and a lifetime prevalence of 50 percent, which means that half of the population is anticipated to have a depressive disorder at some point in life.[6] Large-scale epidemiological studies conducted within the past decade, furthermore, have consistently shown that depression is a gendered phenomenon, typically reporting sex ratios (female : male) in the range of 2 or 3 to 1.[7] Not only is it one of the most common mental disorders diagnosed among women, but it is more prevalent among women than men.

These alarming statistics disclose health sciences' growing reliance on the notion of depression in the diagnosis of mental illnesses. Although this reliance seems to suggest that depression is a well-known disease, it reveals in fact the reverse: depression is the slippery notion par excellence of psychiatry, both because of the present impossibility of finding the precise causes of and effective cures for the disorder; and because of its symptomatic definition, which includes a variety of mental conditions. As psychologist Janet Stoppard has observed, divergences persist not only between ordinary and specialized uses of the term but also among researchers and health professionals who apply dissimilar, conflicting, or sometimes irreconcilable approaches to depression.[8] For specialists, conditions of depression are related to a set of more or less precise symptoms, including feelings of sadness, dejection, and hopelessness associated with a sense of worthlessness; loss of pleasure, often taking the form of irritability or negative thoughts about oneself, one's world, and the future; withdrawal, inhibition, and inwardness; fatigue (listlessness, reduced energy, and diminished motivation); psychomotor agitation or retardation; difficulty in mental processes involving concentration, memory, decision making, and speech; different vegetative symptoms, such as difficulty in falling asleep or in staying asleep, too much sleep, and significant weight loss or weight gain; and, possibly, suicidal thoughts or actions. These manifestations are diverse and deceptive; they, furthermore, have come to designate a panoply of incapacitating states, including major and minor depression, dysthymic disorder, premenstrual dysphoric disorder, melancholia, and a growing quantity of subthreshold depressions. This increasing diversity must be related to the development of SSRI antidepressants (for example, Prozac, Zoloft, Paxil, and Luvox), currently the most recommended treatment for depression, whose range of action is extremely wide. SSRIs act as much on a broad spectrum of mental disorders (including anxiety, bulimia nervosa, and obsessive-compulsive disorder) as on more physiological disorders (such as back pain and premature ejaculation). The Prozac generation of antidepressants not only has made treatment by medication more accessible and more generalized but also has significantly increased the number of disorders that may be generically regrouped under the term *depression*.[9] Differences between ill and normal reactions to loss or stress have been surprisingly banalized by the systematic categorization of depression as a disease in the main manual used by professionals in North America and increasingly throughout the world for the diagnosis of mental illnesses: the American Psychiatric Association's *Diagnostic and Statistical Manual of Mental Disorders,* which is now in its fourth (*DSM–IV,* 1994) and revised fourth (*DSM–IV–TR,* 2000) editions. In short, the status of depression can be compared to the place occupied by neurasthenia at the end of the nineteenth century, in that it has become a crossroad from which all possible diseases can emerge.[10] Because of its vagueness and high rate of occurrence, depression is now one of the privileged categories through which the contemporary subject is being defined and designated, made and unmade, biologized and psychologized. Although the contemporary subject can never be fully defined, deducted, anticipated, or homogenized into a single affective state, sociological studies show how much subjectivity and depressive disorders are increasingly convoluted. In other words, depression

says something about who we are, who we think we are, and who we want to be or don't want to be, consciously and unconsciously, even if the "we" must always be situated in terms of gender, race, and culture.

This book is about contemporary art's enactment of depressive disorders in an age that materializes, at least in its Western developments, the paradigm of depression. It rests on the assumption that if depression is indeed the disorder that "discloses the mutations of individuality at the end of the twentieth century,"[11] then art—one of the important fields of deployment of subjectivity—must somehow be affected by this evolution. But how do these two worlds exactly meet? How can they be said ever to meet? How is art relevant to the question of depression? I contend that these questions can be answered not by psychoanalyzing the artist or by applying theories of depression to art but by being attentive to the interactions between art and science, notably the ways in which art is influenced by the sciences of depression that currently occupy most of the field of depression studies. Concomitantly, emphasis must be placed on the performing dimensions of the artwork despite and apart from science—not only what but also how art represents, how it addresses the viewer, how it says something about the subjective ramifications of depression, how it questions aesthetics and science in its apparent depressiveness.

Concerned with the performative dimension of art, I am arguing that contemporary art (in some of its most original deployments) does not so much represent as *enact* depression in the triple sense of the verb: it simultaneously performs and contributes to the depressive paradigm, but it also acts out depression discursively, structurally, formally, and symptomatically. I use *enactment* following Judith Butler's definition of the term as an act or action that "requires a performance that is *repeated.*" This enactment, however, cannot be narrowed down to "a reenactment and reexperiencing of a set of meanings already socially established; . . . the mundane and ritualized form of their legitimation."[12] To say it more precisely, not only does art reiterate and challenge the already-established set of meanings of depression, but it is also fully active in its own terms in the establishment of meaning. Its specific contribution lies in the aesthetic elaboration of a salient rule of depressive disorders: disengagement. There, I believe, is the meeting point of contemporary art and depression. The depressive paradigm is never as manifest as in artworks that adopt as their own aesthetic rules, but for the sake of probing these very rules, the disengaging symptoms of the depressed—the withdrawal into the self, the radical movement of protection of the self from the other, the subject's signaling (through reduced nonverbal communication) to "keep my distance," the *huis clos* sense of isolation, the rupture of communicational intersubjectivity, perceptual insufficiency. The artistic reiteration of depressed disengagement, I contend, transforms disengagement into an aesthetic strategy of disclosure of the ways in which individuality and depression intertwine today; more important, it uses disengagement to reach the depressed viewer. In this process, art not only changes aesthetics but also casts doubt on some of the leading scientific understandings of depressive disorders.

The Aesthetics of Disengagement is not a generalized statement that aims to cover or elucidate the highly heterogeneous field of contemporary art. Nor do I wish here to

provide a detailed survey of artworks occupied by the question of depression. The objective of the book is, rather, to show that contemporary art cannot be isolated from the depressive paradigm, to attempt to historicize the subject contemporary art represents, performs, assumes, and addresses instead of reducing it, as is still much too often the case in the field of art history and new media studies, to an abstract, disembodied, acultural position or entity. Preferring an in-depth analysis of key art productions to an overview of what would problematically become the new category of "depressive art," I have chosen the work of Ken Lum, Ugo Rondinone, Vanessa Beecroft, John Pilson, Liza May Post, Douglas Gordon, and Rosemarie Trockel not only because of their aesthetic investigation of depressive symptoms—one that first and foremost concerns the image-viewer relationship—but also because of the complementary ways in which they act out disengagement without reinscribing the modernist quest for detached or disinterested autonomy. They have this in common: they consistently rethink aesthetics through a depreciation of its inherent feature, the relational, that is, not only the viewer's connection to the image but also intersubjectivity, communication, community, interpellation, and, still more important, the attachment to the other. In so doing, they must be seen as imagining the disengaged subject of the turn of the twenty-first century, what could be called the individual (the independent being who supplants the autonomous subject as it was defined at the origins of modernity), *l'homme comportemental* (the cognitive-behavioral man), the biological being, or the subject without others. But they are equally an exertion to activate the current debate around depression and to show how art is a significant player in that debate.

As a way to introduce and delineate the issues that will shape this study of contemporary art through the special lens of depressive disorders, it is helpful to consider one of the pivotal artworks to have marked the aesthetic enactment of depression: *Mirror Maze with 12 Signs of Depression,* an installation initially presented in the gardens of the Documenta exhibition in Kassel, Germany, in 2002. For this interior maze, Canadian artist Ken Lum (b. 1956) has juxtaposed a series of mirror panes that plunges the viewer into depressive affects by consolidating a rupture of communicational intersubjectivity. This rupture occurs not only between viewers but also between the viewers and their reflected selves. A closer look at this installation shows how depressed disengagement might be—*is*—aesthetically derived. It also shows how both aesthetics and science are disputed in this very process.

First and foremost, the viewer's mental and physical incorporation into a zone of depression is literally made manifest by etched inscriptions marking twelve of the mirrors, which describe the main symptoms of depressive disorders. Extracted from the world of pop psychology, the inscriptions consist of first-person self-test replies typically found in popular media, which voice the experience of the depressed, such as "I cry for no reason," "I feel like a failure," "I have no friends," "There is no future for me," "I am afraid of doing something bad," "All I ever do is sleep," "I am tired all the time," and "I feel alone in the world." These immediately expose the viewer to the subjectivity of depression and favor

Figure 1. Ken Lum, *Mirror Maze with 12 Signs of Depression*, 2002, Documenta 11, Kassel, Germany. Three steel containers with plywood, frost-touched 1 × 2 m mirrors, Plexiglas, ceiling panels with fluorescent light bulbs and plasticized paper, approximately 10 × 10 m. Courtesy of the artist and Andrea Rosen Gallery, New York. Copyright Documenta Archiv. Photograph by Richard Kasiewicz.

identification with at least one of the symptoms, but they do so through the use of stereotyped formulations of the disorders, which trouble the disorders' apparent authenticity. The lived affects are displayed not as false or manipulated (such a display would prevent the visitor from identifying with the descriptions) but as inevitably coded and constructed through popular science. The inscriptions also gender the viewer from the start, inscribing him or her within the predominantly feminine world of health and lifestyle magazines. From the moment this viewer—let us designate her as a user, given that the maze is more a world of immersion than one of vision—enters the maze, she is engulfed in a kaleidoscopic environment of multiplied mirrors that confuses the passageway between the entry and the exit of the architectural construction. To walk in the passageway is to adventure oneself into a space whose configuration is continuously confused by mirrors that reflect not only the different spectators circulating inside the maze but also the other mirrors of the structure. As the user wanders in the space, she is thus never quite sure whether what she sees is an actual opening or the reflection of an opening, an actual user or an image of a user. Condemned to a mirror-injected form of blindness, spectators have to grope their way along the panes of the maze.

Lum's installation thus sets about to ascribe and convey to the user what mainstream pop psychology has identified as the main symptoms of depression: disorientation, a diminished ability to think and concentrate, an impoverished sense of the past and the

future, fatigue, negative thoughts about the self, a quest for but also ineptness in securing one's identity. It ascribes depression discursively, emotionally, and experientially through first-person descriptions that incite identification and through the distressing assembling of the mirrors, which multiplies the reflection of the users and dissolves social unity. Although much of Ken Lum's art practice, as curator Kitty Scott has observed, "explores the anxiety, confusion, and contradictions that arise when people of disparate backgrounds meet,"[13] the Documenta installation pushes this exploration a step further by asking the viewer to physically experience confusion and disparity following a trajectory that keeps associating reflection, depression, and the rupture of intersubjectivity.

Reflection here is a depressive experience on at least four accounts. First, instead of reinforcing the self as self, it opens up the self to a multiplicity of possible selves. The continuous confrontation with the mirrors brings the user back directly to Jacques Lacan's mirror phase—the key phase in which the child experiences for the first time a sense of self through a gestalt reflection of its body as a whole—but the multiplication of mirrors and the fleetingness of the reflections (in contrast to photography, the mirror fails to fix its image) activate a regression to that phase by preventing the stabilization of identity, bringing us closer to what the mirror phase apparently denies, according to Lacan: the actual lack of coordination of the infant, its noncohesiveness. Second, as the wording of the symptoms illustrates, this inability to fix one's identity is disclosed as a deficit or lived as a negative occurrence. Indeed, as the spectators introduce themselves deeper and deeper into the environment of continuous reflections, these inscribe the self in a growing negative rapport with itself, because the meeting with one's image is repeatedly equated with one's failure to find the passageway. Third, reflection is an experience of self-absorption. By multiplying self-reflection, the specular maze may be said to accentuate one's absorption into even an obsession with the self—a key feature of depressive disorders—to the point of trivializing the presence of the other users in the maze. Finally, accentuating this isolating effect, the multiplied reflections significantly mislead one's sense of spatial relation to the other. Although the beholder can see other users, she never knows for sure whether they are virtual or physical realities, whether they are close by or far away, whether they are sharing the same space or inserted into another corridor, whether they are directly reachable or mirror panes away. To be in the maze space is in fact not to know how the place is shared or whether it is shared at all. When many users circulate in the installation at the same time, the multiplication of reflected mirrors creates a community of atomized units. This inability to relate to the other only increases the spectator's sense of isolation.

How does *Mirror Maze with 12 Signs of Depression* define the depressed if not as this individualized, isolated being—recalling the passerby of contemporary glass-and-mirror architecture or the consumer of fair or carnival architecture—more or less paralyzed by the spatial uncertainties of the panes and condemned to dubiety as to his or her actual relationship to others? The specular image's main functions are to de-secure identity, absorb the self into the self, articulate the break of intersubjectivity, and designate the user's difficulties of orientation as a failure of adaptation or mere deficit. It does so by

multiplying the mirrors and blurring the distinction between specularity and reality, closeness and distance, here and there. These enacting operations by which art adopts the disengaging action of depressive disorders have the effect of consolidating the relative but disturbing autonomy of the mirror image: liberated from the function of relating the user to herself and to others, the image loses its aesthetic, relational dimension.

This work is decisive in many ways, in that it sets aesthetically into play salient symptoms of depression not only to suggest the intertwining of depressive disorders and contemporary individualism but also to question, in so doing, some of the key relational premises of aesthetics. It is this correlation that will form the center of this book. Depression in art is not—and let us insist on this point—just a question of subject matter: artworks representing depressed beings in a moment when depressive disorders have become the leading mental disorder or even the leading cause of disability worldwide. Although statistics are critical for the understanding of today's subject, art does more than simply represent empirical data. In the work I've just delineated, depressiveness unfolds as not so much a theme as an aesthetic depreciation of connectedness. First and foremost, the mirror reflections of the self are not only multiplied but also installed in such a way as to envelop the user; this multiplication and the related enveloping effect immunize the beholder from any sentiment of void, emptiness, or absence to oneself. But in doing so, they also insulate the beholder. The reproduction of mirrors, furthermore, inscribes the user into a logic of endless aggrandizing and proliferation of the self, a logic that counters any residual psychoanalytical perception of the self as emerging from the loss of loved objects so as to propel us into the belief that we can endlessly initiate and re-create ourselves without any other to be lost or gained. Finally, the devising of a labyrinthine space transforms the user into a laboratory rat whose behavior and cognitive reactions are to be measured either positively (for those who are able to circulate more or less freely in the maze) or negatively (for those who experience claustrophobia or agoraphobia)—not as a manifestation of the fear to be trapped, to suffocate, and to die but as a maladaptation, a deficient coping style. Aesthetic melancholia or aesthetics as melancholia, as a discourse of loss, has been utterly reversed here, replaced by an architectural setting that favors the reproducibility, enlargement, expansion, and even immortality of the self to the detriment of the other. Depression—the *insufficiency of self*—could well be, as recent sociology has suggested, the fatigue that results from the individual's compliance with neoliberal norms of independence based on the demand for the *reiterated creation of self* so strongly formulated in Lum's installation.[14]

In such a logic of disengagement, it is easy to seize—and this brings us to one of the central arguments developed throughout this study—that the other becomes somewhat peripheral to the self. To marginalize the other is to protect oneself from the losses that come about in any relationship with any other. This is what *Mirror Maze with 12 Signs of Depression* activates and discloses by its self-absorbing mirrors that keep obscuring the location of the other users. The aesthetic deployment of depression corresponds to a rupture of intersubjectivity. Even the specular image has been liberated from its relational modus operandi of linking the reflected self to the self and to others. It is not that

the other is lost; rather, it has become inappropriate or inconsequent. In this, as it solicits the spectator to experience the disengaging actions of the reflections, the maze must be seen as critically deploying a microcosm of a highly individualized society. It echoes sociologist Alain Ehrenberg's periodization of depression as a disorder that emerged as a leading mental illness in the 1970s, a time of decline of norms of socialization based on discipline, prohibition, and repression, and the concomitant rise of norms of independence based on generalized individual initiative (personified by the model of the entrepreneur), self-sufficiency, and pluralism of values (exemplified by the dictum "It's my choice").[15] These norms of independence structure the users' (non)relationships. They produce individual beings in a search for identity. In such a fragmented microcosm, subjectivity still constitutes itself normatively, but it is as though social constraints have become insignificant or irrelevant, producing a multiplicity of postmodern law-giving selves who dissolve what philosopher Alain Renaut, in his study on individualism, has designated the modern subject's "valorization . . . of a sphere of supraindividual normativity around which humanity constitutes itself and intersubjectivity recognizes itself."[16] If the modern subject, as Étienne Balibar has shown, instituted itself with Kant, both as *subjectum* ("an individual substance or a material substratum for properties") and as *subjectus* ("a political and juridical term, which refers to *subjection* or *submission,* that is, the fact that a [generally] human person [man, woman or child] is *subjected to* the more or less absolute, more or less legitimate authority of a superior power"), then the independent individual of Lum's environment is a *subjectum* who has come to devalue the *subjectus.*[17] The mirror maze—and this is a constant in artworks enacting depression—shows that the problematic requirement today, in matters of identity formation, is to devote oneself to the progress and destiny not of the supraindividual but of the self, that is, to incessantly initiate, create, and claim one's identity instead of being disciplined to do so. This psychic economy brings in new possibilities but also, paradoxically, new forms of depressive suffering—notably, for a growing number of people, a reiterated identity crisis, the increased difficulty but related need to identify "the Self as itself."[18] Art revolving around depressive dispositions enacts but also often succeeds in disclosing this individualism by strategically making fragile, although in a fundamental way, the relational function of aesthetics.

Closely related to this shift is art's apparent abandonment of emancipatory intent, that is, the depreciation of art as a field that believes in the possibility of enfranchising the subject from its subjection to the sphere of supraindividual normativity. This is yet another ramification of art's actualization of depression's disengagement affect. *Mirror Maze with 12 Signs of Depression* is not obviously occupied with any operation of transgression and subversion. It participates in what it denounces so as to criticize it from within, inserting the viewer into the devaluation of connectedness without offering any critical distance from which to observe and act on this decline. Immersed in the mirror passageway, disoriented, confused, and self-absorbed, the user is at a loss as to what causes such an alienated state (the labyrinth borrows from the architectural language of entertainment, but it is persistently labyrinthine). This is true not only of the inside

but also of the outside structure. Indeed, after exiting the installation, the user is confronted with an architecture that fails to reveal any of its interior morphology, preventing any form of reflection on the structural organization of the disorienting apparatus. Abandoning emancipatory discourse, the installation refuses to the depressed the neoliberal belief in self–re-creation and insists on the depressed sense of self-insufficiency. It activates depression as a *subjectus* experience. This is a stunning departure from the aesthetic strategies (montage and distancing, for example) that were fundamental not only to the twentieth-century historical avant-garde known for what Peter Bürger, in his *Theory of the Avant-Garde* (1984), has called the critique of art as an institution (the bourgeois concept of autonomous art),[19] but also to post-1960s art and its critique of the discursive constructs of capitalism, patriarchy, and colonialism (class, gender, ethnicity, the commodity, and the gaze, to name the most obvious).

The aesthetic exhaustion of engagement with the other forces us to rethink criticality outside processes of transgression and subversion, a language that tends to disappear in the world of depression. Historian of psychoanalysis Elisabeth Roudinesco speaks of depression's absorption of hysteria, for example—a disorder that has not simply vanished but is treated today as a form of depression—as emblematic of a new social paradigm that cancels out hysteria's language of opposition formulated against the patriarchal bourgeois order of nineteenth-century Vienna: "To this powerless revolt but highly significant in its sexual contents, Freud attributed a liberating value that was beneficial to all women. One hundred years after this inaugural gesture, we are witnessing a regression. In democratic countries, everything is as though no rebellion is possible, as though the very idea of social, even intellectual, subversion had become illusionary. . . . Hence the sadness of the soul and the impotence of sexuality, hence the paradigm of depression."[20] This is one of the main manifestations of what Roudinesco calls the paradigmatic shift from hysteria, neurasthenia, and melancholia to depression, which brings with it the decline of psychoanalysis as a subversive force.[21] In such a paradigm, the belief in psychic conflict as a potential form of critique of social rules has been subsumed by a claim for identity norms in a period when fixed identity has been devalued (although for different reasons) by both neoliberalism and poststructuralism:

> If the emergence of the paradigm of depression means indeed that the claim for
> a norm has superseded the valorization of conflict, this also means that psycho-
> analysis has lost its power of subversion. . . . [L]ike hysteria, it has been dislodged
> from the central position it occupied not only in the fields of knowledge with a
> therapeutic and clinical aim (psychiatry, psychotherapy, clinical psychology) but also
> in the major disciplines it was supposed to invest (psychology, psychopathology). . . .
> Whereas woman's body has become depressed and the old convulsive beauty of
> hysteria, so admired by the Surrealists, has been replaced by an insignificant nos-
> ography, psychoanalysis is suffering from the same symptom and seems not to be
> suited anymore to the depressive society, which prefers clinical psychology. It tends
> to become a discipline for notables, a psychoanalysis for psychoanalysts.[22]

Depressive fatigue thus sets in as the consequence not so much of identity critique (the desire to subvert the norm) as of identity quest or imperative (the desire to be the ideal propagated by the norm as long as it concerns the self and not the other). This begs the question, is depression aesthetics the end of critical art? Not necessarily. Philosopher Jean-Marie Schaeffer has already showed how aesthetics has gradually been liberated from the philosophical quest for transcendental truth, one that was an inherent part of the speculative tradition from Novalis, Schlegel, and Hölderlin, to Hegel and Schopenhauer, to Nietzsche and Heidegger.[23] More recently, art historian Rose-Marie Arbour has also questioned the simplistic equation of art and emancipation, asking, "[S]hould [art] necessarily be subversive, namely aim to 'change the world'?"[24] This questioning is salutary, for it relieves art from the often dogmatic definitions of what is subversive or not. It allows for new ways of envisaging criticality and suggests that art can be productive even if it succeeds merely in moving us. But, to push this questioning further, how can a seemingly nonsubversive art be critical? Can depression, "a flaw of adaptation and creativity,"[25] be critical? Should it be? These investigations are clearly at the center of the Documenta piece and of any artwork concerned with the paradigm of depression. They are at the center of this study.

The emergence of the individual (the independent being who supplants the autonomous subject as it was defined at the origins of modernity), or subject without others in Lum's installation, is thus not possible without substantially modifying the practice of criticality and aesthetics. But neither is it possible without indicating the discursiveness of depression and without challenging, in its attention to subjective voice and experience, the devaluation of the subjective that has come to exemplify scientific understandings of depressive disorders. The formulaic inscriptions make quite clear their reliance on popular-psychology culture, and the maze obviously appropriates the structure-of-entertainment architectural setting. The installation doesn't reduce depression to these discourses but discloses it as signified by them. In this, the installation shows that to write on, to think about, to represent, or to enact or live a depression is necessarily to inscribe oneself in a complex intertwining of discourses that define depressive disorders. If we follow sociolinguists Adam Jaworski and Nikolas Coupland's definition of discourse as "language use relative to social, political and cultural formations . . . language reflecting social order but also language shaping social order, and shaping individuals' interaction with society,"[26] then depression is not merely a suffering state that is reflected in language but also a discursive construct. This is to say not that suffering is not felt and lived or that it doesn't exist as a physical reality, but that as sufferers or companions of sufferers we draw on discourses to give meaning to pain, to feel pain, and to construct identity in relation to this pain.[27] As Deborah Schiffrin has already argued, language is more than an individual possession, capability, or "instrument" that represents experience. It allows us to "make sense" of experience. Thus, discourse (and language in general) is a part of culture: because culture is a framework for acting, believing, and understanding, culture is the framework in which communication (and the use of utterances) becomes meaningful.[28] To state that depression is a kind of pain is already to inscribe oneself in a discursive field, because the nature

of that pain is necessarily different when experienced in a society in which depression has reached the state of a paradigm; it is also different if we live in a society that values such an experience rather than a society that devalues it as a deficit or mere dysfunctionality. This is especially true of depression today, which is increasingly defined as a disease, a disorder, or a maladaptation, but that is also described, for those who disagree with the predominant discourses and want to establish a distinction between depression as a normal reaction to the stresses of life and more severe forms of depression, as a vulnerability or as an individual's adaptation to stress and loss.

Mental disorders are not found as such in nature. Like all concepts, they are human constructions. They exist only culturally, although they cannot be reduced to culture. I follow here J. C. Wakefield's definition of mental disorders as "internal dysfunctions that a particular culture defines as inappropriate."[29] Such a definition entails that (1) mental illnesses "arise when psychological systems of motivation, memory, cognition, arousal, attachment, and the like are not able adequately to carry out the functions they are designed to perform" (this corresponds to their internal dysfunctionality); and (2) although the functions that are not adequately carried out are not social constructions but human properties, mental affections are "only mental disorders culturally, that is when the functioning of the internal psychological system is inappropriate, unreasonable, excessive, abnormal—terms whose meaning stems from the norms of particular cultures and not from natural processes" (this corresponds to their inappropriateness).[30] Indicative of the constructed nature of depression is the current discursive field around depression, which is now dominated by diagnostic psychiatry and its sister disciplines, neurobiology and psychopharmacology, both of which specify depression as a disease of the brain that is comparable to other physical illnesses. Cognitive psychology is another important dominant voice in that debate. A psychological complement to diagnostic psychiatry, it describes depression as a maladapted coping style whose perceptual deficits must be corrected in psychotherapy. These approaches can be said to operate according to what psychoanalyst Pierre-Henri Castel has called the dementalization of the subject,[31] a terminology that highlights psychiatry's banalization of the psychic dimensions of subjectivity. In the field of depression studies, the mind has been somewhat replaced by the brain. Dementalization is the scientific withering of a conception of subjectivity that emphasized the losses inherent to the self and to its relation to the other. Such a depreciation is one of the manifestations of disengagement this book will try to circumscribe. Emphasizing the subjective voice and experience of the depressed (despite or perhaps because of the discursiveness of depression), Lum's *Mirror Maze with 12 Signs of Depression* brings back the lived, embodied, and critical subject, a subject in search of both experience and meaning, in the understanding of depressive disorders. Thus, it must be seen as a critique of scientific dementalization. This critique, I argue, is a guiding thread that ties together artworks questioning the depressive paradigm today.

Hence, although the discursive reality of depression is certainly an underlying premise of this study—I do adopt a critical perspective on disengagement as a general set of social rules, what Michel Foucault has defined as the set of prescriptive laws "that

govern the different modes of enunciation, the possible distribution of the subjective positions" specific to a discursive formation[32]—discursive analysis is not what the book does or intends to do. The focus here is on how contemporary art inscribes itself in the discursive debate on depression. The book aims to show that art is not only an important yet unacknowledged player in that debate but also, and most important, a player that changes some of its major aesthetic functions as it plays the game. *The Aesthetics of Disengagement* suggests that although art borrows from scientific definitions of depression, it also translates and questions them in a significant way as it produces its own employments. The book also maintains that the understanding of mental illness as a form of subversion, and any practice associated with this understanding—be it art or psychoanalysis—collapses in the depressive paradigm. I see no productivity in trying to reinforce the modern relationship between creativity and madness, which has served to either pathologize aesthetics or posit mental illness as a subversive, antisocial force while denying not only its incapacitating aspects but also the historicity of that force.[33] At issue here are the resonance and dissonance between art and science, between aesthetically defined and medically defined insufficiency, between the artistic field and the main scientific disciplines engaged in the study of depression. I contend that art's original contribution to contemporary debates about depression lies in its fundamental concern for the subject, a subject that art increasingly stages and addresses following a paradigm of depressiveness and whose depressive symptoms are transposed in the actual constitution of the image. Such a symptomatology shatters the relational function of aesthetics as it also complexifies prevalent scientific evaluations of depressive disorders in which the depressed's protection against loss is considered to be the antinomy of creativity and *poesis*. Depression, criticality, and creativity are not necessarily incompatible.

The present study is structured in five chapters, all of which investigate the different ways in which a reformulation of aesthetics and science takes place in contemporary art's enactment of depressive disengagement. The movement of the chapters is best described by the following trajectory: from the disciplinary conditions of possibility for depression aesthetics, to the examination of this aesthetics, to its inscription in the larger scientific debate on depressive disorders.

Chapter 1 addresses the withering of melancholia. The book starts with an examination of contemporary art's investigation of the melancholy tradition as a disappearing aesthetic strategy in an era when melancholia has been absorbed by the category of depression. Melancholia is the main notional ancestor of depression. It is, furthermore, a disposition that has been traditionally and consistently equated, since the Aristotelian association of melancholy with genius, with (masculine) creativity, with *poesis* per se. In its modern formulation, as a discourse about the inevitability of loss and one's attachment to the other through loss, melancholia became in many ways a major aesthetic strategy between the late nineteenth and late twentieth centuries, at a moment when psychoanalysis itself had integrated the notion in its theorization of the subject as a subject of desire. Such an association begs the question, what does the ingestion of melancholy by a disorder

predominantly defined as a flaw of adaptation and creativity entail if it brings with it the devaluation of the subject's engagement with the other (even in loss) and the adjournment of creative capacity, of art as such? The multimedia work of Ugo Rondinone is a crucial production in light of this question: it investigates the role and status of the artist when modern melancholia is itself withering, so as to disclose the manifold dissolution of the relations melancholia generally redeemed in extreme situations of bereavement. To speak about the artistic enactment of depression requires that we speak about the conditions of possibility for such an enactment, that is, about the degree to which the paradigm of depression challenges the very possibility of the discipline of art.

Chapter 2 articulates the crystallization of art's participation in the paradigm of depression: the staging of the depressed subject, that is, the insufficient (feminine) self. This staging genders depressive disorders, showing them to be a feminized experience. It also represents the subject of depression as an individual obsessed with questions of identity, struggling but failing to measure up to predominant norms of femininity and self-absorbed to such a degree that the other becomes marginal or irrelevant. Such a staging significantly alters feminist art as a critical acknowledgment of the "sphere of supraindividual normativity around which humanity constitutes itself and intersubjectivity recognizes itself." Ken Lum's installation does not attempt to transgress the gendering of the depressed individual as female; rather, the maze enacts that gendering. This shift takes place through the unfolding of two concomitant operations: the abandonment of the belief in the possibility of subverting the discursive categories of femaleness and femininity; and the replacement of this critique by a disclosure of women's paradoxical hardship and failed claim for feminine identity in an era of feminism. The passage—which I hope to make clear through an examination of the performance work of Vanessa Beecroft—from a critique to a display of idealized femininity, from a condemnation to an exposure of feminine insufficiency in relation to the ideal projections, appears to me to indicate a major change in the field of art. Not only does it sound the death knell for a specific tradition of feminist aesthetics that had become inseparable from any vibrant understanding of contemporary art—a practice that sought to expose and change, in the field of representation, the construction, erasure, objectification, or submission of "woman" in relation to "man"—it also announces the emergence of depressed individuality as a devaluation of the other (elaborated for the sake of self–re-creation). To put it differently, the work shows the correspondence between the individual's disengagement from the public sphere and his or her engagement with the self. This disengagement is defined as a coping style, one that is evaluated by the viewer according to the individual's ability to adapt to failure. This definition is fundamentally cognitivist. Such is the laboratory setting of Beecroft's performances.

Chapter 3 focuses on image disengagement or, more precisely, disengagement as the depressive symptom now materialized in the texture of the image. The prevalence of this operation implies the destruction of the relational property of aesthetics and the attempt, through this destruction, to reveal the depressed insatiable need to protect the self from the losses that come about in any relationship with any other. If we follow Jean-Marie Schaeffer's definition of aesthetics as inherently relational—as an embodied practice

whose fundamental feature lies in the viewer's attitude or conduct vis-à-vis the artwork, which he names the cognitive act of discernment—then what can be said of an aesthetics that exhausts its relational property? This question is highly significant for the aesthetic enactment of depression, whose chief characteristic is to depreciate not only intersubjectivity but also the image-viewer relationship. Liza May Post's exploration of the image-screen as a protective surface that actively disengages the viewing subject from the represented subject acutely discloses this depreciation and the concomitant reformulation of aesthetics as a nonrelational practice in an era of depressed subjectivity. Art has become a producer of depressive screens that "conserve the living under its *inanimate* form"[34] so as to introduce the viewer into an experience of rejection and denial, one that is lived in relation to a represented subject obsessed with the need to preserve itself from the possible loss of the other.

The subject of chapter 4 is the aesthetic renewal of the symptomatic functioning of the image from within the strategy of disengagement. In such a deployment, the image as symptom is conceived as a mere sign, a summary semiology that disfavors interpretation but might also favor perceptual or mnemonic regeneration. When art either represents in the image or activates in the viewer the depressive symptoms of perceptual insufficiency and memory deficiency—the symptoms par excellence of the depressed disengagement from the other or from any outside object—when it seeks to reach the dementalized subject of depression, how can art be a rich visual site to be seen and looked at, producing visibility and attentive viewers? If one cannot perceive or interpret what's there in the image, what is the function of the image? As two specific installations by Douglas Gordon (*24 Hour Psycho* [1993]) and Rosemarie Trockel (the triptych of *Eye, Sleepingpill,* and *Kinderspielplatz* [1999]) make manifest, art's enactment of depression elaborates a radical move away from the psychoanalytical model of the symptom as a site of interpretable conflict, desire, dream, and phantasm into an aesthetics that merely exposes the viewer to two of the most remarkable symptoms of depression: the need for time and the need for sleep. What does this passage entail? What is the value of an artwork whose main effect is not to solicit interpretation but to produce temporality and weariness for the one who looks? I contend that in this very valorization of depressive symptoms, art is critical not only of the social conditions but also of the scientific discourses that currently frame depressive disorders.

The final chapter addresses the scientific dementalization of the depressed. Although each chapter elaborates an art-science confrontation that situates aesthetics in the scientific debate on depressive disorders, this section closely examines the debate to show how the implementation of the *DSM* and the related development of the main sciences of depression (diagnostic psychiatry, neurobiology, psychopharmacology, and cognitive, behavioral, and interpersonal psychology) have devalued the psychic life and subjective experience of the mentally ill in their marginalization of the psychoanalytical discourse. The objective here is not to reinstate psychoanalysis but to map out the ways in which scientific dementalization has proceeded in the past decades. This mapping both complicates art's practice of disengagement and enables us to assess the unique productivity of the aesthetic enactment of depression discussed in the previous chapters.

Chapter 1

THE WITHERING OF MELANCHOLIA

We do see by experience certaine persons which enjoy all the com-
fortes of this life whatsoever wealth can procure, and whatsoever
friendship offereth of kindnes, and whatsoever security may assure
them: yet to be overwhelmed with heavines, and dismaide with such
feare, as they can neither receive consolation, nor hope of assur-
ance, notwithstanding ther be neither matter of feare, or discontent-
ment, nor yet cause of danger, but contrarily of great comfort, and
gratulation.—*Timothie Bright,* A Treatise of Melancholie

The common sort define it to be a kind of dotage without a fever,
having for his ordinary companions fear and sadness, without any
apparent occasion.—*Robert Burton,* The Anatomy of Melancholy

Aconstant within descriptions of depression and melancholia is the reference to
sadness without cause, without apparent occasion, or without reason. As far back
as the Aristotelian definition of melancholy temperament as a "groundless de-
spondency," and Celsus's recommendation that the dejected state of the afflicted "be gen-
tly reproved as being without cause," melancholia and depression have been suggested to
be not so much causeless conditions as troubled mental states with "an insufficient exter-
nal cause."[1] When causal factors have been set forth, such as black bile in pre-eighteenth-
century accounts or stress in modern descriptions, the characteristic symptoms of fear,
sadness, and fatigue have systematically been understood as being in excess of what is
proportionate to or justified by these factors. One could say that the irresolution of the
affection's origin is itself part of the affection: not knowing the source means being in-
capable of acting on it directly and brooding over it, thus prolonging its effect. Devoid
of an identifiable temporal origin, it requires time, both to live and to heal—if it ever
heals at all. After a brief interval between the late seventeenth and mid-nineteenth cen-
turies, the "without cause" reference resurfaced strongly in the late nineteenth and early
twentieth centuries, notably in the work of one of the key psychiatrists of the period,
Emil Kraepelin, who posited that melancholia and depression are "mostly independent

1

of external causes."[2] In Freud's "Mourning and Melancholia" (1917), the melancholy condition is stated to be activated by the loss of a loved object, but, again, the exact nature of what has been lost is characteristically unclear: "[A]nd it is all the more reasonable to suppose that the patient cannot consciously perceive what he has lost either. This, indeed, might be so even if the patient is aware of the loss which has given rise to his melancholia, but only in the sense that he knows *whom* he has lost but not *what* he has lost in him."[3] In more recent accounts, hypotheses abound as to the possible causes of depressive disorders—from the individual's inability to adapt to the loss of significant others or to stressful life events such as a divorce or the loss of a job, to biological malfunctions of the brain and genetic factors—but no element has yet been singled out as a cause of depression. Contemporaries who have written on their own depression have sustained this equivocation. Philosopher Clément Rosset, in one of the most moving descriptions of a depressed dive into a seemingly endless "night road," writes in his *Route de nuit: Épisodes cliniques* (1999) that the particularity of depressive pain lies in its indefinable nature: "[I]t is without apparent cause. No one understands anything about it, neither psychiatrists nor the writers who have suffered from it and attempted to describe it. . . . I can only say—it is the last definition that I found of it, and it is entirely negative—that it is an over-acute pain, of a non-physical order, whose nature and cause are unknown."[4] Novelist William Styron, who wrote a chronicle of his two-year depression in *Darkness Visible* (1990), concludes in similar terms: "I shall never learn what 'caused' my depression, as no one will ever learn about their own. To be able to do so will likely forever prove to be an impossibility, so complex are the intermingled factors of abnormal chemistry, behavior and genetics."[5]

What is striking in all these descriptions is not so much the persistence of the "insufficient cause" specification as the blending of melancholia and depression operated by this very persistence. For, although melancholia and depression do meet in their apparently causeless maturation, as they also meet in some of their key symptoms (such as sadness, powerlessness, and fatigue, even a fall into immobility), the historical deployment and complexion of their quasi-causelessness are significantly, if not radically, different. For one thing, at least since its Aristotelian formulation, melancholia has invariably been associated with intellectual brilliance, whereas depression, as psychoanalyst Pierre Fédida has observed, is recurrently described as "a flaw of adaptation and creativity."[6] Another peremptory difference: melancholia has been predominantly the prerogative of the male genius, whereas depression is one of the most common mental disorders diagnosed among women. As we have seen, depression is also more prevalent among women than men, studies typically reporting sex ratios (female : male) in the range of 2 or 3 to 1.[7]

More generally speaking, the two dispositions have an opposite relationship to guilt and loss. Melancholia is an affection textured with self-reproach and self-disregard, feelings of abandonment and betrayal, and an acute awareness of the indubitability of loss inseparable from the need not to let go of loss, despite or because of its ineluctability. Hubertus Tellenbach, from the school of Heidelberg, one of the main psychiatrists devoted to the study of melancholia from a phenomenological perspective, argues that the

melancholic continual fixation on order (the subject's "conscious emphasis on cleaning up," diligence, and anchoring of relationships in "an atmosphere free of disturbances, frictions, conflicts, in particular from being *in default* in any manner, shape or form") is sustained by a "greater than average sensitivity to guilt."[8] Any failure in life programming registers as culpability. The *typus melancholicus* is sick of consciousness *and* conscience. It is not, observes Tellenbach, that guilt is experienced through melancholy; rather, "the theme of guilt 'works out,' so to speak, the melancholy. It is as if someone should dig a ditch—but so deeply that eventually he cannot climb out."[9] This sense of guilt is inextricably tied to loss, more specifically, the loss of a loved object. Indeed, as the melancholy subject, one is devoured by remorse for the absence of the other, for the emptiness or privation one believes oneself to be responsible for, a belief that explains one's striving to confirm loss by enacting it, that is, by destroying both oneself and the loved one.[10] In short—and I borrow here Douglas Crimp's definition of the term—melancholy is a fundamental "form of attachment to loss,"[11] that is, an attachment to the lost other whose loss I cling to so as to keep that other close to me, in me. This disposition is remarkably different from depression which is more of a struggle to protect oneself against the loss of the other.[12] Although there are no consensual definitions of depression, the disorder is predominantly explained as a way to block off loss or the inaptitude for adapting to loss, for coping with stress or change; as the failure to reach a projected yet highly normalized ideal of selfhood; or, increasingly, as a neurobiological malfunction. The loss of the loved one has somewhat dissipated itself: the loved other is undesired (the depressed numbs himself or herself in relation to an anticipated loss), denied (the fatigue of the depressed comes from his or her reiterated attempt to defeat defect by identifying with an ideal self), devalued (the depressed is said to be incapable of coping with loss—that is, moving on to other things), or made irrelevant (as in neurobiological assessments of depressive disorders). Depression is an illness not of incompleteness of the self in relation to the other but of insufficiency of the self in relation to itself—the counterpart of the neoliberal ideal of performative autonomy—which has banalized the neurotic's experience of prohibited desire for the other and related feelings of lack, fault, and repression. In a society defending values of initiative, flexibility, self-realization, and the right (even the requirement) to choose one's own life, the chief moral symptom of depression is not culpability but frustration, not repression but incitement, not loss of plenitude but a sheer sense of incompetence.[13] In contrast, masculinized melancholia is endowed with deep insight. In short, the scientific discourses that define melancholia and depression, that diagnose, interpret, treat, and seek to cure the two afflictions diverge accordingly, as though the beings they circumscribe belong to different eras. Their only common thread is the prevalence of an allegedly irresolvable enigma: how is it that melancholia and depression emerge? To try to answer this question is to enter two incompatible worlds. This incompatibility, I argue, constitutes the most eloquent dimension of the enigma.

At the end of the nineteenth century, German psychiatrist Emil Kraepelin, in an attempt to infuse into psychiatry the rigor of the natural sciences, proposed a classificatory approach to the understanding of depression, which was to become the model for the

reformulation of mental illness operated by *DSM–III* (the third edition of *Diagnostic and Statistical Manual of Mental Disorders*), in 1980. This approach led to the publication of nine revised editions of Kraepelin's treatise *Psychiatrie* (a *Compendium* in 1883, a *Short Textbook* in 1887, 1889, and 1893, and then a *Textbook* in subsequent editions) between 1883 and 1927. His classification of melancholia, depression, and manic states under the rubric "manic-depressive insanity"—a family of curable mental illnesses that was opposed to a second division of mental disorders, "dementia praecox" (today's schizophrenia), believed to be deteriorating and incurable—suggested that all mood disorders evolved in phases and that they were actually or potentially either circular or bipolar.[14] Although these labels are now obsolete, Kraepelin's system of classification, which linked mental diseases to specific clusters of observable and rule-governed symptoms, is still predominant today after a moment of disfavor in the mid-twentieth century. His system consolidated the split, which had started to articulate itself in the nineteenth century, between melancholy—the temperament—and melancholia—the clinical disease, characterized by intense depression of spirits, anxiety, brooding, and a deep sense of loss (what Freud came to define as the inability to grieve the loss of a loved object). The decline of melancholy and its gradual replacement by first melancholia and then depression announced the disappearance of the association between melancholy and the modern notion of genius, which was initially formulated by pseudo-Aristotle and reaffirmed in Italian Renaissance humanism (especially through the figure of Marsilio Ficino), thus ending the traditional rapprochement between melancholy states and a compensating brilliance, sadness, and creative energy, Robert Burton's "fear without a cause,"[15] and access to the sublime. The fading of melancholy was congruent with the growing medicalization of madness in the nineteenth century and the modern shift from the conceptualization of madness as "unreason" to its taming as a muted medical condition, that is, from the understanding of depression as a symptom of melancholia to its designation as an independent cluster of symptoms in the eight editions of Kraepelin's classification of mental illnesses (1909–15).

This chapter stands on the hiatus, cleavage, or caesura between melancholia and depression, between the attachment to the other through loss and the decline of loss. It stands there to disclose that very transitional site and, in so doing, to show how contemporary art at the turn of the millennium is one of the richest and most significant articulations of the paradigm of depression precisely because of art's melancholy tradition, which makes us aware of what is gained, transformed, and relinquished when one historically enters the depressive paradigm. Conventionally associated with melancholia, and the discipline par excellence to have visually enunciated the *typus melancholicus* and to be closely linked since the end of the nineteenth century (with its sister discipline, art history) to one of the major modern fields of study of melancholia—psychoanalysis—art can now be said to have depreciated its melancholy condition for the sake of a depressed subjectivity. Why this depreciative process matters both to art and to scientific understandings of depression is the underlying question of the work of Swiss artist Ugo Rondinone (b. 1964).

All of Rondinone's work focuses on a kind of inertia, and his figure lies in the contemporary world just as Orson Welles stood on a dark corner of postwar Vienna, fighting depression through hubris rather than practising "grounding," the procedure invented by the psychiatrist Alexander Lowen to fight clinical depression. "Grounding" is intended to help the patient feel his or her guts in the legs, to feel rooted again in the world. Yet Rondinone's approach to contemporary art is closer to Lowen's philosophy than to Welles's vision of omnipotence and glory. His attitude is in sympathy with that of the cuckoo waiting for the door to open. . . . What does the cuckoo do when it's not yet time to come out? This is a question which belongs to Rondinone's meditation. The little bird, no matter how well it has been carved, always conveys a sense of melancholia for the time it wastes inside the clock. The cuckoo's melancholia is the awareness of knowing that it will never be better than an object because it is an object. The same aware-ness seems to reside in all of Rondinone's work, and in turn, we find the same melancholia and depression.[16]

In this description, writer and curator Francesco Bonami suggests melancholia to be the guiding principle of Ugo Rondinone's art production. But the notion, which refers here to a sense of inertia, waiting, and waste, is hesitantly introduced in connection with a second term: depression. This hesitation shows how much, in the analysis of art, the two concepts can coexist only in a contradictory way. The Aristotelian association of art and melancholia—an association that has historically sustained the designation of art as a melancholy activity—is radically eradicated by depression, a disorder known to be a defect of creativity and whose major symptoms include fatigue (listlessness, reduced en-ergy, and diminished motivation), immobility (the "conservation of the living under its *inanimate* form"[17]), and weakened mental processes involving concentration, memory, decision making, and speech. Moreover, the biologization of mental illness and the re-lated development of psychopharmacology (let us quote Dr. Georges Costan here: "[I]n the majority of cases, antidepressants remain the privileged approach in the treatment of depression"[18]) have tended to reduce the patient to a mindless, dementalized body. Even in more recent, nondynamic forms of psychotherapy, depression is considered an impov-erished behavior—an understanding that can barely make place for melancholy genius. Depressive disorders lack the feature of intellectual insight associated with melancholia. Bluntly, in depression, there is no place for any form of creative compensation; it simply cannot be seen as "the basis for intellectual and imaginative accomplishments, . . . the wellspring from which [come] great wit, poetic creations, deep religious insights, mean-ingful prophecies, and profound philosophical considerations."[19]

Yet Bonami is right to bring melancholia and depression together, for they are con-stantly joined within Rondinone's work. As it troubles but never erases the traditional association of art and melancholia, as it activates the unresolved tensions (differences, similarities, and overlaps) between melancholia and depression, his oeuvre succeeds in disclosing the fundamental loss, the loss of melancholia, that comes about when the

insufficiency of the self is defined as a deficient coping style, what has been called in cognitive science a flaw of creativity (of artistic inventiveness). This flaw, in turn, is not accomplished without revealing the decline of the power of art in contemporary societies. At issue here—and this will be my main argument—is the creative, intersubjective dimension of melancholia and the withering of that very dimension in an era of the predominance of depressive disorders. Rondinone's work continuously yet diversely raises the question of the consequences, for art, of the unsustainability of melancholia. Indeed, what is the role of art, and the status of the artist, when aesthetic attachment is devalued? Melancholia's fragile sense of attachment to art, which guaranteed that, even in loss, one could hope to connect image and reality, viewer and image, artist and public, can only vanish when subsumed into the category of depression, a disorder that manifestly depreciates the subject's engagement with the other. Rondinone's production is but a reiterated and unfinished mourning of melancholia—a melancholia of melancholia—that investigates what is dismissed when it is replaced by the depressive paradigm. What makes the work so relevant to art's enactment of depression are the aesthetic rules of disengagement it sets about as it proceeds with this investigation: the need to enunciate the banalization of melancholia, the imperative not to deny the loss of attachment generated by such a banalization, and the requirement to act out the image-reality, viewer-image, and artist-public ruptures that come about in a paradigm that incessantly reinforces withdrawal into the self.

The Walcheturm Installation

One of the key artworks to have shown this state of affairs is Rondinone's pivotal *Heyday*, made in situ for the Galerie Walcheturm in Zurich in 1995. For this specific installation, the artist built a rough wooden floor that covered the whole surface of the main room, transforming the split-level structure into an enclosed space of uniform height.[20] Alone and isolated on the floor, a life-size polyester cast of Rondinone was installed sitting down, leaning against the left wall, one leg outstretched, the other folded, the right hand propped up beside the body and the left one laid loosely over the knee. Barefoot, the cast immutably sat in a pair of brown, baggy trousers, blue, unbuttoned shirt, and white *maillot de corps*.

A closer look at the morphology of the cast reveals a melancholy depressiveness, which is conveyed by both the general sagging of the body and the vacant quality of the gaze. The figure looks in front of him, "his gaze lost on the floor, all energy dispersed."[21] His fixed vision corresponds to nineteenth-century French psychiatrist Jean-Étienne-Dominique Esquirol's clinical description of the melancholic regard: "[T]he eyes are motionless, and directed either towards the earth or to some distant point, and the look is askance, uneasy and suspicious."[22] Art critic Daniel Kurjakovic speaks more specifically of "a mix of concentration and apathy, melancholia and ennui," whereas Bonami writes with empathy: "He lies on the ground having given up the struggle against gravity, the instinct to do something. He is on the verge of depression, but might be ready to get up and fight back."[23]

At the other end of the gallery room, the wall was painted black, leaving a large open-

Figure 2. Ugo Rondinone, *Heyday,* 1995, Galerie Walcheturm, Zurich. Polyester, cotton, hair, wooden floor, paint, Plexiglas, 90 × 130 × 90 cm. Hauser & Wirth Collection, St. Gallen, Switzerland. Courtesy of Galerie Eva Presenhuber, Zurich.

ing through which one could view images of urban daily life—a bus stop, people waiting, the passage of a tram, the walking of passersby, a tree, a fountain. Every account of the installation stipulates the confusion set about by this opening, whose ambivalent nature oscillates between projection and reality, screen and window, image and vitrine. In his review, Bonami hesitates and then explains: "At the back of the space . . . there is a projection. A projection? What projection? . . . In truth, it's not a projection at all, but the outside reality that the artist has framed and isolated."[24] Hans Rudolf Reust describes the same ambivalent perceptual experience occasioned by a framing procedure that transforms reality into a picture: "Silently, as though in an aquarium, daily life could be observed through the window as if one were sitting in front of a small movie screen. . . . Rondinone now stages the artificiality of the notion that art can 'open onto' reality. The visual oscillation from inside to outside pits two synthetic realities against one another: the institutionally segregated spheres of art and life prove to be equally artificial."[25] Laura Hoptman's review concludes in similar terms: "Carefully framing the view of the busy street by masking all the architectural details of the window and wall under a neutral black drop, Rondinone presents real life in real time as if it were a film, videotape, or even a photograph. On the other hand, the life-size stuffed Ugo-dummy looks like the real thing to spectators both inside and outside the gallery space."[26]

The Walcheturm installation sets into play two crucial elements that, although identified by reviewers, have strangely not been associated in the analysis of the work: the

figure of the artist as melancholic, on the one hand, and the image's confusion of fiction and reality, on the other hand. These two dimensions are a constant in Rondinone's work. They form the thread that ties together an art production otherwise eclectic in its material manifestations, including off-focus target paintings, large-format landscape drawings, looped music video installations, audio mood cells, sadomasochist photography, computer-manipulated fashion photography, written diaries, mute video diaries, and clowns in fiberglass or polyester that are photographed, performed, videotaped, or painted. Far from being dispersed, Rondinone's oeuvre is composed of works that interact with one another around the two inseparable themes emerging so clearly in the 1995 installation—depressiveness and ambivalence. The Zurich piece is indicative of a sensibility haunted by the image's reduced capacity to represent in an unequivocal way. However, aware of the contradiction inherent in any attempt to represent the loss of representation's ability to represent unequivocally, Rondinone is interested not so much in representing loss as in conveying the contemporary artist's depressed response to this reduced capacity, the hopeless waiting of an artist who paradoxically persists in making art while continuously reiterating his acknowledgment of the dysfunctional image.

As will soon become manifest, the unfolding of this response is a multilevel one, gradually shaping itself in an art production that allows for the coexistence of a variety of simultaneous melancholy procedures, including the allegorization of representation, the reenactment of the tradition of the melancholic artist, and the troubling of this very tradition by its confrontation with depression. The coexistence of these procedures is enabled by the artist's tendency to work on different series and subseries at the same time, most of them begun in the early 1990s. His works are dialectically linked, replies to one another, impregnations of opposites. This means that although a particular installation conveys a melancholy response to the loss of meaningful representation, it can never truly be separated from the depressive response conveyed by another piece. My contention, which this chapter sets out to show, is that Rondinone's is a continuous elaboration of the hiatus separating but also connecting melancholia and depression. Psychiatrist René Ebtinger suggests that this hiatus is the very operation that structures the relation between depression and melancholia. Both a separation and an openness, it allows for "the passage from one world to another, of the world of the normal/neurotic to the world of the pathological."[27] In light of such a view, my main question is, what is the heuristic of confronting melancholia and depression? That is, how is such a confrontation productive in its thinking about the fate of the image? of art? of the viewer?

The Preeminence of Representation over Reality

As suggested in my brief examination of *Heyday,* Rondinone's aesthetics establishes itself in relation to representation's reduced capacity to represent. This preoccupation with the (non)meaningfulness of representation must be situated in the context of the postmodern debates of the late 1970s, 1980s, and early 1990s. As I hope to show, postmodernist art, in its critique of the cultural products of modernity,[28] articulates the very encounter

of melancholia and ambivalent representation that is at the core of Rondinone's work, an encounter that is best defined by Craig Owens's definition of postmodern allegorical appropriation as a procedure by which an image is confiscated (rescued, as it were, from historical oblivion) and superimposed on another image (or text) so as to shift the viewer's attention not only to the codes underlying the appropriated object but also, and more importantly, to the equivocal functioning of images.[29] It is only by understanding this context that art's venture into the waters of depressive disorders may eventually be elucidated.

In 1977, Douglas Crimp organized an exhibition for Artists Space, in New York, that was to become emblematic of a new, postmodernist sensibility. Simply entitled Pictures, it included works by Troy Brauntuch, Jack Goldstein, Sherrie Levine, Robert Longo, and Philip Smith, artists who would soon become renowned for their appropriationist approach to image making. Explaining what these artists had in common, Crimp emphasized how art had come to acknowledge not only the predominance but, more importantly, the preeminence of pictures in the contemporary world: "To an ever greater extent our experience is governed by pictures, pictures in newspapers and magazines, on television and in the cinema. Next to these pictures firsthand experience begins to retreat, to seem more and more trivial. While it once seemed that pictures had the function of interpreting reality, it now seems that they have usurped it. It therefore becomes imperative to understand the picture itself, not in order to uncover a lost reality, but to determine how a picture becomes a signifying structure of its own accord."[30]

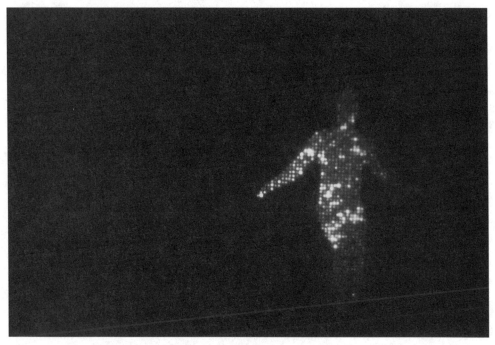

Figure 3. Jack Goldstein, *The Jump*, 1978. 16 mm color silent film, 26 sec. loop. Courtesy of the Estate of Jack Goldstein.

Representation—its encroachment upon reality; the ways in which it becomes a reality in itself instead of an interpretation of reality—becomes here an object of investigation in its own right. In an article written for *October* magazine a few years later, Crimp extended his initial view so as to outline what he now saw as "a predominant sensibility among the current generation of younger artists, or at least of that group of artists who remain committed to radical innovation."[31] This new sensibility is emblematic of performance art, which turns the performed event's literal situation and duration into a highly psychologized tableau so as to explore the "staging" of pictures. Jack Goldstein's *The Jump* (1978), a film structured as a series of short sequences of dives in which a diver leaps, plunges, and disappears within a split second, exemplifies the staging strategy. Shown as a loop that presents different divers in the same repeated mise-en-scène, the film is endowed with a temporality that is tied not to any form of narrative but to the viewer's anticipation. "We wait for each dive, knowing more or less when it will appear," explains Crimp, "yet each time it startles us, and each time it disappears before we can really take satisfaction in it, so we wait for its next appearance; again we are startled and again it eludes us."[32] The staged dimension of the film comes from the film's shaping of the viewer's anticipation, one that is governed not by the subject matter, content, or narrative, nor by the medium, but by the fragmented structure of the film, which maintains the viewer at the surface of the image and, in its tight and repetitive montage treatment, deploys the image as image. As with Cindy Sherman's black-and-white photograph series *Untitled Film Stills* (1978–79), in which the artist adopts a variety of poses, wearing different costumes in different locations in film noir atmospheres, *The Jump*'s fragmentary rendering of the plot solicits the viewer into interpreting the image as "anything but staged."[33] In so doing, the viewer is inserted into an interpretative process that has problematized the access to meaning ("again we are startled and again it eludes us"). Desire, premonition, and anxiety come about in the viewer's response to an image that secures representation as representation and concomitantly sounds the death knell of the window function of the image: "Thus the performances of Jack Goldstein do not, as had usually been the case, involve the artist's performing the work, but rather the presentation of an event in such a manner and at such a distance that it is apprehended as representation—representation not, however, conceived as the *re*-presentation of that which is prior, but as the unavoidable condition of intelligibility of even that which is present."[34]

This elaboration of what art historian Leo Steinberg has called a "flatbed" aesthetics—an aesthetics that articulates a shift "from nature to culture" by forcing the viewer to read the image as "any receptor surface on which objects are scattered, on which data is entered, on which information may be received, printed, impressed" rather than following "the conception of the picture as representing a world, some sort of worldspace which reads on the picture plane in correspondence with the erect human posture"[35]—was reinstated twelve years later, in 1989, by curators Ann Goldstein and Mary Jane Jacob in the exhibition A Forest of Signs: Art in the Crisis of Representation, at the Museum of Contemporary Art in Los Angeles. This exhibition revealed how much Pictures's preoccupation with the staging of representation as an image of images had indeed characterized the art of

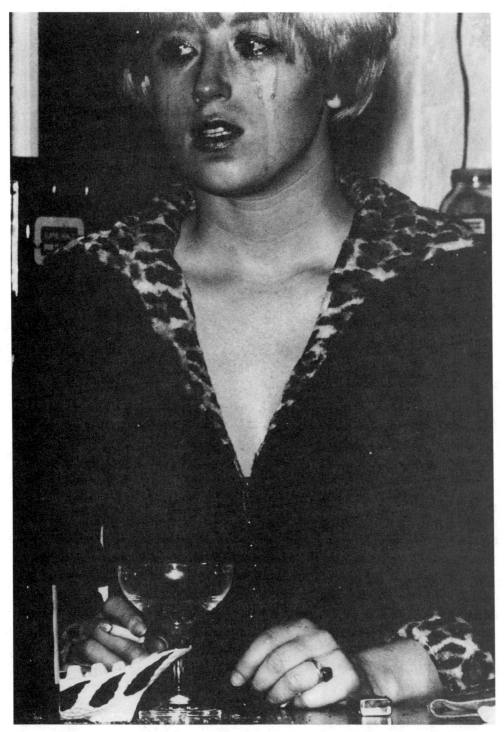

Figure 4. Cindy Sherman, *Untitled Film Still No. 27,* 1979. Black-and-white photograph, 20.3 × 25.4 cm. Courtesy of the artist and Metro Pictures.

the 1980s. A Forest of Signs showed the work of thirty deconstructionist artists, notably Judith Barry, Dara Birnbaum, Jenny Holzer, Mike Kelly, Jeff Koons, Barbara Kruger, Louise Lawler, Allan McCollum, Mat Mulligan, Richard Prince, Cindy Sherman, Laurie Simmons, James Welling, and Christopher Williams—a list that also included most of the artists of Pictures. Comparing the artists of the exhibition to the 1970s generation, art historian Anne Rorimer points out how much their work differed in their approach to representation. Whereas the postminimalist and conceptual artists of the previous generation (we could think here of the work of Marcel Broodthaers, Daniel Buren, Dan Graham, and Hans Haacke) integrated art with the outside world so as to question "the Modernist interpretation of art as an entity unto itself that timelessly transcends the conditions of its existence," the generation of A Forest of Signs examined the reality of representation by acknowledging the "unrealities"—the pictured nature—of contemporary reality:

> These artists have . . . redefined their predecessors' essential concern with reality as direct experience since their work denies an immediate point of contact with existing reality and declares its own reality as representation. Under the assumption that the work of art is cut from the same cloth as the rest of the social fabric, works of the 1980s take on society's falsifying aspects in order to express them. In lieu of attempting to penetrate illusion as if it were a veil that might be pierced or drawn aside, the artists of the 1980s examine the unrealities of contemporary reality, seeking to locate meaning through a multiplicity of representational signs.[36]

In its exploration of a framing device that turns a window view into a picture, Rondinone's Walcheturm installation inscribes itself in the postmodern investigation of the growing intertwining of reality and fiction, what Anne Rorimer calls "the unrealities of contemporary reality." It pushes this investigation into a disclosure of the ambivalence of representation. But in so doing—and this is an essential trait of *Heyday*—the installation deploys and insists upon the state of melancholia of the artist confronted with such a process. Although not underscored by Rorimer and only eventually considered by Crimp, in his study of the melancholy structure of representation explored by gay artists in relation to the AIDS crisis, the question of melancholia is intrinsic to the postmodern debate. As art historian Craig Owens has observed, in one of the most insightful texts on postmodernism, "The Allegorical Impulse: Toward a Theory of Postmodernism" (1980), postmodernist art *is* a melancholy critique of ambivalence. To understand the nature of such a critique, one must be attentive to the problem inherent in any form of denunciation of the equivocal structure of contemporary images: how can the blurring of fiction and reality (of the sign and the referent, of the copy and the original) be denounced through representation if representation is de facto condemned to this very blurring, that is, to ambivalence? Owens suggests that the strategic response to this dilemma—one that will always imply the artist's participation in what he or she seeks to denounce—consists in anticipating ambivalence through the allegorical reading of an appropriated image or text. Allegory, as both an attitude and a technique, "occurs whenever one text is doubled by another"; it is a supplement to (and a commentary on) the original text it seeks rescue.[37]

The palimpsest, or supplemental reading, problematizes the viewer's interpretation of the appropriated object, endowing it with the ambivalent meaning that the artist sets out to denounce. Hence, the critique of ambivalence really comes about only when and if the viewer experiences the ambivalence as he or she interprets the picture as picture. The photographic works and works on paper by Troy Brauntuch, for example—especially those reproducing personal drawings from Adolf Hitler and architectural plans from Albert Speers—are just barely legible; because they function "at the threshold of decipherability,"[38] their subject matter is difficult to interpret. But, as Owens suggests, it is precisely this difficulty of interpretation, the ambivalence in meaning, "that Brauntuch sets out to demonstrate."[39] The reinstitution of ambivalence is also characteristically at play in Robert Longo's *Boys Slow Dance* series of aluminum reliefs (1979). Here the viewer cannot conclude whether the image represents an amorous embrace or a deadly combat between men. "Suspended in a static image," writes Owens about the series, "a struggle to the death is transformed into something that 'has all the elegance of a dance.' Yet it is precisely this ambivalence that allows violence to be transformed into an aesthetic spectacle in photographs and films, and on television."[40]

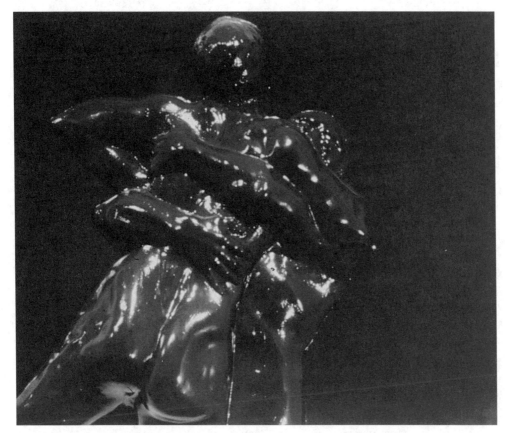

Figure 5. Robert Longo, *The Wrestlers*, from *Boys Slow Dance* series, 1979. Cast Hydro-Stone, wood, lacquer, 101.5 × 124.5 × 30.5 cm. Courtesy of the artist and Metro Pictures.

Allegorical appropriation thus functions as a counternarrative that freezes the narrative by a disjunction that replaces the horizontal, metaphorical unfolding of narratives with a vertical reading of sign substitutions. As the sign is appropriated, it is isolated to set into play a chain of unstable correspondences where signs are constantly being replaced and meaning is constantly being deferred. It is this continuous replacement, deferral, illegibility, and meaninglessness that appropriation art sets out to activate so as to ultimately disclose the ambivalence of contemporary images. Hence, in Cindy Sherman's *Untitled Film Stills,* the literal and symbolic readings of the women she personifies are blocked by an obtuse reading in which the artificiality—the fictional dimension and coded nature—of the represented women is not so much revealed as shown to be indistinguishable from Sherman's identity. As Owens explains, the melancholic perspective denounces meaninglessness (the undifferentiation of reality and code, of identity and identification) by reiterating meaninglessness; yet it does so for the sake of meaning, to disclose, question, and put an end to ambivalence. It is a form of enactment:

> This—the "still"—effect prevents us from mistaking Sherman's women for
> particular human subjects caught up in narrative webs of romance or intrigue
> (a reading which would correspond to Barthes' first, or literal level, which indi-
> cates the position of the image in the anecdote). Instead it compels a typological
> reading: Sherman's women are not women but images of women, specular models
> of femininity projected by the media to encourage imitation, identification. . . .
> And yet the uncanny precision with which Sherman represents these tropes . . .
> leaves an unresolved margin of incongruity in which the image, freed from the
> constraints of referential and symbolic meaning, can accomplish its "work." That
> work is, of course, the deconstruction of the supposed innocence of the images of
> women projected by the media, and this Sherman accomplishes by *re*constructing
> those images so painstakingly, and identifying herself with them so thoroughly,
> that artist and role appear to have merged into a seamless whole in such a way
> that it seems impossible to distinguish the dancer from the dance. It is, however,
> the urgent necessity of making such a distinction that is, in fact, at issue.[41]

Rondinone's blurring of fiction and reality inscribes the Walcheturm installation in postmodernism's melancholy attempt "to distinguish the dancer from the dance," an attempt that can be articulated only by paradoxically (re-)erasing that distinction. The framing of the main window of the gallery (which makes the view appear as a screen or photograph) institutes an ambivalence between fiction and reality. It does so because it is only through the institution of ambivalence that the melancholic artist can hope to show pictures that function—and I again quote Crimp here—not "as the *re*-presentation of that which is prior, but as the unavoidable condition of intelligibility of even that which is present."[42] As in many other works by Rondinone, ambivalence between two types of reading predominates: projection and reality, window and screen, authenticity and code. Even the hyperrealist dummy occasions conflicting readings as to the actual nature of the figure.

Melancholy Loss

But still the question remains: what actually qualifies postmodernism as melancholia? In other words, how is Rondinone's work about loss and the inability to grieve loss? What exactly is being lost here? In this section, I examine three works: Rondinone's monumental series of landscape drawings, the *I Don't Live Here Anymore* photo series, and the photo-audio installation *Sleep*. What these works allow us to do is identify the melancholia stance that structures this production. They also show how much the work owes to prevailing psychoanalytical definitions of melancholia. What I hope to achieve here is a form of elucidation of the melancholy nature of the artist's understanding of contemporary images as resiliently ambivalent in their reiterated usurpation of reality, authenticity, and identity. It is only through this elucidation that the gradual sliding of melancholia into depression—the articulation of a hiatus between melancholia and depression—can truly be made apparent. As we will see, melancholia and depression share many traits, but they also diverge quite substantially. It is, I believe, in the disclosure of this divergence where lies Rondinone's unique contribution to the contemporary debate on depressive disorders.

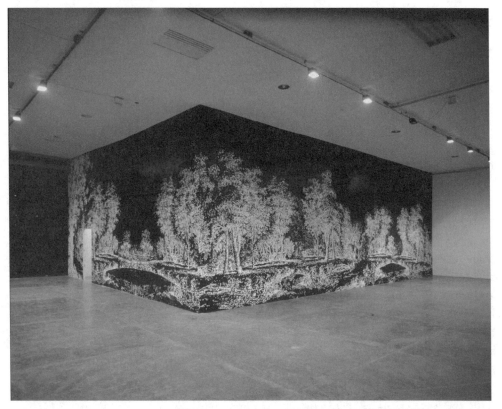

Figure 6. Ugo Rondinone, *No. 133, DREISSIGSTERMAINEUNZEHNHUNDERTNEUNUNDNEUNZIG*, 1996, Where Do We Go from Here? exhibition, Le Consortium, Dijon. Wall painting in india ink, wood, yellow neon light, dimensions variable. Private collection, Zurich. Courtesy of Galerie Eva Presenhuber, Zurich.

Inscribing his art practice in the tradition of early-nineteenth-century plein-air sketching, Rondinone has been engaged since the early 1990s in the production of drawings executed directly from nature during walks in the Swiss countryside.[43] The modalities of exhibition of the drawings imply, however, a series of transformations that systematically break their initial intimacy and indexicality. This rupture is clearly manifest in the paintwork *No. 133, DREISSIGSTERMAINEUNZEHNHUNDERTNEUN-UNDNEUNZIG,* made in situ in Le Consortium (Dijon) in 1996. On show, both the small scale and the handmade execution of the plein-air drawings are radically denied, for what the spectator sees in the gallery results from the slide projection of a photographic negative of the drawings on a large surface—either paper or the gallery wall—painted in grisaille with india ink. The initial drawings are therefore subjected to a layered process of mechanical reproduction, enlargement, and reversal. This state of reproduction is not hidden but displayed through three crucial devices: the titles (which correspond to the dates when the drawings were reproduced and not to their initial dates of plein-air execution), the large scale (which reveals by itself the fact that the drawings are enlarged copies of the initial sketches), and the reproduction of the drawings in the negative (which makes them look like templates). The monumental drawings are, thus, representations of the landscape genre more than representations of actual landscapes. As art critic Laura Hoptman has insightfully pointed out, "Despite their source in plein-air sketches, these works are scrupulously realistic renderings, not of a specific landscape, but of the landscape in art. Rendered in grisaille, and carefully numbered and dated to the day not when the scene was purportedly captured in a preparatory drawing, but when it was inked on a wall, there is no mistaking them for a window onto the world at large."[44] The obviousness of the landscape genre reveals and affirms the preeminence of representation over reality. What truly defines these works, however, is not the affirmation of the picture as picture but the sense of loss attached to this affirmation. This sense is first and foremost conveyed by the motif: these are scenes of idyllic preindustrial landscapes that belong to a remote past. But loss is also undeniably tied to the monumentality of the drawings, which fails to render the affects of authenticity it would have rendered if the status of the drawings as reproductions had been erased or avoided. Monumentality both invites the viewer to perceive the image at the scale of the actual landscape as it was initially experienced by the plein-air artist and invites the viewer to submerge himself or herself in the image so as to penetrate it by following the path that leads the eye from the foreground to the vanishing point. But these sublime experiences of immediacy, fusion, and truthfulness are contradicted by the copy culture to which the drawings belong. Melancholia lies precisely there, in the unresolved tension between copy and authenticity.[45] To be more precise, it lies in the double acknowledgment that the window function of the picture has faded and that it is impossible yet necessary to rescue the immediate experience lost in such a fading. Crimp's "*re*-presentation of that which is prior" and its opposite, representation as "the unavoidable condition of intelligibility of even that which is present," struggle within the same image.

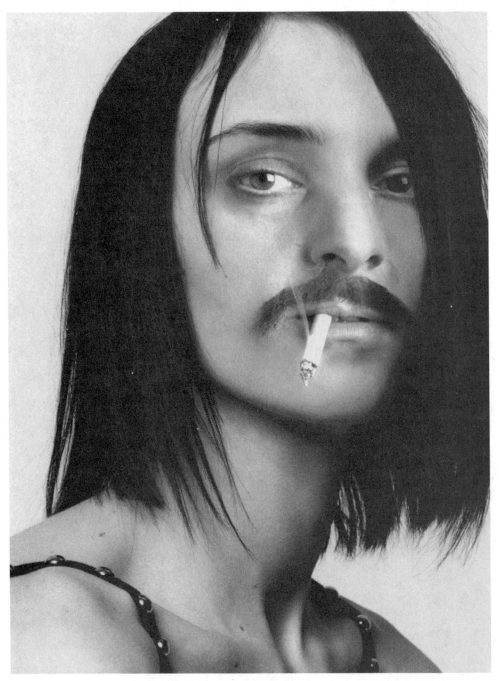

Figure 7. Ugo Rondinone, *I Don't Live Here Anymore (No. 01)*, 2001. C print, Plexiglas, Alucobond. Edition of 2 + 1 AP, 150 × 100 cm. Courtesy of Galerie Eva Presenhuber, Zurich.

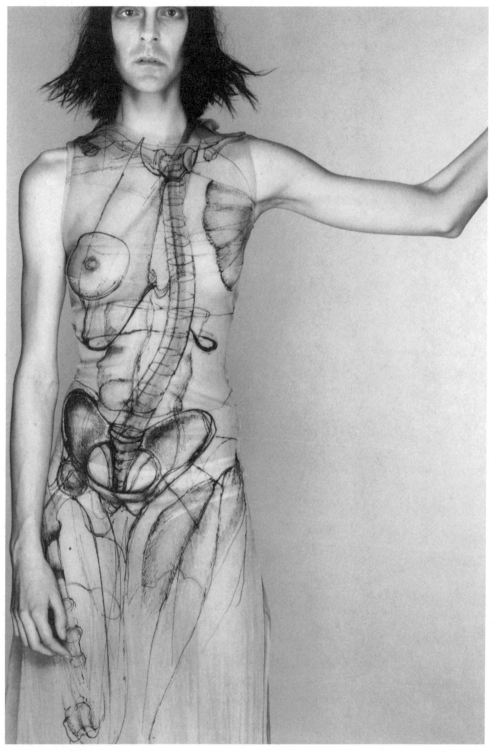

Figure 8. Ugo Rondinone, *I Don't Live Here Anymore (No. 09)*, 2001. C print, Plexiglas, Alucobond. Edition of 2 + 1 AP, 150 × 100 cm. Courtesy of Galerie Eva Presenhuber, Zurich.

Figure 9. Ugo Rondinone, *I Don't Live Here Anymore (No. 14),* 2001. C print, Plexiglas, Alucobond. Edition of 2 + 1 AP, 150 × 100 cm. Courtesy of Galerie Eva Presenhuber, Zurich.

The coexistence of opacity and transparency, reproduction and integrity, screen and window—the simultaneity of images both "encouraging and alienating feelings of authenticity"[46]—equally underlies Rondinone's ongoing *I Don't Live Here Anymore* photo series, also begun in the early 1990s. This time, however, the series articulates coexistence in relation to self-portraiture, as in the Walcheturm installation. Functioning as an in-progress self-portrait articulated through a reiterated but continuously renewed identification of the self with mass-media imagery, *I Don't Live Here Anymore* pushes the deployment of melancholia into the sphere of identity formation. In these photographs, which are always displayed in groups to show the transformations of the sitter from one photograph to the next, the artist has superimposed his own face, through digital imaging, onto images of female models taken from fashion magazines. This approach to self-portraiture allows for both repetition and variation as the viewer rapidly recognizes the same computer-implanted face—with its persisting shadowy mustache—in varying costumes, attitudes, bodies, and styles. The self here is shown to be a reiterated acting out of fashion archetypes, multiplying and renewing its appearance through the unending task of identification, disidentification, and reidentification.[47] It is caught not only in the whirl of interchangeability structuring late-capitalist consumerism but also in the post-1970s shift from what Stuart Hall has designated the great collective social identities founded on social class, economic status, race, nation, sexual difference, and the relation to the West—identities understood as unified, homogeneous, and inclusive categories—to definitions of identity that integrate notions of inner difference and contradiction, to which must be added flexibility, fluidity, and fleeting and always unachieved identification.[48] But this flexible renewal is a limited one, for the self always carries with it the same facial features. Moreover, the masculine never truly merges with the feminine, propelling identity into the sphere of inadequacy and insufficiency. Finally, the sheer and ever-expanding multiplication of the photographic images displays the sitter's continual reliance on images for identity formation, expressing not the freedom of but the repetitive need for identification. The poststructuralist quest for the constant renewal of identity—Donna Haraway's devising of the cyborg as a creature without origins, which forms itself through the continual confusion of boundaries and polymorphous recrafting of bodies, and Judith Butler's plea for a subject that "has no ontological status apart from the various acts which constitute its reality" and whose identity fluidity "suggests an openness to resignification and recontextualization"[49]—is shown to be entrusted to pictures that constantly foil the subject's desire for identity. *I Don't Live Here Anymore* is a crucial series in the artist's elaboration of melancholia: it shows representation to be the lost loved object of the melancholic subject. As it fails to secure the identity of the sitter, it is simultaneously loved and hated, needed and perceived as what betrays the self's quest for authenticity.

If we consider Freud's definition of melancholy loss as it appeared in his "Mourning and Melancholia," a text written and revised to form its final version in 1915 and published in 1917, we can see how Rondinone's (but also Owens's) understanding of representation is grounded in the Freudian formulation of melancholia, in which melancholia

is argued to lie precisely in the inability to grieve the loss of a loved object whose loss, however, can never be clearly identified. In what is perhaps one of the last influential texts on melancholia, published just after Kraepelin's absorption of melancholia into depression, Freud compares mourning to melancholia in the following terms:

> The distinguishing mental features of melancholia are a profoundly painful dejection, cessation of interest in the outside world, loss of the capacity to love, inhibition of all activity, and a lowering of the self-regarding feelings to a degree that finds utterance in self-reproaches and self-revilings, and culminates in a delusional expectation of punishment. This picture becomes a little more intelligible when we consider that, with one exception, the same traits are met with in mourning. The disturbance of self-regard is absent in mourning; but otherwise the features are the same. Profound mourning, the reaction to the loss of someone who is loved, contains the same painful frame of mind, the same loss of interest in the outside world—in so far as it does not recall him—the same loss of capacity to adopt any new object of love (which would mean replacing him) and the same turning away from any activity that is not connected with thoughts of him.
>
> . . . [M]elancholia too may be the reaction to the loss of a loved object. . . . The object has not perhaps actually died, but has been lost as an object of love. In yet other cases one feels justified in maintaining the belief that a loss of this kind has occurred, but one cannot see clearly what it is that has been lost, and it is all the more reasonable to suppose that the patient cannot consciously perceive what he has lost either. This, indeed, might be so even if the patient is aware of the loss which has given rise to his melancholia, but only in the sense that he knows *whom* he has lost but not *what* he has lost in him. This would suggest that melancholia is in some way related to an object-loss which is withdrawn from consciousness, in contradistinction to mourning, in which there is nothing about the loss that is unconscious.
>
> . . . In melancholia, the unknown loss will result in a similar internal work and will therefore be responsible for the melancholic inhibition. The difference is that the inhibition of the melancholic seems puzzling to us because we cannot see what it is that is absorbing him so entirely.[50]

The ambivalence of representation displayed in Rondinone's Walcheturm installation, monumental landscape drawings, and *I Don't Live Here Anymore* photo series is at the center of the psychoanalytical understanding of melancholia. Attentive to the similarities of and differences between mourning and melancholia (as had been his disciple Karl Abraham, whose 1911 article became Freud's theoretical point of departure[51]), Freud observes that two specific aspects distinguish the latter from the former: whereas the lost object in mourning is due to death, the melancholic patient ignores what he or she has lost in this object; and whereas the world seems empty for the mourner, it is the ego that is impoverished in states of melancholia, an impoverishment made manifest by a lowering of self-regard tied to a delusional expectation of punishment.[52] The importance

of these two related traits cannot be overestimated, for they disclose the melancholic narcissistic identification with the lost object. In the Freudian theory of melancholia, the libido freed by the loss of the loved other is reinvested into the self: the patient is said to introject aspects of the other, which then become internalized aspects of the subject. The outside world, as an object of love, is narcissistically denied to the self, to exist only as an unreachable phantasm. Once introjected, the loved object cannot be said to be really lost—it is not only paradoxically both lost and kept as a phantasm, it is also a fundamentally ambiguous object, because the subject doesn't know exactly what has been lost.[53] Psychoanalyst Jacques Hassoun, in his *La cruauté mélancolique* (1995), specifies this founding paradox by stipulating that the melancholic inability to grieve the loved object comes precisely from the consistent experience of the object as not lost, in the sense that it never happened, was never made alive and present, and therefore was never subject to loss.[54] Bluntly, introjection entails that although the melancholic subject seems to be in an acute state of self-reproach, he or she is in fact attacking both himself or herself and the lost, introjected, loved object, following a narcissistic identification of the ego with the lost object.[55] This means that, for Freud, melancholia sets into play a regression to primary narcissism, bringing the ego back to the infant's ambivalent love-hate relationship with the other. In her Lacanian reading of Freud's formulation, Julia Kristeva confirms this view by defining melancholia as a form of disenchantment that resonates with old personal traumas that the depressed has not yet been able to grieve. "The disappearance of that essential being," she specifies, "continues to deprive me of what is most worthwhile in me; I live it as a wound or deprivation, discovering just the same that my grief is but the deferment of the hatred or desire for ascendancy that I nurture with respect to the one who betrayed or abandoned me. My depression points to my not knowing how to lose—I have perhaps been unable to find a valid compensation for the loss?"[56] Melancholia, from the psychoanalytic perspective, is one's experience of abandonment—the belief that the loved object has betrayed one.

Articulating the love-hate ambivalence that underlies the Freudian understanding of melancholia, Rondinone's photographic images persist in their ambivalence, and melancholia rules, as it were, through this persistence. Melancholia thus becomes the mood that discloses how much we expect pictures to be, as art critic Jan Verwoert has insightfully suggested, the "authentic expression of our own uniqueness" and yet feel betrayed, "because they already had masses of other lovers before and beside us, ultimately proving to be the clichés of a culture that enjoys deluding us into thinking, for a time, that we are among those chosen to be individuals."[57] What is this series disclosing, then, if not the undoable knot of melancholia and representation? Art is shown to be the very activity by which representation—the landscape genre and the fashion prototype—is appropriated, separated from its initial context, fragmented but rescued, re-devalued (authenticity is not reached and ambivalence persists), and potentially revalorized in the interpretative activity triggered by its persisting ambivalence. In accordance with Kristeva's understanding of melancholia as "the most archaic expression of the unsymbolizable, unnameable narcissistic wound"[58]—what philosopher Max Pensky summarizes as the

"self-lacerating longing for the prelinguistic Thing, obsessive-repetitive, necessary, and impossible search for the metalinguistic in language, for the unpossessible in desire, for meaning beyond any signification"[59]—melancholia is the experience of an abyssal absence of meaning. Loss—ultimately the loss of original meaning, the immediate meaning prior to the separation of the subject and its objects—is central to the notion of melancholy in that the melancholic subject attempts to recover a meaning that is impossible to recover in any symbolizable form. The Walcheturm installation's polyester cast is precisely this subject, who "broods over fragments" with the hope of reaching meaning through these very fragments so that the enigmatic dimension of fragments may work as an incitement for a renewed interpretation.[60]

In Owens's allegorical art (and also in Walter Benjamin's allegorical thinking on which Owens relies for his own definition of postmodernism), the postmodernist appropriation of images is motivated by an awareness that they must be rescued from historical oblivion: threatened to disappear, caught in the "irreversible process of dissolution and decay, a progressive distancing from origin," the object (or representation, in Rondinone's case) is appropriated so as to counter its irremediable loss.[61] Allegory, a mode of writing or picturing that elaborates a fragmented view of the world to show the world to be a rebus in need of interpretation, is the melancholic attitude par excellence, for it signals both the incapacity to mourn and the hope to recover the lost loved object. This inability is made manifest in Rondinone's ongoing series, which repetitively (re)produces representations as a means to reach authenticity but also denounces, through this very repetition and through the blurring of code and identity, the loss of authenticity. Representation, the loved object, is performed only to be lost again, but never to be lost for good. This aspect is crucial for the assessment of the criticality or uncriticality of allegorical appropriation, as it proclaims that criticism can be articulated through a melancholy perspective, a stand that was denounced two years after the publication of Owens's article, by art historian Benjamin Buchloh, in his "Allegorical Procedures: Appropriation and Montage in Contemporary Art" (1982).

Assessing the work of Sherrie Levine, notably her photographs of Walter Evans and Edward Weston photographs, Buchloh sees in her rephotography an attempt to deplete for the second time the commodity status of the photographs—the loss of their historical meaning due to technological reproduction—so as to reveal this very commodification. Yet, for Buchloh, the "melancholic complacency" of the work only reaffirms what the artist seeks to denounce, as it can bring about only passive contemplation to the detriment of critical negativity:

> The faint historical spaces the work establishes between the original and the re-
> production seduce the viewer into fatalistic acceptance, since these spaces do not
> open up a dimension of critical negativity that would imply practice and encoun-
> ter rather than contemplation. . . . Walter Benjamin, in spite of his devotion to the
> allegorical theory and its concrete implementation in the work of Baudelaire and
> the montage work of the '20s, was aware of the inherent danger of melancholic

complacency and of the violence of the passive denial that the allegorical subject imposes upon itself as well as upon the objects of its choice. The contemplative stance of the melancholic subject, the "comfortable view of the past," he argued, must be exchanged for the political view of the present.[62]

In the case of allegorical appropriation, Owens has convincingly shown, however, that melancholia neither simply nor necessarily activates passive contemplation. Indeed, the "staged" dimension of Sherman's *Film Stills*, the irresolute reading of Longo's *Boys Slow Dance* as both an embrace and a struggle, Rondinone's Walcheturm doubleness (fiction *and* reality, screen *and* window)—these contemplations trouble the viewer's reading activity. If the artists' strategy is to participate in the ambivalence they seek to denounce, it is precisely in order to have the viewer experience that very ambivalence. As Owens argues, "When the postmodernist work speaks of itself, it is no longer to proclaim its autonomy, its self-sufficiency, its transcendence; rather, it is to narrate its own contingency, insufficiency, lack of transcendence."[63] Criticism here is articulated from within, following the premise that there is no privileged point of view outside ambivalence. It is this very reality that melancholy appropriation ultimately discloses—the inability to reach authenticity, to get to the Thingness of things. Hence, even Owens admits that the "urgent necessity" of "distinguish[ing] the dancer from the dance" is precisely what is counteracted in the work. This conclusion also shows that Buchloh is not completely wrong when he states the difficulty of articulating criticism through melancholia; for, in the context of representation's growing encroachment upon reality, even the melancholic call to refuse to grieve the loss of loved realities is condemned to be read with ambivalence. Yet, as Max Pensky has observed in his examination of Walter Benjamin's melancholy dialectics, the creation of ambivalence is itself an incitement to interpret and to produce meaning through interpretation. Although Benjamin, in his "Leftist Melancholia" article of 1931, condemned the work of Weimar intellectuals, which encouraged political resignation under the guise of leftist moral indignation, he understood the melancholy way of seeing as conveying more than mere sadness or passivity, defining it as a critical vision occupied by the question concerning the possibility of meaning, one that the melancholic subject phantasmically attempts to resolve.[64] The denunciation of ambivalence through ambivalence finds its productivity in the renewal of meaning it potentially generates. The melancholic has a redemptive relation to the appropriated image.

I am suggesting here that Rondinone's work elaborates itself precisely as a critical project by which the meaninglessness of the image might activate new meaning. By its insertion of the depressed polyester cast figure of the artist in front of the screen-window image, the Walcheturm installation reveals the artist's difficult task of reinvesting representation after the Pictures generation's assessment of the growing intertwining of reality and fiction. But this figure has not totally lost hope; for the function of the cast is fundamentally that of the "commentator" as it was formulated by Leon Battista Alberti in his *De pictura* of 1435–36 and strongly activated in Domenico Veneziano's St. Lucy altarpiece (ca. 1445), whose role is to solicit the beholder to interpret the image. Similarly

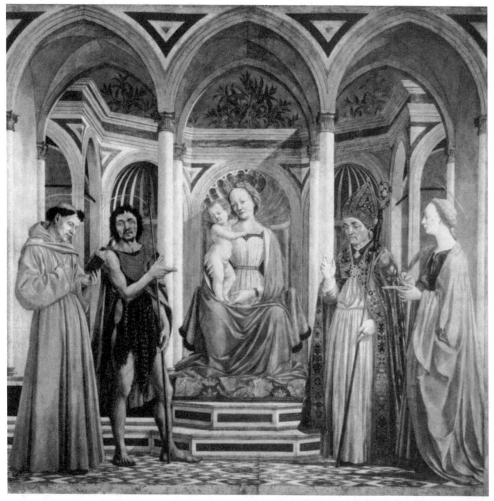

Figure 10. Domenico Veneziano, *Madonna con Bambino e Santi* (St. Lucy altarpiece), ca. 1445. Tempera on panel, 209 × 216 cm. Galleria degli Uffizi, Florence.

to the Albertian painted commentator, "who admonishes and points out to us what is happening there [in the *istoria*]; or beckons with his hand to see; . . . or shows some danger or marvellous thing there; or invites us to weep or to laugh together with them,"[65] the polyester self-portrait forces us not to stay outside the image as mere observers; it brings us into the image to experience its ambivalence and activate a desire for resolution.

This being said, and although the monumental ink drawings and the *I Don't Live Here Anymore* photo series do ground Rondinone's production in the postmodernist allegorical approach to representation, and although Walcheturm confirms this melancholia stance, it is nonetheless hard to see the latter as a mere reaffirmation of appropriation aesthetics. I suggest that it opens up a hiatus between melancholia and depression; for, although the installation attempts, through the figure of the commentator, to both reveal meaninglessness and transform meaninglessness into meaning, it radically intensifies

the melancholic insight into the image's fall into ambivalence. This intensification results from Rondinone's complication of the quattrocento commentator into a self-portrait and its localization *in front of* the image. The cast overdetermines the figure of the commentator by cumulating in the same body the positions of commentator, artist, and beholder. In so doing, it not only asks us to interpret the loss at play in the image but also shows the artist and beholder in a state of *affaissement,* lethargy, and utter withdrawal. The installation is about the increased inability to produce unequivocal images, to represent *tout court.* The appropriationist's hope for distinction has declined substantially, questioning the very productivity of art.

What interests me in Rondinone's work is not so much the persistence of melancholia as the moments when the disposition starts to falter, when the critical vision it sets about begins to be inefficient and is represented as such. It is only then that the realm of depression—or, more precisely, the hiatus between melancholia and depression—comes to the fore. By creating a melancholy amalgam of commentator, artist, and beholder, Walcheturm decreases substantially the possibilities of renewed meaning through allegorical appropriation. It thus starts to question the critical value of melancholia as it also shows how the loss of this value reinforces depressiveness. As we will see, the disclosure of the withering of melancholia, as a creative dialectics by which the experience of loss becomes the very trigger for the recovery of meaning, is an operation that incessantly occupied Rondinone's production after 1995. The video clown series that I will examine shortly is an emblem to the decline of the meaninglessness/meaning, loss/recovery dialectic initiated in Walcheturm. But before turning to these works, it is useful to briefly look at *Sleep* (1999), which abolishes any hope of using melancholia as a counterdiscourse to depression. What this work shows is the fact that it is now the withering paradigm of melancholia that must be perceived in its potential for criticality.

A cliché reply to clichés, *Sleep* is an installation of 167 pale color photographs displayed on a rough board of whitewashed planks, whose assemblage narrates the story of a possible—yet always failed—encounter between a young man and a young woman wandering along the same beach. Here, the tension between authenticity and inauthenticity comes mainly from the contradiction between the musical score and the lighting of the installation. Viewed to the looped music of a female voice slowed down to a man's pitch, singing, "Sleep. I won't wake up. I haven't closed my eyes in days," the photographs are backlit by thirty floodlights in rainbow colors (green, magenta, orange, blue, and yellow), whose rays glare through the cracks between the slats of the planks. Whereas the monotonous music supports the viewer's entering into the story of the lovers' impossible encounter, the lighting stages the photographs as visual fabrications of romance, with the promise of rainbow happiness.[66] In this work, the viewer is thus confronted with the reality of generic soap opera. The installation is a romantic stereotype of impossible love: as the man and the woman search for true love, they will never meet—each walks alone among the dunes in a different direction and looks out at the ground, at the sea, or into the distance but never in the other's direction nor toward the camera. The disclosed typified Harlequin mise-en-scène turns romantic longing into what art critic

Figure 11. Ugo Rondinone, *Sleep*, 1999. White wooden wall, 167 white-framed photographs, 30 colored spotlights, 15 speakers, dimensions variable. Courtesy of Galerie Schipper & Krome, Berlin, and Galerie Eva Presenhuber, Zurich.

Jan Avgikos has called the "look" of romantic longing: not melancholia but fashionable melancholia.[67] Hence, the strain between authenticity and inauthenticity can barely be sustained, as the latter has completely absorbed its opposite. Melancholia is thus disclosed as a ready-made, and Rondinone's oeuvre clearly becomes a melancholy quest for authenticity conscious of the coded nature of this quest. Once melancholia is understood as yet another conventional and highly commodified discourse, there is no possible coming back to Freudian melancholia. Fed by *Heyday,* which disclosed the artist's increased inability to produce unequivocal images—to represent *tout court*—*Sleep* displays the increased inability to deploy melancholia as a critical representation of loss of meaning. With this piece, the aesthetic strategy of disengagement may be said to enter clearly into the work. Indeed, whereas previous artworks speak about art's withdrawal from reality (its increasing inability to represent reality and representation's absorption of the latter) in a melancholy discourse of loss that maintains the artist's or viewer's attachment to that lost reality, the 1999 installation breaks that attachment. This is not to say that melancholia totally disappears—it persists throughout the art production—but its cognitive, creative, even poetic dimension is disclosed as faltering. In Rondinone's art production, melancholia is thus never a straight affair, for it is a state that is both of loss and in loss, a state that struggles with depression on each side of Ebtinger's hiatus.

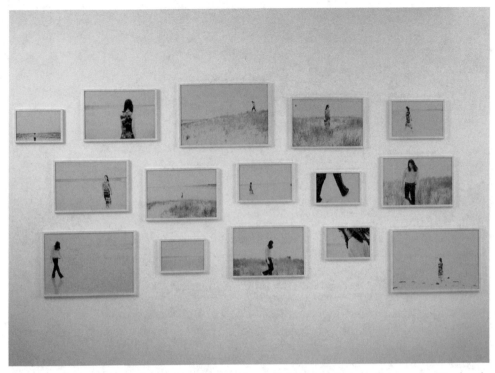

Figure 12. Ugo Rondinone, *Sleep*, 1999. White wooden wall, 167 white-framed photographs, 30 colored spotlights, 15 speakers, dimensions variable. Courtesy of Galerie Schipper & Krome, Berlin, and Galerie Eva Presenhuber, Zurich.

The Melancholia of Art

To understand this larger motif, it is important to identify the tradition that has been so crucial for the association of melancholia, criticality, and art, a tradition that is being both resurrected and lost in Rondinone's work: the doctrine of melancholia in art. The tradition that will be mapped out here (a tradition that is more of a debate than a fixed idea of the melancholy of art) is exactly what is signaled as vanishing in the post-Walcheturm production. As we consider this disclosure of disappearance, I hope to make clear that the "why?" of melancholia—Rondinone's persistence in keeping this notion if only to show its growing obsolescence—has everything to do with the requirement to show its loss (through disengagement) so as to think anew contemporary art's potential as a creative, critical practice. As I intend to show later on, the disclosure of the withering of melancholia is itself a critique of the psychiatric absorption of melancholia into the category of depression, an absorption that has emptied depressed mental illnesses from their creative, critical dimension.

Raymond Klibansky, Erwin Panofsky, and Fritz Saxl's *Saturn and Melancholy: Studies on Natural Philosophy, Religion, and Art* (1964) is one of the key art historical studies to have examined the historical association of art and melancholia as initiated in the Aristotelian

reformulation of the Hippocratic doctrine of the four humors. Their analysis is remarkable in its attempt to follow the transformations of the notion of melancholy in art and philosophy, and in its defense of a dimensional view of the categories of melancholy and melancholia according to which mental illnesses unfold along a continuum ranging from normality to abnormality. The major studies dealing with the historical development of melancholia and depression all agree on the following point: the dimensional view of melancholia began with the Aristotelian *Problemata,* book 30, which ceases to consider the affection as a mere pathology (despite its devastating effects) insofar as it connects melancholia with creativity and intellectual brilliance.[68] In the Hippocratic thesis of the four humors (phlegm, blood, yellow bile, and black bile), from which derives that of the four temperaments (the phlegmatic, the sanguine, the choleric, and the melancholic), melancholy was the most markedly pathological and destructive of all temperaments, a distinction facilitated by the fact that the disease called melancholia was characterized by symptoms of troubling mental change (including fear, misanthropy, depression, delusion, obsession with death, delirium, and madness) and physical deterioration (including lethargy, slowness, sleeplessness, and irritability) with a physical origin—the black bile.[69] The Hippocratic writings established a typology of four temperaments perceived to be a set of specific predispositions for specific illnesses. But although temperament and disease were related, they still remained distinct. This distinction started to erode itself with Plato, not so much through a revaluation of melancholy humor, which became primarily a form of moral insanity, as through his formulation of divine frenzy, in which mania and high spiritual exaltation were inherently connected. As Klibansky, Panofsky, and Saxl have suggested, the Aristotelian notion of melancholy merged the medical concept of melancholia and Platonic frenzy. The association found its formulation in the following question, raised in book 30 of the *Problemata,* thought to have been written by a follower of Aristotle rather than Aristotle himself:[70] "Why is it that all those men who have become eminent in philosophy or politics or poetry or the arts are clearly melancholics, and some of them to such an extent as to be affected by diseases caused by the black bile?"[71] Among the eminent men working in the fields of art, poetry, philosophy, and statesmanship believed to be "melancholics by constitution," pseudo-Aristotle names the tragic heroes Ajax, Heracles, and Bellerophon, along with Socrates and Plato.[72] Caused by an imbalance of the black bile, melancholia was postulated as varying from one individual to another according to age and in relation to the temperature of the black bile; heat and cold produced quite different effects, with heat being "located near the seat of the intellect" and so the most susceptible to triggering brilliance, eroticism, anger, exaltation, and ecstasy.[73]

Notwithstanding these variations,[74] what is important to emphasize in light of the melancholia-depression hiatus I am describing here is that the Aristotelian reformulation of the Hippocratic theory of the four humors ceases to perceive the sharp distinction between natural melancholy and pathological melancholia, melancholy, and genius as antinomic. They are tied together,[75] for even a moderate melancholy can transform itself into a true disease either under the effect of the provisional increase of the quantity of

bile or under the influence of heat and cold on the temperature of the bile, which can induce "paralysis or torpor or depression or anxiety" when cold or "cheerfulness, bursting into song, and ecstasies and the eruption of sores and the like" when overheated.[76] Indeed, though still considering melancholy as the most devastating of all humors, the Aristotelian *Problemata* 30 became, as philosopher Giorgio Agamben rightly stipulates, "the point of departure of a dialectical process in the course of which the doctrine of genius came to be joined indissolubly to that of the melancholic humor under the spell of a symbolic complex whose emblem ambiguously established itself in the winged angel of Dürer's *Melencolia*."[77] Always risking an excess of black bile but endowed with a predisposition to great accomplishment, the melancholy artist walks on a narrow path "between two abysses"—temperamental and pathological melancholia; *état d'âme créateur* and forceful depression.[78] Psychiatrist Hubertus Tellenbach suggests that the assumption of such a precarious walk is formulated in Plato's and pseudo-Aristotle's designation of sickness as *ametria*, a loss of measure found only in mania or melancholia, and inherent to the genius:

> What on the one hand is sickness rooted in *ametria*, deviation from the life path, is on the other hand—in the existence of genius—*symmetria* or *meson*. The glooms and ecstacies of genius—indistinguishable in mere appearance from morbid states, because phenomena lying outside the biopsychic distinction of normal and abnormal—are capable of being the expression of an innate measure in the human being of genius. Consequently what can bring him out of this measure into *ametria* has an altogether different character. The genius enters into *ametria* when he moves away from being himself, which may be considered as the real "illness" of genius, in fact his "death."[79]

As the Aristotelian notion reemerged in the fifteenth century, in the context of the advent of *Homo literatus*, notably through the work of Neoplatonist philosopher, physician, and priest Marsilio Ficino, it also made its way into visual arts, notably in *Melencolia I*, Albrecht Dürer's engraving of 1514. Ficino, who perceived himself as melancholic, reestablished the Aristotelian dialectical understanding of melancholy by ennobling the influence of Saturn, still considered to be the most malefic of planets directly associated with melancholy humor.[80] For Ficino, most intellectually remarkable men (his comments were gender-exclusive) were under the influence of Saturn and thus suffered from melancholia, but the latter—and this accounts for genius achievement—took the form of "divine contemplation": "[The black bile] raises thought to the comprehension of the highest, because it corresponds to the highest of the planets."[81] Furthermore, his doctrine established that it was only the body and man's lower faculties that were subject to the influence of the planets; the faculties of the soul—*imaginatio* (imagination), *ratio* (discursive reason), and particularly *mens* (intuitive reason)—were free of astral influence.[82] Thus, although the creative melancholic genius was under Saturn, it was only his body and lower faculties that were subjected to it. This entails that the melancholic philosopher had the aptitude to engage himself in the highest intellectual activity of contemplation, which occurs only in

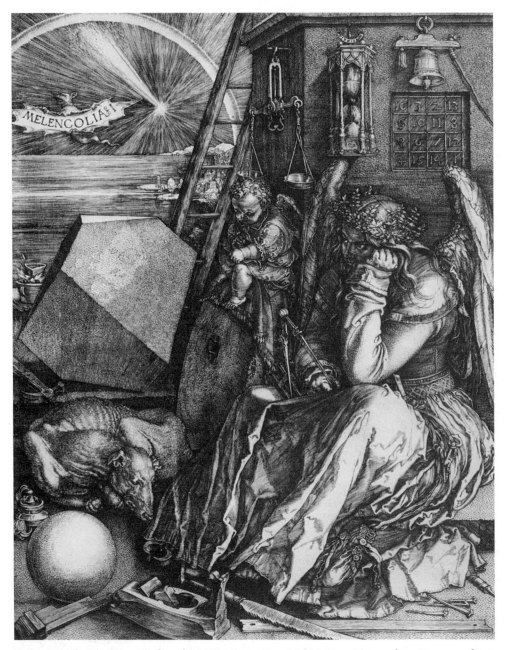

Figure 13. Albrecht Dürer, *Melencolia I,* 1514. Engraving, 24 × 18.5 cm. Metropolitan Museum of Art, Harris Brisbane Dick Fund, 1943.

the *mens,* so as to counteract astral danger "by the very act of turning voluntarily towards that very same Saturn."[83] The Renaissance's new humanist was therefore heightened to a position of self-sufficiency only to be split between the extremes of self-affirmation and self-doubt unto despair.[84] The new intellectual model was that of the modern genius, who could recognize himself only under the redefined sign of Saturn and melancholy.

Klibansky, Panofsky, and Saxl's argument is by now well known. Dürer's *Melencolia I* "owes a debt to the notion of melancholy propagated by Ficino, and would, in fact, have been quite impossible but for this influence," despite the fact that "this assertion can be based only on internal evidence from the engraving itself."[85] Ficino's influence is particularly notable in the engraving's elevation of melancholia to the dignity of the symbol, one that created a true concordance between an abstract notion and a concrete image. Dürer's representation is neither a personification of the black bile—a human figure incorporating the abstract and impersonal notion of melancholy, as in the miniature *The Ages of Man and the Temperaments* from the *Tractatus de quaternario* of about 1100, which relies on the legend to identify the temperament in question—nor an exemplification of the abstract and impersonal notion of melancholia with its consequent loss of universality, as in fifteenth-century representations of the sinful sloth.[86] As an allegorical realization of melancholia, Dürer's winged woman "*is the image of* an abstract and impersonal notion symbolised in a human figure," so that the spectator may conclude, without relying on a legend or on the identification of an iconographic convention, that this figure is melancholy itself and not the example of a melancholy state or person; so as to reach a form of universalization.[87]

It is crucial here to underline that, from Klibansky, Panofsky, and Saxl's art historical, specifically iconographic, point of view, the linking of melancholia and genius relies on the unifying view of allegory implicit in the Warburgian heroic understanding of the melancholy artist—a perspective that was later abandoned by Walter Benjamin in his rereading of Panofsky and Saxl's study of the engraving, and that is totally absent from Rondinone's work, where the principle of allegorical unity collapses in favor of a dialectical tension between meaning and meaninglessness, creativity and fall, fiction and reality. For Panofsky and Saxl, Dürer's allegory unites the idea and the image of melancholia in the single figure of the winged woman, while it also replaces the association between melancholia and sloth by a connection to contemplation. This new unity allows for a heroic form of melancholia, one that confirms Ficino's belief in the power of the individual to turn "voluntarily" to Saturn and to apply himself to the spiritual contemplation provided by this planet so as to counter melancholia's devastating effects, a movement that turns the planet against itself.[88] Dürer's innovation encompasses yet another process of unification: the engraving is the site of a pictorial fusion of the portrait of *ars geometrica* with that of *Homo melancholicus,* a melancholic Geometria, as it were, whose essential characteristic "is that she is doing nothing with any of these tools for mind and hand, and that the things on which her eye might rest simply do not exist for her. The saw lies idly at her feet; the grindstone with its chipped edge leans uselessly against the wall."[89] The studio has become a chaos of unused objects, but the inaction of Melancholy ceases to correspond to "the idler's lethargy and the sleeper's unconsciousness" so as to represent "the compulsive preoccupation of the highly-strung."[90] An imaginative, spiritual, contemplative Melancholy is thus operative, with the hope that it may overcome the surrounding chaos. It is this unity of *ars geometrica* and *Homo melancholicus* that, for Klibansky, Panofsky, and Saxl, is in the end the true innovation of the work. As these two

figures are merged into one, *Melencolia I* endows Geometria with a soul and Melancholy with a mind, showing that the art of geometry belongs to the sphere of human struggle and failure and that the animal heaviness of the sad temperament can be elevated "to the height of a struggle with intellectual problems."[91] The new meaning lies precisely in its association of geometry—the art of measurement par excellence, which was for Dürer an essential aspect of the artist's practice[92]—and melancholia, which raises the activity of imagination to melancholic insight: "*[Melencolia I]* is above all an imaginative Melancholy, whose thoughts and actions all take place within the realms of space and visibility, from pure reflexion upon geometry to activity in the lesser crafts; and here if anywhere we receive the impression of a being to whom her allotted realm seems intolerably restricted—of a being whose thoughts 'have reached the limit.'"[93] The engraving therefore both confirms and enlarges Ficino's doctrine, which related melancholia exclusively to creative intellects engaged in contemplation, the highest level of intellectual life, where the mind was notably delivered from the chains of imagination.[94] By enhancing the value of imagination, *Melencolia I* elevates Geometria to the melancholy sphere but also shows its limits: art's inability to reach the incorporeal, metaphysical realm when exclusively based on geometry.[95]

Although Klibansky, Panofsky, and Saxl are right to point out Dürer's innovative rapprochement between *ars geometrica* and *Homo melancholicus,* and although *Melencolia I* can be said indeed to reactualize the Aristotelian association between black-biled temperament and disease, their understanding of the image as overcoming the medical distinction of pathology and creative genius ("Herein lies the greatness of Dürer's achievement; that he overcame the medical distinctions by an image, uniting in a single whole, full of emotional life, the phenomena which the set notions of temperament and disease had robbed of their vitality; that he conceived the melancholy of intellectual men as an indivisible destiny in which the differences of melancholy temperament, disease and mood fade to nothing"[96]) sets out to confirm Renaissance art as the paradigm of unity and wholeness. This paradigm also underlies their conception of allegory as the site of fusion between the idea and the image of melancholia. Yet, as Walter Benjamin and, more recently, Rudolf and Margot Wittkower, Giorgio Agamben, and Max Pensky have argued, the Aristotelian formulation and Neoplatonist reformulation of melancholia do not abolish the difference between disease and contemplative genius but connect them dialectically.[97] Responding to Panofsky and Saxl's 1923 work on Dürer's engraving, Benjamin insists on the importance of acknowledging how Ficino considered Saturn to be a malefic influence and melancholia a primarily unhappy condition. Melancholia's effect had to be limited with the help of medicine—including herbal, dietetic, astrological, and magical remedies—cosmology, ethics, and philosophy.[98] Creative melancholia would emerge exclusively through contemplation, the only operation that could counteract astral danger "by the very act of turning voluntarily towards that very same Saturn."[99] Although Benjamin relies heavily on Panofsky and Saxl's study of *Melencolia I* for his own examination of melancholia, he argues that the art historians' concentration on the individuality of the subjective melancholy genius prevented them from understanding

that genuine creativity comes about not in the individual but, as Pensky has observed in his study on Benjamin, "between subjectivity as such and the physiognomy of its object realm," between contemplation and pathology, between creative access to order and a fall into dead nature.[100] Saturnine imagery does not articulate the heroic triumph of unity and reason over sloth or apathy *(acedia)* but subjects humans to the earthly, the decayed, the fragmented—an operation made manifest for Benjamin in the image of the stone in *Melencolia I,* which he saw as a symbol of inert mass. Pensky convincingly grasps Benjamin's insight when he observes that, in the latter's examination of Renaissance art and baroque *Trauerspiel,* art, creativity, and melancholia are associated in a dialectic of meaning and meaninglessness: "The hopeless loyalty to the world of things constitutes, in the *Trauerspiel,* what in the Renaissance emerges as the creative dimension of melancholy genius: both illustrate the dialectic of melancholy as the subject plunges even deeper into the fragments of an empty world in order to produce a profusion of objects for its own contemplation."[101]

The relation between art and melancholia, thus, can be truly understood only if one considers what should be called the phantasmic nature of the melancholic attempt to reach the truth of the Thing while fully aware that It is inaccessible and can only be, at best, reconstituted by imagination (a phantasmic imagination through which the self seeks to escape the ascendancy of reality over it to retrieve the lost object). This aspect is absent from Klibansky, Panofsky, and Saxl's account. Although the study is attentive to *Melencolia I*'s attempt to raise imagination to the height of inspired melancholy activity, it fails to acknowledge the crucial role of phantasm in melancholia—an acknowledgment that would have questioned the view of the Renaissance as a paradigm of coherence and heroic melancholia. Yet the phantasmic dimension of melancholy illness had already been recognized much before Dürer, in the medieval scientific studies of Ramon Llull and Albertus Magnus, as well as in Ficino's writings.[102] Moreover, it found its pictorial association only a few decades after Dürer's completion of *Melencolia I,* in Romano Alberti's treatise on painting, *Trattato della nobiltà della pittura,* of 1585.

Defining art as a phantasmic activity, Alberti situates the painter's melancholia in the very act of imitation, which is always grounded on loss because of the impossibility of representing nature as it is (the passage of time ineluctably alters the objects under observation) without the mediation of imagination. This description shattered the view of another Alberti (Leon Battista), who argued in his own treatise on painting, in 1435–36, that painters painted what they saw. To paint, explains Romano, the artist relies on phantasm—a mental, abstracted impression of nature that might easily take the form of a daydream recall or a fantastic fictionalization distorting initial perceptions—which signals the remoteness of what was initially seen: "Painters become melancholics because, wishing to imitate, they must retain the phantasms fixed in the intellect, so that afterward they can express them in the way they first saw them when present; and, being their work, this occurs not only once, but continually. They keep their minds so much abstracted and separated from nature that consequently melancholy derives from it. Aristotle says, however, that this signifies genius and prudence, because almost all the ingenious and prudent have been melancholics."[103]

As Agamben suggests, the traditional connection between melancholia and art "finds its justification" in the phantasmic dimension they both share: "Both place themselves under the sign of the *spiritus phantasticus,* the subtle body that not only furnishes the vehicle of dreams, of love, and of magical influence, but which also appears closely and enigmatically joined to the noblest creations of human culture."[104] The melancholia generated by the very activity of art thus asserts art as a medium of dream, imagination, fantasy, and poetic transformation.

Although never explicitly referring to but clearly expanding on Romano Alberti's statement, French philosopher Sarah Kofman has also argued that the melancholy state emerges specifically from the artist's acknowledgment of the limits of mimesis and concomitant impulse not to fill the gap between the perceived and the fantasized. The heuristic of melancholia in art lies precisely here: in the artist's deployment of a representation that does not resolve the indubitable distance separating imitation and the imitated. In Kofman's examination, what is postulated as being lost in the act of making art takes different names: reality, beauty, fleetingness, vicissitude—all that, in the pictorial system of mimesis (but not exclusively there), is desired by the artist yet impossible to represent in its fullness. Her study proposes certainly one of the most insightful understandings of the tradition of melancholia in art produced in the last decades, because of its ability to address not only the "what" and the "how" but also the "why" of representation. As she considers this latter question, Kofman makes sure to underline the melancholic demand *not* to consider the gap between representation and reality as opposing irreconcilable realms and to envisage it, on the contrary, as the very site in which antinomies both oppose and come closer together. Critical of the speculative philosophical tradition that attempts to resolve the question, what is art? by a series of metaphysical oppositions between art and nature, appearance and reality, form and content, matter and spirit, Kofman maintains that melancholia is inherent to artistic practice when the question of art is acknowledged as an irresolvable one; for art is what "solicits" the metaphysical system of oppositions, bringing about, through this very solicitation, the *inquiétante étrangeté* that emerges each time the double is maintained, each time art fails to fully render life.[105] The double, contends Kofman, worries and panics artistic activity: "This is why beauty is never exempt of melancholia: it is as though in grief of philosophy. With art, there is no simple negative work but a work of grief which cannot be relieved by any mastering dialectics."[106]

It is in her reading of Diderot's Salon writings on Jean-Baptiste Greuze's *Le malheur imprévu* (before 1763) and *Une jeune fille qui pleure son oiseau mort* (Salon of 1765) that Kofman's connection of melancholia and creativity comes to the fore. Following Diderot's invitation to go beyond the literal reading of the dead bird or broken mirror as the cause of the girl's sadness (Diderot: "This child cries for something else, I tell you"), she suggests that Greuze's paintings are about the irrevocable loss of any loved object. "[T]he bird," writes Kofman, "is always already flown away, the mirror broken, cracked, and it is this break of meaning over which the young girl cries, the loss, with the mirror and the bird, of all reference, and hence of all discourse; she cries over the 'sacrifice' of

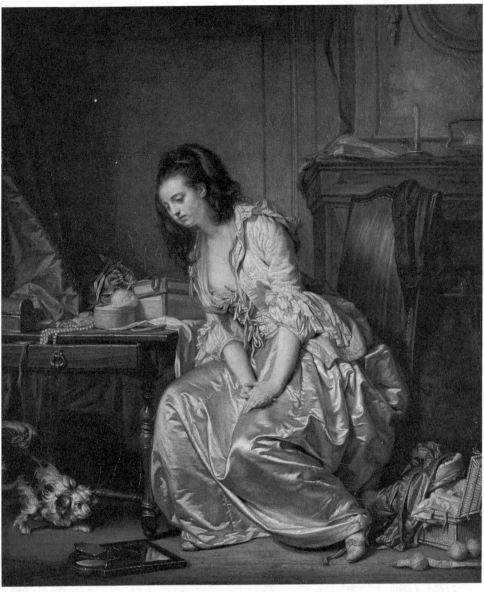

Figure 14. Jean-Baptiste Greuze, *Le malheur imprévu (The Broken Mirror)*, before 1763. Oil on canvas, 56 × 45.6 cm. Reproduced by kind permission of the trustees of the Wallace Collection, London.

the subject or the loss of the object, what, indeed, according to Freud, engenders melancholia until the work of grief is accomplished."[107] But this loss can be conveyed only if mimesis lets go of its imitation thrust. The necessity to go with loss is set into play in Diderot's concomitant celebration of the artist's technical ability to imitate reality—to enter the game of mimesis—and condemnation of academic painters who rely on rules and conventions so as to rigorously imitate nature. This double operation is the basis of his formulation of an aesthetics that admits the gap between art and reality. Writing on

the portraits of La Tour for the Salon of 1767, Diderot supports the rule of imitation but wants to restrain the rigor of imitation for the sake of a creative mimesis.[108] Reproductive mimesis—the portraitist's rigorous adherence to the rule of imitation by which the portrait must resemble the model—has a pharmaceutical function inasmuch as it works as a counterinvestment to the anguish that comes about when one attempts to convey, in art, the losses inherent to reality: the passage of time, fleetingness, absence, vicissitude, the flow of identity, and the irreversible decay of flesh. What Kofman is defending here is Diderot's conception of a creative mimesis—the art of embellishment and idealization of nature—that follows the melancholic impulse to face, instead of camouflaging or making bearable, the unbearable losses of life, a conception that confirms the fundamental gap between art (its long-lasting durability and fixation of signs) and life (its ephemeral and fleeting nature):

> There is no art—art that lasts—and, by definition, there is no art without this duration which is its time proper by opposition to the fugitive instant of life, without a minimal gap between imitation and the imitated. The minimum of "poetics" of all art holds precisely in the fact that art introduces duration and fixedness where there is only fugitive and evanescent life. . . . Indeed, what makes the rigorous imitator mad is that he cannot render the vicissitude of flesh, the ephemeral and fleeting character of all things, the absence of identity of the model that continually changes under his eyes, to his great torment.[109]

Aesthetics can thus be said to be a melancholia that goes with loss inasmuch as the reality that the artist attempts to represent is unreachable but systematically desired. Defined as such, aesthetics is the antipharmaceutical function par excellence, refusing the numbing, protective, and reanchoring effects of pharmaceuticals. When it resists reproductive mimesis, it opens up to evanescence, death, and horror. Facing it, the artist or viewer cannot stand up, dominate the scene, and be guarded from the madness of loss that would be safely "represented" in the image. Melancholia must therefore be considered an aesthetics whose main productivity is to disclose representation's inability to fully render life and to fully oppose life and death, presence and absence, durability and fleetingness, while simultaneously searching for this unreachable reality. In so doing, it ensures the creativity of mimesis. Melancholia is the locus of this creativity. The contemplative angel in Dürer's *Melencolia I,* then, could well be, as Agamben has suggested, "the emblem of man's attempt, at the limit of an essential psychic risk, to give body to his own phantasies and to master in an artistic practice what would otherwise be impossible to be seized or known."[110] The now useless tools signify the epiphany of the unattainable to a melancholic winged figure for whom "only what is ungraspable can truly be grasped."[111]

Not only has melancholia thus been traditionally associated with art, but also its productivity lies in the psychic life of dreams and phantasms, the aptitude *not* to make the economy of death and horror, the refusal of the numbing effects of pharmaceuticals, and the allegorical impulse to both reveal meaninglessness and transform it into the possibility of meaning. I want to suggest that this melancholia, so characteristic of Rondinone's

monumental landscape drawings and the *I Don't Live Here Anymore* photo series, is precisely what starts to falter in the Walcheturm installation. By inserting a polyester cast of the artist—whose gaze "is lost on the floor, all energy dispersed" and whose body "lies on the ground having given up the struggle against gravity, the instinct to do something"—into the empty space in front of the window/screen image, Walcheturm brings the tradition of melancholia in art to the fore.[112] But the crystallization of the positions of commentator, artist, and beholder in one single figure turns the viewer into a mere consolidation of the artist's state of withdrawal, lethargy, and despair. In so doing, the installation narrows down the melancholy possibility of reopening meaning through interpretation. Creative melancholia is also what is being shattered in *Sleep* as melancholia is itself transformed into a ready-made. By showing melancholia to be a mass-media fabrication, just another cliché propagated in popular representations of romantic love, the 1999 installation worries the black-biled mood; it brings it to the fore only to accentuate its increased commodification. This is to say that if Rondinone persists in his melancholy approach to images, image making, and art, it is ultimately to declare the decline of what melancholia once engendered: the possibility of artistic inventiveness (jeopardized by its mass-media reification).

The Decline of the Melancholy Sense of Loss

It is surely in Rondinone's representation of clowns that this decline is most markedly formulated. But, as I hope to show, it is in this series as well that the possibility of depressed inventiveness is most strongly suggested. The clown is a recurrent figure in Rondinone's work. Since 1992, it has ceaselessly made its appearance in performances, videotapes, installations, notebook covers, graffiti paintings, Polaroid photographs, and sculptures.[113] Although Rondinone has performed as a clown himself, most of his artworks rely on actors and models. Adopting a similar attitude to that of the polyester self-portrait of the Walcheturm installation (a similarity to which I will come back, to show how the clown functions as an alter ego of the artist), his clowns are characteristically lying down or sitting against walls. Flabby, feeble, worn-out, mute, bored, quasi-immobile (if they move it is only to change positions for the sake of comfort), and absolutely passive, the clowns have abandoned their role as entertainers. In *Dogdays Are Over,* for example, a work presented in 1996 at Zurich's Museum für Gegenwartskunst, Rondinone created a multichannel piece that took the form of both a performance and a video installation, whose main figures were clowns who had renounced making the public laugh. At the exhibition's opening, middle-aged clowns lounged passively on the floor. Sound devices equipped with sensors had been fixed to the ceiling to generate an outburst of laughs activated by the visitor's entrance into the gallery space. For the remainder of the exhibition's run, the clowns were replaced by their videotaped portrait, played on different monitors installed precisely where each clown had sat or lain down.[114]

In a later version of the installation, *Where Do We Go from Here?*, presented at the 1996 São Paulo Biennial and in 1997 at Le Consortium in Dijon, the gigantic buffoon

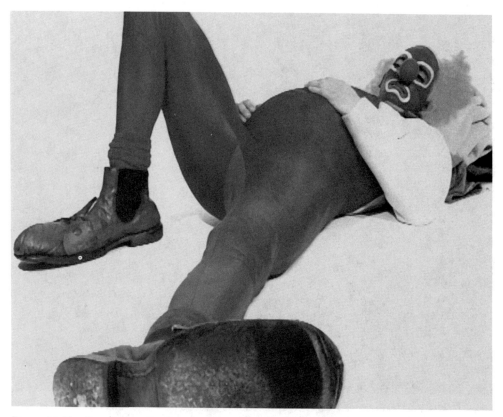

Figure 15. Ugo Rondinone, *Dogdays Are Over,* 1996. Six VHS PAL videotapes (each 30 minutes), twelve speakers, twelve sensors, sound (laughter). Edition of 2 + 1 AP, dimensions variable. Collection Migros Museum für Gegenwartskunst, Zurich. Courtesy of Galerie Eva Presenhuber, Zurich.

images were projected onto the four walls of a dark, enclosed, rectangular room. In this version, two projections were displayed on the wall facing the viewer as he or she entered the space, and two other projections were shown separately on the right and left adjacent walls. As in *Dogdays Are Over,* Rondinone presented mute, passive clowns "permanently cut loose," to quote art critic Catherine Millet, "from the laughter they once provoked."[115] The laughs, triggered by the visitor's walk into the space, had the effect of reversing the roles of viewer and artist: the object of the laughter was not the clowns but the spectator. As described by Pierre-André Lienhard, "It is thus the viewers themselves who, by progressing across the space, set off a series of outbursts of laughter. The gigantic dimensions of the clowns are impressive indeed, but far more spectacular still is the breach between their immobility and the gales of at times almost hysterical laughter."[116] The electronic triggering of prerecorded laughs revealed simultaneously the clowns' loss of entertainment value, the disembodiment of laughter due to its technological reproduction, and the breach of contract between the public and the clowns. Neither activated by the clowns nor coming from the visitors, the outbursts worked mostly as a sound screen that both estranged the habitual link between the public and its entertainers and protected the

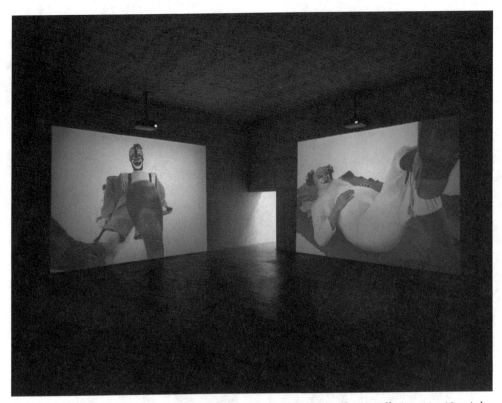

Figure 16. Ugo Rondinone, *Where Do We Go from Here?* 1996. Four video installations, 4 × 10 m ink-on-wood drawing, neon light, sound. Edition of 2 + 1 AP, dimensions variable. Fond National d'art contemporain, Paris, on permanent loan at the Musée d'Art Contemporain, Strasbourg. Courtesy of Galerie Almine Rech, Paris, and Galerie Eva Presenhuber, Zurich.

clowns from the public's presence. Such a distancing can only, in the end, emphasize the clowns' loneliness, isolation, abandonment, persisting passivity, and lethargy. Whereas the allegorical Walcheturm installation managed (although in a highly restricted way) to reactivate the ambivalence of the image so as to interpellate the beholder into its interpretative activity, the clown figures have been divested of their virtuosity in reaching the viewer through laughter. The melancholy dialectic between loss of meaning and recovery has been called to a halt. This is where the hiatus between melancholia and depression comes about. In other words, Rondinone's aesthetics now articulates a "flaw of adaptation and creativity."[117]

To understand this shift, one must be attentive to one of the main features of both *Dogdays Are Over* and *Where Do We Go from Here?,* namely, the immobilization of the clown figures, their disclosure as beings in a state of quasi-death. It is also important that we keep in mind Pierre Fédida's phenomenological description of depression as "a conservation of the living under its *inanimate* form."[118] In one of the middle projections, a clown with a yellow face is shown sitting on the floor against a white background, facing the viewer as though waiting to be filmed or photographed. He poses and, as he poses,

transforms himself into a still image.[119] In his examination of the photographic nature of the pose, Craig Owens has suggested that the pose enacts the subject's desire to be apprehended as a picture. It is a form of anticipation of the camera shot, which transforms the body into a still as it waits to be photographed: "What do I do when I pose for a photograph? I freeze . . . as if anticipating the still I am about to become; mimicking its opacity, its stillness; inscribing, across the surface of my body, photography's 'mortification' of the flesh."[120] This operation is the very process represented in the yellow clown projection. In other words, the pose here doesn't merely anticipate the camera shot but is shown, through video, in its full temporality. The pose of the clown articulates a "stilling" of the self extended to the thirty minutes or so of the projection, as though the clown keeps anticipating both the still he will never become and the memory he will never come to represent. Images fail to fix him for posterity, so the dissolute clown waits in a state of quasi-immobility. It is true that, as time passes, the stilling introduces a slight transformation in the clown's posture, but this is only to expose us to a growing sagginess and increasing immobilization. As we will see in chapter 2, the stilling of the body and gradual disintegration of the pose also structure Vanessa Beecroft's work. In her performances, however, disintegration leads to the deployment of the coping activity of the performer, who affirms her identity in this very act of coping. With Rondinone, depression sets in to inscribe the clown in a dynamic of wait devoid of the Beecroftian belief in adaptation. The eyelids become heavier, and the eyes seem increasingly locked up in the arc of their encircling makeup. Concomitantly, the smile becomes frozen. The clown is stilling to be recognized, seen, filmed, or photographed.

The three other clown projections of *Where Do We Go from Here?* all convey a similar state of depressiveness, intermixing body heaviness and withdrawal, entrapment and inability to move, so as to consolidate depression as a loss of creativity. On the right wall, a white clown lies on his back diagonally to the screen, his head slightly raised toward the viewer. Static except for a few body readjustments, the clown moves his eyes to indicate a state of awakening despite the body's immobility. The emphasis here is on the clown's round belly, whose protuberance is accentuated by the diagonal positioning of the body. The recurrent sound of a balloon being blown up followed by the expiration of air makes manifest, by contrast, the motionlessness of the clown's belly. The body appears to be full of air, but no expiration takes place. The breathing—the process of inhaling and expulsing air, which signals the victory of life over death—is taking place elsewhere, either aurally in the balloon or implicitly underneath the fabricated belly.[121] Motionlessness, further emphasized by the static hand covering the stomach, is crucial here, for it signals the infiltration of the inanimate into the animate. Further down on the left wall, two additional clown projections confirm the near-paralytic state of the depressed.

Whereas the photographic image, as Roland Barthes has suggested, touches us in its ability to disclose what was once there in front of the camera and so to expose the viewer to the ineluctability of death, the video rendering of the waiting clowns discloses a never-ending death in the making.[122] The temporality of video divulges the presence of death in life, the anticipation of death in life. Indeed, all these clowns act as though

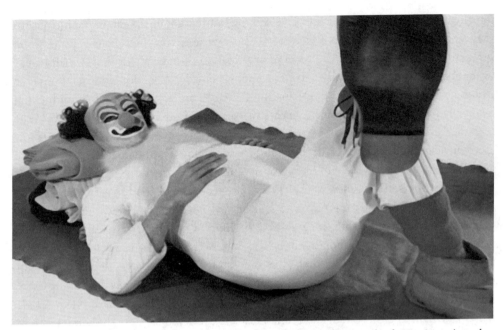

Figure 17. Ugo Rondinone, *Dogdays Are Over*, 1996. Six VHS PAL videotapes (each 30 minutes), twelve speakers, twelve sensors, sound (laughter). Edition of 2 + 1 AP, dimensions variable. Collection Migros Museum für Gegenwartskunst, Zurich. Courtesy of Galerie Eva Presenhuber, Zurich.

they were inanimate despite the obvious fact of their animation (the eyes are always explicitly in motion). Enacting what constitutes for Pierre Fédida one of the main features of depression—the subject's identification with death—they imagine inanimate life:[123] "Depression is this experience of disappearance [of self] and this fascination with a *death state*—perhaps a *dead person*—which would then be the sole capacity to stay an inanimate living being."[124] In a similar vein, psychoanalyst Alexandra Triandafillidis maintains, "Although the depressed 'acts like a dead person,' although he 'mimes death,' the suspension remains as though animated from the inside, vibrating from the waiting which determines it. . . . In other words, the depressed *anticipates death*: he lives 'the incoming death' *following the model* of the 'death' he has already lived and which he has survived. . . . The grief that is inaccessible to the depressed, would it not be paradoxically the *grief of death* . . . ? . . . [U]nable 'to kill death,' the depressed cannot live life."[125] In *Where Do We Go from Here?* the deathlike status of the clowns thus discloses the association between depression and the loss of melancholia: that is the loss of insight, creativity, imagination, the power to make laugh, and even criticality.

The nature of this loss becomes manifest when contrasting Rondinone's work with the *Clown Torture* installation produced by Bruce Nauman in 1987, a work that *Where Do We Go from Here?* both quotes and collapses. In Nauman's four-monitor and two-projection installation, the tortured clowns are surely represented in a state of despair and loneliness, but they are still entertainers—an aspect completely abolished in Rondinone's clown installations.[126] The stacked monitors (one of which is turned upside down and another

on its side) play four narrative sequences in a perpetual loop staging different clowns engaged in absurd misadventures: one clown struggles to hold a fishbowl on the ceiling with a broom; another receives a bucket of water on the head and falls on the floor after opening a booby-trapped door; a third clown narrates a story that condemns the narrator to endless repetition ("Pete and Repeat are sitting on a fence. Pete falls off. Who's left? Repeat. . . ."); and a fourth one repetitively shouts, "No, No, No!" in a hysterical fit. While the wall projection to the right of the monitors presents a changing selection of one of the four clown narratives, the opposite wall shows a single sequence, "Clown Taking a Shit," in which a supposedly off-duty clown suffering from constipation is recorded using a public bathroom by a surveillance camera. In all of these scenes, the clowns are staged in a state of torture as though caught in an impasse from which they cannot be delivered: stuck with the fishbowl, the first one cries out for help, but no one comes; as the second one opens the door, he is only to be hit again by a bucket of water; the third is forced to repeat a nursery rhyme because of its very lines; the fourth incessantly screams "No!" because his scream is never heard; and, sitting on a toilet bowl, the fifth waits and waits. Although the sequences of *Clown Torture* refer to a communicational rupture between

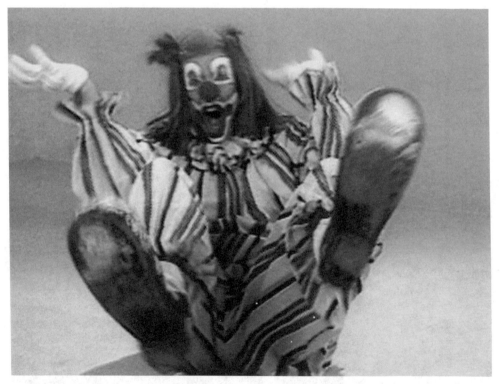

Figure 18. Bruce Nauman, *Clown Torture,* 1987. Four color video monitors, four speakers, four laser disc players, two video projectors, four laser discs (color, sound). Watson F. Blair Prize Fund; W. L. Mead Endowment; Twentieth-Century Purchase Fund; through prior gift of Joseph Winterbotham; Gift of Lannan Foundation, 1997. Reproduction, Art Institute of Chicago. Copyright Bruce Nauman / ARS (New York) / SODRAC (Montreal) 2004.

clown and viewer, the clown is still staged as an entertainer whose main role is to make us laugh. Moreover, the clowns exercise power over the viewer and maintain intersubjectivity through this very power. The loop structure, the monitor reversals, the repetitive actions, and the shouting—the conjunction of these elements gradually transforms laughter into annoyance, torturing the viewer in a way that makes him or her want to "glaze over, tense up and flee."[127] Nauman's clowns are thus possibly victims, but they also have the power to fight back. In short, as is the case for most of his art production, "[i]n Nauman's world there's always a catch—no matter what you do, you become either the aggressor or the victim, the stalker or the stalked, the passive voyeur or the object of the artist's belligerence."[128] By contrast, Rondinone's clowns have lost their entertainment value and empowerment possibilities together with the clown-public intersubjectivity they used to institute. As for the viewers, their presence becomes useless, obsolete, unnecessary. The machine's fits of laughs may well liberate the clowns "from the laughter they once provoked," but they also deprive the spectators from the laughter they once performed. As such, they affirm the obsoleteness of the viewer, intensifying and disclosing a public-artist disengagement. Melancholy has now switched into depression.

What makes these clown works highly significant to the overall question of depres-

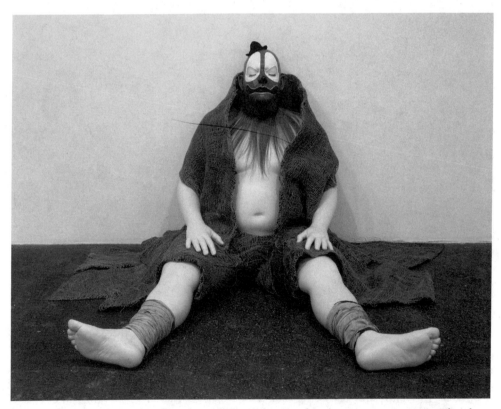

Figure 19. Ugo Rondinone, *Saturday,* from *If There Were Anywhere but Desert* series, 2001. Fiberglass, paint, clothing, life-size. Private collection. Courtesy of Matthew Marks Gallery, New York, and Galerie Eva Presenhuber, Zurich.

sion in art is the loss of creative melancholia they so obviously articulate as they enter into the gloom of depressiveness. The exploration of the clown figure, which has consistently functioned (in modern art, at least) as the alter ego of the artist, only reinforces this articulation of loss. As mentioned earlier, Rondinone has made many clown works, and some of them refer explicitly to the tradition of the clown/artist. This is particularly true of his solo exhibition presented at the Kunsthalle Wien in the summer of 2002, in which Rondinone installed likenesses of three buffoons (*Thursday, Friday,* and *Saturday*) in the central gallery room. Life-size, made out of fiberglass, and shown lying down or sitting on the floor, the works were in fact extracts from a larger, seven-part series, *If There Were Anywhere but Desert* (2001), representing the days of the week through different buffoon figures. The pose taken by the sitting figures recalled directly the sitting polyester self-portrait of the Walcheturm installation. Except for the eyes—closed in the case of the clown and looking toward the floor in the case of the Walcheturm dummy—the bodies shared the same paralysis, the same state of lethargy. In one of the few interviews given by Rondinone, the artist speaks precisely of how the clown functions as an alter ego. Moreover, he describes the clown as the isolated figure who, in his work, fails to address the viewer: "The clown is an invention of high nobility to push away boredom and melancholy out of the court. At the same time, it functions as a substitute: it has a freedom of speech that his masters don't have. On the other hand, my clowns do not move. They only sit or lie down, do not laugh, do not say either good day or good night. By its absence of demonstration and its disinterest for the outside world, the character of the clown is possibly a self-portrait. He leads to a melancholy empty of meaning, which perpetuates itself in the vacuity of a world without irony."[129]

The use of the clown figure as a metaphor of the artist is not new. It is a constant in modern art and literature, having strong antecedents in the nineteenth and early twentieth centuries, notably in the work of Charles Baudelaire, Henri de Toulouse-Lautrec, Pablo Picasso, Georges Rouault, Max Beckmann, and Paul Klee, and, closer to the present day, in the production of Thomas Schütte, Jonathan Borofsky, Bruce Nauman, and Paul McCarthey. In these art productions, such as Toulouse-Lautrec's *The Seated Clowness Mademoiselle Cha-U-Kao* (1896) and Beckmann's *Portrait of the Russian Actor, Zeretelli* (1927), the clown is explored as an allegory of the social condition of the artist and serves to disclose the artist's social status as an outsider always at risk of being rejected or misunderstood by the public. For art historian Jean Starobinski, the modern artist's investment in the image of the clown is a form of identification that enables the artist "to raise the question of art."[130] The work of Baudelaire is particularly significant in relation to Rondinone's, because he is one of the main poets to have conferred to the artist, through the figures of the clown and the traveling performer, a contradictory destiny of flight and fall, altitude and abyss. This contradiction, as Starobinski has shown, underlies the archetype of the tragic clown as it was embodied by the character Fancioulle, whose destiny shows how the artistic genius falls at the precise moment when he receives, from the public or the ruler, an acute sign of refusal or opposition to his art.[131] The artist, for Baudelaire, walks between two abysses—beauty and death, glory and rejection—only to

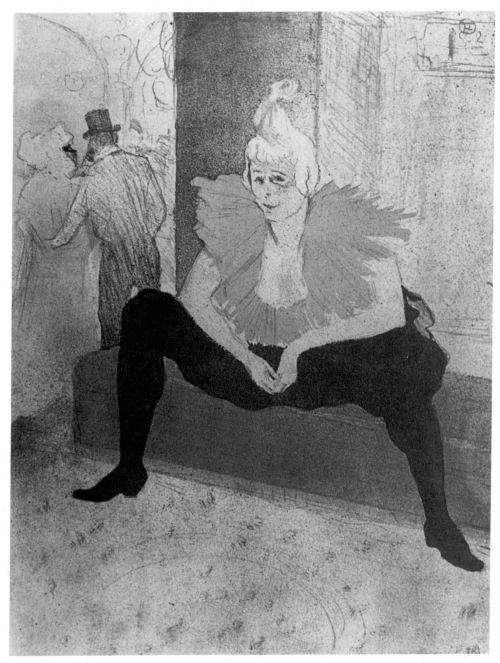

Figure 20. Henri de Toulouse-Lautrec, *The Seated Clowness Mademoiselle Cha-U-Kao*, 1896. Color lithograph. Edition of 100, 52.1 × 40 cm. San Diego Museum of Art. Gift of the Baldwin M. Baldwin Foundation.

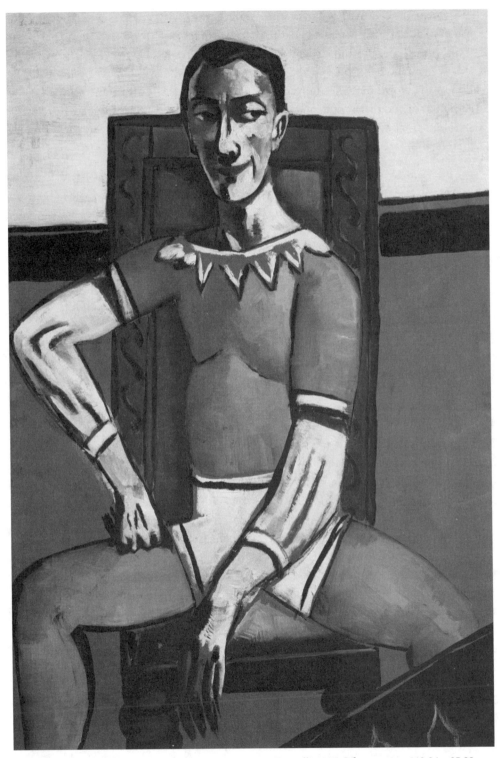

Figure 21. Max Beckmann, *Portrait of the Russian Actor, Zeretelli,* 1927. Oil on canvas, 140.34 × 95.89 cm. Courtesy of the Fogg Art Museum, Harvard University Art Museums. Gift of Mr. and Mrs. Joseph Pulitzer, Jr. Copyright Estate of Max Beckmann / VG Bild-Kunst (Bonn) / SODRAC (Montreal) 2004.

fall because of his creative brilliance. The contradiction between flight and fall is equally at play in Baudelaire's other alter ego, the *vieux saltimbanque* (the old traveling performer), condemned to enter into "silent decay" and "insurmountable powerlessness" as he experiences public rejection.[132] The image of the artist who still hopes to attract the attention of the crowd but whose inventions fail to animate the crowd brings with it the artist-public divide that is endemic to Rondinone's clown installations. More precisely, as Starobinski maintains in his study of Baudelaire's *vieux saltimbanque,* such a figure reveals the indifference of the public vis-à-vis the performer:

> The *Vieux Saltimbanque* . . . has separated himself from men to go on the boards: he still hopes to attract their attention; but he has ceased to be of interest, and it is men who move away from him. The separation is double, for it corresponds first to a distance taken by the artist, then to its removal by the public. . . . But these two characters—Fancioulle and the travelling performer—resemble one another despite all what opposes them: . . . the artist, in opposition to power (embodied by the prince or the people), is not strong enough to survive power's condemnation decreed against him. However, whereas the tyrant desired to see Fancioulle die in the supreme exercise of his talents, the quasi-unconscious cruelty of the public consists in *not seeing* the *Vieux Saltimbanque.*[133]

The melancholic clown, as the modern alter ego of the artist, takes its tragic destiny from the very fact of *not being seen.* This indifference is precisely what is being deployed in Rondinone's *Where Do We Go from Here?* although unproductive seeing must now be attributed both to the public and to the clown and amplified by the prerecorded outburst of laughs. Indeed, it is not only the public who fails to see the clown (a failure made especially manifest in the yellow clown projection) but also the clown who fails to see the public (a blindness caused by the buffoons' intense withdrawal and acute lethargy). The passage from melancholia to depression—a passage that is never complete because of Rondinone's continual reliance on the tradition of melancholia, if only to reveal it as a withering paradigm—is activated precisely when the clown-public disengagement takes place through a mutual negation of seeing. Disengagement initiates the loss of melancholia together with the creativity of the artists that melancholia had come to represent. But still, if depression does set in—ingesting melancholia, as it were—it has the following critical productivity: to refer to the wavering of the melancholia tradition in art, by which great artistic achievements have been explained since the Aristotelian *Problemata.* By confronting melancholia with depression through a hiatus strategy that marks their differences and similarities, their distinctiveness and continuity; by enacting an artist-public, image-reality disengagement that does not hide but still manages to signal the nineteenth-century roots of this divide, Rondinone's production is first and foremost a disclosure of what is being lost when depression subsumes melancholia: the values of creativity, insight, and criticality; the psychic life of dreams and phantasms; the insistence on the indubitable gap between imitation and the imitated; the aptitude *not* to deny loss, death, and horror; the talent to induce laughter; the refusal of the numbing

effects of pharmaceuticals; and the allegorical impulse to both reveal meaninglessness and transform it into the possibility of meaning. It is an attempt to see how some of these traits could be reclaimed for the depressed, through a practice of the melancholia of melancholia. The rule here is not to rescue melancholia's attachment to the lost other but to redeem it as a withering paradigm and disclose what is depreciated in that process. The value of art today, suggests Rondinone's work—its condition of possibility—lies in this disclosure.

Chapter 2

The Laboratory of Deficiency

First elaborated in 1935 but revised many times subsequently, the depressive position theorized by Melanie Klein pertains to the child's distressed reaction to weaning and, in a more general way, to experiences of loss of and separation from loved objects. In the latter half of the first year, "the baby," writes Klein, "experiences depressive feelings which reach a climax just before, during and after weaning. This is the state of mind in the baby which I termed the 'depressive position,' and I suggested that it is melancholia in *statu nascendi*."[1] The depressive position refers to the range of affects lived by the infant during the first period of separation from the mother: anger in not having total control over the loved object, guilt about the ambivalent demands expressed toward it, anxiety in the face of the possibility of losing the security and intactness it has provided, and sadness "relating to expectations of the impending loss of it."[2] A successful resolution of the position comes about when the infant acknowledges that the mother it hates (the "bad object") and the mother it loves (the "good object") are actually one (the "whole object").[3] The failure to integrate these two part-objects and the consequent inability to institute a good internal object were postulated by Klein as constituting the basis of a variety of adult neuroses, including melancholia and manic-depressive, obsessive, and paranoid conditions.[4]

In the psychoanalytical field, the Kleinian theorization of melancholia and manic depression as resulting from unsuccessful childhood loss resolutions still holds, although in modified versions. Pierre Fédida has recently designated the depressive position as a depressivity that is inherent to psychic life, whereas depression ("a conservation of the living under its *inanimate* form") corresponds to a failure of depressivity.[5] Acquired during childhood, depressivity is seen here as a beneficial position that supports the formation of self in relation to the loss of the loved object. It corresponds more specifically to the "capacity of openness and closure" with which the individual responds to contact and protects and exposes itself to sudden changes from the outside.[6] In cases of depression, argues Fédida, it is this depressivity that must be restored, and with it the very psychic mechanism that provides protection, regulation, and balance to the self. Judith Butler, in her performative model of subjectivity, also postulates that identity is first engendered by melancholy identifications that constitute the self when it loses a loved object. She insists, however, on the sexual nature of these (dis)identifications: in a social order in which the

predominant structure of sexual difference is heterosexuality, the child must learn to repudiate the homosexual loved object to identify with the law of heterosexuality. As the child engages in these identification processes, not only is the loved object lost but its loss is eventually disavowed by the incorporation of the object, which is magically sustained "'in the body' in some way."[7]

Psychoanalysis thus grounds the depressed's loss of self—his or her incapacity to keep identifying "the self as self"[8] or simply to keep knowing who he or she is[9]—on childhood experiences of loss, with the understanding that loss is a structural component of human subjectivity. Underscoring the depressive attachment to loss (one that can take the form of an incorporation of the lost loved object), the psychoanalytical view elaborates a melancholic decipherment of depression that depathologizes mental affection to consider it mostly as a mandatory phase in the development of identity. Indeed, the becoming of the self occurs only through a depression position following the separation from the loved object, what Julia Kristeva has called the abjection of the mother.[10] Of course, this original depression can be the starting point of future depressions (especially when it is ill resolved), but it corresponds first and foremost to the moment of constitution of the self that comes about when the child loses the sense of plenitude provided by the infant's symbiotic relation with the mother. In contrast, even though the loss of self is still assumed to be intrinsic to depression,[11] today's cognitive psychology emphasizes not loss but the depressed's inability to adapt to loss, not the inseparability of selfhood and loss but the need to correct the loss of self emerging from the failure to adapt. In cognitive formulations, the melancholy dimension of depression is abolished to confirm the latter as what it has become since the 1980s—a disease. Loss does not disappear, but it is palpably devalued and detached from the individual's life story.

This chapter is interested in how contemporary art represents the loss of self—not in the psychoanalytical sense of an original constitution of the self *through loss* but in the now-predominant cognitivist sense of loss as a maladapted, deficient coping style. It is also interested in how art has addressed the gendered reality of that loss. The performance work of Vanessa Beecroft is highly significant in this regard: not only does it stage fatigued coping female figures, it also and more importantly rethinks both aesthetics and scientific discourse through this very staging. Her work forces us to reassess substantially post-1960s feminist art and criticism, because it enacts not so much the female subject's aspiration to counter or subvert femininity as her persistent yet unreachable desire *to be* feminine. Beecroft's displays disclose the contemporary subject as an individual preoccupied with identity, with both the erasure of self and the related need to continuously re-create the self through processes of idealized identifications. Such an obsession with the independent self entails a specific form of disengagement with the other, one that suspends, through self-absorption, the role of intersubjectivity in identity formation. As already suggested, loss of self here has more to do with insufficiency and maladaptation than attachment to loss. It is, furthermore, never truly a loss, for Beecroft incessantly stages performers that keep failing and affirming their identities. This apparently simple oscillation, I argue, profoundly complexifies the depressive affect; it also knots together

depressiveness and contemporary subjectivity. Therein lies the uniqueness of Beecroft's aesthetics. In short, art's enactment of depression—its inscription in the contemporary controversy on depression—finds in Beecroft an original player, one who compels us to perceive fundamental notions of subjectivity (identity, femininity, the viewing other) according to rules that radically challenge our feminist and psychoanalytical horizons of expectation.

The Work: Displacements of Feminist Criticality

"I like the idea of a combination of a feminist background—not a real background but knowledge and awareness of it—and a Helmut Newton portrait of a naked woman in heels. I like to see if the two parts can match. . . . I want to show women in a way that it's painful for people to watch."[12] This statement, by Italian, New York–based artist Vanessa Beecroft (b. 1969), was made in 1999, after she had completed a series of more than thirty-five performances begun in the early 1990s. It lays out the main elements that have come to structure Beecroft's work: the conflation of feminism, femininity, and Helmut Newton's femme-fatale imagery; the confrontation between performance and photography; the staging of naked women in a state of "to-be-looked-at-ness"; and pain—not only the pain of the performer but also the pain involved in the viewer's very act of looking. Two years later, in an interview with Dodie Kazanjian, Beecroft clarified the influence that *Vogue* photographer Newton has had on her work since 1995: "I like the way he portrays women, which is not the same as I do. His big nudes deal with sex, power, politics, Germany. They are smart-asses. They have control. Mine are more vulnerable, not so stylized, not so beautifully perfect and refined. More like self-portraits."[13] The performances are thus meant to generate vulnerable beings, showing them as such because of their failure to reproduce Newton's feminine ideal of monumentality, control, power, and perfected beauty. Newtonian photography is the desired image that Beecroft's performances cannot reproduce: *within the duration of the event,* the models painfully cope with their inability to be the snapshot Newton ideal. As I hope to show throughout this chapter, it is in this very double bind—the desire and the necessary failure to be the ideal—that Beecroft's art production enacts depression as a constitutive part of contemporary subjectivity.

Most of the performances produced between 1993 and 2001, notably *VB35: Show* (1998), stage a group of young, predominantly white, underwear-clad or unclad women wearing high heels, who are often chosen for their resemblance to one another and are asked to stand still or to move slowly and pose in front of an audience in a state of near-immobility, of impossible motionlessness.[14] Designated by Elizabeth Janus "orchestrated nonevents,"[15] the live tableaux give the appearance that nothing is happening:[16] the women are silent, they are quasi-immobile for two to four hours, and they are instructed not to interact in any way (either verbally or through eye contact) with the public.[17] "In the service of the purely visual spectacle," writes art historian Jan Avgikos, "the girls are mute, alert, non-confrontational, expressionless: They do not engage."[18] Chosen for their similar physique,

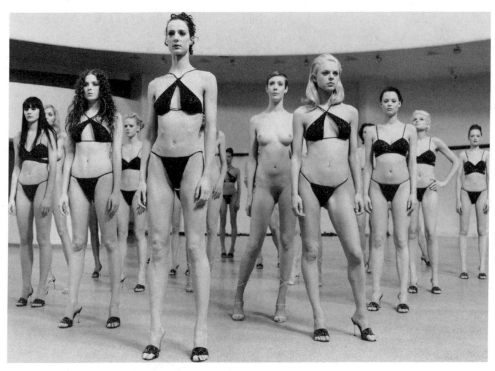

Figure 22. Vanessa Beecroft, *VB35: Show,* VB35.377.ms., 1998, Guggenheim Museum, New York. Photograph by Mario Sorrenti. Copyright Vanessa Beecroft. Courtesy of the artist.

removed of their particularities by wigs and makeup that homogenize the group, anonymous (they go uncredited), and lit by lights that render their bodies flawless, the models are set to lose their selves as they are immediately absorbed by feminine stereotypes. Whether these stereotypes are national—the blond Swedish woman in *VB34* (1998), for example, or the pale-skinned, red-haired English type in *VB43* (2000)—or cinematographic—such as in *VB09* (1994), in which thirty women were asked to "be Edmund," the young protagonist in Rossellini's *Germany Year Zero*[19]—they systematically reproduce the fashion standards of femininity: slenderness, containment, youth, whiteness, the woman as body, the woman as spectacle. Hence, Beecroft's performances are not, in their initial moments at least, about diversity, individualized identity, or empowerment but, as art critic Clarisse Hahn has observed, about an identity that "erases itself in front of pure appearance."[20] The loss of self occurs in this very neutralization of appearance.

Such an obsessive preoccupation with homogenized body images and standardized ideals of femininity is rooted in the artist's personal experiences. This entrenchment was revealed in Beecroft's first solo exhibition, in 1993 at the Galleria Inga-Pinn in Milan, where she presented a series of drawings and excerpts from a "Book of food" entitled *Despair,* a typewritten diary she had kept for the preceding eight years (between 1985 and 1993) to record her daily ingestion of food through specifications of quantities and colors. As a whole, the exhibition provided a detailed description of eating habits, psy-

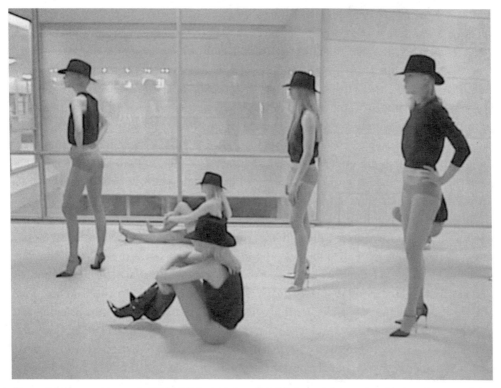

Figure 23. Vanessa Beecroft, *VB34*, VB34.095.vb., 1998, Moderna Museet, Stockholm. Photograph by Vanessa Beecroft. Copyright Vanessa Beecroft. Courtesy of the artist.

chiatric visits, reflections on the act of dressing, lists of foods and diets, love and hate relationships with her own body, and attempts to deal with anorexic-bulimic disorder.[21] Since then, she has declared that she suffers from exercise bulimia—"a compulsion to burn off calories that she considers excessive."[22] For the 2003 retrospective of her work at the Castello di Rivoli, she reexhibited the "Book of food" and devised *VB52*, a performance that staged indifferent women (young models, aristocrats from Turin, and Beecroft's mother and sister) sitting around a glass dinner table and being served insipid aliments (again specified by quantity and color) in a Buñuelesque atmosphere.[23]

Beecroft thus made the decision, from the start, to act out her obsession with body image and to expose the vulnerability conveyed by eating disorders. As she stated in the 2001 interview with Kazanjian, her performances must be seen as "self-portraits." Yet this decision has usually been received with great ambivalence. Critics speak of the challenge and difficulty of reading performances in which the "effort to examine women's roles, stereotypes, and access to power" is "not so clear-cut" and is more "open-ended" than in feminist art of the 1960s and 1970s.[24] Writer Wayne Koestenbaum, for example, contrasts Beecroft's *VB35: Show* with Carolee Schneemann's performance *Interior Scroll* (1975)—an action in which the artist extracted an inscribed scroll from her vagina to read it aloud—stating how much the former lacks the transgressiveness of the latter: "Art

actions, at their most transgressive, intend to erupt, to confuse, to undercut a set proceeding. *Show,* forewarned, well-publicized, may have been a curious, pretty spectacle, but it forbade fissure and error, an artist's best friends."[25] The comparison between feminism and the so-called postfeminism of the 1990s is a constant in the critical reception of Beecroft's work.[26] The comparison exposes the problem of an art production that reiterates norms of femininity and embraces the visual spectacle of female nudity. Beecroft's performers, increasingly chosen from modeling agencies, are gathered together in a public space and asked to pose almost totally naked in front of an audience; they wear designer shoes, designer underwear, and designer stockings or swimsuits; their bodies meet the criteria of late-twentieth-century fashion models (young, predominantly white, proportioned, slender, and flawless).

The representation of women as the object of the look—what feminist theoretician and filmmaker Laura Mulvey called, in her critique of Hollywood cinema, the divide between women as objects to be looked at and men as subjects of the look[27]—and the consequent reification of woman as body are precisely what feminist artists have attempted to disclose, denounce, and displace during the last four decades. In the naked actions of Carolee Schneemann, such as *Meat Joy* (1964), bikini-clad women were asked not to pose but to roll around in raw chicken, sausages, and mackerel; *Interior Scroll* invited audiences not merely to look at a passive female nude but also to listen to the artist read from a folded piece of paper as she pulled it from her vagina. In 1974, performance artist

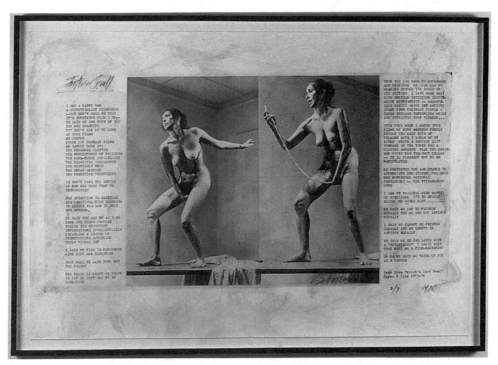

Figure 24. Carolee Schneemann, *Interior Scroll,* 1975. Photograph collage with text: beet juice, urine, and coffee on photographic print, 117 × 170 cm. Photograph by Anthony McCall. Courtesy of the artist.

Lynda Benglis published a photograph of herself naked in *Artforum International,* holding a huge plastic phallus at the level of the pubic area, both appropriating what has been psychoanalytically defined as the male prerogative and exposing the phallus as an artifice, a phantasmic construction to be played with at will. Ana Mendieta photographed herself with fake facial hair, wigs, and makeup, and Suzy Lake produced self-photographed portraits with facial distortions, both of them questioning criteria of feminine beauty. Nancy Spero's 200-feet-long scrolls were covered with antiwar imagery and monumental walking mythical female figures in an act of celebrating womanhood. Martha Rosler elaborated a variety of documentary agitprop installations and video works about anorexia, the semiotics of the kitchen, the Vietnam War, and urban gentrification. Mary Kelly's *Post-partum Document* (1973–79) proposed a psychoanalytical reading of the mother-child relationship reread through a phenomenological account of her own experience of the institution of motherhood. All these works not only openly elaborated a feminist criticism of ideologies of femininity but also disclosed and acted out the female body as a battleground for power positions. In contrast, the work of Beecroft displays women with different "looks," seeking to embrace femininity instead of deconstructing it. As Jan Avgikos has observed, "In contrast to her feminist predecessors, Beecroft silences the voice, depersonalizes the female body, and pumps up its image as a purely visual spectacle, charging it with unmistakable provocation."[28]

In light of such mute, depersonalizing displays, art critics are usually undecided as to the critical dimension of Beecroft's actions—do they reinforce or denounce femininity? Elizabeth Janus speaks about the "seeming ambiguity of her intentions . . . precariously balanced between exploitation and empowerment," yet also states that "her unique vision . . . has put an undeniably new spin on performance art."[29] Dodie Kazanjian writes about how Beecroft's performances have "impressed" her "in all sorts of contradictory ways—I've felt mesmerized, bored, baffled, aesthetically moved, and overwhelmingly embarrassed."[30] Cherry Smyth is reminded, with *VB43* (2000)—a performance featuring twenty-three young women with an "English-Irish look," instructed to stand for four hours naked but for spike heels, wearing curly bright orange or strawberry blond wigs—of Sydney Pollack's dark *They Shoot Horses, Don't They?* (1969), a film about the limits of endurance, which stages a marathon dance contest during the Great Depression, in which poverty-stricken competitors struggle to keep dancing in order to win the cash prize. But she also insists that the work "fails in substance," because it "reinforces and literally displays female passivity with alarming insouciance."[31] After revealing her initial hesitation (does the artist critique or perpetuate the stereotypes of fashion industry?), another critic condemns the same *VB43* for its shallowness and complicity with the art market and the fashion industry:

> Ultimately, it's fantastically shallow art. Rather than condensing a range of
> incisive ideas and subverting them with integrity, *VB43* showed Beecroft to have
> a thoroughly collusive relationship with the art market, the media, the fashion
> world, advertising, and everyone's basic instinct for dumbed-down sensationalist
> entertainment. . . . If Beecroft's performances are to be more than *Vogue* shoots,

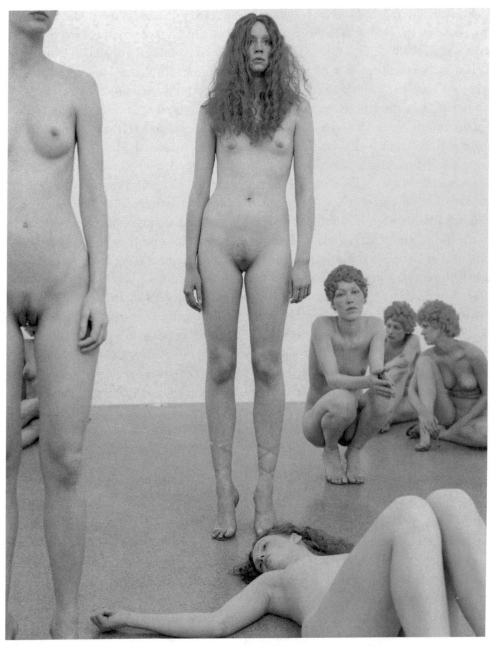

Figure 25. Vanessa Beecroft, *VB43*, VB43.005.te., 2000, Gagosian Gallery, London. Photograph by Todd Eberle. Copyright Vanessa Beecroft. Courtesy of the artist.

she's got to start accounting for the whole situation. We are all mesmerised by beauty, but it's disingenuous to present this as "art" when she's actually doing little more than perpetuating an already unholy alliance between the art and the fashion industry.[32]

What all these reviews make manifest is the expectation, shaped by feminist art and theory, that criticality will deploy itself through an act of deconstruction of femininity. The reintegration of the passive or fashion-stereotyped woman is seen as a return to prefeminist times or a jump into a postfeminist amnesia to feminism, a view that Beecroft herself has adopted.[33] As the counterpart of the same logic, most critics agree that, because stereotypes of femininity are being staged in the work, it is difficult to merely detach it from a feminist intent: the staging of stereotypes should or could in itself be a sign of criticality. But these considerations obstruct the fact that the (non)events remain undecidable in this regard, for there is nothing in the performances that enables the viewer to say for sure whether Beecroft is critical of the standards she keeps staging and restaging. The mere display of feminine types does not constitute by itself a denunciation of femininity. On the contrary, from one performance to another, the women keep performing homogenizing models of femininity. The displays reproduce society's incessant production of standardized ideals of femininity as mass-reproducible prototypes to be picked up, disseminated, and integrated in processes of identity formation. They are a "let us see," in upscale gallery environments, of women's desire to be feminine. Moreover, Beecroft's production does not in any way articulate a critique of the art institution or the art market that frames her performances. Yet I argue that within the uneventful and apparently uncritical visual spectacle, a critical event (what Michel Foucault calls a "reversal of a relationship of forces"[34]) does occur: the performers cannot stand still—their body movements are about the continual effort to do so and the failure to meet the prescribed expectation of the pose—whereas the spectators look, move around, and exchange comments with each other. The event emerges precisely there, within the visual unfolding of the performers' attempt to reenact the standard prototypes of ideal femininity and the necessary acknowledgment of their continual effort to cope with the impossibility of this reenactment. Indeed, at the start, the performers have the monumentality, control, and perfection of Helmut Newton's models: they stand motionless, in photographic stillness, within the public space. But as the performance unfolds in time—as the "live" component of the performance deploys itself in the two- to four-hour duration of the piece—Newtonian beauty inevitably breaks, and vulnerability sets in. Photographic stillness and the phantasmic snapshot of control (control that recalls the anorexic-bulimic fantasy of corporeal containment) are subsumed by the slow disintegration of posture. This is when the models' lower backs start to ache and they begin to slouch, kneel, crouch, bend, sit, lie down, and withdraw. As Avgikos has descriptively observed, the ideal collapses for both the viewer and the performer precisely when fatigue settles in: "If one looks long and thoughtfully enough, there's probably all the world to see. The picture Beecroft sets in motion is one of disintegration, a façade that is compromised by the 'human-ness' of the girls who grow tired over the duration of the performance, which spans several hours. Inevitably, the 'picture' begins to twitch and fidget, to sag, droop, and collapse. The perfect, and perfectly problematic, picture quite literally falls apart."[35]

Beecroft's performances thus force us to displace the question of criticality, that is,

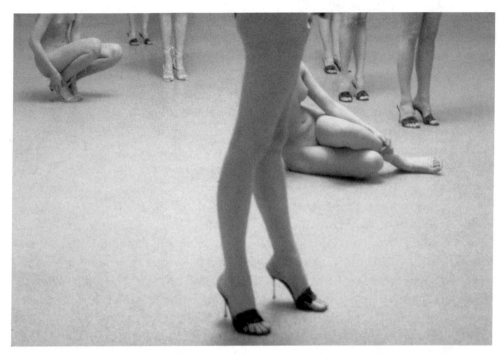

Figure 26. Vanessa Beecroft, *VB35: Show*, VB35.354.al., 1998, Guggenheim Museum, New York. Photograph by Annika Larsson. Copyright Vanessa Beecroft. Courtesy of the artist.

to see how they might be critical not in their denunciation of femininity but in their exposure of the persistence of ideals of femininity more than fifty years after the publication of Simone de Beauvoir's *The Second Sex* (1949). They disclose this persistence of the desire to be feminine—a persistence that has been consistently recognized in social studies dealing with the contemporary gendering of identity[36]—along with the more recent acknowledgment by younger feminists of the need to address the embodied and personal self, realms that have been somewhat forgotten or undervalued in the wake of the social, economic, and political successes of feminism since the 1960s. As writer Gaby Wood has insightfully observed, issues of femininity and femaleness persist in a historical moment when, as a result of feminism, women have acted in spite of, "rather than in collusion with," their personal selves:

> [I]n an age when eating disorders are on the increase, when women feel even more pressure both to succeed and look beautiful, when the problems of balancing work and domestic life have . . . actually become worse than ever, the personal can't be left in the lurch. . . . Your beliefs about sexual equality don't prevent you from feeling ambivalent about your appearance or insecure about your intelligence. Your ambitions for your career may sit uneasily with your desire to have a child. In other words, though the personal may be seen as having a political reach, the political doesn't always impinge on the personal as much as many of us hope it might.[37]

What is the meaning of the disintegration of the pose? To be more precise, what exactly is being shown here? Standardized femininity? The collapse of the feminine? Women's reduction to the body, to the look, to the to-be-looked-at-ness? The projection and, perhaps, dismissal of the viewer's fantasies? The powerlessness of women? Empowerment? Couldn't it be argued that *all* these operations are at play and that none of them really predominates in a way that would eclipse its contrary? Beecroft's performances are not so much about what should be or should not be (femininity or feminism? power or vulnerability?) as about an artistic enactment of depression, one that shapes itself around the reiteration of subjective acts of failure and coping, loss and idealization, insufficiency and re-creation. They are in many ways disappointing, because of their absence of hidden meaning, underlying laws, and metaphysical finality: displays for a Foucaldian genealogist, they provide overviews, visibilities, surface events that solicit the viewer only in the small, depressive shifts that shape but also unshape them. The fact that these enactments have not much to do with morality and criticism of female stereotypes and more to do with the creation of depression experiments is manifest in the statement of *VB46* (2001) performer Heather Cassils, who stipulates that the three exhausting days of preparatory sessions of hair bleaching, hair waxing, manicuring, body painting and makeup, and photo and video shootings were meant to "break" the models before the public event.[38] Clover Leary, another performer of *VB46*, explains in the following terms how the models' positioning as objects of spectacle brought about an experience of powerlessness, a salient mechanism of depressive disorders:

> [T]he experience of being viewed and treated as an object that directly was pretty horrifying to me. . . . It was a complicated and traumatic experience for a number of reasons. Seeing the who's who of the LA art world, collectors, curators, etc., gathered for the dubious entertainment of watching thirty nude, lightly painted, hairless, well paid models stand at attention until they could no longer stand was a bit disheartening. . . . During the performance I felt livid, defensive, and mortified. . . . The gaze of the audience felt both violating and objectifying. . . . There seemed to be a profound separation and imbalance between the audience and the models. . . . I felt disempowered.[39]

Let us be attentive to the symptoms that emerge from Beecroft's performances: fatigue, the failure to perform, the loss of pleasure, the loss of self (at least in the first stages of the performance), psychomotor retardation, muteness, withdrawal, inwardness, and the rupture of communicational intersubjectivity between the performers and the viewers. These symptoms are among the prevalent features of depressive orders, as classified in the *DSM–IV* and as identified by current behavioral-cognitive, interpersonal, constructionist, and psychoanalytical approaches to depression.[40] This is not to say that the performers are represented in a state of pathological depression. They are coping. Following what should be called a dimensional perspective, depressive features are shown to be not the symptoms of a disease but "normal" configurations of contemporary subjectivity. Let us also be attentive to the presence of viewers required to observe the models at a

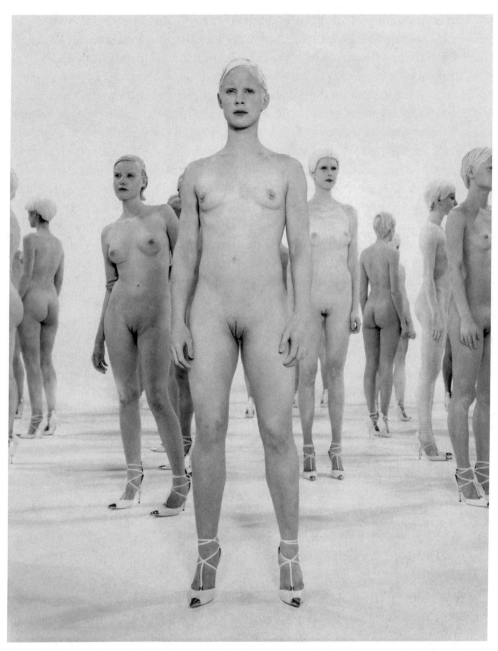

Figure 27. Vanessa Beecroft, *VB46*, VB46.001.al., 2001, Gagosian Gallery, Los Angeles. Photograph by Armin Linke. Copyright Vanessa Beecroft. Courtesy of the artist.

distance (verbal exchange is forbidden, and the performers are instructed not to look at the public). The viewers are described, in critical reviews, as scopically removed from the space of the performers, appalled and admiring as they imagine who such a model might be, predict what she might do or what might happen to her, identify the woman who probably is the toughest, and gossip and exchange observations with other viewers. They

adopt the position of both the spectator—what Jonathan Crary has called the "passive onlooker at a spectacle"[41]—and the diagnostic observer who examines from a detached position. Beecroft's performances thus are shows, but they are mostly laboratories of depressed subjectivity that not only test the subject's endurance and ability to cope with failure but also ask the viewer to analyze, evaluate, compare views, look, and ignore while being ignored by the performers in that very process. The deployment of a laboratory of subjectivity, a space that brings together self-absorbed subjects and their unrecognized observers in the context of an experiment structured by a series of strict rules, whose purpose is to let us see (and not to subvert) through its refabrication the complex persistence yet necessary historical mutation of norms of femininity: such would be—and this is the underlying hypothesis of the present chapter—the critical act of Beecroft's work. This empirical laboratory shows how femininity is now tied to depressiveness and how the mere act of feminine self-absorption in identification and coping processes is structured by disengagement as it suspends or delays the other. Performatively speaking, the laboratory is a site of convergence of at least four processes through which the depressive paradigm is both ratified and complicated: the depathologizing of depressive disorders, the gendering of depression, the designation of the subject as a coping machine, and the insertion of that subject into a performance-management model of performative subjectivity. These four operations interrelate to expose the tight contemporary intertwining of subjectivity and depression. This exposure, however, occurs aesthetically, through a transformation of performance into an in-gallery laboratory.

The Depathologizing of Depressive Disorders

One of the major features of Beecroft's work is its depathologizing delineation of depressed subjectivity. Her models cannot be designated depressed, yet they are noticeably engaged in a depression of the pose. They, furthermore, enact key scientific symptoms of depressive disorders. The strength of this production lies precisely in its consequent rapprochement between contemporary subjectivity and depression, that is, in its establishment of a continuum between "normal" femininity and depression. By this I suggest that her work deploys the current generalization and banalization of depression. It exposes depressiveness to be lurking at the confines of our identities. As sociologist Alain Ehrenberg has argued, depression might well be to the contemporary individual what neurosis was to the late-nineteenth- and early-twentieth-century subject. This dimensional view of depressive disorders is what Beecroft's performances both adopt and deploy. In so doing, they not only engage themselves actively in one of the central debates currently shaping scientific discourses on depressive disorders—should depression be approached according to a categorical or a dimensional understanding of mental affection?—but also contribute to this controversy aesthetically, through a major rethinking of feminist critical strategies. This debate is surely among the most fascinating ones in the field of depression studies, because it touches directly the ways in which the most intimate affective moods of the depressed are argued either to constitute a disease or to elaborate normality.

On and on throughout the twentieth century, psychiatrists raised the question of what distinguishes depressive disorders from disturbances of mood. Is there a marked difference between normal states of sadness, demoralization, stress, and "blahs" and the psychiatric illness known as major depression? If so, is the difference quantitative or qualitative? or is it a question of intensity? Whereas the dimensional perspective posits that depressive states unfold on a continuum ranging from normal blues to identification with death,[42] the categorical view seeks to establish a definitive cutoff between normality and abnormality. In 1980, the American Psychiatric Association (APA) published the third edition of the *DSM,* which officially recognized the prevalence of the categorical approach on the premise that mental illnesses can be both classified and differentiated into specific clusters of symptoms. Since then, the *DSM* has become the main manual used by professionals for the diagnosis of mental illnesses. Yet, despite this official consolidation of the categorical perspective, researchers still find it impossible to agree on a universal categorization of depressive disorders. The controversy surrounding the dimensional versus the categorical approach shows how much the distinctions between disease and illness, between the physiological "how?" and the experiential "why?" between normality and abnormality, and between society and biology are not easy ones to establish in the case of depression.[43] As psychologist James C. Coyne has observed, the controversy is likely to persist until questions relative to the etiology of depressive disorders are resolved or clear markers for depression are identified.[44]

One of the central questions underlying this debate is the following: is it possible, if one adopts a dimensional understanding of depression, to identify a cutoff point above which a patient should be diagnosed with a depressive disorder?[45] If the dimensional perspective were to identify such a cutoff point, it would become more compatible with the categorical logic of the *DSM* and would surely enrich it. To date, however, the continuum hypothesis works more as a critique of the shortcomings of the *DSM,* notably disclosing its failure to include a larger spectrum of depressive experiences. Hence, in the current situation, where the categorical approach prevails, some individuals who feel depressed are not diagnosed as depressed, and some individuals who have been diagnosed as depressed fail to enter therapy, often because of the simple need to go on with their lives and with the understanding that depression is a troubled affective state related to the circumstances of everyday life. Following a recent study comparing the categorical and dimensional approaches, the researcher concluded that "an ideal categorical classification system should specify the defining features of a disorder, and the category should have points of rarity with normality and other disorders. However, many mental disorders and a considerable number of physical diseases fail to conform to this ideal."[46] In the case of personality disorders, for instance, the reliability of diagnosis is often diminished by the exclusion of a dimensional approach. Critics such as Armand Loranger and Lee Anna Clark advocate the need to use dimensional information "to supplement the categorical diagnosis . . . , to the benefit of both clinician and research investigator."[47] For the diagnosis of personality disorders, "despite firm evidence of their various strengths, dimensional approaches have failed to be adopted in the official taxonomy."[48] The *DSM's*

categorical perspective is thus increasingly seen as denying the fact that dimensional approaches "are theoretically consistent with the complexity of symptom patterns that are observed clinically . . . [and] are theoretically consistent with the observed lack of discrete boundaries between different types of psychopathology and between normality and psychopathology."[49]

In recent years, however, the dimensional view has been gaining ground, as made manifest by the growing acceptance of minor, subtype, shadow, and subthreshold forms of depression and the classification of such specifications in the *DSM*. These additions have been made on the basis that the nosological criteria established by the *DSM*—those which distinguish illnesses in view of their systematic classification—are much too loose to be fully operative. For example, whereas a major depressive disorder may be classified as mild, moderate, severe without features, or severe without psychotic features, dysthymic disorder is often referred to as a minor or moderate form of depression or as a minor depressive disorder, a subthreshold type of "Depressive Disorder NOS (Not Otherwise Specified)." The difference between dysthymic and major depressive disorders is still an area of intense research; in fact, there is little conclusive evidence that dysthymia is a disease entity distinct from major depressive disorder.[50] The critique of the categorical model is also grounded on studies suggesting that certain minor depressive disorders progress into major depressive disorders.[51] It has been proved, for instance, that more people have a high score on a depressive-symptom questionnaire than are diagnosed with depressive disorders.[52] Individuals described as "distressed," "dysphoric," or "demoralized" may in fact be depressed although not diagnosed as such.[53] Demarcations between distress, dysphoria, and depression appear increasingly useless in light of the recent hypothesis that outcomes for minor depression "may be even worse than for major depressive disorder," a conclusion based on the observation that individuals with minor depression have 51 percent more disability days than persons with major depression.[54] According to psychologist Constance Hammen, "[W]hile a very short-lived period of mild depressive experiences would have little significance for a person's life—and indeed would be a normal reaction to the inevitable disappointments and failures of daily living—increasing evidence suggests that recurrent or persistent mild symptoms might have important consequences."[55] Subthreshold conditions often foretell the development of diagnosable depression. Hence, in a large epidemiological study made in 1990, it was found that the majority of individuals with minor depression were depressed persistently over the year, and that 10 percent of those individuals went on to develop a major depressive episode.[56]

Categorical diagnoses of depression are further complicated by the fact that its symptoms are at play in more than one mental or somatic disease and that many symptoms are necessary but not sufficient for the diagnosis of specific diseases. In a 1994 national comorbidity study, of all the subjects diagnosed with major depressive disorder, only 44 percent had a "pure" depression, in contrast to the other 56 percent, who had depression plus at least one other diagnosis.[57] A long list of medical conditions, such as Alzheimer's disease, multiple sclerosis, hypothyroidism, heart disease, and cancer, can

produce symptoms of depression.[58] In this case, it is not depressive disorder that is at the root of the problem but a medical condition. Depression is also known for psychiatric comorbidities, which means that it is often accompanied by other mental disorders, such as bipolar disorder, schizoaffective disorders, panic disorders, anxiety disorders, substance abuse, alcoholism, and eating disorders.[59] Debates concerning the distinction between depression and anxiety disorders persist, because anxiety is frequently comorbid with major depression, because the disorders often share common risk factors, and because similar interventions may be effective for both.[60] Besides co-occurring with mental disorders, depression often occurs in individuals with personality disorders (for example, narcissistic personality disorder, borderline personality disorder, and avoidant personality disorder). The high level of comorbidity in cases of depression has important implications for the validity of the diagnosis of depression, given that comorbidities are commonly not reported by specialists. This means that it is difficult to know whether one is speaking about depression in a coexistent morbidity or about another illness with depressive overtones. Moreover, the commonality of comorbidity both breaks with the *DSM*'s assumption that symptoms of depression have the same source (a disorder within the individual) and leaves unresolved the question as to how the morbidities relate (does one cause the other and, if so, which one?).

Such findings have led a significant number of psychologists and psychiatrists to revalorize the continuum hypothesis that was delegitimized with the publication of the *DSM–III* in 1980.[61] Hammen, for instance, states that "depression ranges from a normal sad mood lasting only moments to a profoundly impairing condition that may be life-threatening,"[62] a conclusion also evident in Richard West's statement that "a continuum can be seen to exist going from normal human sadness through neurotic misery to psychotic delusions."[63] Psychiatrist and historian of psychiatry David Healy has come so far as to suggest that categorical models are not really useful and that dimensional models are probably more productive, "for the perceptible trend in neuroscientific and genetic research is toward complexity and biological diversity rather than any convergence on unitary mechanisms of disorder. . . . [A] range of biological factors will be found to trigger these disorders or inhibit their resolution, with different factors operative in different people, rather than that one or two unique factors will be found to cause depression and rigidly determine its course."[64] James Coyne describes quite well the present state of contention between the continuum and categorical perspectives, emphasizing the limits of the cutoff practice underlying the categorical model but also insisting on the need to keep the debate alive instead of merely opting for one perspective to the detriment of the other:

> [D]efinitional problems continue to plague the study of depression, and they
> are not going to be readily resolved. There remains considerable disagreement
> as to what extent and for what purposes a depressed mood in relatively normal
> persons can be seen as one end of a continuum with the mood disturbance seen
> in hospitalized psychiatric patients and to what extent the clinical phenomena

[are] distinct and discontinuous with normal sadness and unhappiness. Should we limit the term "depression" to those people who are most distressed and seeking treatment? And what do we make of the "merely miserable" that we have defined out of the "depressed" category? If we agree to make a sharp distinction, where is it to be drawn? What of the differences *among* the depressed persons? The positions on these questions that one takes have major implications for who one studies and who one treats and how, what data are going to be considered relevant, and how one organizes data. . . . We cannot pretend to resolve those controversies, but we can at least identify them. . . . There are striking differences *among* depressed persons that invite some form of subtyping. . . . [H]owever, efforts to derive such subtypes are generally controversial, and any scheme is likely to be more satisfactory for some purposes than for others. Confronted with all of this ambiguity and confusion, one must be cautious and not seek more precision than the phenomena of depression afford, and one should probably be skeptical about any decisive statement about the nature of depression.[65]

In short, if the categorical approach seems less and less useful for the diagnosis, understanding, and treatment of depressive disorders, it is because categorization cannot hold when the etiology of a mental illness is unknown and because depression is a complex, heterogeneous, changing, and usually nonspecific condition not easily diagnosed in primary-care settings. But the increased acceptance of the continuum perspective also means that depression is becoming more vague and less useful as a designation. The vagueness of the notion, what psychoanalyst Pierre Fédida designates the "hardly-just-notion" of depression, results not only from nosological inconsistency but also from the extended use and consequent banalization of the term.[66] Such vagueness may explain the high percentage of life prevalence of the disorder, which is now said to reach, in certain Western countries, 50 percent of the population and whose burden is projected by a 1996 Global Burden of Disease (GBD) study to increase worldwide by at least 50 percent by 2020.[67] As epidemiologist T. Bedirhan Üstün observes, depressive disorders are expected to become the main cause of disability: "In light of demographic and epidemiologic transitions as well as social factors concerning family structures, urbanization, migration and mobility, and alcohol and drug use, the risks for mental disorders will certainly increase. Increased population, longer life expectancy, possible increases in the rate of depression, and a relative decrease in other communicable conditions will result in depressive disorders becoming the leading cause of disability and overall burden worldwide. The results of the GBD study have shown variations by country and region, but patterns and trends are remarkably similar worldwide."[68] In light of these figures, sociologist Allan Horwitz has recently proposed that nonpsychotic forms of depressive disorders cease to be considered mental diseases and be understood instead as normal vulnerabilities that come about from the experience of stressful life events.[69] Although this approach has the merit of depathologizing minor forms of depression and defining depression as a legitimate response to stress, contemporary sciences of depression agree (as they rarely

do) on the persistence of the two following facts: even in cases of nonpsychotic forms of depression, stressful events can never be said to be the sole cause of depression; and, although minor depressions can be phenomenologically distinguished from more severe forms, they may be—in their development and ramifications—as distressful as the latter. The dimensional-versus-categorical debate is, thus, far from being resolved. Having said this, it is important to point out the paradox generated by this debate: although the *DSM*'s categorical perspective still prevails, the dimensional view has been gaining so much ground as to widen the spectrum of depressive disorders. In other words, the advancement of the dimensional approach has not necessarily led to the depathologizing of depression. Rather, the disease categories of depression have increased. But with this increase, depression has come to incorporate such a huge variety of mental affections as to weaken the referential efficiency of the notion.

The understanding of mental disorder as a dimensional state—one that is not radically distinguishable from normal states—is at the center of Vanessa Beecroft's production. Although her performances set into play key traits of depression, notably fatigue, performative failure, withdrawal, muteness, loss of pleasure, and the rupture of intersubjective communication, these traits are disclosed not as symptoms of a disease but as constitutive parts of (feminine) subjectivity. They stage not subjects in depression but individuals with depressive symptoms. Indeed, Beecroft's depression enactments are not fundamentally impairing; for, although the performers' profiles meet many of the symptoms of the *DSM* classification of minor or major depression, the unfolding of the performances shows the models adapting and maladapting to fallibility, shows them weakening but also coping and shaping their own identity in this evolution. Depression thus becomes a form of living related to a loss of self but inextricably tied to the development of the self. This means that, for Beecroft, the depressive condition is more a process than a result, more a genuinely painful part of identity formation than an abnormality of identity. It is a reality that can never really dissipate itself but could, potentially, become more severe. Depression cannot be defined as simply an abnormal state that "happens" to the otherwise normal subject: considered as a constitutive part of subjectivity, it is removed from the disease context to which it has been increasingly condemned in recent years with the growth of pharmaceutical and biological approaches to depression. This is a crucial point for at least two reasons. First, by deploying depression as a modus vivendi, the performances exhaust the view of art as inherently transgressive. We are far here from the surrealists' embrace of female hysteria as an irrational force that might be aesthetically explored to subvert the bourgeois order. The performances have also abandoned the critical requirement to depreciate the feminine that was so emblematic of feminist art and criticism from the 1970s through the 1990s. Beecroft's dimensional view precludes an oppositional voice, one that would be different from the norm. It exposes the norm by embracing it. Her performers are always already part of the norms of femininity they seek to embody; they ratify the norm of white slenderness, so their depressiveness is related to that normative process. The aesthetic staging of the performers might be critical—they are displayed in their inability to be the norm they desire—but surely it is not liberating.

This is to say that when art enacts depression, it tolls the death knell of aesthetics as a subversive practice.

Second, as it relates depression to the affirmation of the self (and not merely to its annihilation), Beecroft's art production reveals our era's obsession with identity, the effort to create it anew, the need to affirm its uniqueness, and the imperative to self-manage its deployment in a gesture that necessarily depreciates intersubjectivity. The depressed loss of self is here continuously associated with its re-creation, as though the former could only favor the activation of the latter.

The Gendering of Depression

To fully appreciate art's enactment of the depressive symptom of the loss of self, an enactment that not only situates depression as part of "normal" subjectivity but also ties it to a double-bound sense of self wherein insufficiency triggers the need for self re-creation, we must now consider the second component that comes into play in Beecroft's laboratory: the gendering of depression as female and feminine. In this section, I want to show how the dimensional view is specified in gender by the laboratory's quasi-systematic staging of female performers. This systematization is highly significant with regard to the feminization of the disorder: it both ratifies the feminization and reveals this feminization in that very ratification. More importantly, however, Beecroft's "let us see" of feminine practices is one that radically embodies the depressive paradigm while attending to the sociality of the disorder. It insists on the depressed subject's attachment to norms of femininity (her unreachable desire to be the feminine ideal) but describes this attachment as fundamentally corporeal. This attention to corporeality is pivotal, as it shows how the depressive paradigm relies on feminized bodies to develop itself. In this, I contend, the performances both side with and renew the feminist social constructivist critique of scientific literature that problematizes prevailing biological explanations of the specificity of female depressiveness.

The nineteenth-century decline of melancholy (the temperament) and its gradual replacement by melancholia (the clinical disease) and then depression announce the disappearance of the association, which was initially formulated by pseudo-Aristotle and reaffirmed in Italian Renaissance humanism (especially through the figure of Marsilio Ficino), between melancholy and the modern notion of genius, ending the traditional rapprochement between melancholy states and compensating brilliance, despair, and access to the sublime.[70] What needs to be underlined here, especially in relation to Beecroft's all-female performances, is the gendered dimension of the slippage from melancholy to melancholia to depression. As the slippage occurs, writes philosopher Jennifer Radden, "melancholia has become associated with feminine gender. . . . Melancholy, with its loquacious male subject, leaves little room for the mute suffering of women. Women, instead, are victims of depression."[71] Bluntly, whereas Renaissance and post-Renaissance conceptions of melancholia converged in the belief that melancholia—a mental disorder informed by intense depression of spirits, anxiety, brooding, and a deep sense of loss,

compensated by creative genius—was essentially a masculine form of suffering, the more medicalized view of late-nineteenth-century and twentieth-century depression has tended to relate depressive disorders to womanhood.

This shift took place in a period when mental disorders were increasingly explained biologically and the body perceived as the realm of uncontrollability. Indeed, in the wake of the nineteenth-century medicalization of madness, the affective life of moods and emotions, perceived as unruly, irrational, disordered, and uncontrollable, was associated with the body, subjectivity, and femininity. Such associations led increasingly to the generalized identification of women with madness.[72] Some evidence also shows that melancholia and depression were more and more perceived as feminine, often on the basis of female reproductive biology. Psychiatrist Jean-Étienne-Dominique Esquirol, one of the founders of modern psychiatry, known for his classification of delirium, mania, and dementia, defined melancholia as "a cerebral malady, characterized by partial, chronic delirium, without fever, and sustained by a passion of a sad, debilitating or oppressive character." In his *Mental Maladies: A Treatise on Insanity* (1845), he asked himself, "Are not women under the control of influences to which men are strangers, such as menstruation, pregnancy, confinement and nursing?" He also believed that women were prone to erotic and religious melancholia on the basis that amorous passions are "so active in women" and that religion "is a veritable passion with many [women]."[73] Psychiatrist Emil Kraepelin established the same gendered link when referring to the patient population at the Psychiatric Clinic in Munich, observing in 1920 that "about 70% of the patients [suffering from manic-depressive insanity] belong to the female sex with its greater emotional excitability."[74] If one needs more evidence indicating that women were in fact the predominant population diagnosed as and institutionalized among the insane in the nineteenth century, this belief was a source of concern for reformers, and medical texts increasingly associated mental disorders with the female reproductive system. Furthermore, even if such associations related to specific forms of madness that were not explicitly designated illnesses of depression (notably, hysteria, neurasthenia, and manic-depressive illness), these forms, as Radden points out, "appear to have been ill-defined and overlapping conditions" in such a way that neither one could be "clearly distinguished from melancholia."[75]

According to a recent epidemiological study conducted by the National Institute of Mental Health, nearly twice as many women (12 percent) as men (7 percent) are affected by a depressive disorder each year.[76] Moreover, findings deriving from studies of hospitals that offer treatment services for people diagnosed with mental disorders in various countries all converge to conclude that the most common diagnosis among women hospitalized for treatment of a mental illness is depressive disorder. Research findings published in the 1980s and 1990s also revealed that women are the major recipients of antidepressant drugs. One 1988 study, in particular, reported that approximately two-thirds of all prescriptions for antidepressant medication in the United States go to women.[77] This is to say not that women are significantly more depressed than men but that they have received this diagnosis twice as many times as men. Some argument has been made to the effect that

women's greater tendency to seek professional help may account for such a gender cleavage, although certain research methods are said to have taken this fact into consideration. It has also been observed that depression in men may be buried under the diagnosis of alcoholism, a mental disorder believed to be more important in men than in women.[78] Yet the fact remains that there is a higher level of diagnosis of depression in women.

Much research has developed in the last decades to explain the predominance of women among the depressed, focusing on the etiological question of what causes depression and why subjects in a specific category become more depressed than others. Different approaches to this question have been explored, the two most important ones being biological and women-centered psychosocial perspectives. More recently, however, feminist social constructionist views have been devised to further the understanding and treatment of depression in women in a way that both demedicalizes depression and provides more agency to women sufferers. At the center of this approach is the belief that discourses of femininity, more specifically the failure to meet the ideals conveyed by such discourses, play a major role in the emergence and development of depression in women. This is why such a perspective is crucial for the understanding of the intertwining of subjectivity and depression in Beecroft's performances, which are shaped by identification setbacks. One of the key psychologists to elaborate this approach is Janet Stoppard, author of *Understanding Depression: Feminist Social Constructionist Approaches* (2000). Discourses of femininity refer to shared beliefs within a specific culture about what it means to be a woman, argues Stoppard; they produce and reflect "implicit cultural guidelines for women on how to behave in womanly ways—how to be a 'good' woman . . . , from assumptions about proper behavior for mothers to notions of fashionable modes of dress for women."[79] Discourses of femininity are therefore the implicit standards against which women evaluate the adequacy or inadequacy of their individual efforts to meet the standards of femininity. Stoppard has proposed a material-discursive approach to depression in women that emphasizes the role of such discourses in the development of depressive orders—not that discourses can be said to cause depression but that depression may well be proved to result from the fatigue or exhaustion coming from a woman's efforts to adhere to the socially constructed ideal of the good woman. The dimension of embodiment is crucial here, as it is so obviously in Beecroft's performances, and this is where lies the originality of Stoppard's approach. Hers is an attempt to acknowledge the embodiment of depression, one that doesn't reside in the reduction of the body to a biological entity or in the medicalization of women's distress through a conceptualization of illness as disease.

Two main biological approaches have been developed in recent years to explain depression in women. The first one conceptualizes depression in terms of genetic influence or as a set of biochemical processes within the brain. The second predominant perspective is a continuation of the nineteenth-century association of female depression with reproductive biology (including menarche, menstruation, pregnancy, childbirth, and menopause), with a new emphasis, however, on hormonal influences. Stoppard observes that the main problem with biological approaches is that they tend to erase the cultural constitution

of the body by positing it as a timeless, ahistorical, natural organism. Furthermore, the establishment of a direct causal link between depression and reproductive biology, which would confirm the existence of postpartum depression (as a distinct form of depressive disorder) and premenstrual dysphoric disorder (the *DSM–IV*'s psychiatric categorization of PMS, premenstrual syndrome), has not yet been supported and has often been contradicted by empirical findings.[80] When biological approaches locate the source of depression within the body's biology, not only do they reinforce the nineteenth-century belief that the female body is virtually dysfunctional and disordered, but they also justify the development and prescription of drugs for women, who represent an expanding market and an increasing source of profits for pharmaceutical companies.[81] In an attempt to formulate an alternative to biological approaches, which deny the role of culture in depression, while still acknowledging the *DSM*'s identification of physical symptoms in depression (such as sleeping difficulties, weight change, and lack of energy), Stoppard envisages depressive fatigue as a woman's failed effort to be the norm. This material-discursive approach emphasizes the fact that "limits are set on women's possibilities for attaining the good woman ideal by social structural conditions and the female body as a finite physical resource."[82] These limits become even more manifest in the context of contemporary discourses of femininity that enunciate—in support of the neoliberal ideal of performance—the figure of the liberated woman who combines family responsibilities with work outside the home, that is, the career woman who now has to juggle the demands of the "double task." This is what Stoppard has to say about the nature and role of material limits in the development of depression:

> A woman's capacity to engage in activities which signify to herself and others that she is a good woman is limited . . . by the finite material resources of the physical body. The material limits imposed by the body may be evidenced by tiredness and fatigue, complaints which are commonly reported by women and typically attributed to burdensome family responsibilities. A woman's ability to engage in practises of femininity also is governed by the material circumstances of her everyday life, which in turn are shaped by pre-existing structural conditions. . . . The material conditions of a woman's everyday life may frequently present situations in which she falls short of her own or others' expectations of the good woman. . . . To overcome her sense of demoralization a woman may increase her commitment to practises of femininity. Perhaps by working harder (and managing her time more efficiently), she can capture the illusive sense of fulfillment which is supposed to be her reward for engaging in activities signifying that she is a good woman. Rather than increasing well-being, however, the more likely consequences are continued fatigue and further demoralization. These experiences are brought into sharper focus with a woman's realization that any sense of satisfaction she achieves is hardly commensurate with the effort she expends. Under such conditions, the more probable outcome is exhaustion of a woman's body and depletion of her morale.[83]

Because of its disclosure of the role of effort, fatigue, bodily limits, and failed identifications with discourses of femininity—aspects that have come to structure Beecroft's (non)events—in the development of depressive disorders, the constructionist perspective is highly relevant for the understanding of the intertwining of subjectivity and depression articulated in Beecroft's performances, notably in relation to the gendered and embodied nature of her performances (an embodiment of which the artist is fully aware, as is made manifest not only in the staging of the public events but also in the organization of the preparatory sessions: both are devised to exhaust the performer). Stoppard's approach, with its emphasis on physical limits and awareness of the nonproductivity of hard work and time management, contrasts sharply not only with current entrepreneurial models of performance subjectivity but also with mainstream psychiatric formulations that tend to pathologize distress. Her framework defines depression "as experiences which arise in conjunction with a woman's embodied efforts to meet socially constructed standards defining the good woman."[84] At the center of Stoppard's conceptualization of depressive disorders lies the notion of unproductive effort, the performative but failed effort of alignment with discourses of femininity that one can never *be* and that are always necessarily limited by material and physical resources. When the effort of alignment "fail[s] to engender feelings of fulfilment and well-being," it is likely to be interpreted by the distressed individual as an inability to meet ideals of femininity, as it will also deplete her energy resources and health.[85] To put it differently, when a woman evaluates herself negatively (failing as wife, mother, worker, or professional; or failing to meet social feminine prerogatives of bodily appearance, reproductive body, and caring work) and when her reliance on physical resources unfolds into sleep deprivation, tiredness, and fatigue, depressive symptoms are likely to emerge. Crucial here is Stoppard's exploration of a dimensional perspective that radically questions the psychiatric reduction of depressive disorders to disease. Her approach goes so far as to assume that feelings of hopelessness and powerlessness, sentiments of self-blame and self-disgust, withdrawal, lethargy, and lack of interest in daily activities, which are diagnosed as depression, "are better understood, from this material-discursive perspective, as a woman's response to insoluble dilemmas in her life."[86] Nonpsychotic forms of depression, then, become a way of coping with life events, one that entails remarkable suffering but is removed from the cognitivist epithets of negative thinking, deficit, and distorted cognition. Part of life, inseparable from identity formation, depression is an integral dimension of contemporary subjectivity. Such a position resonates with Pierre Fédida's understanding that "if there is no doubt what so ever that, in its depressed state, the patient feels ill—even physically ill—, it cannot be said that depression is a disease."[87] This is a fundamental move away from the disease model predominant in current psychiatry, a model that has been heavily influenced by psychopharmacology, especially since the successful launching of a new generation of SSRI antidepressants (for example, Prozac, Zoloft, Paxil, and Luvox) in the 1980s, whose sales are now estimated to be approaching $6 billion annually.[88] As psychiatrist David Healy maintains in his support of a dimensional view of depression, the categorical disease-model has been increasingly developed for pharmaceutical ends,

in an economic context in which pharmaceutical companies have been encouraged to develop drugs for disease indications despite unconvincing results as to the efficiency of antidepressants, and in which drug availability has been restricted to prescription-only status—with the alarming consequence of "a mass creation of diseases":

> [T]he pharmaceutical industry has developed a capacity to make markets: If drug availability was to be restricted to diseases, it was perhaps predictable that a mass creation of diseases would result. . . . In order to sell its compounds, the pharmaceutical industry has educated prescribers and the public at large to recognize depression as a widespread disorder affecting more than 350 million people worldwide that leads to considerable disability and economic disadvantage as well as suicide. Thus, depression is accepted as being treatable with antidepressant drugs, even though only minimal evidence indicates that these drugs are helpful for even a significant proportion of these disorders and despite concerns that, in some cases, antidepressants may increase rather than reduce suicide rates.

> The question is whether neuroscientific and regulatory frameworks to date have favored categorical disease-based models for reasons of convenience rather than accuracy.

> The premium put on categorical models of disease rather than dimensional models radically changed the face of psychiatry. The exemplar of a categorical disease state was the bacterial infection. In contrast, within psychiatry, dimensional models of pathology were emphasized heavily until the psychopharmacologic era. The Freudian school of thought was dimensional in the extreme. The emerging behaviorism focused on disabilities rather than on disease categories. Dimensional thinking held sway within biology as well, and psychiatric textbooks contained photographs exemplifying different constitutional types.[89]

In their emphasis on embodied identification processes, Beecroft's performances actively contribute to the dimensional understanding of depression in women, which not only highlights the role of discourses of femininity in the development of identity processes but also emphasizes the impact of material limits (both physical and environmental) in the difficulty of matching these discourses. It is not so much the failure to identify that brings about depression as the negotiation around failure. As fatigue, lethargy, loss of pleasure, muteness, and withdrawal set in *within the duration of the performance and through the performers' unproductive effort to maintain the feminine ideal,* depression (understood as a continuum and not as a disease) infiltrates the performances of subjectivity. Beecroft's embodied view of contemporary subjectivity—an embodiment that comes about in the fatigue of the performers, the display quality of the performances, and the coping through which the performers affirm their identity—is one that rests on the acknowledgment of the fallibility of the body in relation to rules of femininity as a high vulnerability factor in the development of depressive states. This perspective doesn't so much counter the current feminization of depressive disorders as challenge scientific

literature dealing with the specificity of women's experience of depression that tends to situate the causes of the disorder in the female reproductive system without historicizing or culturally contextualizing that system.

The work's embodied enactment of feminine depression becomes even more manifest if we consider its long-standing preoccupation with the question of eating disorders. As was evident in her first show, in 1993, where she first presented the "Book of food," the journal compiling her daily ingestion of food for the preceding eight years, and in *VB52* (2003), the Catello di Rivoli performance that staged women around a dinner table being served aliments classified in quantity and color, the artist has devised a production traversed by the perdurable question of anorexia and bulimia. Feminist scholar Susan Bordo, in her examination of the female body as a locus of reproducibility of femininity, has observed that eating disorders (including anorexia and bulimia, which are not exclusive to but are predominant among women) must be understood not as abnormalities but as a dramatic ramification of norms of femininity, a self-destructive suffering that reveals "the continuum between female disorder and 'normal' feminine practice."[90] Anorexia nervosa, in particular, painfully embodies the intersection of two decisive series of rules: the rules of traditional femininity according to which women are required to feed not the self but others (so that self-feeding or any form of hunger—for public power, autonomy, sexual pleasure—is perceived as excessive and is contained adequately); and, in a historical moment when women are entering increasingly into the public arena, the traditional masculine rules of self-mastery, self-control, self-management, and self-determination.[91] The ideal of contained slenderness provides the illusion that women can meet these contradictory demands through a careful daily management of their bodies and an amazing act of will over a culture that is "dedicated to the proliferation of desirable commodities."[92] But in our current social system, it is bulimia—played out in eating and dieting or in any other practices that imply a conflictual logic of unrestrained consumption followed by acts of purging—that exemplifies the contemporary eating disorder par excellence, as it succeeds in embodying "the unstable double bind of consumer capitalism."[93] Although eating disorders represent a form of empowerment (the ability to master one's desire) or even protest against predominant homogenizing and normalizing rules of femininity, they are but a self-defeating protest that endangers a woman's life, ultimately reiterates her sense of insufficiency, and centers the self on itself.[94] In this, eating disorders must be seen as reinforcing withdrawal and as making women vulnerable to states of depression. Bordo explains: "Through the exacting and normalizing disciplines of diet, makeup, and dress—central organizing principles of time and space in the day of many women—we are rendered less socially oriented and more centripetally focused on self-modification. Through these disciplines, we continue to memorize on our bodies the feel and conviction of lack, of insufficiency, of never being good enough. At the farthest extremes, the practices of femininity may lead us to utter demoralization, debilitation, and death."[95]

Beecroft's performances are a pressing acknowledgment of the body, reaffirming Michel Foucault's insight of the body as "imprinted by history" and the concomitant process of "history's destruction of the body" through which corporeality is but a "volume

in perpetual disintegration."[96] The female bodies are displayed as surfaces of inscription of the dominant rules of slenderness, containment, whiteness, and youth through which docile bodies (corporealities that have become habituated to the normalizing rule of "improvement") are being produced in contemporary Western societies. They reactivate art historian Lynda Nead's critical reading of the aesthetic distinction between the naked and the nude (Western art's confirmation of its field through the exclusion of the naked and the concomitant inclusion of the nude as a practice by which the artist gives form to matter) by disclosing the nakedness of the nude.[97] Yet, despite the apparent containment of the slender, flawless, and homogenized female bodies, these are struggling, naked embodiments. In this very deployment, the performances show how depression is both a discursive construct that relies on the female subject as body—a body that modern science still generally perceives against a male standard, as "not whole"[98]—to secure the definition of depression as deficiency, and a state acted out (imitated but also sometimes displaced) by that very body. Hence (and here lies the productivity of Beecroftian corporeality), it is not simply that depression is a feminine or feminized disorder whose predominantly female subject must be studied to circumscribe the vulnerability of women to this particular condition but, more importantly, that the discursive formation called depression anchors itself on the indefatigable perception of the female body as imperfect and incomplete, leaking and uncontrollable. This anchoring can only consolidate depression as a flaw of adaptation and creativity.

The Subject as a Coping Machine

The intertwining of depression and subjectivity in Beecroft's performances comes about through a visual and embodied deployment of depression as an identity-performance failure, the inability of the model to perform the Newtonian ideal and the insufficiency of the self entailed in uniform femininity. And yet, if we are attentive to the transformations at play throughout the performances, the performers' actions are not merely failures but mostly modes of coping with failure. Beecroft's rapprochement of depression and subjectivity can be truly delineated only if we acknowledge the gradual emergence of a differentiated self from within failure. I contend that this emergence takes place, because her laboratories of subjectivity are set out to ultimately display the depressed as a coping individual to be assessed in terms of adaptability and unadaptability. The depressed is a being who exists only inasmuch as he or she is a (successful or unsuccessful, efficient or inefficient) coping machine. I want to establish in this section that the assessment modality is central to Beecroft's enactment of depressed subjectivity: it not only confirms the fact that her subjects are continuously looked at following specific criteria of observation but also posits that the operation of coping is one of the main underlying principles governing the contemporary interrelation between depression and subjectivity. The performances, which take their criticality not so much from their questioning as from their displaying of contemporary individualism, are cognitivist laboratories reinforcing the model of the subject as a coping machine. In these specific instances, art not only merges

with behavioral-cognitive psychology's making of subjectivity but also, most fundamentally, discloses subjectivity in this very merger. It does so by connecting depression and coping. To better understand this connection, it is crucial first to underscore how much, in their staging of subjects, the performances are observation laboratories. It will then be useful to examine in more detail one of Beecroft's recent actions with the following question in mind: how does her work interrelate depression, coping, and subjectivity?

The Laboratory as a Site of Observation

The adaptive model in Beecroft's work really becomes manifest only if we consider how much the audience is a significant part of her performances, even though its presence is constantly negated by the nonexchangeability of the performances. The performances are conceived and exist only as public events. They presuppose an observer who will acknowledge both the pain (Beecroft: "I want to show women in a way that it's painful for people to watch"[99]) and the coping skills of the performers. In her many interviews, Beecroft constantly states her wish to use the performances as a laboratory for prototypes so that their credibility, value, legibility, efficiency, and meaning may be tested in the

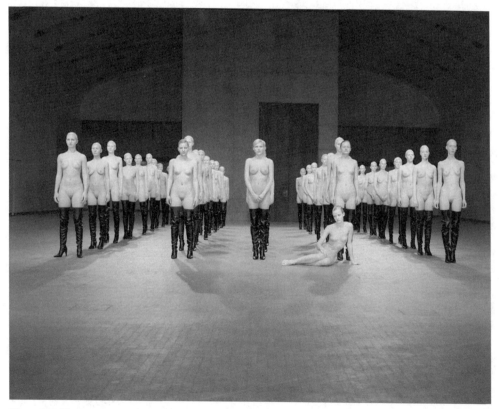

Figure 28. Vanessa Beecroft, *VB45*, VB45.103.dr., 2001, Kunsthalle, Vienna. Photograph by Dusan Reljin. Copyright Vanessa Beecroft. Courtesy of the artist.

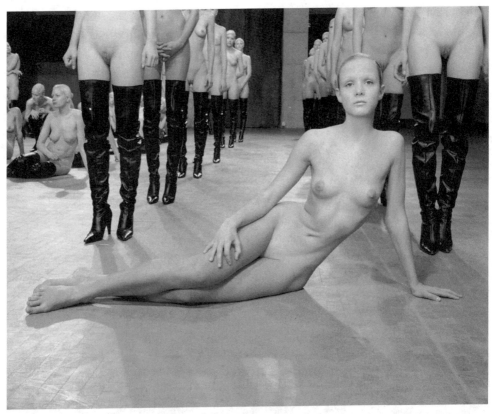

Figure 29. Vanessa Beecroft, *VB45*, VB45.005.dr., 2001, Kunsthalle, Vienna. Photograph by Dusan Reljin. Copyright Vanessa Beecroft. Courtesy of the artist.

public space of the gallery. Referring to the motivations behind *VB46*, a performance presented in March 2001 at the Gagosian Gallery in Los Angeles, she states that she want-ed to bring "flat, skinny, tiny" nude girls together so as to test the resilience of sexuality despite their androgynous look ("They think breasts mean sex. OK, let's get rid of breasts. Hips mean sex: let's get rid of them. I want to see if the picture still works"[100]). For *VB45*, a 2001 performance staging forty-five tall blonds in thigh-high black boots by Helmut Lang, she "wanted to do a kind of Nazi-looking picture" to see how it stood. For her 1998 *VB35* performance, at the Guggenheim Museum in New York, significantly subtitled *Show*, she assembled fifteen women in red Gucci bikinis and high-heeled rhinestone shoes, together with five naked women in heels, in the pit of the Frank Lloyd Wright snail curve for two and a half hours, so as "to see how far people could take the work as art."[101] As stipulated earlier, in a general statement about her work, she argues, "I like the idea of a combination of a feminist background . . . and a Helmut Newton portrait of a naked woman in heels. I like to see if the two parts can match."[102] These comments confirm how much Beecroft's performances are experiments to be displayed, shown, seen, and tested by the viewer, but also how they are entertainment spectacles.

Describing the reaction of the public to *VB35*, Wayne Koestenbaum writes, "Invitees

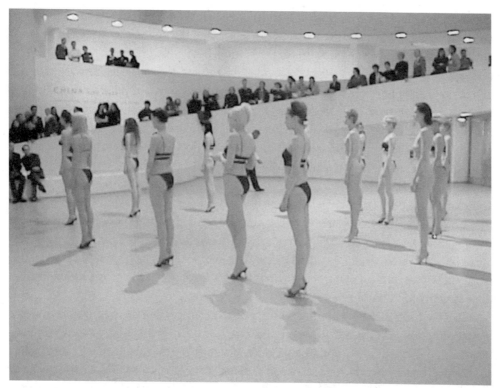

Figure 30. Vanessa Beecroft, *VB35: Show,* VB354.079.al., 1998, Guggenheim Museum, New York. Photograph by Annika Larsson. Copyright Vanessa Beecroft. Courtesy of the artist.

poured in, a glittering bunch, among them Leonardo DiCaprio and Condé Nast editorial director James Truman, and *Show* began to resemble a party with a risqué ice sculpture, slowly melting, on which guests desultorily commented, though the artifact remained a sidenote to the headier labor of gossip, flirtation, rubbernecking, and networking."[103] Peter Schjeldahl also emphasizes how much the viewing public is an integral part of the performances, maintaining that "Beecroft's work is a spectacular, entertaining way of making us conscious of what the situation of art is now in terms of audience and publicity and gossip."[104] Bluntly, the performances must be understood in their logic of "to be seen." Such an experience reveals how the posing of the female bodies is a spectacle inasmuch as the models are not agents of the look, and how the fact of discarding the viewers through the performers' refusal to exchange optically or verbally with them can be turned into a strong condition of possibility for the positioning of the spectator as a voyeur.

Beecroft's (non)events unfold for a public and must be understood in their logic of display and exposure. The naked posing women are the "to-be-looked-at-ness" of the spectacle. *VB46* performer Clover Leary explained in these very terms the simultaneous loss of subjectivity and reinforcement of role-playing that took place in the context of a performance structured on the cleavage between the female naked bodies occupying the position of "to-be-looked-at-ness" and the public as bearer of the look.[105] The

performances exist only inasmuch as they are seen, with a seeing that is required to follow the rule of nonexchange (models are instructed not to interact with the viewers, either verbally or by eye contact). In this economy of the look, the performer and the observer exist on two different sides of a divide. The former does not need the latter for the efficacy of disciplinary practices: engaged in a process of constant self-management, the model's behavior apparently depends not on exterior demands but on self-absorption, self-policing, self-transparency, and self-generation, actualizing what Foucault calls the technologies of the self, "which permit individuals to effect, by their own means, a certain number of operations on their bodies, their own souls, their own thoughts, their own conduct, and this in a manner so as to transform themselves, modify themselves, and to attain a state of perfection, happiness, purity, and supernatural power."[106] The viewer is thus positioned as intersubjectively irrelevant yet required for the surveillance and overseeing of the performances. In agreement with Beecroft's prohibition of exchange, they are to be seen from a distance. Such a distancing is crucial in relation to what is seen: the performers' reenactment of norms and their insufficiency in relation to the ideal, but also their stress-coping skills.

What we have here is the perfect replica of a scientific laboratory in which subjects are asked to take part in an experiment that will test their reactions and coping abilities to a specific stressful life event. The productivity of this experiment relies on its being observed by an analyst whose observation can mature only if he or she looks from a place that is separate from the observed, and whose presence is not required for the management of the behaviors. Moreover, the psychological transformations of the performers belong to the realm of the visible; they manifest themselves through the body, and the viewer seizes them solely at that level. The performers' "interiority" is never truly accessible. Beecroft's events are, after all, "shows," and the models are explicitly asked by Beecroft to put on a facade, as in *VB46*, for instance, in which they were required to look bored, strong, detached, and relaxed.[107] This is why the performances must be acknowledged as displaying the *DSM*'s diagnostic gaze as a technology that seeks (for the sake of reliability) to counter the considerable role of subjective judgment in the diagnosis of mental illness through a discarding of the underlying causes, reasons, or meanings of morbid symptoms. In contrast to the deepness of the melancholy disposition, depression is shown to be a surface affection. By insisting on the "let us see" of the performances (the emphasis on the woman-as-body, the full visibility of these bodies, and their spectacle dimension), Beecroft exposes this mental reduction of depression. As indicated earlier, this insistence on visible corporealities also shows how science relies on the female subject as a body that is "not whole" to define depression as deficiency.

The Coping Subject

How is Beecroft's performance work changing the field of aesthetics, and how does it contribute to the scientific debate around depression? How does it relate coping skills to the intertwining of depression and subjectivity? And what does one exactly mean by a "coping

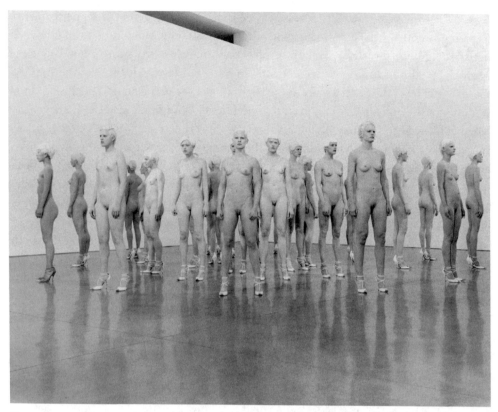

Figure 31. Vanessa Beecroft, *VB46*, VB46.017.dr., 2001, Gagosian Gallery, Los Angeles. Photograph by Dusan Reljin. Copyright Vanessa Beecroft. Courtesy of the artist.

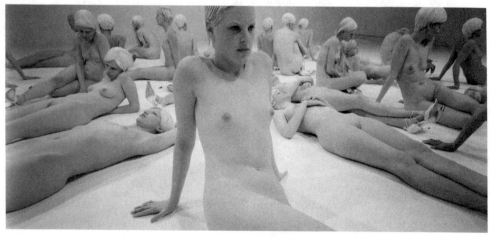

Figure 32. Vanessa Beecroft, *VB46*, VB46.029.al., 2001, Gagosian Gallery, Los Angeles. Photograph by Armin Linke. Copyright Vanessa Beecroft. Courtesy of the artist.

style"? These questions are best addressed by considering *VB46*, a three-hour performance featuring twenty-six naked women shod with white strappy Manolo Blahnik four-inch heels. The group consisted mainly of professional models recruited through modeling agencies but also included two art students from the California Institute of the Arts. As the viewer entered the gallery space at the beginning of the performance, the group stood still, motionless and strong, in a mass that highlighted and reinforced the homogeneity between the women. The models fit prevailing fashion criteria of feminine beauty: female, young, thin, white, androgynous-looking. Their homogenizing whiteness was emphasized by the presence of an Asian American model, whose skin, like all the others, had been spray-painted white with semitransparent makeup. All but one model had short, white-bleached hair or wore a wig and had had their pubic hair completely removed. Standing in a pack in the middle of the gallery, they occupied a space outlined by the path of a red-haired model (with pubic hair) walking around the group. This figure functioned as both a mediating and a protective device. Because of her nudity and her different hair color, she belonged at once to the two groups—the performers and the viewers—allowing for a transition between the two and establishing a distance between the inside and the outside so as to reinforce the absence of exchange that characterizes all of Beecroft's performances.

After a period of ten to fifteen minutes, photographic Newtonian perfection, control, stillness, and monumentality started to fail as the models slid into a series of poses that betrayed their inability to stand still. Among the forty-one rules handed out to the models beforehand was the clear stipulation that they had to "be as still as possible." As the performance progressed, "some small movement" would be permitted, but the models still had to "hold each position adopted as long as possible," "stand as much of the time as possible," "stand up straight," and "be strong." After the first half hour, they were allowed to sit down and, toward the end, to lie down. The slow disintegration of the pose in Beecroft's performance is crucial here, for, following Cherry Smyth, "fatigue separate[s] individuals from the group."[108] As the models struggle with the feminine ideal, they paradoxically gain individuality. To put it differently, the homogeneity of the group by which individual identity initially erased itself, "in front of pure appearance,"[109] starts to falter. The affirmation of identity articulates itself not only through individualized fatigue but also, and perhaps even more so, in the performers' coping with pain and stress—a coping that, because of the absence of exchange between model and viewer, takes the form of intensified withdrawal. As Heather Cassils, one of the models of the *VB46* performance, recalls, "I did what I could from the inside" so as to live through the performance.[110] The performers explore the muteness to which they have been condemned, turning it into a withdrawal strategy to assert the self and survive the endurance test of the performance. Within this inward movement toward the self, each woman asserts her unique way to deal with distress and thus distinguishes herself from the others. As writer and curator Pier Luigi Tazzi stipulates (and this relates to all of Beecroft's performances), "The reiterated image apparently results in the dissolution of the individual identities that lie behind a common appearance; yet all the same there's a never-flagging game of the contraposition of repetition (individuals have been chosen

and prepared by an eye intent on their similarity) and variation (individual identity persists despite the first impression)."[111]

Depressiveness is thus shown here to be not so much a loss of identity, as mainstream psychology advocates, as a struggle between the failure to imitate the idealized and the benefits of this imitation, between homogeneity and difference, between feelings of insufficiency and the need to re-create the self that comes into play through the deployment of an imaginary bubble that affirms the self through a disengagement with the other. Depressive affects become a strategy by which one shapes one's individuality. Whereas Elizabeth Janus is right to state that Beecroft's performances convey a sense of "existential hopelessness,"[112] they stage depression-in-the-making as shaped not only by the models' effort to be a norm of idealized femininity but also by a coping activity that might bring them to affirm their individualized selves. More importantly, as I hope to clarify, this depression-in-the-making (which is also individuals-in-the-making) is a coping practice inasmuch as this coping is examined by an apparently denied observer. An attentive reading of behavioral-cognitive and interpersonal perspectives—the leading psychological approaches to depression today, both of which have marginalized psychoanalytical theory to posit the subject as a coping machine—will show how Beecroft's performances produce and disclose both individual performers who struggle for their identity in terms of coping and viewers who have come to see in terms of coping in a logic where individual and observer are inseparable units in the making of (depressed) subjectivity. Art and science meet here in the enunciation of coping individuals and the correlative interpellation of the viewer as a cognitivist observer. I am contending here that the criticality of Beecroft's work lies not in any attempt to subvert prevailing definitions of femininity but in its merger of art and cognitive science, which exposes the strong impact of cognitivist discourse on current daily makings of subjectivity.

Cognitive theories of depression assume the existence of schemata or internal representations—latent cognitive patterns about the self built up from early life experiences—that shape one's perception of the world.[113] A crucial notion here is that of perception, for mental illnesses are presumed to emerge not so much from life events as from one's perception of life events.[114] To put it differently, even though cognitions have more recently been given less of a causal role, cognitive science postulates that affect and behavior are largely determined by the way an individual *thinks* about the world. In the case of depression, individuals are generally said to maintain a negativistic style of thinking in their interpretation of past and present life experiences as well as their expectations for the future. Martin Seligman, for example, an early key researcher in the field, whose experimental approach interrelates behaviorism and cognitivism, formulated a learned-helplessness theory of depression, which posits that depression occurs when individuals come to believe that their actions cannot appreciably influence the outcome of events in their lives.[115] Passivity, a negative cognitive set, introjected hostility, loss of appetite, and stress are some of the symptoms Seligman identified as resulting from the belief in one's own powerlessness. Even if such beliefs are affected by life experiences, depression is a sense of helplessness in relation to one's actions and not in relation to the world. "The

hypothesis is 'cognitive,'" write Lyn Abramson, Seligman, and John Teasdale, "in that it postulates that mere exposure to uncontrollability is not sufficient to render an organism helpless; rather, the organism must come to expect that outcomes are uncontrollable in order to exhibit helplessness."[116] The work of Aaron Beck has also been crucial for the development of the cognitive approach to depression and its further development into a diathesis-stress model.[117] For Beck, schemata are the basic structural components of the cognitive organization through which individuals identify, categorize, interpret, and evaluate their experiences. In cases of depression, schemata—what Beck has defined as "inflexible, unspoken, general rules, beliefs, or silent assumptions developed from early experience"[118]—are characterized by negative views, including the perception of the self as defective, undesirable, and inadequate; the view of the world as demanding and defeating; and the sense of the future as hopeless. He posits a cognitive triad—negative views about oneself, the world, and the future—to account for the psychological basis of depression, a mental illness whose main symptoms include emotional (dejected mood, self-dislike, loss of gratification, loss of attachments, crying spells, and loss of mirth response), cognitive (low self-evaluation, negative expectation, self-blame and self-criticism, indecisiveness, distorted self-image, loss of motivation, and suicidal wishes), and vegetative or physical (depth of depression, fatigability, sleep disturbance, and loss of appetite) manifestations. Identified before the publication of the *DSM–III* (1980), many of these symptoms have been integrated into the *DSM*'s classification of depressive disorders and have become the official symptoms of major depression. Negative views, such as aberrant standards for self-evaluation and dysfunctional self-focus, have been postulated by Beck (and this is a constant within cognitivism) as maladapted cognitive distortions to be eventually corrected by a therapist.

Best summarized by the APA, cognitive-behavioral therapy (seen to include cognitive psychotherapy) "maintains that irrational beliefs and distorted attitudes toward the self, the environment, and the future perpetuate depressive affects. The goal of cognitive behavioral therapy is to reduce depressive symptoms by challenging and reversing these beliefs and attitudes."[119] One of the main criticisms of cognitive theories is that they assume that some individuals are depression-prone and that negative schemata cause depression. Such an assumption does not stand evidence. Although research shows that the thinking of depressed individuals is dominated by negative thoughts,[120] it has not yet been proved in a consistent way that negative thoughts are in fact schemata that precede depressive episodes.[121] Adjusting to these findings, cognitive science has become more refined through the years, in a refinement that is the basis of the current reliance on the notion of coping to explain the avoidance or onset, maintenance, and remission of depression. Whereas early cognitive models tended to postulate the primacy of dysfunctional cognitions, more recent approaches have been considering what Nicholas Kuiper, Joan Olinger, and Rod Martin have called "the complex relationships among cognitive factors, life stressors, and specific vulnerabilities," leading to different diathesis-stress psychosocial models.[122] The diathesis-stress approach posits that individuals with specific psychological traits (the "diathesis" component) who experience a stressful life

event (the "stress" component) congruent with the psychological diatheses are likely to become depressed. Diatheses are hypothesized to increase one's vulnerability to depression in the occurrence of stressful life events that have a negative implication for the individual's adaptation. One of the predominant diathesis-stress models today, the personality model, has been developed by Aaron Beck, and David Clark and Robert Steer.[123] It postulates that individuals prone to depression have personality traits that predispose them to depression. Two such traits are sociotropy (a form of social dependency characterizing individuals who place high value on having close interpersonal relationships and who "satisfy their needs for security and self-worth by pleasing others and avoiding others' disapproval through maintenance of close interpersonal attachments") and autonomy (characteristic of individuals who place high value on personal independence, achievement, and freedom of choice and who "[derive] self-worth from mastery and achievement, which may lead to excessive personal demands for self-control and accomplishment").[124] Even if many problems persist with diathesis approaches—they imply that because of personality an individual is inherently depression-prone, and that the broader social environment of the individual plays a marginal role in the onset and maintenance of depression—this model is part of mainstream understanding of depression, a fact made manifest by the wide use of the Beck Depression Inventory (BDI) by mental health professionals during clinical interviews.[125]

As I have stipulated, in order to resolve the problems attached to the postulation of proneness or predisposition to depression, emphasis is increasingly made on coping effectiveness and ineffectiveness. Kuiper, Olinger, and Martin, for example, have identified a personality type characterizing individuals who attempt to maintain a positive view of self by fulfilling unrealistic performance demands through hard-driving, work-directed behaviors.[126] The compulsive and overzealous work habits of this personality type are postulated as a maladaptive coping style employed to minimize negative self-evaluations. As long as they are able to meet their performance standards, such individuals will maintain a positive view of self and will experience positive affect, but these self-worth contingencies are unrealistic and therefore very difficult to meet. When they are not met—when coping attempts are unsuccessful—the perceived failure to meet personal performance standards will result in diminution of self-esteem and increased depressive affect. The coping-style model is also at the heart of Tom Pyszczynski and Jeff Greenberg's view of depression as the consequence of persevering efforts to regain a lost object when it is impossible to do so.[127] This persevering is believed to occur when an individual has lost a primary basis of self-worth and does not have sufficient alternative sources from which to recover this self-worth. The resulting self-regulatory persevering is posited to entail a chronically high level of self-focus, which produces a spiral of escalating negative affects, including self-blame, disparagement, and motivational deficits that ultimately result in negative self-image and depressive self-focusing, which in turn perpetuate the depressed state. Again, depression is defined as a maladaptive coping strategy or, more precisely, as one's inability to reduce or shift self-focus to superordinate goals in circumstances where there are no behavioral options to meet predefined standards. "[R]ather than

viewing depression as the result of the individual generally giving up on goals," write Pyszczynski and Greenberg, "we view it as the result of the individual failing to give up on an unobtainable goal when it would be adaptive to do so. Thus we view depression as a breakdown in adaptive self-regulatory functioning."[128] The maladaptive profile of the persevering type is manifest in the following passage, where the individual is described in terms of inadequacy, inability, unwillingness, blind persistence, and repetitive focus on lost goals:

> Unfortunately, people are sometimes unable or unwilling to withdraw from their goal-directed pursuits, even when goal attainment is unlikely or impossible. They persist in devoting psychological energy to hopeless causes and ultimately begin to experience a variety of psychological changes that are commonly referred to as depression. We refer to this inability to disengage from a highly desired goal as *self-regulatory perseveration* and view this state as a central component of the process that leads to depression. *The state of self-regulatory perseveration is one in which the individual is preponderantly and repetitively focused on the lost goal, its significance for the self, and ways to regain what was lost.*[129]

More recently, James McCullough, in an attempt to complexify cognitive definitions of depression by integrating the interpersonal aspects of the disorder, has developed a cognitive-behavioral-analysis system of psychotherapy, which assumes that chronic depression results from maladaptive social problem solving and the accompanying perceptual "blind spot" that prevents individuals from "recognizing a connection between *what they do* and *the effects of what they do* on others." Insisting on the crucial role of coping failure in depression—a role that makes depressed individuals ultimately responsible for their illness—McCullough maintains that "chronic depressive disorder is best understood when it is viewed as the result of a person's long-term failure to cope adequately with life stressors."[130] Interpersonal psychotherapy (IPT), which sees depression as the result of problematic interpersonal relations, also emphasizes the key operation of maladaptation in depression. Focusing, according to the APA, on "losses, role disputes and transitions, social isolation, deficits in social skills, and other interpersonal factors that may impact on the development of depression," interpersonal therapy seeks to facilitate mourning and promote recognition of related affects, to resolve role disputes and transitions, and to overcome deficits in social skills so as to enable the acquisition of social supports.[131] The work of Charles Holahan, Rudolph Moos, and Liza Bonin is significant in this regard, as it examines adaptive interpersonal functioning and its role in protecting individuals from depression and other health problems.[132] The main premise of their theory is that coping strategies that involve approach as opposed to avoidance, such as direct problem solving and seeking information from others, can buffer people against the depressogenic effects of negative life events. By contrast, avoidance coping strategies, such as denial of problems and withdrawal from others, are associated with a variety of maladaptive behavioral outcomes, including depression.[133]

With their "partial or total ruling out of the importance of unconscious motivations

or inferential processes," cognitive and interpersonal psychotherapies conceptualize depression in terms of adaptation deficits and distortions, negative coping styles to be corrected in therapy.[134] The narrowness of this view lies not only in its reduction of subjectivity to an adaptation model but also in its understanding of depression as a dysfunctional adaptation to loss, change, or stress. In contrast to psychoanalysis, cognitive and interpersonal psychotherapies favor speedy recovery. For this purpose, the question of origins (the identification of a negative schema as related to the patient's life story) is brought up in therapy by the therapist himself or herself, in a "simple statement" or "brief description," only so that the actual therapy—the mutual agreement on the treatment plan, the setting of the agenda for therapy sessions, the assignment of homework, the completion and review of homework assignments, and problem solving—may take place.[135] The main objectives of cognitive therapy (CT), interpersonal psychotherapy (IPT), and the cognitive-behavioral-analysis system of psychotherapy (CBASP) are, generally speaking, "behavior change, personal empowerment and amelioration of emotional dysregulation," together with the modification of cognitive distortions through the highlighting of thinking errors (in CT) and the improvement of the social adjustment of the patient (in IPT).[136] Current psychotherapies are therefore regulated by the criteria of re-adaptation of the individual. Depression, perceived as a deficit of adaptation and creativity, is ultimately the opposite of the performance style to which the therapist must return the patient. Effective coping strategies are those which keep the subject within the neoliberal performance-management paradigm of efficiency through flexibility, self-transformation, diversity, initiative, and innovation—an aspect to which we will soon return in more detail.

By devising performances that stage both models whose sole activity is to cope with the feminine ideal and viewers who will evaluate those models accordingly, Beecroft is disclosing not only how depressive symptoms come into play in the identification failures of the contemporary subject, but also how coping with failure has come to be envisaged as an affirmation of self. This affirmation-through-coping model is a reiteration of current behavioral-cognitive views of depression that define subjectivity in terms of adaptive or maladaptive coping and seek to cure the depressed individual by restoring his or her adaptive abilities. Beecroft's (non)events are an interpellation of a behavioral-cognitivist gaze for which subjectivity in the making is a visible affair, a set of symptoms to be seen and minimally deciphered. Beecroft does not try to counter this model but instead displays it; the performers are failing, coping, affirming, and playing themselves. The performances do not challenge but merge with the cognitive perspective on depression. Yet, by devising performances as scientific laboratories that include both performers and viewers, Beecroft exposes how much contemporary subjectivity is shaped by cognitivist appraisal. This appraisal designates the subject as a coping machine whose depressiveness is both assumed and overcome, both losing and affirming the self following a reiterated structure of failure and (hopefully but not necessarily) cure. Beecroft's performances can thus be said to enact depression only inasmuch as depression is shown to be constitutive of a cognitivist view of what contemporary subjectivity is or, more precisely, is required

to be. It is only by adopting the performance mode that such a rapprochement can be articulated, for the denied viewer must be made a significant component of the artwork to allow the latter to build and stage this rapprochement. It is ultimately the performance of the viewer, a detached and suspended but scopically active observer from beginning to end, that makes manifest the inextricability of depression, subjectivity, and adaptation deficiency. In these (non)events, one acts and sees through coping. "I cope, therefore I am": there lies, in this visual yet mute enunciation, Beecroft's contribution to the debate around depression. The laboratory is a site that brings together coping beings who can cope only through an engagement with the self that is so intense that it disengages the individual from the other.

The Performance-Management Model of Performative Subjectivity

When depressive disorders are envisaged as emerging not from loss (as first theorized by Freud in "Mourning and Melancholia," in 1917) but from one's maladaptive coping style, and when a person's life story is reduced to the development of a negative cognitive view of the self, the world, and the future, depression ceases to be an integral part of the psychoanalytical subject defined in terms of lack, conflict, and repression. It becomes instead (and this becoming is the final operation in Beecroft's work that substantiates the intertwining of depression and contemporary subjectivity) the disavowing counterpart of entrepreneurial subjectivity, a disease of performance to be cured by the restoration of adaptive coping strategies. Such is ultimately the case with Beecroft's models. The ineptness in incarnating femininity is resolved—at least until the next performance, when failure is sure to resurface again—by coping with ineptness, a coping by which one affirms the diversity of the self and its capacity to adapt and self-transform in moments of loss and stress. This model, which brings us to the fourth operation structuring Beecroft's laboratory, is a reenactment of the contemporary performance-management paradigm of organizational theory and practice. It discloses depression (showing it without obviously criticizing it or providing an alternative) as an integral constituent of the neoliberal entrepreneurial perspective of subjectivity.

But what does one mean exactly by "entrepreneurial subjectivity"? I adopt here new media theoretician Jon McKenzie's definition of performance management as a paradigm of organizational theory and practice that has shaped management in the United States and worldwide (through American economic and political hegemony) at least since World War II. Displacing rather than replacing Taylorism, it is a model that seeks efficiency through decentralized and flexible styles of management instead of highly centralized bureaucracies with a top-down management philosophy; "styles that, rather than controlling workers, empower them with information and training so that they may contribute to decision-making processes."[137] Historically, Frederick W. Taylor's scientific management of industrial work, applied at the beginning of the twentieth century as much by Henry Ford for the mass production of automobiles through carefully orchestrated assembly lines as by the Soviet Union for the industrialization of its own

economy, promoted, for the sake of maximum production, the optimal use of tools. This was a task-oriented approach to production defending strict specialization, centralized planning, and the suppression of useless motion. Although this machinelike model is still present today in certain sectors of the economy, it soon became apparent that, in most sectors, efficiency was better maximized with less centralized bureaucracy and heightened organization flexibility so as to accommodate a growing informational society. Human-relations theorist Douglas MacGregor describes well the contrast I wish to highlight between scientific and performance management. He keenly observes that scientific management is a process in which managers direct the efforts of the employees, "motivating them, controlling their actions, modifying their behavior to fit the needs of the organization," whereas in the performance-oriented model, employees are motivated to be creative and independent so that they may direct their own performance toward desired goals. Clearly taking sides with performance management because of its privileging of the creative potential of the employees, MacGregor writes, "The essential task of management is to arrange organizational conditions and methods of operation so that people can achieve their own goals *best* by directing their *own* efforts toward organizational objectives." Management must, moreover, "involve the individual in setting 'targets' or objectives for *himself* and in a *self*-evaluation of performance annually or semi-annually."[138]

The paradigm of performance management regroups a variety of discourses, practices, and conceptual models (including human relations, systems theory, organizational development, information processing and decision making, and peak performance) that articulate different ways of generating, developing, measuring, and evaluating performances for the sake of efficiency.[139] But these different models converge in their promotion of a type of management that aims at empowering workers instead of controlling them, promoting participatory interactions between employees and managers, and delegating information processing and decision making to everyone. The key concepts of such organizational models are diversity, innovation, invention, sense of initiative, responsibility, creativity, self-evaluation, self-transformation, and supportive feedback (the manager's means to measure and evaluate performance). Although this organizational model can be seen as an improvement over the more machinist-oriented perspective of Taylorism, it normatively enforces the view of the independent subject who is required to be inventive, creative, full of initiative, and self-transformational. In his assessment of the performance paradigm, McKenzie thus concludes that whereas, as Foucault's writings have shown, power regimes of modernity were once modeled on an epistemology of discipline (based on the juxtaposition of the discourses of penal law and the architectural mechanisms of surveillance embodied in Bentham's panoptic prison), they are now modeled on an epistemology of performance, which is simultaneously organizational, cultural, and technological.

Relevant to our analysis of Beecroft's production is the way the performance-management model favors efficiency through the same traits that gradually come about in her events: diversity through self-differentiation (in contrast to the initial moments of homogeneity),

self-transformational creativity (the passage from the quasi-perfect, Newtonian femme fatale to a woman who fails and struggles), and problem-solving action (turning inward so as to survive the experiment). The coping model is structured by the performance-management ideology; it is a process that sets into play the very norms of that discursive formation (adaptability, flexibility, responsibility, and decision-making ability, to name a few). I suggest that, by enacting these traits, Beecroft's (non)events significantly complexify our understanding of depression; for if depression is to be understood as a state that comes about and resolves itself through coping, and if these styles are normalized by performance-management discourse, isn't it the case then that depression is the failure to keep up with the performance-management demands of constant self-creation and self-actualization? In other words, isn't depression a pathology of performance management, a pathology of adaptability, flexibility, responsibility, and, most importantly, reiterated self-creation?

It is useful here to briefly refer to *Mr. Pickup* (2000), a three-monitor video installation by John Pilson (b. 1968), which establishes a similar association of depression, deficient coping style, and performance-management philosophy. Contemporary to Beecroft's performances, *Mr. Pickup* constructs its own laboratory of subjectivity so as to create a behavioral-cognitivist viewer whose main task is to observe the collapse of a professional unable to cope with the performance requirements of the business world. The installation features a single seventeen-minute take of a lawyer in the process of picking up files before an important meeting. About to close an important deal, he attempts to gather the required folders, but this simple action becomes a sheer impossibility. As soon as he picks up a file, another one falls. When he picks up the contents of one file sprawled on the

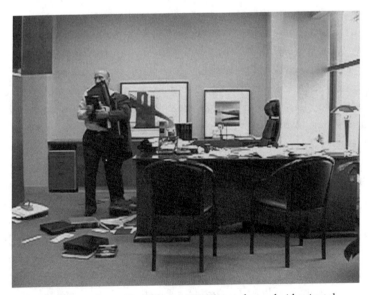

Figure 33. John Pilson, *Mr. Pickup*, 2000. Three-channel video instal-
lation, 17 minutes, dimensions variable. Courtesy of Nicole Klagsbrun
Gallery, New York.

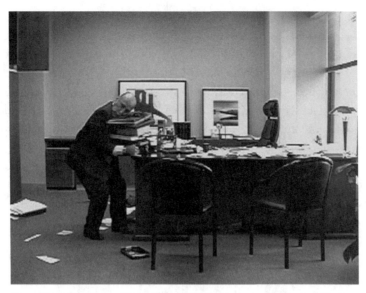

Figure 34. John Pilson, *Mr. Pickup,* 2000. Three-channel video installation, 17 minutes, dimensions variable. Courtesy of Nicole Klagsbrun Gallery, New York.

floor, the rest slip away. As he succeeds in organizing a pile, it is sure to break apart and collapse on the floor. Sweating, he removes his jacket to gather the papers anew but fails again. He calls for help, but nobody answers. These gestures are repeated until (without the files!) he finally leaves the room in a state of chaotic mess. Crucial here is the way in which the monitors have been installed. Arranged side by side at eye level, they enable the viewer to observe the coping style of the individual by comparing the different images. The three monitors present the same sequence but with a slight discrepancy. After looking at one monitor, the viewer is thus invited to look at another so as to either anticipate what is to come or reflect on what has just happened. This is to say that the setting of the monitors allows us to identify the chain of action-reaction of the subject whose behavior is under observation, to measure the time length of these reactions, to elaborate hypotheses about the causes of dysfunctionality, to diagnose the pathology (is this depression?), and to predict what, how, and why this dysfunctionality has come about. We have become behavioral-cognitivist viewers. Moreover, we evaluate the coping skills of the subject according to the performance-management values of flexibility, adaptability, responsibility, decision making, and problem-solving ability. But, as the installation exposes these values and shows us the lawyer in a state of collapse, it also opens up the hypothesis that mental disorder here emerges precisely from the lawyer's failure to meet the values according to which we have been evaluating him.

This complexified view of depression resonates with the findings of Alain Ehrenberg, whose *Fatigue d'être soi* (1998) shows that depression emerged as a leading mental illness in the 1970s, a period of decline of norms of socialization based on discipline, obedience, and prohibition and the concomitant rise of norms of independence based on generalized

individual initiative (personified by the model of the entrepreneur) and pluralism of values (exemplified by the dictum "It's my choice").[140] With its valorization of the creation and assumption of responsibility of the self, the culture of individualized independence is at the root of performance-management philosophy. In such a culture, constraints still pressure subjectivity, but the imperative is to initiate one's own identity instead of being disciplined to do so. Discipline has been replaced by the highly mediatized idea that one has the right (even the duty) to *choose* one's own life: to liberate the self from prohibiting laws, to prioritize personal blooming, even to share one's intimate problems publicly (notably, on television reality shows). Norms of independence are also supported by the judicial system, notably through the legalization of abortion, the facilitation of divorce, and the legislation of euthanasia and genetic engineering—domains that consolidate the right to choose one's life and to dispose of one's body. What these norms do is incite the individual to be the sole agent of his or her subjectivity, to be the subject of himself or herself. This also means, however, that the individual will be affected by troubles of the self.[141] "Depression," writes Ehrenberg, "is the counterpart of the democratization of the exceptional, of this quest to only be oneself,"[142] in societies where "no moral law, no tradition shows from the outside who we have to be and how to conduct ourselves."[143] Psycho- and pharmacotherapy thus become the motor by which the main characteristics of depression—inhibition, fatigue, the diminution of cognitive activity—are treated so as to reinstate the independence of the individual. Depressive disorders are not so much a failure to perform as a failure to perform the self in a culture whose norms of socialization are based on self-creation.

Beecroft's performances are thus laboratories of subjectivity that articulate a shift away from the Freudian-Lacanian model of *loss* to the performance-management–behavioral-cognitive model of *independent efficiency*. They deploy beings whose subjectivity has more to do with the reiterated yet failed effort to align the self with a feminine ideal than the need to repress what is socially prohibited. For the sake of productivity and as a means to cope with depression, Beecroft's neoliberal subject must inscribe itself in the entrepreneurial logic of adaptability, initiative, flexibility, and reiterated creation of the self so as to ensure its survival. The subject doesn't lack a forbidden plenitude. It doesn't need to subvert or reach what has been repressed. Rather, it needs to anticipate and prevent the loss of plenitude that lies ahead, the sheer impossibility of constantly meeting the requirement of the performance of the self by the self. As indicated earlier, the productivity of these actions lies not in their questioning but in their staging of one of the main conditions of possibility of contemporary subjectivity: adaptive coping, not only as an indispensable buffer for depression but also as a key vulnerability factor for depression. By approaching the subject as a coping machine, behavioral-cognitive psychology provides to the depressed an explanation of and cure for his or her recurrent depressive states. But it is also a remedy for the depressiveness endemic to its own performance-management model. The productivity of Beecroft's actions also lies in the inventiveness of her aesthetic strategies. Her staging of the intertwining of depression and contemporary subjectivity can take place only through a merger of art and science, that is, through the adoption of a

dimensional view of depression, the regendering of depression as feminine, the reproduction of the cognitive perspective of the subject as a coping machine, and the reiteration of the performance-management ideal. But this staging, I have contended, takes its originality from Beecroft's transformation of the gallery site into a laboratory of subjectivity that brings together performers and denied viewers as the essential components of the behavioral-cognitivist turn. When art deals with depression, the disciplinary boundaries of art and science are brought into question. Creativity, moreover, becomes the display of *required* creativity (the rule of self-re-creation), which is endemic to neoliberal contemporary subjectivity and may well be one of the reasons for its depressiveness.

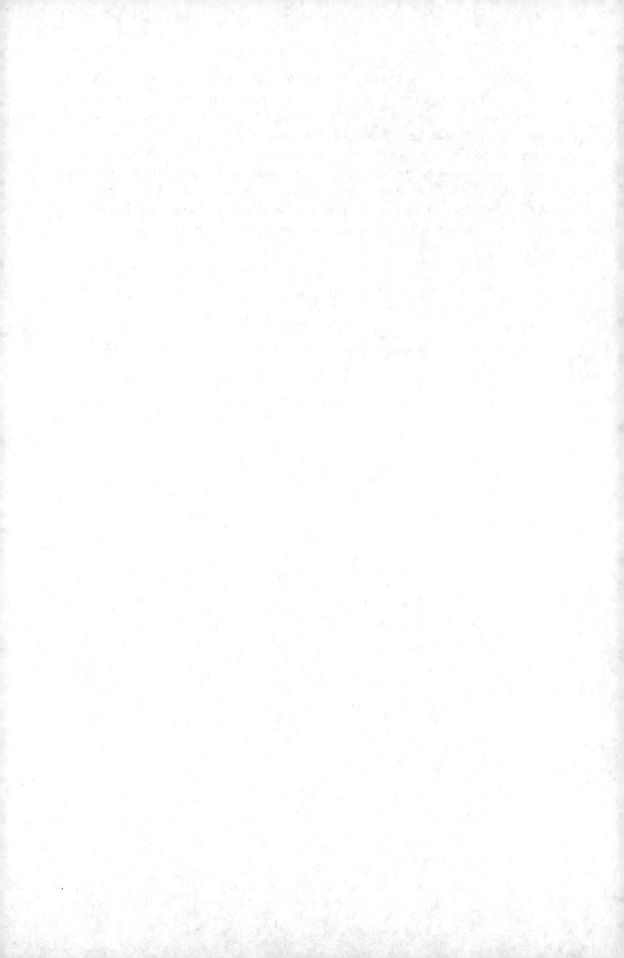

Chapter 3

IMAGE-SCREENS, OR THE AESTHETIC STRATEGY OF DISENGAGEMENT

> I will suggest that the screen or cultural image-repertoire inhabits each of us, much as language does. What this means is that when we apprehend another person or an object, we necessarily do so via that large, diverse, but ultimately finite range of representational coordinates which determine what and how the members of our culture see—how they process visual detail, and what meaning they give it. And just as certain words suggest themselves to us more readily than others, because they are the currency of daily use in our society, so certain representational coordinates propose themselves as more appropriate frames through which to apprehend the world than others, simply because they are subject within our society to a more frequent and emphatic articulation. The full range of representational coordinates which are culturally available at a particular moment in time constitute what I have been calling the "screen," and those which propose themselves with a certain inevitability the "given-to-be-seen."—*Kaja Silverman,* The Threshold of the Visible World

n his epistemology of contemporary aesthetics, philosopher Jean-Marie Schaeffer singles out the "relational" as the fundamental property of the viewer's attitude or conduct vis-à-vis the artwork. This formulation is highly significant to art's enactment of depression, whose main characteristic is to depreciate not only intersubjectivity but also the image-viewer relationship. If depression, as we have seen not only in Ken Lum's *Mirror Maze* installation and Ugo Rondinone's clown series but also, to some degree, in the performance work of Vanessa Beecroft, is precisely what shatters the relation between a spectator and an object, a beholder and any other, can it ever be considered an aesthetics? And what exactly does one mean by "relational"? The answer to this latter question is sharply formulated in Schaeffer's main thesis, which he enunciates as follows: "The aesthetic dimension is a relational property and not a property of the object."[1] This statement means first and foremost that, although a great number of artifacts are created with

an aesthetic intention and with the desire to incite an aesthetic response, art is not the only object predicated on an aesthetic dimension (any object—nature, popular culture, a useful object—can be singularized with such a dimension); neither can it be reduced to an aesthetic experience.[2] More importantly, Schaeffer's is a statement about the role of the beholder in the elaboration of aesthetics: when an object has an aesthetic dimension, the relational property lies not in the object per se but in the relation that exists between the viewer and the object. To put it differently, strictly speaking, there is no such thing as an aesthetic object; there are only aesthetic conducts and aesthetic attitudes.[3]

For anyone minimally exposed to Kantian philosophy, Schaeffer's definition doesn't appear to be particularly new. In his *Critique of Judgment* (1790), Kant postulated that aesthetics is essentially a subjective experience of satisfaction or dissatisfaction (pleasure or displeasure), that is, that it relies not on the qualities of the object but on the contemplative subject. However, in his attempt to isolate aesthetic conduct from cognitive and practical attitudes, Kant argued that (dis)pleasure derives from the state of disinterestedness in the subject. Schaeffer's notion of the relational assumes an *interested* experience. Whereas Kant's aesthetics presupposes a suspension of the cognitive act of understanding—a presupposition that has led many contemporary thinkers, including Nelson Goodman and Arthur Danto, to conclude that there exists a clear incompatibility between (dis)pleasure and understanding, sensation and interpretation, aesthetics and knowledge—Schaeffer suggests that aesthetics cannot be divorced from the cognitive act of discernment.[4] His study, together with the work of Richard Shusterman, to which we will return in chapter 4, has been crucial in showing that the supposed incompatibility between aesthetics and cognition is a mere denegation of how much they "constitute each other."[5] This mutual constitution is made manifest in Schaeffer's postulate that the aesthetic experience is "a cognitive activity regulated by its index of internal satisfaction."[6] It engages a cognition that, like any other cognition, is a complex activity involving a diversity of intertwined operations, including attention, intention, selection, underlining, combination, and isolation.[7] But—and this is what distinguishes aesthetics from other cognitive operations—it is an activity of discernment that is charged affectively, valorized for the (dis)satisfaction or (dis)pleasure it provokes. Bluntly, (dis)pleasure is an integral part of aesthetic conduct only inasmuch as it is causally related to the unfolding of the cognitive activity itself: it is induced by the operation of discernment itself and not by the result of that operation.[8] Moreover, its interestedness implies that aesthetics ceases to be a form of transcendental communicational intersubjectivity, one that Kant hoped to reach by opposing aesthetics to understanding (an opposition that showed how, as a disinterested *Homo aestheticus*, man was not totally determined by the world of objects and could claim to make valid universal judgments). When interest is reintegrated into the aesthetic relation, immanence and relativism set in.

It seems to me extremely relevant, in light of the whole question of contemporary art and depression, that the "relational" is posited here as one of the central structuring dimensions of the interpretation of art. The aesthetic conduct opposes depressive disorders in three important ways: depression is an exhaustion of the cognitive act of

discernment—it is essentially a state of numbness, psychomotor retardation, and lethargy involving a diminished ability to think or concentrate; it sides exclusively with the loss of pleasure (an emotion that is neither pleasure nor displeasure but a lack of such affects); and, through its symptoms of self-absorption, inhibition, reduced communication, and identification with death, it elaborates a rupture of intersubjectivity. Whereas aesthetics solicits the relational, depression implodes the relational. This begs the question, what can be said of an aesthetics that puts its very relational property into question? And how can depression be conceived as an aesthetics?

If, as Schaeffer affirms, "the aesthetic dimension is a relational property and not a property of the object," if there is no such thing as an aesthetic object but only an aesthetic conduct setting into play a cognitive activity of discernment whose unfolding provides affects of (dis)pleasure, then depression must be seen as a state that brings aesthetics into crisis. The distinctiveness of art's participation in the depressive paradigm—and this is the main hypothesis underlying this chapter—lies precisely in the depreciation of the relational. It partakes of an aesthetics that declares, reveals, or activates the erosion of aesthetics *tout court*. To gain a better sense of this founding paradox, it is imperative to be attentive to artworks that show the image as an obstructing surface that materializes, in its electronic thickness, the protective syndrome endemic to depressive disorders, what psychoanalyst Pierre Fédida has called the "conservation of the living under its *inanimate* form."[9] This is what I would like to call the "screen" effect of the image, one that discloses, activates, builds, and capitalizes on the cognitive impoverishment of the depressed viewer to turn the image into a barrier somewhat indifferent to the viewer. I contend that this is not a modernist denial of the beholder but a denial constitutive of a depressed subjectivity. Such an indifference is at the core of Rondinone's 2000 and 2002 video installations and Liza May Post's video, photo, and performance productions, works I will discuss presently.

The Image as an Obstructing Surface

Ugo Rondinone's *It's late and the wind carries a faint sound as it moves through the trees. It could be anything. The jingling of little bells perhaps, or the tiny flickering out of tiny lives. I stroll down the sidewalk and close my eyes and open them and wait for my mind to go perfectly blank. Like a room no one has ever entered, a room without doors or windows. A place where nothing happens. (Stillsmoking, Part V)* was first produced for the Guided by Voices exhibition at Kunsthaus Glarus in 1999. A six-channel black-and-white video installation, it consisted of six large-format, floor-to-ceiling video projections presented inside a dark room filled with purplish blue light emanating from the ceiling. The images, projected in slow motion, were either culled from Antonioni, Pasolini, and Fassbinder films from the 1960s and 1970s or shot by Rondinone himself. Projected without sound but immersed in an ethereal, monotonous rock-music environment punctuated with a single-line song ("Everyday sunshine") repeated over and over again, they showed isolated men and women performing mundane, looped actions in enclosed spaces: one man

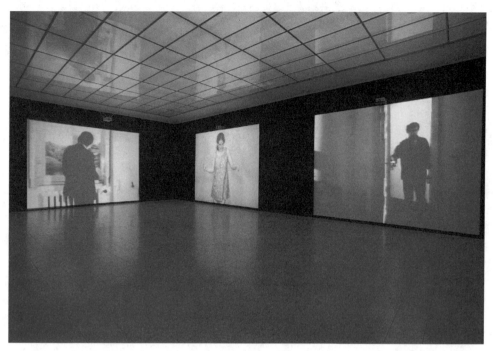

Figure 35. Ugo Rondinone, *It's late and the wind carries a faint sound as it moves through the trees. It could be anything. The jingling of little bells perhaps, or the tiny flickering out of tiny lives. I stroll down the sidewalk and close my eyes and open them and wait for my mind to go perfectly blank. Like a room no one has ever entered, a room without doors or windows. A place where nothing happens. (Stillsmoking, Part V),* 1999. Six video projectors, twelve video loops (1 × 6 VHS, 1 × 6 Betacam SP, one CD player, one amplifier). Edition of 2 + 1 AP, dimensions variable. Courtesy of Matthew Marks Gallery, New York, and Galerie Eva Presenhuber, Zurich.

walked along an endless brick wall; another man got out of a car and disappeared into heavy fog; a man with his eyes shut floated in shimmering water in a state of quasi-trance; a self-absorbed woman danced in a flowered minidress; a man looked out a window as he flicked aside a curtain tassel; a woman lay in bed with her eyes wide open, then suddenly rose, looked out, and fell back again; another woman, sitting on her bed in sharp obscurity, lifted her head and leaned it forward while rocking herself from side to side; a man opened a door without entering the room and shut it again while another sequence showed a woman opening a door and closing it as she entered the room; a naked woman kept tearing down a large sheet of paper off the wall. All these sequences represented beings in a state of isolation, entrapped in enclosed or dead-end spaces. The feeling of entrapment was continuously reinforced by the monotonous musical score, whose loop structure integrated the actions into a perpetual process of repetition devoid of any sense of future or resolution. Sung amid the monotony of the images and musical score, the reiterated lyrics became a lament of unfulfilled hope.

Three years later, Rondinone made a video installation for the Kunsthalle Wien, which increased the sense of enmeshed isolation conveyed in *It's late . . . (Stillsmoking, Part V)*

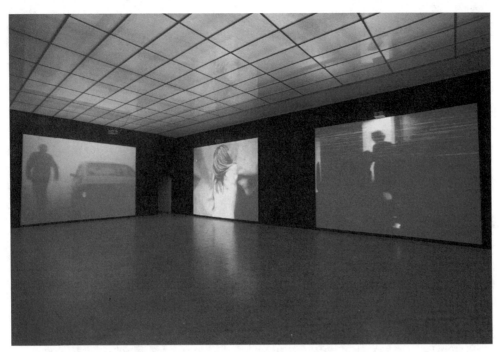

Figure 36. Ugo Rondinone, *It's late and the wind carries a faint sound as it moves through the trees. It could be anything. The jingling of little bells perhaps, or the tiny flickering out of tiny lives. I stroll down the sidewalk and close my eyes and open them and wait for my mind to go perfectly blank. Like a room no one has ever entered, a room without doors or windows. A place where nothing happens. (Stillsmoking, Part V),* 1999. Six video projectors, twelve video loops (1 × 6 VHS, 1 × 6 Betacam SP, one CD player, one amplifier). Edition of 2 + 1 AP, dimensions variable. Courtesy of Matthew Marks Gallery, New York, and Galerie Eva Presenhuber, Zurich.

by filming the figures in extreme close-up and reducing the narrative to its minimum. Entitled *No How On,* the eight-channel video installation was framed by a mirrored mosaic structure leading the visitor to the eight monitors hung at eye level along the walls of the closed room. As in *It's late . . . (Stillsmoking, Part V),* the black-and-white clips were shown in slow motion, without sound, and in perpetual loop, and the room was shrouded in a sad, monotonous, looped music. Six short video sequences (lasting from four to five minutes) and an additional changing selection of two of the six sequences were played on the eight monitors of the installation, which meant that the sequences continuously changed location, passing from one monitor to another. The viewer was thus immersed in an atmosphere of fleetingness and interchangeability. Contentwise, *No How On* staged a world of loneliness, hopelessness, self-absorption, and endless waiting: a man presented in profile walked back and forth along a large window; a head shot from the back moved slightly from left to right and right to left in front of a window; another sequence showed a face in a similar oscillation but whose visibility was obstructed by moving hair; a man's face presented in profile turned away from the viewer to plunge itself into full obscurity; a woman lay in bed, rose, and fell back again; a hand incessantly flipped a small

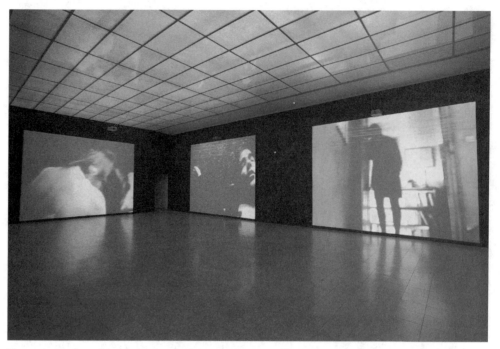

Figure 37. Ugo Rondinone, *It's late and the wind carries a faint sound as it moves through the trees. It could be anything. The jingling of little bells perhaps, or the tiny flickering out of tiny lives. I stroll down the sidewalk and close my eyes and open them and wait for my mind to go perfectly blank. Like a room no one has ever entered, a room without doors or windows. A place where nothing happens. (Stillsmoking, Part V)*, 1999. Six video projectors, twelve video loops (1 × 6 VHS, 1 × 6 Betacam SP, one CD player, one amplifier). Edition of 2 + 1 AP, dimensions variable. Courtesy of Matthew Marks Gallery, New York, and Galerie Eva Presenhuber, Zurich.

cylindrical object from one finger to the next. Moreover, each sequence ended by fading into images of railroad tracks that had been filmed by a camera endlessly following the perspectival path of the tracks toward an unreachable vanishing point.

Notice how, in the two installations, most actions evolve in an environment including a window or a door whose opening fails to establish a contact with the outside world. Consonant with the camera that falls short of reaching the vanishing point, the figures miss their encounter with the other, who never appears in the image and whose presence in front of the image is never acknowledged. Indeed, as they wander around window and door structures, the video figures never look out toward the spectator's space, and their attitude systematically denies that space: their bodies are faced away or moving away from us, their faces veiled and gazes totally self-absorbed. In *It's late . . . (Stillsmoking, Part V)*, when a man opens a door, a ray of light follows the movement of the door to allude to the spectator's site as an extension of the lit room. But the man who is about to enter the room stays on the other side of the door with an impassive face. A few seconds elapse. He then closes the door and, as he shuts it, shuts himself off from the viewer's sight. This figure cannot be said to reject the viewer. Rather, he looks for someone but is

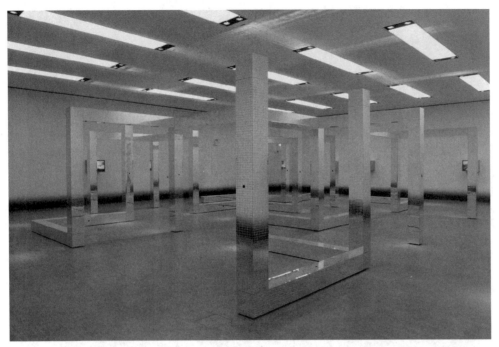

Figure 38. Ugo Rondinone, *No How On,* 2002. Forty-six mirror pillars, speakers, eight monitors, six Betacam tapes, six DVDs, audio CD. Edition of 3. Each pillar 275 × 25 cm, dimensions of the installation variable, floor space at least 170 square meters. Courtesy of Galerie Eva Presenhuber, Zurich.

Figure 39. Ugo Rondinone, *No How On,* 2002. Forty-six mirror pillars, speakers, eight monitors, six Betacam tapes, six DVDs, audio CD. Edition of 3. Each pillar 275 × 25 cm, dimensions of the installation variable, floor space at least 170 square meters. Courtesy of Galerie Eva Presenhuber, Zurich.

Figure 40. Ugo Rondinone, *No How On,* 2002. Forty-six mirror pillars, speakers, eight monitors, six Betacam tapes, six DVDs, audio CD. Edition of 3. Each pillar 275 × 25 cm, dimensions of the installation variable, floor space at least 170 square meters. Courtesy of Galerie Eva Presenhuber, Zurich.

blind to anyone else's presence or unable to establish contact. A similar scenario unfolds in the sequence involving a woman lying, eyes wide open, in her bed. When she suddenly raises her head, her eyes look actively toward the right as though she has heard something or someone coming. But the head finally falls back on the pillow, subjected to its heaviness and to the woman's despair. No one has arrived, no one will ever arrive; nothing more is about to happen. The body reimmobilizes itself, but the eyes remain active, partly lit in the obscurity of the room. Again, the other—more precisely, the viewer—is designated as absent or indifferent.

The dismissal of the door or window as an intersubjective interface is transferred, in *No How On,* to the image per se. This is particularly noticeable in sequences representing blocked windows, usually shown parallel to the screen, which define the image as an obstructing surface whose function is to preclude the relationship between the represented and viewing subjects. The blocking effect is best exemplified in the sequence that stages a man walking incessantly from right to left and left to right, in a movement that is parallel not only to the screen but also to the window in the background. The window does not offer any view of the outside world; its role is exclusively internal as it closes off the figure from the exterior and defines the screen as yet another closed window protecting the inside from the outside. In another sequence, a head filmed from behind is positioned

in front of a window. Recalling the footage of *It's late . . . (Stillsmoking, Part V)* in which a man filmed from the back is shown looking out of a window while pushing the tassel of a curtain, the *No How On* clip dramatizes the man's sense of entrapment. In the Matthew Marks Gallery installation, the sense of enclosure mostly comes from the man's self-absorption, whereas the Kunsthalle Wien installation narrows down the space between the foreground and the background, squeezing the figure between the two parallel surfaces delimited by the screen and the window. The head barely fits in this in-between space and is hardly legible, because the scene is too obscure to enable the viewer to clearly identify the body. The low definition of the image entailed by the close-up view and the use of slow motion accentuate the overlap of the sealed window and the screen. The image is thus more an obstructing than an obstructed surface. As a partition or impenetrable barrier, it actively materializes in its electronic thickness the protective, psychoanalytically defined symptom of depression so as to keep the other at distance as though in fear of identity collapse. In so doing, it activates the depressive operation par excellence, one that naturally comes about when one seeks to conserve oneself through immobilization: what Fédida has designated the rupture of communicational intersubjectivity.[10]

The electronic deployment of windows and screens as blocking membranes follows the overall law of visibility and invisibility that structures both installations, a law that

Figure 41. Ugo Rondinone, *No How On,* 2002. Forty-six mirror pillars, speakers, eight monitors, six Betacam tapes, six DVDs, audio CD. Edition of 3. Each pillar 275 × 25 cm, dimensions of the installation variable, floor space at least 170 square meters. Courtesy of Galerie Eva Presenhuber, Zurich.

reinforces the depreciation of the relational function of the image. States of unreachability take different forms in the two video pieces, but they always unfold in a baroque theater of light and shadow, clarity and obscurity, seeing and blindness. After offering a glimpse of a human figure, many sequences plunge the subject back into the dark—the realm of shadows, cloud absorption, or electronic noise—which both entraps the figure in space and protects it from the viewer's gaze. In *It's late . . . (Stillsmoking, Part V)*, for instance, a man (whose face is barely visible) opens a car door, gets out, and walks toward the background into the fog, where his body finally disappears. Intersubjective rupture is generated here not so much by the figure's movement away from the viewer as by its fog absorption, which puts him literally out of sight and leaves the viewer blind to his presence. In another sequence, a woman sitting on a bed is shot from the back. Again, we cannot see the face. She lifts her head and leans it forward, moving from side to side. Her axes of displacement are minimal but suffice to create a slow oscillation between light and obscurity through which she repetitively appears and disappears. Hence, whereas the figure's look is blind to the viewer's presence (she has her back to us), the viewer's own look is introduced in a similar blindness: it cannot always really see what is there and is confronted with a screen that functions as a defective window. Pushing this tenebrous blinding effect a step further, *No How On* proposes a sequence in which a young man's face in profile slowly turns away from the viewer and is absorbed by the shadows of a claustrophobic environment. Here, the living space of the figure is so narrow that its state of being barely legible appears highly impoverished. In an echo of this impoverishment, the viewer can hardly see the figure. In another video sequence, the blinding or sheer denial of the look comes about in the staging of a face that is shot from the front, shown oscillating from side to side, but whose legibility is obstructed by hair and by a framing of images that has left parts of the face off-camera. The technical characteristics of the videos that obscure the legibility of the image—slow motion, close-ups, and the perpetual loop—support this going nowhere of the look. This means that blindness belongs as much to the represented subject in the image as to the viewing subject in front of the image. The image is a defense barrier whose conservation principle transforms it into a dissociating machine. It is, even more, a waiting screen that paradoxically pushes away the awaited; a screen that awaits the other who never comes, who will never come however close he or she may be. Both the video figures and the viewer are exposed as indifferent or denied. They have lost their capacity to see the other.

It is to the credit of these installations that they succeed in simultaneously turning the figures and the viewers into similar blind, blinded, and blinding beings *and* preventing their meeting or mutual recognition in this process. Considering the *repoussoir* effect of depression—what psychologist James McCullough has designated the psychologist's or partner's "sense of helplessness and futility in being able to help to change" someone engulfed in helplessness and his or her "feeling of apprehension about working with an individual who is so detached"[11]—*It's late . . . (Stillsmoking, Part V)* and *No How On* can homogenize and assimilate the two poles of the seeing/being-seen axis only by enhancing their inability to get closer and recognize themselves in the other.

These two installations make manifest the withering of the relational function of the image. It is important to underline here that this depreciation is not and cannot be understood as a modernist denial of the viewer. Meaning is not posited as intrinsic to the artwork, nor does it come about in a temporality of immediacy, and the image, as Michael Fried's definition of modernist art suggests, does not struggle *not* to include the beholder as a constitutive part of the object.[12] On the contrary, duration is a crucial dimension of the viewing process: the beholder finds himself or herself engaged in an installation that cannot arrest meaning because of a looped structure that keeps replaying the same images and sounds with no promise of resolution. The view of the installations is, furthermore, never graspable as a whole but always unfolding as the viewer circulates in the room from one screen to another. More importantly, whereas the images repetitively exclude the beholder, the figures are systematically represented as attempting but failing to communicate with the other, as waiting for someone who never comes—even the outside viewer. The installations are thus about the process of relational rupture, an articulation that indicates that this work is not about the modernist requirement not to rely on the beholder for meaning but about both the antimodernist desire to rely and the ineptness to do so. Its phenomenology may be explained by the distancing nature of depression.

Perceptibility

The weakening of the relational property of aesthetics in art's enactment of depression— what should be called the aesthetic depreciation of intersubjective communication— comes about through a materialization of the symptom of conservation of the animate under its inanimate form (by which the image is transformed into a protective wall), but only inasmuch as this materialization is accompanied by an impoverishment of perceptibility, both as a condition of possibility and as an effect. In the realm of visual arts, perceptual impoverishment may take many forms. It occurs notably in images that represent subjects or solicit viewers in a state of absorption, closed off from their environment, whose perceptual system is cut off from the outside of the image or whose perception is engaged in a loss of sharpness and variety of (visual, aural, tactile, olfactory, and taste) sensations, which narrows down the relatedness of the individual to others. So as to understand the criticality of this operation and its implications for the fate of the contemporary image, I want to examine here one of the key art productions to have associated intersubjective rupture and impoverished perception: the photographic and videographic work of Dutch artist Liza May Post (b. 1965). This examination will enable us to better understand the modus operandi of the image-screen, an image that has become, as most images today are, inseparable from the screen and whose expansion is tied to the growing convergence between computer, film, telephone, and video technologies. What is the function of this expanding image, I ask, if it cannot secure intersubjectivity, if it fails to bound and link, if it cannot be a motor for communities and communication? What is there to be gained from an aesthetics that supports this undoing of the key relational property of the aesthetic attitude? Does it merely support disengagement?

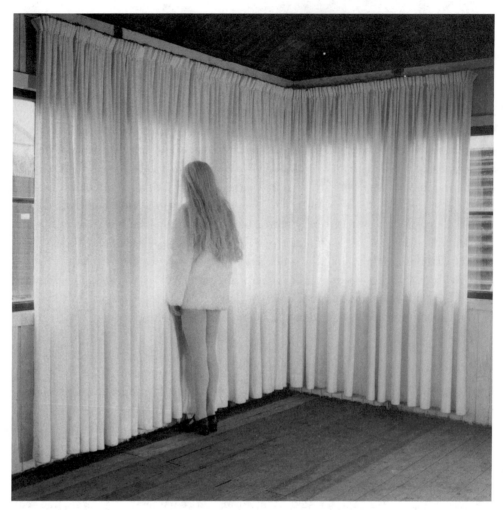

Figure 42. Liza May Post, *Untitled,* 1994. Color photograph mounted on aluminum, 139 × 150 cm. Courtesy of Annet Gelink Gallery, Amsterdam.

Untitled, a photograph dated 1994, is a decisive work in Post's production, as it succeeds in bringing together the realms of perception, space, and intersubjective failing. Here, a young white woman stands in front of a closed white curtain, which itself is pulled across closed windows. The windows are made slightly visible by the daylight coming from the outside, only to reinforce the function of the curtain as a surface that cuts off the figure from the outside world. Seen from the back and slightly from the left, the woman fails to detach herself clearly from the curtain she faces inexplicably. Consisting of white tights and a short furry jacket, her clothes are of the same white as the curtain, and her long blond hair barely contrasts with the whiteness of the whole. This tension between visibility and invisibility, between seeing, being seen, and unseeability, resonates throughout the photograph. The look of the *femme-enfant* is clearly turned away from the viewer, yet it is itself blocked by the proximity of the closed curtain covering the windows. The back and the curtain thus

function as screens; they both protect and isolate the figure from her surrounding and from the viewer's gaze. The viewer may use these screens as a means to imagine or fantasize about the figure, but the woman's looking activity is nonetheless immune to these projections. Yet what needs to be emphasized here is the double-bound quality of the screens, for the screens are not merely a protective device whose usefulness is to counter the power of the viewer's look but also a mechanism that weakens perception. The back imposes "an artificial, protective layer between the Self and the social"[13] and thus both protects and separates the figure from the outside. Yet, by immobilizing the body just in front of the curtain, *Untitled* states that there is a price to pay for such a protection: the price of perceptual impoverishment. Indeed, sheltered from the viewer's voyeurism, Post's *femme-enfant*'s look unfolds, but because of her positioning with her back to the camera, which isolates her from both the viewer and her immediate surroundings, and because of her extreme proximity to the curtain, which inevitably obstructs the look and forces its partial or total interiorization, this looking activity has also been significantly reduced. The narrowing down is reinforced by the general diminution of differentiation that comes about through the white-against-white display of body and curtain. This lack of contrast is experienced by the viewer who looks at the photographic image, but it should also be seen as a representation of what is lived by the figure—her becoming-the-curtain through her own looking and clothing.

I want to suggest here that the impoverishment of perception—the depreciation of one's capacity to have perspective, to distinguish, to compare, to interact with the outside— together with the desire to dissolve oneself into one's space, comes mostly from the mimicry acted out by the female figure in *Untitled*. The *femme-enfant* attempts to become her environment; she is the result of a woman's mimicking of childhood, a form of disavowal of adulthood that enables her to correspond to the ideal of feminine malleability, fragility, and inferiority. In his description of the colonial logic of mimicry, postcolonial thinker Homi Bhabha speaks of mimicry as the operation by which the other makes himself or herself recognizable to the white viewer "as *a subject of difference that is almost the same, but not quite,*" "[a]lmost the same but not white."[14] Although Post's female figure can be said not to imitate the viewer but to identify with the child so as to become an object of desire for the viewer, Bhabha's notion of mimicry as an activity of failed sameness or incomplete differentiation (a nonwhite figure who mimes the whiteness of the viewer can never be white, nor can he or she claim to be fully different) designates well the "not-quite" identity and perceptual faculties of the *femme-enfant*. Her ability to perceive in terms of identity and difference is highly reduced because of her localization near the curtain, which cuts her off from the rest of the room. She must be seen as someone who does "not quite" perceive and does "not quite" not perceive; her self is in between childhood and adulthood, and her appearance melds—but never completely—with her environment. This minute gap between seeing and unseeability (the white against white, the infinitesimal distance between the body and the curtain, and the back view) as embodied in the *femme-enfant* discloses the desire (the image cannot tell us whether it is the woman's desire or whether it has been imposed from the outside) to be barely seen and to barely see. It is a fact, in this photograph at least, that when the viewing subject itself barely sees, it is also barely seen.

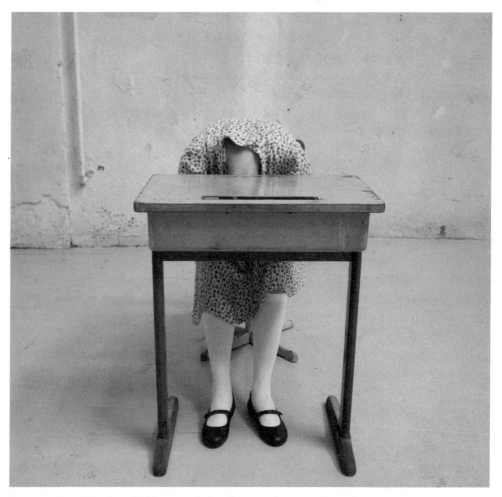

Figure 43. Liza May Post, *Table,* 1992. Color photograph mounted on aluminum, 122 × 122 cm. Courtesy of Annet Gelink Gallery, Amsterdam.

Post's photographs produced between 1992 and 1996 stage similar not-quite-child, not-quite-adult female figures whose faces are systematically turned away from the viewer and whose bodies are caught in a tight tension between visibility and invisibility. *Table* (1992) presents a young woman alone in a white room, dressed in white, virginal socks. She sits behind a school desk, her body folded between the chair and the table with the head completely hidden from the viewer and from anyone who would be standing in front of the desk. In *A Slower Life* (1992), the *femme-enfant*, in white kneesocks, is wearing a short white skirt. Located in a white bedroom, she would be indistinguishable from her environment if it weren't for her brown hair, shoes, and suitcases. Shot from the back, she slightly leans forward, and her look is again refused to us. *Misprint* (1993) sets the *femme-enfant* in the space of a white hospital room. She is shot again from the back, and we can see only her naked thighs and white-socked legs, while the rest of the

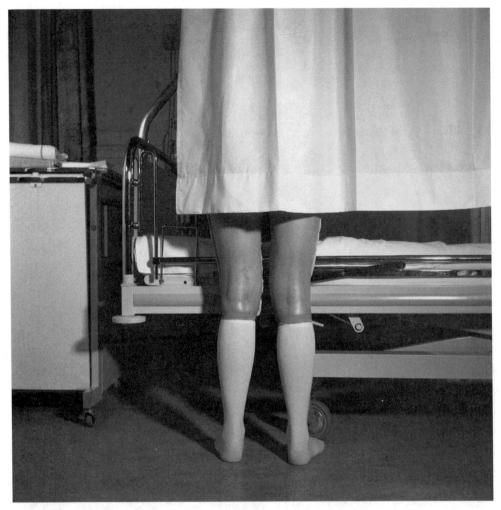

Figure 44. Liza May Post, *Misprint,* 1993. Color photograph mounted on aluminum, 122 × 122 cm. Courtesy of Annet Gelink Gallery, Amsterdam.

body remains hidden by a curtain. The immobility of the body is so acute that its appearance oscillates between artificiality and naturalism. As is also the case with *Table,* which presents the legs as cut off from the body and endowed with a whiteness that makes them appear to be made out of porcelain, *Misprint* never resolves the ambivalence of the legs; they could be natural or prosthetic body parts. Although *Spilling* (1994) injects more narrativity into the picture—a young girl is shown kneeling on the floor in front of a puddle of red liquid, a mise-en-scène that refers to menstrual blood and the unexpected passage from child to adulthood—it still closes off the face from the visible realm because of the leaning head and falling hair that covers the eyes and face.

In *Bound* (1996), perceptual impoverishment is as strongly displayed as it was two years before in *Untitled,* but now the sexual overtones of the *femme-enfant* are set aside

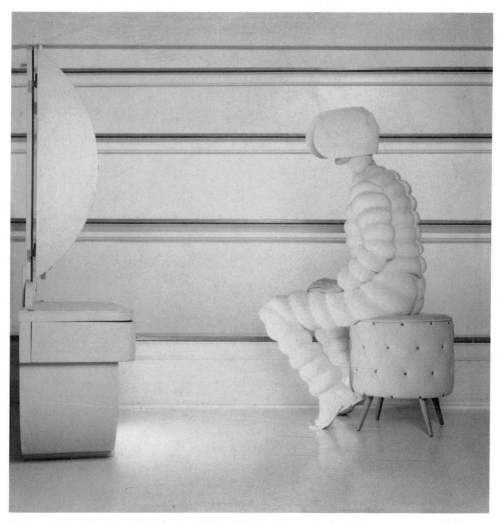

Figure 45. Liza May Post, *Bound*, 1996. Color photograph mounted on aluminum, 148 × 150 cm. Courtesy of Annet Gelink Gallery, Amsterdam.

to focus on a woman's relationship to a mirror. Represented in profile, sitting in front of a mirror cabinet, the female figure is shot with the same sense of immobility, white camouflage, and impoverished look. More dramatically camouflaged than in Post's previous photographic works, she is dressed in a white, padded astronaut-like outfit and located in a white room. Here, she figuratively becomes part of the furniture. Her humanness is recognizable only in a hand and chin that have been left uncovered. Her head is framed by blinders similar to the shutter that frames the mirror. Thus, not only is the figure's gaze inaccessible to the viewer, it is also considerably cut off from its immediate surroundings and completely directed toward the mirror. The body and the cabinet can be said to hold a symbiotic relationship, for the blinders and the shutter create a set of closed parentheses enclosing the female look and the mirror. Such a staging both makes this woman barely

visible and substantially reduces her own seeing activity, as it is fully absorbed by reflection and specularity. The closed parentheses created by the shutter and the blinders also exclude the viewer from the woman's private imaginary world: they protect her from the viewer's gaze as much as they occlude her from the outside world, intensifying the realm of interiority but preventing the viewer from knowing this interiority. Because of this, she cannot be said to be a character or even a protagonist.[15] The woman's psychological world is both denied to the viewer and radically weakened by her isolation from the outside.

Emphasizing the visual divide that takes place between the figures and the viewing subjects in Post's work, art writer Adam Phillips writes,

> [T]he figures themselves are the elsewhere within the frame—it is as though they quite literally could not face us. As though to look at the camera would be to make an appeal that has never occurred to them. They are not resisting our gaze, they are hiding us from themselves.
>
> . . . Indeed, at first sight, we may think of Post's figures as not wanting to be disturbed. But the more we look we realise that we may not be able to disturb them; they offer us no invitation, none we can recognise. And the photographs themselves invite an uncanny paralysis—a smile of unease—in the viewer. It is part of Post's light, eerie artfulness to confront us with the terror of having nothing to offer someone. Her figures are isolated, secluded in their situations; but they are not seeking alternatives. They are the enemies of opportunity. Their next move is utterly improbable.[16]

Phillips's comments catch the interaction between perceptual impoverishment and intersubjective rupture I am trying to describe here: the relational property of aesthetics is broken not only through the figure's unacknowledgment of the viewer but also, and more importantly, through the figure's own impassive self-absorption. The rupture is rendered through an orchestration of sight—of the seeing/being-seen axis—that transforms the image into a protective screen, a quasi-armor, whose main function is to separate, disempower, and provide self-contained autonomy to the two main protagonists of the look described by Laura Mulvey in her "Visual Pleasure and Narrative Cinema" (1975).[17] For Mulvey, Hollywood cinema of the 1950s and 1960s articulated a gender split in which a female character was subjected to the masculine look in such a systematic way that she came to occupy the position of to-be-looked-at-ness in relation to a male viewer's position as bearer of the look. Mulvey sees film narratives that activated voyeurism, scopophilia, and fetishism on the part of the viewer as elaborating a gender division that was still, however, a matter of visual relatedness. With Post—and this becomes even more manifest in her video installations—the division takes place only to elaborate the growing unrelatedness of the two visual poles and to disclose a diminution of the perceptual faculties of the subject. A polarization of the positions of to-be-looked-at-ness and bearer-of-the-look still takes place through the representation of the female figure as the looked upon, but that polarization, which is still a relation in Mulvey's account, is problematized both by the female figure's refusal to acknowledge the look of the viewer

and by her white camouflage, which makes her less perceptible to the viewer. The back, the curtain, the hair, the white on white: all these details function as protective screens that disrupt the power of the viewer's gaze over the female body.

Yet to this protection and concomitant intersubjective disruption is connected another crucial operation: that of a decline of perceptual acuity. This is what notably distinguishes Post's work from Lorna Simpson's photographs made during the same period (between the mid-1980s and the mid-1990s), which set into play the same "back" presentation of the female body. Although Simpson also photographs her female figures (in this case, black women) from behind, her juxtaposition of images and text works to contradict social categorizations of blackness. The viewer, both exposed in his or her ideological expectations and incited to reexamine his or her racial views, becomes an active part of the reinterpretative process.[18] In contrast, Post's viewer becomes critical only inasmuch as he or she acknowledges that the image is an act of exclusion and perceptual depreciation for both represented and viewing subjects. Not only is the viewer's look denied by the figure, but also the figure's own look is negated, hidden, and shrunk in its perspectival, interpretative, discerning, and scanning abilities. In short, it is as though the two functions of to-be-looked-at-ness and bearer-of-the-look were staged (set into position) but voided of the power that the latter exercised on the former. With Post, the functions gain in independence (protected, as they are, on each side of the image-screen), but as they do so they lose both in intersubjectivity and perceptibility. They coexist, isolated and perceptually impoverished, on each side of the protective screen.

Perceptual impoverishment is a historical event that has often been represented in modern art as a by-product of late capitalism. In his study of Marcel Duchamp, art historian David Joselit specifies how, since the end of the nineteenth century, Western art has reiteratively questioned the metaphoric representation of the body in light of its increased commodification.[19] One of the earliest artworks to establish an equivalence between the body, the sign, and the market is Edouard Manet's *Olympia* (1863): here, the reclining figure—whose meaning at the moment of its reception oscillated, as Timothy Clark has shown, between the ideal nude and the prostitute of the *faubourgs parisiens*[20]—is not like a commodity but is a commodity. Her nature and use value have been subsumed by exchange value, together with its metaphoric rendering, according to a logic that not only transforms the natural body into currency but also makes it imperceptible to the viewer. Not that the body has disappeared; rather, it starts to retire as a natural entity. Colonized by the capitalist laws of exchange, it exists only through its semiotic and commodified dimension. Joselit sees a similar yet more abstract articulation of the loss of the body to sight in Duchamp's *The Bride Stripped Bare by Her Bachelors, Even (The Large Glass)* of 1915–23. In its division of a glass panel into two separate spaces that isolate the bachelors from the bride, the work elaborates a *poesis* of endless delay of erotic exchange between the sexual partners. By enunciating this delay on a glass window similar to that of a store vitrine, Duchamp proposes bodies that have figuratively ingested the logic of consumerism, a logic by which desire is both activated and never satisfied. This loss of the modern body to vision, a hypothesis elaborated by Joselit but initially formulated by Rosalind

Figure 46. Marcel Duchamp, *The Bride Stripped Bare by Her Bachelors, Even (The Large Glass)*, 1915–23. Oil, varnish, lead foil, lead wire, and dust on two glass panels, 272.5 × 175.8 cm. Philadelphia Museum of Art. Bequest of Katherine S. Dreier. Copyright Estate of Marcel Duchamp / ADAGP (Paris) / SODRAC (Montreal) 2004.

Krauss in her examination of cubism, must be seen both as a disclosure of capitalism's shaping of subjectivity, body, and look, and as a critique of illusionism. It is this latter disclosure of the obsoleteness of illusionism that structures analytic cubism and the collages produced by Picasso between 1911 and 1912, such as *"Ma jolie" (Woman with a Zither or Guitar)* (1911–12). During this period, as Krauss has convincingly shown, Picasso attempted to banish all tridimensionality from the image to affirm the disappearance of the tactile and the carnal from the field of vision. Illusionism, defined by Krauss as that which gives us "access through the vehicle of sight to reality in all its carnal fullness—to its weight and density, to its richness and texture, to its heat and vaporousness, to the evanescence of its very perfume,"[21] is reduced to its minimum. This is accomplished by an artist who has stopped believing in the possibility of experimenting with carnal reality through the look, in a world more and more codified by signs that cannot be said to merely reflect reality.

Although the loss of the modern body to vision may well be caused by the development of capitalism and the growing encroachment of signs upon reality, can this loss not be correlatively associated, as Walter Benjamin postulated in his study of the Parisian arcades of the early twentieth century, with a reduction of the perceptual faculties of the modern subject?[22] Benjamin suggested that, in an attempt to parry the aggressions of modern life—which he saw as emerging from the intertwining of industrialization, urbanization, the massification of life, and the expansion of the public over the private space—the subject has learned to anesthetize its perceptual and memory faculties by the use of different forms of intoxication, not just drugs but also mass entertainment (including film, the trade fair, and the department store). Benjamin's socioneurobiological perspective opens up the hypothesis of impoverished perceptibility. It is this hypothesis that is at play in Post's production. Her female figures are deprived of the viewing capacity to establish connections between the inside and the outside, between the foreground and the background. In *Untitled,* for example, the woman's sense of perspective is eroded by her extreme proximity to the curtain, which, moreover, blocks the view of the outside world. This sense is completely abolished in the folding of the woman's body onto itself behind *Table*'s school desk. In *Bound,* the closed parentheses of the blinders and the shutter dramatically narrow down the woman's vision to a visual corridor that fixes the eyes to the mirror reflection. This impoverishment not only characterizes the perceptual activity of female protagonists but also shapes the spectator's experience. As his or her own ability to distinguish forms and borders is challenged and as he or she cannot establish contact with the inside protagonist, the viewer is also confronted with a screen (for which *Untitled*'s and *Misprint*'s curtains are a metaphor) that blocks the eye's access to the "weight and density," the very "richness and texture," of the figures. It is not that photography refuses here to represent bodies in their three-dimensionality, as in Picasso's 1911–12 anti-illusionist collages or Duchamp's *Large Glass.* The photographs do not seek to counter illusion. Rather, they represent the experience of bodies losing themselves or being lost to sight. They do so through (at least) three interdependent operations: the deployment of protective screens (the back, the curtain, the image), intersubjective rupture,

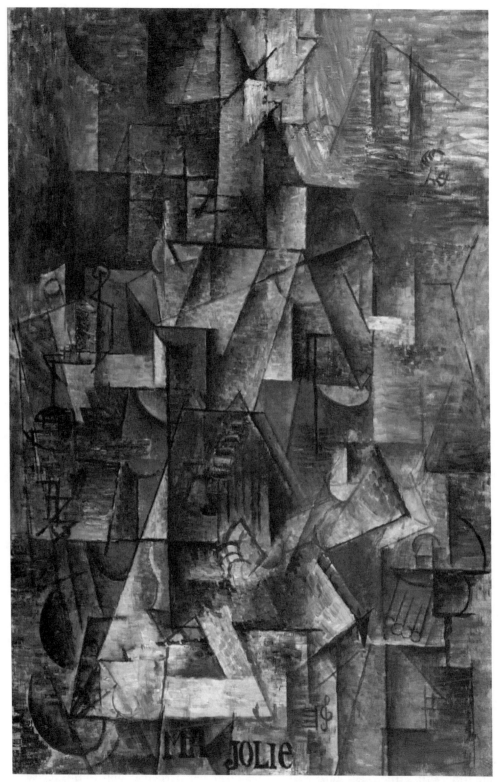

Figure 47. Pablo Picasso, *"Ma jolie" (Woman with a Zither or Guitar),* 1911–12. Oil on canvas, 100 × 65.4 cm. Acquired through the Lillie P. Bliss Bequest. Museum of Modern Art, New York. Digital image copyright Museum of Modern Art. Licensed by SCALA / Art Resource, NY. Copyright Estate of Picasso (Paris) / SODRAC (Montreal) 2004.

and the narrowing down of perceptual acuity. These three operations continually feed one another. They are the causes and effects of each other.

The Video Association of Perceptual Impoverishment and Depression

In a series of short video works made between 1996 and 2001, Post pushes the association between the impoverishment of perceptual faculties and intersubjective rupture by anchoring it in depressed subjectivity. Video, as a temporal art, sets in motion the features of Post's photographic image (the body's immobilization, the figure's withdrawal and self-absorption, the narrowing down of perception, the turning of the figure's look away from the viewer). This enables the artist to underscore the stasis of the figures, for it is in the temporality of electronic media—whose duration is emphasized by the uneventfulness of the narratives and the one-shot direct filming of action—that the lethargy of the protagonists is most strongly conveyed. Video temporality correlatively allows Post to propel the (non)actions of the protagonists into the public sphere so that the viewer may observe them as living social beings whose historicity is tied to a subjectivity of waiting. They cease to be merely figures; they become living subjects. Figuration passes into anthropology. With the three color-video wall projections presented in the Dutch Pavilion at the 2001 Venice Biennial—*While* (2001), *Place* (1996), and *Under* (2000)—an aesthetics of depression, whose main trait is to disclose the intertwining of subjectivity and depression through an active exploration of the nonrelational properties of the image-screen, literally takes shape so as to perform the image's indifference to the viewer. The image itself becomes an indolent screen, as though the protagonist's indolence has been projected onto the electronic surface.

Commenting on the depiction of temporality in her work, Post states simply, "[I]n reality, we would rather do nothing and passively wait."[23] *While* is the work that displays most powerfully this specific understanding of temporality. In this silent video wall projection, four individuals are shown sitting in a waiting room. During the three minutes and forty-five seconds of the projection, they are presented in a state of waiting. No one looks at another, no one talks; the figures are immobile except for a few movements that serve only to reveal the lived state of this immobilization. Soon after the beginning of the sequence, however, an odd, unexpected event occurs: dark confetti starts to fall from above. But the event turns out to be more of a nonevent. Indeed, no one reacts except for a man who gently dusts off the confetti from his neighbor's shoulder in an action that only reinforces the stasis of the individuals in the group, for, as the man articulates a gesture of openness and care toward his neighbor, the latter stays completely indifferent. A woman turns her head slightly, observes the action, and resumes immediately her initial position. As though in reaction to the neighbor's impassivity, the man turns his head away from the group and looks out toward the left, distancing himself even further from the others. The flow and quantity of confetti intensify; it now covers the ground and accumulates on the bodies. The sequence ends arbitrarily while the confetti is still falling and the sitters are still waiting. The video starts again, to be shown in a perpetual loop. In this repeated

Figure 48. Liza May Post, *While,* 2001. 35 mm film transferred to DVD, 3.45 minutes. Courtesy of Annet Gelink Gallery, Amsterdam.

projection, the subject is defined through an animated logic of inanimate waiting, a logic that breaks communicational exchange or reduces it to its functional minimum.

Explaining the role of waiting in depression, psychoanalyst Alexandra Triandafillidis sees it as a mechanism of protection against the threat of loss. If one follows Triandafillidis in her attempt to complexify Freud's theorization of melancholia as the subject's inability to grieve the loss of the loved object, depression can be described as a mental affection whose fundamental function is to defend the self against loss through an abstaining from action.[24] Anticipating a loss similar to those experienced in childhood, the depressed conducts herself or himself "as though loss was present": he or she foresees, expects, and awaits so as to neutralize and avoid the trauma of annihilation of self lived in the experience of the annihilation of the other.[25] Triandafillidis's hypothesis is based on Melanie Klein's formulation of the depressive position as the state that the child must occupy

Figure 49. Liza May Post, *While*, 2001. 35 mm film transferred to DVD, 3.45 minutes. Courtesy of Annet Gelink Gallery, Amsterdam.

when it experiences the loss of the mother (or whoever looks after it) for the first time. It is essential to point out, however, that the Kleinian perspective is here both reaffirmed and transformed. On the one hand, depressive waiting confirms the fundamental role of childhood losses in the deployment of adult depression. As indicated earlier, in the Kleinian viewpoint, the positive resolution of childhood loss relies on the introjection of the lost loved object so as to recover and reinstate it as a good object. This depressive position may also lead to a negative resolution, especially when the loved object fails to be "preserved in safety inside oneself" and is internalized instead as a bad object.[26] Later experiences of loss build on such clusters of good or bad internal objects; they lead to depression if and when the lost object cannot be aligned with the good objects of infancy. But, on the other hand and contrary to Klein, Triandafillidis's hypothesis also postulates

Figure 50. Liza May Post, *While,* 2001. 35 mm film transferred to DVD, 3.45 minutes. Courtesy of Annet Gelink Gallery, Amsterdam.

that the depressed individual seeks to neutralize loss. Depression could thus be said to be a process of actualization of loss (it brings into the present a past experience of loss), waiting (it anticipates a loss in the future echoing the model of a past loss), and repetition (it repeats, in the present, the situation instituted by the initial loss) *only inasmuch as this triple process enables the individual to block the experience of loss.*

Waiting is a forceful operation in the evolution of depressive disorders, because it is what "suspends the threat inherent to the unfolding [of loss]," writes Triandafillidis. To say it differently, waiting arrests "the time of life so that the immanence of its interruption may seemingly be averted," even though this suspension is only apparent, illusive: "[B]y immobilizing itself, the depressed may believe he retains an all-powerful mastery . . . but no attempt of fixation . . . can prevent the passage of time."[27] Bluntly, immobility

guarantees, at an imaginary level, the protection against the reliving of loss. Again, what is apparent here is the antinomy of melancholia and depression: the former concerns a subject living a loss grounded on past losses; the latter articulates the decline of the experience of loss—its rejection. In *While,* waiting as a defense mechanism against loss is shown by the gesture of the man dusting confetti from his neighbor's shoulder: not only is this intersubjective gesture minimal, it also immediately activates a defensive reimmobilization of the man following the neighbor's indifference. The subjectivity of waiting is precisely shown to be shaped by the depressed's fear of losing or being rejected by the other. The man is quick to withdraw, and the others stay put: all of these mobilizations act to block an anticipated loss. But they also, in turn, nourish the feared indifference. Each body thus becomes a protective screen vis-à-vis the outside, fully internalizing the logic of *Untitled*'s back and curtain, of the photographic image itself.

Whereas *While* enunciates depressive waiting through the individual's closure and immobility in relation to the other, *Place* and *Under* push this investigation further to reflect upon the (non)relational status of the image per se. What happens between the subjects in the image now occurs as well between the subjects in and before the image. In *Place,* notably, a woman in a pale blue dress sits on the ground in a public place, her back turned to the viewer. The square is empty. Beside her, a tea set of the same pastel blue has been installed on the ground. For the whole two minutes of the sequence, the protagonist stays immobile except for one movement: a slight swing of the hips. Birds sing in the background. But, in contrast to this sound, the public space is not a meeting place: it is a narrow spot (the close-up framing of the square scene cuts the body out of the wider area), it is void of pedestrians, and the figure is alone. Despite the empty setting, she waits with her tea service nearby, signaling the desire for social encounter. Even the movement of the hips, with its sexual overtones, can be read as a desire for the other. But she still waits passively. Intersubjectivity is thus disclosed as hoped for but nonexistent and unachieved.

Place must be considered as more than a simple anticipation of *While* (produced five years later), for it constructs an image that proposes not only a three-dimensional representation of a place but also a surface projecting and acting in the actual space of the installation. As in Post's photographic work, the face of the human figure is hidden from the viewers and her back position is a form of denial of the viewers' presence. With this specific staging of the figure, the image reasserts itself as an armored screen, protecting the protagonist inside itself but also separating her (in a separation confirmed by the close-up framing of the public square) from the outside viewers. From the perspective of the spectator, the image-screen functions like a disengaging wall, a surface against which one collides because of one's lack of recognition and because of the sheer impossibility of imagining oneself entering and circulating in the narrow space filmed from above. Yet, in contrast to the photographic work, the wall effect is subdued when the visitors move in the space and start to attend to what is happening at the surface of the image. I am speaking here of the projection of the viewers' shadows onto the small projection wall designed to stand in the middle of the exhibition area. Through this projection, for a brief

Figure 51. Liza May Post, *Place,* 1996. Video transferred to DVD, 1.05 minutes. Courtesy of Annet Gelink Gallery, Amsterdam.

moment, a virtual form of encounter does occur: the public space in the image becomes alive, animated, as it were, by the moving shadows that share the same scale as the sitter. But, paradoxically, it is this very experience of projection—the interaction (brief though it may be) between the inside and the outside via a screen that receives the shadows of the viewers—that consolidates the wall effect of the screen, for the shadow animation fails to produce any form of relational space. The inside and outside bodies never truly communicate: they merely coexist in the same frame. Not only is the female figure indifferent to the movement of the shadows but the shadows fail to interact with each other. If this is so, it is because the visitors per se do not interact. Ultimately, in *Place,* it is the actual public gallery space that is disclosed as depressed.

Under reaffirms the disclosure set about by *Place*'s screen, but it does so by activating

Figure 52. Liza May Post, *Under,* 2000. 35 mm film transferred to DVD, 4 minutes. Courtesy of Annet Gelink Gallery, Amsterdam.

a relationship of continuity between the represented space and the physical space of the viewer. As we are about to see, this continuity paradoxically reinforces (as in *Place*) the divide between the inside and outside subjects. The projection stages five individuals in a basement. The only action of the scene involves a male protagonist who walks slowly and with great difficulty in the enclosed space, his legs and waist imprisoned in a skirt made out of floral-patterned fabric whose hem has been sewn together into a bag. The other individuals stay in a state of impassivity and quasi-immobility. As the feminized man (a gendering that is crucial in light of the current feminization of depression) moves awkwardly in the room, he systematically approaches each protagonist, only to be rejected or to receive sheer indifference. The confined claustrophobic space is one of incommunicability: individuals are gathered together, but they do not talk, they refuse to look at each other, they are unable to exchange—except for the man's reiterated half-hearted attempt to enter into contact with the others and the others' rejection of this being—and no inside gaze succeeds in acknowledging the presence of the viewer. As art writer Kate Bush notes, the scene recalls Samuel Beckett's *Waiting for Godot* (1953), but it intensifies the sense of incommunicability delineated in the play: "Like Vladimir and Estragon in *Waiting for Godot,* their only function as figures seems to be to verify their mutual existence—and yet in Beckett's painfully non-eventful scenario, Estragon and Vladimir conversed with one another: here there appears to be a total breakdown of communication."[28] Such a breakdown is reinforced, as is the case with *While,* by the rejection of the protagonist, who timidly attempts to establish contact with the others, each rejection reinstituting the depressiveness of the figure, who finally re-isolates himself in the room. Communication breakdown both results from and reinforces intersubjective rejection, but (again, as in *While*) it also results from and reinforces waiting—the deathlike immobility of the protagonists, whose frozen anti-loss state is made manifest

by the contrast provided by the activity of a car and passersby unfolding beyond the back window.

Yet, in this work, Post orients the narrative toward a commentator's interpellation that turns the physical space of the viewer into an extension of the represented space, only to eventually affirm the divide between the inside and outside subjects. The figure of the commentator, the Albertian character whose main function is to incite the spectator to look and to enter imaginatively into the represented *istoria,* plays a determining role (as determining as the polyester cast in Rondinone's Walcheturm installation) in the unfolding of intersubjective rupture. At the end of the four-minute sequence, the woman sitting in front with her back to us gets up and turns around toward the viewer but stops this opening gesture by never looking out. After a few seconds, she looks down at her bench and reenters a state of self-absorbed waiting. These last seconds of projection are decisive, for, as she turns to the viewer, she enacts the interpellation of the viewer, inviting him or her into the *istoria.* Because of the localization of the projection on the wall (the image's base is the actual floor of the gallery) and the equivalence of scale between the inside figures and the outside viewers, the movement of the female figure starts to introduce the viewer into the image by articulating a continuity between the imagined and physical spaces. Yet, once spatial continuity is established, she immediately suspends the interpellation by looking down. Disengagement sets in. The sequence ends with this specific scene of failed reciprocity between two subjects. But it is this failing—and not the mere absence—of intersubjectivity that *Under* sets out to disclose. The failing comes about by a furtive restitution of the Albertian window function of the image, which is immediately followed by a blocking-surface effect. The depressed looker—potentially any female figure and viewer—is disclosed as a subject who is so absorbed in her own thoughts that she sees without seeing and being seen, ending the Panoptic regime of vision that Foucault describes.[29] Indeed, as within Post's *Untitled* of 1994 and *Bound* of 1996—photographs in which female protagonists are perceptually deprived by the obstruction of their looking activity, either through the eyes' extreme proximity to the curtain or the closed parentheses delimited by the blinders and the shutter—the localization of the filmed figures in a half-lit, isolated, narrow, and sensorially poor subterranean space together with the countered interpellation of the viewer entail an impoverishment of perceptibility.

The spatial ramifications of Post's aesthetics are crucial in its disclosure of one of the main effects of the depressed subjectivity of waiting: the denial of space as place. In the two installations just examined, the relational, embodied, concrete, and social dimensions of space are blocked; the artworks' key operation is to reduce to its minimum the bond between body and space, both within and in front of the image. This reduction radically questions any belief that modern alternative relational understandings of space have successfully materialized and suggests that the capitalist conceptualization of space so vehemently denounced by sociologist Henri Lefebvre in *La production de l'espace* (1974) as an abstract entity independent of human practice still prevails.[30] To better understand the denial of place articulated in Post's work, it is useful to refer briefly to Edward Casey's study of the historical development of the philosophical idea of space,

which distinguishes notions of embodied place from those of disembodied place. In *The Fate of Place: A Philosophical History* (1997), Casey has shown how modern thinkers not only have questioned the idealized Aristotelian conception of space as a mere product of the mind but also have proposed alternative models that embody space through the category of place: "The more we reflect on place . . . the more we recognize it to be something not merely characterizable but actually experienced in qualitative terms. These terms, for example, color, texture, and depth, are known to us only in and by the body that enters and occupies a given place. Site may be bodiless—it entails a disembodied overview, a survey—but there can be no being-in-place except by being in a densely qualified place in concrete embodiment. Indeed, how can one be *in* a place except *through* one's own body?"[31] Retracing to Kant the first Western acknowledgment of the bond that exists between body and space (notably, the understanding that there is no place without bodies to give it orientation and directionality) and emphasizing the legacy of Merleau-Ponty's phenomenology in the comprehension of space as both embodied and relational, Casey contends—and here he adopts Merleau-Ponty's insight—that the subject is not merely *in* space and that space is not merely *in* the subject as a representation or intuition; rather, the lived body is "the subject of space."[32] Without bodies, observes Casey, space "would be merely a neutral, absolute block or else a tangled skein of pure relations built up from pure positions."[33]

In light of Casey's argument, what can be said of contemporary artworks that depreciate the relational dimension of space? Such an aesthetic deployment, I argue, questions recent theories that merely embody and concretize space without acknowledging how much this conception is an idealized one, perhaps a hopeful and legitimate perspective but not truly anchored in the actual sociology of space. Contemporary subjectivity may well be, as Post's work suggests, the very site that devalues the phenomenological bond between body and space. Aesthetics, what Jean-Marie Schaeffer has designated the site of the relational, becomes the enactment by which the decline of the relational is both articulated and displayed.[34] The critical dimension of Post's installations lies in their ability to at once represent in the image and activate for the viewer a body-space rupture, a rupture that recognizes the subject as a subject in space only to show its decline. *Place* and *Under* are here particularly relevant in their exploration of the screen as an interface that incites, mediates, divides, isolates, reduces, and denies the act of seeing for the subjects inside and outside the screen. It associates sensorial degeneration and the loss of communicational intersubjectivity, an association that is disclosed as inherent to contemporary subjectivity.

The Scientific Definition of Depression as a Rupture of Intersubjectivity

In their deployment of blocked window-screens, both Rondinone's and Post's works participate in scientific literature on depression that defines depression as a failed intersubjectivity. But what is art's specific contribution to this debate? How does the image-screen challenge or add to scientific findings? To answer these questions, it is important to ac-

knowledge from the start that what failed intersubjectivity means and the understanding of the role it plays in the development of depressive disorders have varied significantly in scientific literature during the last twenty-five years. Initially, intersubjective deficit was perceived more as a provoking agent or a vulnerability factor for the onset of depression. Gradually, it came to be considered first a deficient interactional style and then a sheer symptom, as well as an effect, of depression. Explanations in this area have also tended to be social or sociological, although, more recently, interpersonal psychology has become a central discipline in the appreciation of the role of intersubjective failure in mental affections. In one of the key studies using a social-interpersonal approach to depressive disorders, *Social Origins of Depression: A Study of Psychiatric Disorder in Women* (1978), George W. Brown and Tirril Harris defined depression as a situation of generalized hopelessness provoked by severe life events, such as the loss of a significant other, material loss, and impaired close relationships. Still close to Freud's understanding of melancholia as an illness of loss, Brown and Harris's conception nonetheless provided a complex view of the impact of loss on mental disorder, arguing that the loss of a loved object becomes significant when it deprives an individual of a major source of value or reward, more precisely, when it leads to "an inability to hold good thoughts about ourselves, our lives, and those close to us. Particularly important . . . is the loss of faith in one's ability to attain an important and valued goal."[35] Moreover, they observed that life events involving loss can be said not to cause depression but only to influence its onset if and when life events are combined with specific vulnerability factors, including the absence of an intimate, confiding relationship, the loss of one's mother before age eleven, having three or more children under fourteen living at home, and lack of employment outside the home.[36] Intersubjective deficit, notably, the loss of a significant other or the absence of a close relationship, was thus hypothesized to be either a key severe life event (in the former case) or a vulnerability factor (in the latter case) that provokes or makes individuals susceptible to depression.

Although published in 1978, concerned mainly with women's depression, and mainly interested in how the loss of loved objects makes a person vulnerable to depressive disorders or influences their onset, Brown and Harris's study proposed a theory of intersubjective deficit that is still considered to play a major role in depressive disorders. This is especially true in interpersonal psychotherapy (IPT) approaches, which understand the individual as embedded in a human environment that influences and is influenced by that individual. Interpersonal psychologists argue that early interpersonal experience in life lays down psychological models that influence later adaptation, confirming Avshalom Caspi and Glen Elder's insight that "it is not so much a personality trait or a psychoanalytic-like residual of early childhood experience that is maintained across time, but an interactional style that evokes reciprocal maintaining responses from others."[37] Intersubjective breakdown thus ceases to be merely a triggering or vulnerability factor and becomes a coping interactional style now part of the individual's identity, one that predisposes some individuals to depressive disorders. "From this point of view," psychologist Constance Hammen maintains, "the social context of relationships between

and among persons is the primary focus, although the context may additionally include numerous other important variables. By definition, the interpersonal perspective is about transactions, or reciprocal influences, among individuals, and these transactions create a dynamic process of change and flow."[38] In their postulation that interactional style is pivotal in the development of depression, interpersonal psychologists have markedly argued that loneliness is a crucial interpersonal mediator between causal factors and depressive outcomes: according to Thomas Joiner, James Coyne, and Janice Blalock, for example, many interpersonal risk factors, including self-silencing, shyness, involuntary subordination, and the lack-of-connection schemata, could contribute to loneliness, which in turn increases vulnerability to depression.[39] Relying on the work of Abraham, Freud, Rado, and Klein, who have all maintained that the mental wellness of the self depends on interpersonal gratification, psychologists Joseph Becker and Karen Schmaling have, furthermore, emphasized how the inability to receive interpersonal gratification causes low self-esteem, which leads to excessive interpersonal dependency (made manifest by clinging, manipulative, or controlling behaviors to prevent loss and abandonment) and predisposes one to depression.[40]

Researchers continue to confirm that the loss of connectedness with significant others is one of the chief vulnerability factors for the onset and development of depression. This emphasis on the interpersonal nature of depression—that is, the positive role of connectedness and the negative impact of lack of connectedness—is at the core of sociologist David Karp's understanding of depression as an illness of isolation and disconnection: "[D]epressed persons greatly desire connection while they are simultaneously deprived of the ability to realize it. Much of depression's pain arises out of the recognition that what might make one feel better—human connection—seems impossible in the midst of a paralyzing episode of depression. It is rather like dying from thirst while looking at a glass of water just beyond one's reach."[41] With this hypothesis, however, intersubjective failing as a vulnerability factor ceases to be located within the individual (as an interactional style) and is situated instead in the very texture of the social realm, notably individualistic societies. Indeed, Karp maintains that although it cannot be established that social structures cause depression, the "excessive individualism" related to the weakening of social attachment in contemporary Western societies plays an important role in the depressed person's extreme difficulty in communicating.[42] Philosopher Clément Rosset formulates a similar view, emphasizing the high probability that individualism increases depression occurrence: "The origin of depression would thus be as old as the world. But it is likely that there has been a progression of depression because of the aggravation of solitude provoked by modern society which isolates individuals instead of reassembling them. This explains, in passing, the incessant increase of consummation of psychotrope medication in western societies."[43] The growing sense of isolation of the modern subject is also considered, by Pierre Marie, to be a crucial vulnerability factor: for the psychoanalyst, the Enlightenment articulated the crucial passage from a closed, definite, and hierarchized world to a Pascalian infinite and indefinite world; this passage means that human beings are now condemned to live with strangers, a situation

that Marie believes has "tetanized" desire.[44] The hypothesis of depression as an illness of disconnection has its main roots in Émile Durkheim's 1897 *Le suicide,* which tied suicide rates to degrees of social integration. The study showed that modern Western civilization—notably Durkheim's own nineteenth-century France—was less successful than agrarian societies in providing sources of integration for its members, and that this lack of integration (a form of "anomie") increased suicide rates.[45]

In all these (social, interpersonal, and sociological) perspectives, disconnection is a state that amplifies or predisposes a person to depression in one way or another. Yet connection does not, by itself, protect one from depression and might, in certain circumstances, even provoke it. This is one of the main paradoxes of depressive disorders. In *Silencing the Self: Women and Depression* (1991), psychologist Dana Crowley Jack notes that it is in fact the "dependency" model that prevails in understandings of depression in women, in which the relational self is considered to either characterize or predispose a woman to depression.[46] Hence, for Silvano Arieti and Jules Bemporad, "pathologic dependency is perhaps the one characteristic of the depressive that has been unanimously emphasized in the psychiatric literature," and for Paul Chodoff, "depression prone people are inordinately and almost exclusively dependent on narcissistic supplies derived directly or indirectly from other people for maintenance of their self-esteem."[47] Depressive affections are therefore also seen as the inability both to detach the self from a lost relationship and to affirm the separate self. Similarly, relational theory posits that depression is fundamentally interpersonal: depression is the impossibility of sustaining supportive, authentic connections with a loved person because of the individual's inability to feel securely attached to the loved one. Highly critical of explanations that tend to locate the deficit within the individual and to devalue the self-in-relation model, which is a profound organizer of women's experience,[48] Jack proposes to focus on how connection affects women's sense of self. Basing her perspective on John Bowlby's attachment theory, according to which attachment bonds (that is, dependency) are necessary for healthy functioning throughout life (a postulate that implies that uncertainty about the reliability and availability of support creates "anxious attachment behaviors" such as clinging, fear of separation, requests for reassurance, protest, despair, and detachment behaviors), she stresses the importance of both recognizing the inevitability of dependency and examining why, in certain cases, dependency results in a "loss of self" and depression for women.[49] For example, although features traditionally associated with feminine development—flexible ego boundaries, empathy, and the disposition to care for others—are valued as strengths by relational feminists, they carry with them a vulnerability that needs to be addressed. "Women," writes Jack, "describe their depression as precipitated not by the loss of a relationship, but by the recognition that they have lost themselves in trying to establish an intimacy that was never attained. For most depressed women the sense of hopelessness and helplessness stems from despair about the possibility of bringing their own needs and initiative into their relationships, and from their equation of failure of attachment with moral failure."[50] From a feminist perspective, connection (or, more precisely, the pursuit of connection) can be, as in cases where it activates a loss of self, not a form of protection but a path to depression.

The degree to which connection is a protection or a vulnerability factor is hardly measurable, but this uncertainty shows by itself how depression revolves around states of intersubjectivity made fragile. In the realm of contemporary psychoanalytic theory, Pierre Fédida, whose examination of depression relies on the still-underestimated phenomenological studies of Ludwig Binswanger, Roland Kuhn, and Hubertus Tellenbach, has maintained that one of the key symptoms of depressive affections is the rupture of intersubjectivity. The depressed person characteristically suffers from a sense of infernal isolation, similar to Sartre's *huis clos,* that prevents communication with the other and produces self-images that are ceaselessly diffracted in the representation of the other.[51] In the clinical framework, the depressed patient is unable to represent the other, and the patient's facility with verbal expression usually masks a "void of intersubjectivity."[52] For Fédida, this void is indicative of how communicational psychotherapy, notably the intersubjective model of countertransference, is highly problematic. This model has come to characterize contemporary psychotherapy in its search for an ethics of prevention against the patient's dependency on the therapist. The ethics requires that the therapist recognize both the subjectivity of the patient (his or her intentions, thoughts, emotions, and actions) and his or her own reactions to the patient so as to communicate these findings to the patient.[53] Intersubjective communication is also a crucial strategy in behavioral, cognitive, and interpersonal psychotherapies, which focus on patient-psychologist agreements and problem-solving approaches. However, inasmuch as depression corresponds to a rupture of intersubjective communication, it is hard to see how such a communicational strategy can succeed.[54] Studies in speech and language therapy have also pointed out how the psychiatrist's reliance on verbal and nonverbal communication for the establishment of diagnosis and treatment of the patient is often contradicted by the mentally ill person's sheer difficulty in communicating. In the case of depression, patients are usually reluctant to talk; they tend to avoid social contact and reduce eye contact, facial expression, and intonation to the minimum.[55] The depressed might "greatly desire connection" while being "simultaneously deprived of the ability to realize it," as Karp suggests, yet he or she also paradoxically works hard to distance the other. Zvia Breznitz and Tracy Sherman have found that the speech of depressed individuals is punctuated by long pauses, "due possibly to the interjection of depressed thoughts that interfere with the patient's speaking rather than being reflexive of overall motor retardation."[56] In the following passage, Jenny France, cofounder of the Speech and Language Therapy Special Interest Group in Psychiatry, describes quite well how the erosion or rupture of communication is a crucial and intrinsic dimension of depressive disorders:

> The patient's reluctance to talk of their distress, problems, hopes and fears, and their denial of difficulties, is often seen to be the easiest and simplest way out. To admit to problems is thought, by the patient, to be a sign of weakness and it may also promote unwanted change and produce further difficulties, thereby adding to the patient's feelings of hopelessness. Patients may talk about other symptoms as these are perceived to be respectable, such as physical symptoms of feeling

tired or ill, but they are unlikely to discuss the major problem, that of the depression. Feelings of low self-esteem and the risk of being rebuffed prevent disclosure. Depression of mood can be manifested by sadness, tearfulness, hopelessness and gloominess, together with feelings of despair, conflict and alienation thus creating social changes and difficulties. The depressed person is more likely to avoid social intercourse, is therefore less likely to seek help and through reduced non-verbal communication will signal "keep your distance" and thereby limit social approaches and resulting interactions.[57]

The rupture of intersubjectivity has thus been consistently associated with depressive disorders, and, in the context of a historical period in which depression has become *the* leading mental disorder and is projected to reach, in a few years (as a lifetime prevalence), 50 percent of the population, it must be understood as a symptom that makes and unmakes, shapes, or surrounds contemporary subjectivity. It also seems that communicational psychotherapy exploring intersubjective strategies might well be unsuccessful in its objective to reach the depressed. This is a key observation for the understanding of art's contribution to the scientific debate on depressive disorders. It shows how aesthetics, especially an aesthetics critical of communicational intersubjectivity, can be a privileged site of interpellation of the depressed understood in its dimensional unfolding. This interpellation, as I hope to show, occurs through the unfolding of the image-screen. In this, aesthetics manifests how the fate of intersubjectivity is tied (partially, at least) to new media—their current technological and social developments, their representational and perceptual functions.

The Screen

In the present context of the multiplication, expansion, and technological convergence of screens, the viewer's relationship to the image-screen has become an object of much debate in the field of new media studies. Some authors, such as Margaret Morse, Oliver Grau, and Martin Lister, argue that in virtual reality, for example, the screen is tending to disappear from the user's sight: immersion is described as an entry into the image beyond the screen interface, and the user as a blind observer for whom the screen has, for all practical purposes, dissolved. Others—Lev Manovich and Kaja Silverman spring to mind here—maintain that, at this stage in the development of digital technologies, the disappearance of the screen is only a theoretical disappearance and that, in any case, as Silverman observes, vision is always a matter of mediation. There is no immediate vision of the world; the human subject always sees through the screen of language and images proper to a culture.[58] A close examination of this debate shows that one of its central questions concerns us directly: how do image-screens today interpellate the beholder? Interestingly, new media studies are advancing the idea that image-screens tend to deny or blind the user and that the image-screens themselves tend to dissolve for that very user. So as to emphasize and designate the disengaging aesthetics of art's

enactment of depression, I contend here that the functioning of the image as screen is at the core of Post's undermining of the relational *operandus* of the image, of aesthetics *tout court*. We have already seen it at work in Rondinone's video installations *It's late . . . (Stillsmoking, Part V)* and *No How On,* which toll the death knell of the window function of the image to render viewers (inside and outside of the image) blind to the other's presence. Following a baroque theater of light and shadow, clarity and obscurity, seeing and blindness, his images are transformed into a waiting screen that paradoxically pushes away the awaited. In many ways, we could also say that Beecroft's prohibition of exchange is but another dissociating screen inserted between the viewers and the performers. The image-as-screen is endemic to art's enactment of depression. However, contrary to the screens mapped out in new media studies, these artworks do not dissolve but affirm the screens as obstructing surfaces, barriers, blocked windows, and material surfaces. What are the modalities of such an image? Does the image have any critical value in relation not only to aesthetics (for what is aesthetics when its relational property has been so sharply shattered?) but also to psychotherapy (whose predominant approaches favor communicational intersubjectivity)? To appreciate Post's exploration of the image-screen as an interface of intersubjective rupture, it is crucial to situate it in the current debate revolving around the nonrelational disposition of the media screen. This contextualization will show how her disengaging screens have much to do with not only how new media technologies disengage the user (Post's work participates in this logic but might also be said to expose the logic through this repetition) but also, more generally speaking, how art's enactment of depression historicizes the disengaging image-screen as constitutive of contemporary depressed subjectivity.

One of the pivotal sites of deployment of the media screen is certainly virtual reality, where it becomes the very membrane that disengages viewers from their physical space, making them blind to that space. In their study on virtual reality, Martin Lister and colleagues have focused on one of the main metaphors that describe the immersion experience: the user, wearing a head-mounted display, *passes through* the screen in order to enter *into* the image.[59] This metaphor designates the screen as a renewed version of Alberti's window initially theorized in his *Della pittura* treatise of 1435–36: an open window through which the artist sees what he or she wants to paint, and through which the viewer attains a view on the world. However, this metaphor suggests that, contrary to the Albertian viewer, the user now has the possibility of immersing himself or herself in the imaginary world of the fictional space. This metaphor is the basis of Margaret Morse's study *Virtualities: Television, Media Art, and Cyberculture* (1998), in which she argues that in virtual reality the user passes through "the movie screen to enter the fictional world of the 'film'"; one is now "able to walk through one's TV or computer, through the vanishing point or vortex and into a three-dimensional field of symbols."[60] Here, the spectator's point of view is situated inside the projection of the image, contrary to the Albertian system, which positions the viewpoint in front of and exterior to the image. The screen thus becomes, as Lister and colleagues observe, a "thin membrane" between the immaterial world of fiction and the material world from which one sees this fiction.

From this perspective, the image is no longer what one looks at but an environment that one inhabits.[61]

Although this observation is not unfounded, it is not entirely accurate. The study by Lister and colleagues has been successful in complicating the metaphor of the "entry into the image" by comparing the phenomenon of virtual reality with the system of perspectivist construction that has formed the basis of the Western tradition of pictorial representation since the Albertian formulation of the *costruzione legittima,* so as to understand what happens to the viewer's position in this shift from the window-screen to virtual-reality representation. The study led to the formulation of a decisive observation: in virtual reality, the viewer's traditional position is, in a way, split into two, because although the user's body remains where it was (in the material world external to the image), it is a "body that cannot see the world it occupies."[62] The electronic stimuli generated by the small, binocular LCD screens placed close to the eyes of the immersed viewer fill his or her field of vision, make him or her blind to the world in which he or she is physically situated, and prevent him or her from establishing a relation between this world and the virtual one he or she is experiencing. This split is amplified by the fact that the wearing of a head-mounted display isolates the immersed viewer from others. In other words, the necessarily individualized virtual-reality occurrence signals the death of the rituals of exchange based on glances or words that, among other things, underlie the museum experience of art and the collective reception of cinema and television. Of course, other viewers can occupy the physical space of the user, but they see only the user's body "moving to the logic of a space that they, in turn, cannot see."[63]

The understanding of the screen as a disengaging mechanism has also been advanced by new media artist and theoretician Lev Manovich, but with the specification that new image technologies do technically allow more interactivity between the user and the image. In *The Language of New Media* (2001), Manovich contends that new media— the convergence of computing and media technologies—articulate a new conception of the screen, one that generates innovative modes of viewer participation because of its combination of two pictorial conventions: Renaissance pictorial illusionism, which defines the image-screen as a window opening into a virtual space to be looked at by the viewer; and the convention of graphical human-computer interfaces, which divides the computer screen into "a set of controls with clearly delineated functions, thereby essentially treating it as a virtual instrument panel."[64] This is to say that although the screen still functions as a window to be looked at from the separate physical space of the viewer, it is also, paradoxically, a surface that presents itself "as a virtual control panel, similar to the control panel on a car, plane, or any other complex machine," to be manipulated at will by the user.[65] Manovich acknowledges this doubleness in its potential productivity, as a means to rethink the relationship between the screen space and the physical space of the viewer. Whereas the classical screen of painting and cinema separated two distinct spaces by creating an image into which the viewer would enter by staying immobile in front of the screen (as Anne Friedberg has shown, the more the image became mobile, the more it paradoxically required the immobility of the viewer),[66] the computer screen

incites the viewer to move in the physical space and to act directly on the image so as to enter virtual space. Yet Manovich's true insight lies in the distinction he establishes between the technical innovations of new media technology and the history of the screen to which it belongs; for, although new media do propose a transformable screen, this screen is still explored to facilitate the viewer's entrance into virtual space through his or her increased immobilization, to the detriment of his or her actual physical space. The need to connect the user to the virtual-reality system with helmet, joystick, cord, and mouse continues and amplifies body immobility. Moreover, the screen is still conceived as "a flat, rectangular surface . . . acting as a window into another space," with the result that the physical space of the viewer is increasingly "disregarded, dismissed, abandoned."[67] Interactive as a screen may be, argues Manovich, "a screen is still a screen" and as such can only reinforce the dismissal of the viewer's space and body. This acknowledgment contrasts sharply with Manovich's own definition of the new media screen as an "image-interface" or "image-instrument," which technically facilitates a more direct and potentially more creative participation from the viewer.[68]

The contemporary media screen produces a user who becomes blind to his or her environment and loses the ability to establish a relation between that world and the virtual world he or she is experiencing. The shared collective viewing of images tends also to evaporate, together with the beholder's critical ability to distinguish fiction and reality. Although this transformation, as we will see in the next chapter, is not necessarily negative, it does considerably exhaust the relational function of the image. This diminishment is not a marginal phenomenon exclusive to virtual reality. Indeed, video already dissolves the image as a delimited and fixed entity. Furthermore, if one considers the interdependence of current media, the virtual-reality phenomenon will likely influence the orientation and perception of other media. As film historian Anne Friedberg has recently observed, although computer, television, and film screens are usually found in separate spaces, their images are increasingly becoming utilities, and each type of screen is losing its specificity as a medium.[69] Highly relevant to the screen aesthetics of Post's and Rondinone's work is the acknowledgment that new media technology disengages the user from other users, turns the user into a blind, immobile observer, and produces images that deny the space of the user. It is safe to say that their work reiterates a phenomenon that has become more and more generalized in the experience of contemporary images. I argue, however, that it would be wrong to assume that Post and Rondinone merely repeat this more general phenomenon.

Indeed, the study of Lister and colleagues in particular points out how the diverse disengagement effects of new media images come about because their screens tend to disappear for the user. Where the material surface of the image stood (the pictorial surface, the window, the screen), they maintain, there is now nothing left. In virtual reality, the screen has in fact dissolved because of the extreme proximity of the LCD screens that present the eyes of the immersed viewer with an image the contour and surface of which can no longer be detected.[70] The contour and the surface can only be "resurrected for the 'secondary' audience," through the intermediary of more traditional media (photography

or video, for example). This is also the conclusion of art historian Oliver Grau, who, in *Virtual Art: From Illusion to Immersion* (2003), stipulates, however, that the experience of virtual reality tends to make the image disappear and not the screen: the user does not "see" an image on a screen in any real sense, because the image, in most cases, exists only by virtue of the observer's movements and his or her stereoscopic vision; in other words, the image physically exists only directly in the stimulated neurons of the brain.[71] It is an entirely private and essentially ephemeral image that is modified by the simple movement of a user, a transformative process without a material basis, an environment detached from a fixed support, whose almost total immateriality (the materiality of the image is limited to the individual pixel) prevents it from taking shape in memory and as memory. This observation applies not only to virtual reality but also to video technology. The latter already abolishes the image as a fixed entity, because it is only through the supposed phenomenon of retinal persistence that the effect of a complete image is produced on the screen; the image is nothing more than the result of an electronic scanning of the screen that inscribes itself in a continuous process of appearance and disappearance.[72]

Hence, if the new media user has become blind, self-absorbed, isolated, cut off from the space he or she physically occupies, and oblivious to others who might happen to be in that same space, it is because he or she cannot see an image that is now more of an environment in itself. It is not that the screen has literally vanished; the screen remains, however interactive and minuscule it might be. The possibility of projecting images onto any surface, including the walls of an architecture that incorporates them, or of projecting virtual-reality images directly on the retina with laser scanners, in no way changes the fact that we are still in the era of the screen (in the latter case, it is the retina that acts as the screen surface). But technical persistence does not necessarily guarantee phenomenological persistence. As Lister and Grau demonstrate, it is not so much the screen that is disappearing in new media technologies as our experience of a detectable frame, surface, and image. The screen convention of the frame that once served to separate reality from fiction is no longer operational. Although this convention, as Henri Lefebvre has shown to be the case in matters of space, has never stopped reality and fiction from being intermingled, and although it never meant that the imaginary is independent from social reality, the frame has traditionally acted as a separating agent by virtue of this very convention. The frame's function is to delimit representational time-spaces that "invite imaginative projection."[73] In the experience of virtual reality (but also in other media, such as video), it is this separation that is tending to disappear. Considering that the frame, or any stage whatsoever, was a means to articulate a distance vis-à-vis the social world in order to imagine it otherwise or simply to offer a space for thought, the critical question raised by recent media developments becomes, how do new media articulate this distance? Do they still articulate it at all? Are we not witnessing a significant diminishment of the critical distance in the observer's relation to the image? In Grau's words, "As the interfaces seem to dissolve and achieve more natural and intuitive designs so that the illusionary symbiosis of observer and work progresses, the more psychological detachment, the distance from the work vanishes. . . . In virtual environments, a fragile,

core element of art comes under threat: the observer's act of distancing that is a prerequisite for any critical reflection."[74]

In contrast, art's enactment of depression opposes the dissolution of the image-screen and of the delimiting frame. Although it insists on reiterating its generalized disengaging effects, it does so by opposite means, that is, by reaffirming the materiality of the image-screen—its disconnection between the inside and the outside, fiction and reality, you and me. It reestablishes distance to the point where distance has transformed itself into distancing. Yet this is not exactly what Grau has in mind when he speaks about the need to return to critical reflection through the observer's act of distancing, for here it is not the observer who acquires a distance from the image but the image that distances the observer. The productivity of the reaffirmation of the image-screen comes more from its engagement of the viewer within the process of disengagement, a procedure that might disclose to the viewer the generalized disengaging effects described by Lister, Grau, and Manovich in their examinations of new media images.

Disengagement through engagement is manifest in the work of Liza May Post. Her video screens combine the two pictorial conventions Manovich outlines: the image as window and the image as instrument or control panel. It is through the viewer's contradictory experience of the image as a window that eventually closes itself to him or to her, that the image-screen as a *process* of relational failure, rupture, or discontinuity is enounced. In the case of the photographs, the figure's turning away from the viewer and the white-on-white display of the figure within her environment block the viewer's entering look midway. It is only once the eye has started to travel in the represented space that the access to the *femme-enfant* is denied, prevented, or banalized. The back, the curtain, and the image are screens, because the window function of transparency or semitransparency has been transformed into a protective function that liberates from one another the two poles of to-be-looked-at-ness and bearer-of-the-look, providing them mutual autonomy but also elaborating a loss of relation. In this operation, the image itself is condemned to greater self-sufficiency. As it loses its interrelation possibilities as a medium, it isolates as a screen. The video installations *Place* and *Under* amplify this effect when the surface quality of the image becomes the imaginary wall that breaks the intersubjectivity that was about to form: *Place*'s reflection of the viewers' shadows does activate a meeting between subjects, but the meeting will finally be disclosed as a mere coexistence of bodies; *Under*'s female figure does turn toward the viewer, and a continuity between the represented and physical spaces does start to form, but only to be arrested by the figure's reimmobilization. Because the video images are an active part of the gallery space, they gain in materiality, in the sense that their disengaging effect is activated through an architectural setting—a wall in the middle of a room or at the periphery—that localizes the images in continuity with the actual space but whose physicality becomes manifest once continuity is denied in the image. This materialization process is another modality of the functioning of the image as screen: the more the image is manifest as a physical partition, the more its mediating function—its role as an intermediary between eye and world, between protection and touch—appears ill, obsolete, or inoperative. Bluntly, in Post's production, it is the midway dysfunctionality of the mediating

electronic surface that makes the contemporary image deploy itself as a screen. The screen is explored as an interface—a reflexive surface in *Place* and a spatial continuation of the viewer's physical space in *Under*—but it is a failing interface. Her screens thus value only to rapidly devalue the imaginary entering of the viewer into the image on the other side of the screen. The artworks make the point of engaging the viewer in that very failure of relatedness. They articulate not the disappearing screen but its persistence, making us aware of or attentive to the rupturing mechanism of the contemporary image-screen. The criticality of the installations thus lies in their ability to activate not the breakdown but the modus operandi of the breakdown of the relational operations that the screen traditionally conveyed when it supported a window or mirror definition of the image and thereby enabled the spectator's imaginary entry into the image. It can also be said that the installations amplify the spectator's disengagement with his or her own space as he or she enters into the screen. These ruptures are phenomenologically intensified, as is the case with *Place* and *Under*, when experienced in the context of installations where the image-screen somewhat abandons the viewer standing in the space in front of it. In this, they disclose not only the failing of the interface but also the decline of the spectator's point of view.

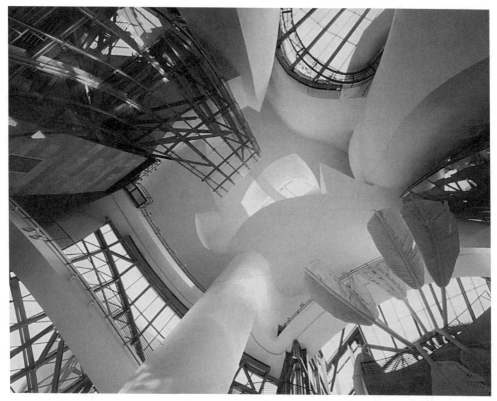

Figure 53. Frank Gehry, Guggenheim Museum Bilbao, 1997. Copyright FMGB Guggenheim Bilbao Museo. Photograph by Erika Barahona Ede. All rights reserved. Total or partial reproduction is prohibited.

In his *Warped Space: Art, Architecture, and Anxiety in Modern Culture* (2000), architectural historian Anthony Vidler argues that although perspectival representations of space still prevail in contemporary images, a fundamental repositioning of the subject's point of view has indeed taken place, at least since the end of the nineteenth century.[75] Vidler's account suggests a vanishing of the Lacanian mirror function. Not only is the Lacanian subject—the subject that constitutes itself in relation to the mirror image—"entirely different," but the "new mirror" is perhaps not specular at all, operating "more as a screen than a reflective surface."[76] The vanishing of the mirror function is particularly noticeable in numerical imagery used for the conceptualization of architectural space. "What has changed," writes Vidler, "is . . . the place, or position, of the subject or traditional 'viewer' of the representation. Between contemporary virtual space and modernist space there lies an aporia formed by the autogenerative nature of the computer program, and its real blindness to the viewer's presence. In this sense, the screen is not a picture, and certainly not a surrogate window, but rather an ambiguous and unfixed location for a subject."[77] One of the key examples of this change is Frank Gehry's conception of the Guggenheim Museum Bilbao, in Bilbao, Spain (1997). In this specific case, Vidler maintains, the devising of the complex forms of the building necessitated a combination of software that emphasizes its internal logic of digital projection to the detriment of architecture's traditional preoccupation with the viewing subject. When the construction of space ceases to be grounded on the perspectival model, as in Gehry's Bilbao, architecture banalizes the need to confer a viewpoint to the subject:

> But, more importantly from our point of view, any formal reliance on traditional perspectival space, or for that matter on the traditional subject, is abandoned. This subject is now embedded within the "gaze" not of a hypothetical viewer but of a scanning system; it is as if, by some means, the subject might be able to "see" through the 3D lens of the CAT scan machine as it maps the observing brain and measures its responses. From this admittedly problematic point of view, whether or not we can enter the building and walk around inside it, or whether or not we can snatch traces of the old perspectivism in the new folded spaces, or whether or not we can trace its outer forms to early expressionist precedent, Bilbao remains *in the process of its conception* profoundly indifferent to our presence. I mean this in the sense that while of course it is possible to construct perspectival and humanistically traditional space through the use of software—virtual reality engines are doing this all the time—the way in which this software is used, and the increasing reliance on its subtle internal and programmatically defined determinants, gradually moves toward a state in which the building begins to construct its own identity like some revived dinosaur, finding solace in its one self-absorption. . . . Digital representation . . . has introduced a decisive difference. Where perspective and other geometrical projections were controlled, so to speak, by the ruling metaphor of the primacy of the viewing subject, digital projection has its own internal logic.[78]

Although digital architectural imagery can be said to favor the software's "internal logic" over the subject's viewpoint, one should not restrict the decline of perspectival positioning to computer technology. As Vidler himself shows in his study of modern conceptions of space, especially in his examination of Walter Benjamin's view of the modern city as articulating the collapse of perspectival space and the concomitant erosion of the space of criticism, prospect, and standpoint, the humanist construction of space as it was elaborated during the Renaissance was perceived already in the nineteenth and early twentieth centuries as flattening itself out, closing in, and becoming increasingly obsolete, in a decline that shattered the viewer's positioning at the viewpoint.[79] The fading out of perspectival space (which is related to the abolition of time distances by speed distances through the instantaneous transmission and retransmission of televised images) and its gradual replacement, in the era of electronic media, by what Paul Virilio has called opto-electronic teleology are two of the important factors that come into play in the denial of the viewer and his or her exclusion by the screen.[80] At least since the turn of the twentieth century, artists and theorists have disclosed the vanishing of the viewer's viewpoint. For Vidler, the anxious interpretations of space at play in the studies of Georg Simmel, Siegfried Kracauer, and Walter Benjamin and, closer to us, in Robert Smithson's 1969 land-art mirror displacements (which both reflect and deflect the site by excluding the viewer from the reflections) and Rachel Whiteread's 1993–94 *House* project (a concrete cast of a demolished three-story row house that shuts out the inside space and thus prevents the viewer from entering the house) are tied to the historical development of an urban subject increasingly exposed to the spatiotemporal dislocations of modern life.[81] These artists and thinkers have attempted to "warp"—to inject anxiety into—space so as to express its inherent denial of the subject. Liza May Post's institution of a subjectivity of waiting, one that becomes manifest not only through the category of space but also through the category of electronic time, and her reiterated staging of indifferent lookers, which falls short of providing a specific viewpoint to the viewer and recognizing the presence of that viewer, must be read in light of the historical and now digital vanishing of the viewpoint. Her images have indeed lost their traditional mediating function. The viewers' shadows may interconnect with the figure, but they are shown finally only to coexist without exchange. A female figure may activate the spatial connection between the represented and physical spaces, but the continuity will be irremediably denied by her inability or refusal to look toward the viewer. The immobilization of the body—its waiting stance—which is, for Manovich, the ultimate sign of the persistence of the screen and its inherent disregard of the viewer, is everywhere the main trait of Post's represented subjects. But her installations do more than confirm the media screen as a failing unifying specular interface: they associate this disengagement process with the historical development of depressed subjectivity at the turn of the twenty-first century; they historicize (embody, socialize, gender) the viewing subject, who otherwise always remains an abstract position in new media studies. Such is the unique participation of aesthetics in the mapping of the image-screen. The failing of the unifying specular interface, which affirms the image as a screen, can be said to perform the inherent pathology

of the independent, neoliberal subject: depressive disorder. It injects anxiety both into the image and into space in order to expose the anxiety of our times. The primordial concern here is the media image's making and unmaking of contemporary subjectivity.

Relational Aesthetics?

In an attempt to counter the neoliberal development of the entrepreneurial subject and the related consolidation of individualistic societies, art and art history have started to revalorize notions of community and intersubjectivity through what art critic Nicolas Bourriaud has called *l'esthétique relationnelle.*[82] Relational aesthetics has been defined, in a recent issue of *Flash Art,* as an approach "in which the artist loses his ego-centrality, in order to create a good communication with his 'object'—but at the same time [is] always deeply respected as a 'subject.'"[83] Bourriaud speaks more precisely of an art "which takes, as its theoretical horizon, the sphere of human interactions and its social context, rather than the affirmation of an autonomous and *private* symbolic space."[84] Relational aesthetics considers intersubjectivity to be its central objective and *l'être-ensemble* (the being-together) its central theme, so as to facilitate the "encounter" between the viewer and the artwork, together with the "collective elaboration of meaning."[85] One of the key manifestations of this aesthetics may be found in the "littoral art" of Canadian artist, writer, and theorist Bruce Barber. Defined as "the intermediate and shifting zone between the sea and the land," littoral art refers metaphorically to "cultural projects that are undertaken predominantly outside the conventional contexts of the institutionalized artworld." It sees itself as public, community-based art, emphasizing social interactions between artists and spectators "through co-operative achievements of understanding among participants."[86] The main development of littoral art is communicative action, an art activity that favors dialogue over avant-garde provocation.[87] In the following passage, Barber exposes quite well the Habermasian basis of relational aesthetics—the understanding that a communicative act relies on the assumption of a background consensus between artist and spectator in relation to the validity claims of communication, a consensus that apparently ensures democratic dialogue between subjects:

> In Littoral Art projects no one individual should assume absolute control of the communicative process; rather, it should be, in the best sense possible, participatory and democratic.
>
> Public art projects are aimed at stimulating dialogue and participation within a specific community to engender (or engineer) conscientisation, and possibly, social change.
>
> The interaction between marginal groups, and their integration in such projects can lead to extraordinary results in which artistic, social and environmental objectives overlap.
>
> Littoral art helps to stimulate dialogue and elevate the standards of conversation between different communities and disciplines whose paths would normally not cross.[88]

Yet, as is implicitly manifest in Barber's description of littoral art as participatory and devoid of control, the whole difficulty of Habermasian communicational intersubjectivity lies in the presupposition that the communicative act corresponds to an ideal speech situation and that the background consensus on the claims that make communication valid (intelligibility, truth, rightness, and sincerity) does in fact exist.[89] In other words, communication relies on both a communicative competence and a claim to validity that speakers and hearers, artists and spectators do not necessarily have or share. The reality of noncompetence or nonuniversality is even more acute in cases of individuals suffering from mental affections, especially depressive disorders. As Jenny France has significantly pointed out, communicational disturbances in situations of mental illness "can result in the reduced intelligibility of messages, or in deficient listening skills. This imposes limitations on the communication of thoughts and feelings. It frequently also engenders messages of intolerance, ridicule and rejection by society. This can encourage feelings of isolation, hostility and anger in those affected, which are frequently accompanied by feelings of low self-esteem, a lack of self-confidence, and worthlessness and uselessness."[90] Psychiatrist Jurgen Ruesch states that most psychopathologies are in fact communicational difficulties.[91] This is to say that, although one can only approve of art practices that aim to (re)build inter-subjectivity, it is also crucial to investigate how and why contemporary intersubjectivity is in crisis, as well as the role of media in this crisis. Highly critical of Bourriaud's notion of the relational, art historian Paul Ardenne argues that relational aesthetics often denies the following two indubitable facts: community has already been lost; and Western socie-ties heavily engaged in a culture of comfort and entertainment, for which living art has more a playful than a critical function, do not need art—art, in other words, has lost its function as social link.[92] This is why, more often than not, artistic intersubjective efforts reach only the already converted, usually occupying public, consensual spaces that have lost their power to subvert the social order. Opposed to what he sees as a naive aesthetics, Ardenne proposes an art that both inhabits social space as it is instead of predefining what it should be and admits to its loss of power without asking for any recognition in return. Although Ardenne's promotion of a "humble" and "discrete" aesthetics underestimates the power relations of the art world, such as the need to be recognized in order to be heard, it does offer a substantial reflection on the contemporary possibility of political art. In his perspective, criticality comes not from the relational but from an anticommunity stance: art's role should be to disclose the decline of the community. Such artworks have the merit, according to Ardenne, of disclosing the undesirability of environments that have become inhospitable, unbearable, and isolating.[93] It is not that community is dead once and for good (let us move away from the rhetoric of ends and beginnings), and it is not that attempts to forge bonds through art should be discouraged. Rather, it is to say that community is a structure that has become problematic and deficient, part of the reason why art, as an aesthetic experience that is, by definition, relational, has been increasingly marginalized in relation to entertainment culture.[94]

The rules of disengagement enacted in the work of Beecroft, Rondinone, and Post (to which must be added the work of Douglas Gordon and Rosemarie Trockel, soon to be

examined), and of any art practice directly or indirectly concerned with the intertwining of depression and contemporary subjectivity, must be seen as a radical alternative to relational aesthetics. Aesthetics here is an exploration of the contemporary downfalls of the being-together. The depressed is the very figure, the very symptom, of this failure, once depression is understood as a disorder of disconnection and misconnection. The reenactment of intersubjective break is a critical representation of the withering of the relational and the related constitution of the responsible, self-sufficient individual, especially in matters of depression. *L'esthétique dépressive* is one half of a Janus face whose other side is *l'esthétique relationnelle*; it is the dystopian flip side of the utopian belief in community as a being-together, reflecting science's ineffective deployment of communicational strategies to treat the depressed. This does not mean that communicational intersubjectivity is being denied in art's enactment of depression; rather, it is being shown both as an unrealized reality and a problematic connection model. This divulgence operates through a major redefinition of aesthetics, one that shatters its inherent relational property. We are left with an image-screen, a media image affirmed as a screen that solicits the viewing subject only to deny it, supporting but also exposing the depressed need to protect the self from the possible loss of the other. Contemporary art is, and can be, a disclosure of the decline of the value of loss, but it performs this disclosure paradoxically by reinforcing this very decline.

Chapter 4

NOTHING TO SEE?

O ne of the main points of contention separating the psychiatric and psychoanalyti-
cal approaches to depression (and to mental disorder in general) is the question of
the symptom, its nature and value at the moment of diagnosis and its treatment.
In both approaches, the symptom—the observable phenomenon that, in cases of illness,
manifests or that enables the observer to detect a morbid state or evolution—belongs
to the visible world, but only as a constituent of a wider phenomenon (a disorder). The
understanding of what this visibility reveals, however, is substantially different in the two
approaches. Whereas the prevalent *DSM* diagnostic stream envisages the symptom as a
sign of dysfunctionality so that it may eventually become the target of pharmacological
intervention or behavioral-cognitivist correction, the psychodynamic perspective views
the symptom as the description of an internal state or evolution in need of interpretation,
under the assumption that it is only through the interpretative act (one that takes place
in the talking cure between patient and therapist) that the symptom may truly become
meaningful. Definitional divergences occur as well at the level of observation, in the
ways in which symptoms are perceived. Psychiatry has come to favor what Pierre Fédida
has called "summary semiology"—the observation of signs without interpretation or in
accordance with an explicit diagnostic criteria. This conception takes its heuristic from
detached observation: the recording of symptoms as mere signs reduces clinical inference
to its minimum so as to guarantee the reliability of the diagnosis and facilitate communi-
cation between therapists. The symptom is more specifically understood as a measurable
sign, one that can be compiled in accordance with agreed criteria so that psychiatry may
be accountable for its evaluations, decisions, and actions. Symptomatology must thus
secure psychiatry's categorical approach. More pragmatically, summary semiology—
description without interpretation—compensates for the lack of progress in research on
depressive disorders and science's inability, at this time, to circumscribe the cause(s) of
depression.[1] Gone is the conception of the symptom as a plastic phenomenon, a process,
a site of crisis of resemblance and knowledge characteristic not only of psychoanalytic
discourse but also of the poststructuralist approach to images. As psychiatrist Mitchell
Wilson has shown, the *DSM–III* in 1980, the edition responsible for the reinauguration
of the diagnostic approach to mental illness, articulated both the dismissal of "neurosis"
(defined by Jean Laplanche and J.-B. Pontalis as "a psychogenic affection whose symptoms

are the symbolic expression of a psychic conflict which has its roots in the subject's infantile history and constitutes compromises between desire and defense"[2]) as a classificatory principle and the marginalization of the clinical, psychodynamic tradition for which this concept stood.[3] This shift reinitiated the conception of the symptom as what is "publicly visible" (a sign to be rapidly identified, recorded, and communicated) rather than what is "privately inferred" (a felt ailment to be deciphered). For Wilson, the main consequence of this shift was "the narrowing of the psychiatric gaze in contemporary psychiatry," one that has come about in the following three interrelated ways:

> First, there has been a loss of the concept of depth of mind, a loss of the concept of the unconscious. We are now teaching our residents to focus on the superficial and publicly visible. Second, the consideration of time has become sharply limited. The biopsychosocial point of view, within which I include psychoanalysis and Meyerian psychobiology, emphasized the unfolding of a life over time—the development of the person and the place of his or her symptoms within this development. With the advent of DSM-III, time has shrunk from a lifetime to a moment, from the extended evaluation to the 45-minute cross-sectional interview. Finally, and most importantly, there has been a constriction in the range of what we as clinicians take to be clinically relevant, a narrowing of the content of clinical concern. Personality and the ongoing development of character, unconscious conflict, transference, family dynamics, and social factors are aspects of a clinical case that are deemphasized, while the careful description of symptoms is often taken to be an adequate or even proper assessment of the patient. Further, the emphasis on careful description fosters the confusion of the easily observable with the clinically relevant.[4]

The constriction of the psychiatric gaze comes about through the isolation of the symptom from the psychodynamic approach's key notions of unconscious conflict and family dynamics as the predominant factor in the psychic development of the individual. Psychoanalysis or any psychoanalytically derived psychotherapy, as Ernest Gellner's sharp description points out, is a technique "in which a therapist encourages a patient to 'free-associate'" with the assumption that "this will in due course lead to the uncovering of the unconscious, 'repressed' mental contents, which could not have been elicited by any more direct approach; and that their extraction and recognition by the patient will have significant and beneficial therapeutic consequences," whereas sciences of depression devalue the rapprochement between symptom and life story, illness, and repression.[5] As I will argue in chapter 5, the *DSM* diagnostic observation of symptoms—at play not only in psychiatry but also in neurobiology, psychopharmacology, and behavioral, cognitive, and interpersonal psychotherapies—implies a series of operations that dementalize the subject, including the denial of symptomatic time and change; the marginalization of the psychic dimension of the subject (the realm of desire, dream, and phantasm, the subjective sense of loss and time, the world of conscience and conflict); and the increased biologization of mental affections, which denies the role of social and environmental

factors in the development of disorders (despite the fact that depression cannot be said yet to be biologically derived). The pressing questions, thus, are these: What model of the symptom is art proposing in its depressive enactments? As it critically disengages, does art challenge—through the image as symptom—the dementalizing sciences of depression? What would be today the most productive way to reopen the psychiatric gaze?

Although Wilson and Fédida are right to specify how much the symptom has been impoverished in diagnostic psychiatry, it is difficult to imagine, as a critical alternative, the simple reinstatement of the psychoanalytical perspective. This is especially true in matters of depression. As Alain Ehrenberg has argued, the contemporary subject is quite different from the one theorized by Freud, Klein, or Lacan. In the specific case of depressive disorders, the conflicting structures of the psyche as a cause or vulnerability factor do not seem to play an important role in the outcome and development of the mental disorder. More than the conflict between desire and prohibition, it is the cleavage between the possible and the impossible, characteristic of a subject governed by norms of individualistic independence and by the neoliberal entrepreneurial valorization of self-invention, that is so endemic to depression. As I will argue later in this chapter, in matters of depression, the mere upholding of psychoanalytical subjectivity and its corresponding interpretative model is highly problematic, deeply anachronistic, even obsolete. So the questions in relation to this issue become these: How can the psychiatric gaze be reenriched outside the traditional psychoanalytical perspective or in a fundamentally renewed psychoanalytical perspective (such as Fédida's)? How can the symptom—or any form of visibility, including the image—regain status in complexity, temporality, and process quality?

The artworks examined in this chapter must be seen as contributing to the contemporary scientific debate around the symptom. Their contribution lies precisely in the tension they set up between diagnosis and interpretative observations of the image as symptom. In an exploration of the image as a depressive symptom (a materialization of the symptom of conservation of the living under its inanimate form within the very thickness of the image) and a reiteration of their acknowledgment of the perceptual impoverishment of the depressed viewer, Liza May Post and Ugo Rondinone complexify the symptomatic nature of the image in a way that does not necessarily solicit hermeneutical or psychoanalytical interpretations but transforms the image into a matrix—not so much what artist and media theoretician Edmond Couchot has called the image matrix, which signals the morphogenetic and hybrid nature *of the digital image* (its technical state of perpetual transformation and potential for infinite combination of data operated at the level of the image),[6] as a screen matrix that signals the image's ability to transform itself through the impact of a multitude of data *at the level of the viewer*—whose function is to activate perception. It does so, in a gesture that directly counters the cognitivist reduction of depression to a flaw of adaptation and creativity, through an aesthetic valorization of two of the most apparently unproductive symptoms of depression: the need for time and the need for sleep. The main objective of this chapter is to further the thinking of the image as screen initiated in the last chapter to examine how derelational

aesthetics can sometimes be a site in which perceptual disengagement becomes a condition of possibility for a regeneration of perception. What makes the artworks in this chapter so relevant to the scientific controversy around the symptom is that this reactivation takes place not through an anachronistic resurrection of the Freudian paradigm of the interpretable symptom (as a sign of unconscious conflicts) but through a critical reinstatement of psychiatry's banalization of the symptom. The image as symptom here has value not because it is potentially meaningful through interpretation but because it creates temporal duration and dormancy, even dullness. It does not solicit interpretation but opens up a space for what could be called, in an era of speed and performance, the critical symptoms of depressiveness: waiting immobilization and insomnia. The two artworks examined here must be seen as articulating that space. Grounded on the assumption that the contemporary subject is perceptually impoverished, Douglas Gordon's *24 Hour Psycho* (1993) and Rosemarie Trockel's 1999 Venice Biennial triptych installation, comprising *Eye, Kinderspielplatz,* and *Sleepingpill,* investigate impoverishment so as to make it the very modality by which the depressed person's experience, and demand and need for time and sleep are both recognized and aesthetically deployed. Nourished by the loss of the aesthetic tradition of melancholia (as a discourse of loss) and the concomitant requirement to be attentive to the subject's claim for protection against loss, recent art rethinks the symptomatic image in light of this exigency.

Time

First presented in 1993 at the Tramway in Glasgow and the Kunst-Werke in Berlin, *24 Hour Psycho,* by Douglas Gordon (b. 1966), consists of a freestanding three-by-four-meter electronic screen that hangs from the ceiling in the middle of a dark gallery room. On the screen one quite easily recognizes Alfred Hitchcock's film *Psycho* (1960). But the relative ease of this act of recognition is soon complicated by a difficult interplay between perception and memory, a complication that comes about because of two major alterations operated on Hitchcock's original film: the suppression of the sound track and the extreme stretching of the film to twenty-four hours by slowing the speed to two frames per second instead of twenty-four. The famous shower scene, for example, in which Marion (played by Janet Leigh) is stabbed and dies, lasts more than 30 minutes in Gordon's video projection instead of the 2½ minutes of the original version. The film is projected on both sides of the translucent screen, inviting the spectator to move around the screen and adopt different viewpoints, but the viewing activity is constantly challenged, tested, and disclosed as inadequate. The film's extension to twenty-four hours implies not only that it cannot be seen in full but also that perception has become somewhat of a problem.

By reproducing the film *Psycho* in extreme slow motion—that is, by slowing down the time frame of the initial version—and by cutting the sound, Gordon in *24 Hour Psycho* disrupts the original narrative of the film to such a degree that memory and perception clash over the reconstruction of the film. The viewer fails to recreate the original story. To really measure the degree of perceptual insufficiency that is at play here, it is

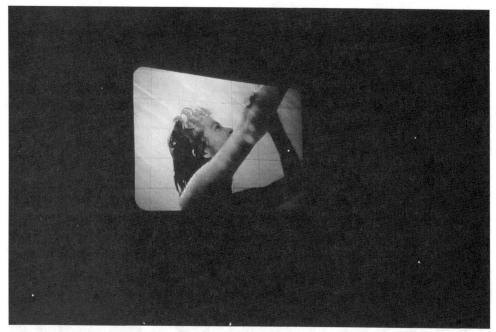

Figure 54. Douglas Gordon, *24 Hour Psycho,* 1993. Single-screen video installation, 24 hours. Edition of 2. Photograph courtesy of Gagosian Gallery. From *Psycho,* 1960, directed by Alfred Hitchcock, Universal Studios. Copyright Universal.

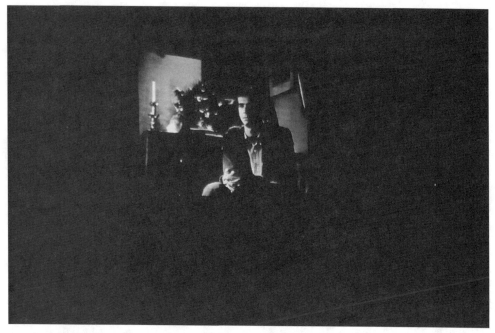

Figure 55. Douglas Gordon, *24 Hour Psycho,* 1993. Single-screen video installation, 24 hours. Edition of 2. Photograph courtesy of Gagosian Gallery. From *Psycho,* 1960, directed by Alfred Hitchcock, Universal Studios. Copyright Universal.

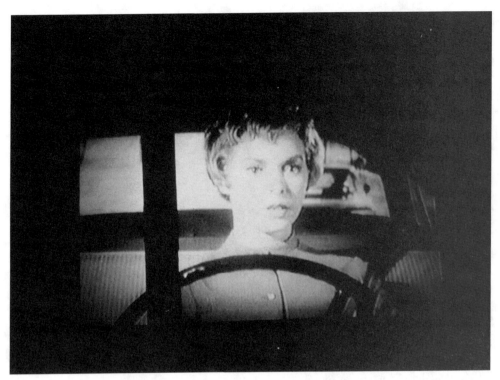

Figure 56. Douglas Gordon, *24 Hour Psycho*, 1993. Single-screen video installation, 24 hours. Edition of 2. Photograph courtesy of Gagosian Gallery. From *Psycho*, 1960, directed by Alfred Hitchcock, Universal Studios. Copyright Universal.

important to emphasize that *24 Hour Psycho* stages a classic of Hollywood cinema. Most viewers already know the film or have heard about it. This means that, in the installation, perception is activated by a series of mental processes that bring memory into play, such as remembrance, recall, expectation, and anticipation. Slow motion plays an important role in this interpellation, for it both promises and fails to help us remember. It gives us more to see: it amplifies details, articulates the analytic cutting of the action, and lingers over the signs of the thriller. Yet it is also a process of abstraction that blurs the legibility of the image, detaches the action from the narrative structure, unties body expressions and movement from the plot, and prevents the cause-and-effect association of images. At all times, it risks disengaging the viewer. In short, *24 Hour Psycho* dissolves diegesis, to the point where, more often than not, there is nothing to see. The installation exploits, indeed constructs and supports, a perceptual impoverishment that shares with current cognitive science, as we will see, a concern for the limits of perception. Its temporal expansion articulates a depression of the image.

This installation articulates and exemplifies a significant shift in the realm of contemporary art, from what I would call a performance-based to an insufficiency-based conception of subjectivity. It shows how contemporary art has become critical of the performative requirement for incessant openness to resignification, recontextualization,

and self-re-creation. Put another way, it shows how art at the turn of the millennium constitutes, questions, and addresses the subject as insufficient. But this is not just any kind of insufficiency. By insufficiency, I refer not to a sense of lack, unfulfillment, or conflict—as would be the case for a Freudian, psychoanalytically defined subject—but to a sense of cognitive, behavioral, and neoliberal inadequacy—the subject's inability to adapt to change, to match ideal models of performance, and to re-create itself anew, together with the fatigue that ensues from such an inability. In his numerous interviews, Douglas Gordon reiterates the understanding of perceptual insufficiency as a dysfunction when he affirms that what interests him is the growing occurrence of this phenomenon. "[S]tatistically," he claims in a 1996 interview for *Blocknotes,* "almost every family has had, or will have, some experience of dysfunctional behaviour. So, it's something we live with. We can be fascinated by this subject and we can be terrified of it."[7] Two years later, in a conversation with Jan Debbaut, he speaks more precisely of dysfunctional perception and memory as a form of "breakdown," "an incredible, complex machine, with an amazing power to recall, and an equally unpredictable possibility of failure": "I suppose [my work is] to do with perception—or how the mechanics of perception work. . . . By looking at something as broad as this mechanism I can make specific investigations into territory to do with memory (or the malfunction of memory), and the ways in which perception breaks up, or breaks down. . . . I'm more interested in those areas where perception breaks down or the fact that we don't actually know how it works or why it malfunctions, or what aspects of our experience we carry around and are unaware of how they might be shaping our perception."[8]

For Gordon, perceptual breakdown and the subject's difficulty to "cope" with the "memory of events"[9] are symptomatic of an era of diversification of information technologies, an era that not only drowns the subject in a "flood of images and . . . information" but also pressures the subject into a "schizophrenic co-habitation" of different technologies, best described by one's use of "the Internet while watching TV, listening to music, speaking and drinking, all at the same time."[10] This is to say that Gordon's view of perceptual and mnemonic impoverishment has more to do with deficiency than with psychoanalytical notions of lack of plenitude or psychic conflict. It is related both to the field of neurobiology and its study of physiological dysfunctions *and* to the field of current cognitive-behavioral science and its mapping out of the perceptual coping deficiencies of the contemporary subject. Gordon's *24 Hour Psycho* inscribes itself even more notably in cognitive science's increasing concern for the limits of perception and memory, the inhibitory processes of perception and the subject's limited abilities to perceive multiple visual inputs simultaneously. However, as I hope to show, the installation gives deficit a productive value, one that contrasts sharply with cognitive science's usual attempt to correct perceptual insufficiencies for the sake of optimal perception.

Jonathan Crary has recently shown that the interest for the inhibition component of perception has occupied science since the second half of the nineteenth century.[11] Yet it cannot be emphasized too strongly that notions of distraction, diminution of activity, transience, and fleetingness have become increasingly important in contemporary

cognitive research, especially in the context of the growing preoccupation with ADHD (attention deficit–hyperactivity disorder), Alzheimer's disease, and depression—any disorder, in fact, in which perception and memory are impaired. The novelty of recent cognitive research lies in the examination of the interaction between mechanisms of inhibition and excitation in their relationship to attention. The work of Kimron Shapiro and Kathleen Terry, for example, defines attention in terms of limits: "[A]ttention is a highly functional property of the brain, whereby limited cognitive resources can be directed to facilitate the processing of other information competing for the same resources."[12] If attention is a selective activity, this means that it selects. In other words, as Harold Pashler maintains, "the mind is continually assigning priority for some sensory information over others."[13] For cognitive science, the attentive subject cannot select anything at anytime; he or she cannot be attentive to multiple complex stimuli at the same time, and, more importantly, his or her activity of detection elaborates itself to the detriment of other detections, which cannot occur simultaneously.[14] In its study of perceptual inhibitory processes, cognitive science speaks notably of "inattentional blindness" and "inattentional amnesia" to refer to the failure to perceive or memorize in conditions of inattention, including "attentional blink," which is a deficit of divided attention occurring when two successive visual targets fail to be detected together when they are separated by less than 500 milliseconds, and another inhibitory phenomenon called "repetition blindness," which refers to the failure to report the features of two visual stimuli when they are identical and when the delay between the two presentations is too brief.[15]

Because of its extreme slow motion and suspension of sound, *24 Hour Psycho* propels the spectator into the zones of perceptual and memory insufficiency recently theorized by cognitive science, zones in which amnesia, blindness, and blinks set in, to the detriment of selection and detection. The viewer may well anticipate what is coming, but what comes is slow to appear, submitted to delay, and too extended to allow memory to match the images or the beholder to grasp the narrative. The beholder is created as depressed. Inhibition is part of the perceptual activity. Yet, if the installation shares with cognitive science a preoccupation for the limits of perception, it discloses, supports, activates, and reinforces a disengagement that cognitive science seeks to quantify and control, a quantification manifest in the cognitivist reiterated attempt to identify the spatiotemporal thresholds beyond or below which attention, perception, or memory is inoperative, and to distinguish the processes that come into play in perception (such as retina stimulation, attention, short-term memory, short-term conceptual memory, and long-term memory). Although failure is acknowledged to be part of perception and memory, dominant cognitive science measures failure so as to ultimately disavow it by using the data for the study of optimal perception. By critical contrast, I contend that *24 Hour Psycho* gives deficit a productive value.

But why? And how is deficit critical? To answer these questions, it is imperative to consider what is being brought into deficiency. First and foremost, *24 Hour Psycho* blurs a film known and appreciated for its psychoanalytical deployment of the oedipal scenario, initially theorized by Freud so as to counter its historical decline.[16] Hitchcock's films con-

tinuously stage the problems of that decline, which corresponds to the weakening of paternal symbolic authority. Oedipal decline underlined Freud's attempt to reinstate a Law of the Father, a law that intervenes, as Slavoj Žižek explains, "to prevent direct contact with the incestuous object" and thus to support the subject as a being of lack, living in the gap between the big Other and *jouissance,* with the impossibility of synchronizing the two.[17] In Hitchcock's *Psycho,* not only is the father absent but his function of authority is replaced by the maternal superego that Norman Bates (played by Anthony Perkins) wants to be. If the suspension of the paternal prohibitory figure haunts Hitchcock's entire production, in *Psycho* the shaking of the American family has reached a problematic stage. Indeed, the film delineates a psychosis related to the loss of paternal authority—a failed symbolization by which a son is unable to maintain a distance from the symbolic order because he unconsciously refuses to follow the symbolic prohibition against the imaginary real.[18] Norman doesn't act like the mother; he wants to, and will in the end, become the mother. As film historian Linda Williams has pointed out, even the construct of gender is represented by Hitchcock as an unstable affair: "[T]he combination of young male body and older female voice" creates a tension between masculinity and femininity, making *Psycho* an "important point in the pleasurable destabilizing of sexual identity in American film history."[19] This does not mean, however, that Oedipus has completely vanished. On the contrary—and I refer here to film theoretician Raymond Bellour's examination of Hitchcockian cinematography—Hitchcock's narratives are oedipal narratives that represent again and again the masculine hero's entry into the symbolic order, usually acquiring coherence in opposition to the woman's lack and fragmented body.[20] So although their decline is staged, their reenactment is also hoped for, as it is within Freud's theoretical system. Reproducing and resuscitating Hitchcock's *Psycho* for today's subject, *24 Hour Psycho* must thus be seen as deploying, in the space of the viewer, the Freudian struggle for Oedipus. But it does so through electronic manipulations—slow motion and the expansion of time—so as to propel the psychoanalytical scenario into illegibility, evanescence, disappearance. Thus, it sounds the death knell of a withering paradigm. The critical potential of the installation lies in this depressive act, for it is only through the video depression of film that both psychoanalysis and cinema may be revealed as in decline (acting out, as it were, the decline of the decline of Oedipus). The installation *24 Hour Psycho* is a memory of which the viewer loses memory as he or she fails to reconstitute the film, and it is a memory from which he or she acquires—has perhaps already acquired—an emotional distance.

The slowing down of *Psycho* is also—and here is the second characteristic that situates the criticality of deficiency—an electronic disruption of a film that Hitchcock, in an interview by François Truffaut, defined in its ability to create "mass emotion," which he described in the following terms: "My main satisfaction is that the film had an effect on the audiences, and I consider that very important. I don't care about the subject matter; I don't care about the acting; but I do care about the pieces of film and the photography and the sound track and all of the technical ingredients that made the audience scream. . . . It wasn't a message that stirred the audiences, nor was it a great performance or their

enjoyment of the novel. They were aroused by pure film."[21] Recently designated by Linda Williams as the first postmodern Hollywood cinema of attractions, *Psycho* reached the audience as no other American narrative film had done before. It created a mass emotion, marking "the important beginning of an era in which viewers began going to the movies to be thrilled and moved in very visceral ways."[22] The notion of cinema of attractions comes from Tom Gunning and his research on early cinema. It describes a type of cinema that seeks "to solicit the attention of the spectator" through exhibitionist confrontation, sensual or psychological impact, and sense of wonder—a cinema that activates "the direct stimulation of shock or surprise at the expense of unfolding a story or creating a diegetic universe."[23] "Through a variety of formal means," says Gunning, "the images of the cinema of attractions rush forward to meet their viewers. . . . The audience's sense of shock comes . . . from an unbelievable visual transformation occurring before their eyes, parallel to the greatest wonders of the magic theatre. . . . This cinema addresses and holds the spectator."[24] At the time of its release, in 1960, *Psycho* functioned as a machine whose efficiency was located in its power to create emotion, to solicit, shock, hold, and rush forward to meet the viewer. By slowing down the narrative to two images per second, by cutting the sound and extending the film to an impossible twenty-four hours, *24 Hour Psycho* blocks this efficiency of solicitation. What is being staged here is not the film per se in its absorption of the spectator into diegesis or into technically produced shock effects, but the spectator and his or her difficulty in engaging with film. The viewer is not emotionally interpellated, shocked, surprised, or attracted by the image; one cannot cling to the spectacle to constitute identity and guarantee one's subject position. Instead, the viewer is confronted with a limit, a dysfunction, a disengagement, a sense of unrealizable wholeness. Video's distancing of filmic attraction both stages and amplifies the vicissitudes of perception. Visual pleasure has shifted from the act of being shocked to that of slowing down. Gordon's *24 Hour Psycho* favors and incites perceptual deficit. My contention is that the productivity of the "nothing to see" lies not so much in the resurrection of this object, Hitchcock's *Psycho,* as in the perceptual impoverishment entailed by such a resurrection. Facing this depreciation, the viewer can neither take the time nor refuse the time to struggle with the object and put himself or herself into play in relation to the rescued yet ruined *Psycho.*

The institution of slow time is both endemic and crucial to depressed subjectivity. As Ehrenberg convincingly argues, depression is "a pathology of time (the depressed is without a future) and a pathology of motivation (the depressed is without energy, his movement is slowed down, his parole is slow)."[25] Fédida also describes depression as an illness in which "the times proper to psychic life—to remember, to represent to oneself, to desire, to project—seem to have been frozen in the immobility of the body."[26] The withering of psychic temporality entails that the depressed must be given the time (Fédida insists on this specific point) to recover a language of associations, emotions, communication, and recall. In other words, the freezing of time experienced by the depressed can be cured only by an allotment of time to the depressed. And yet, according to anthropologist Tanya Luhrmann, one of the main problems of managed-care psy-

chiatry is precisely the reduction of time given to the patient, not only at the moment of diagnosis but also during therapy. Doctors lack time, which means that they usually cannot and do not go through the list of diagnostic criteria in any in-depth way.[27] It has been calculated that a majority of diagnoses are now made after just three to five minutes of interview.[28] University of Kentucky medical residents are said to take thirty seconds to establish a diagnosis, bringing Luhrmann to conclude that, for young psychiatrists, "diagnosis is more like recognizing chairs and tables than it is like pulling out a manual and carefully double-checking the printed criteria."[29] Furthermore, despite the speedy identification, the precocious diagnosis will stay the same at the end of the interview in most cases. Clinicians also remain vague or make errors when asked about the reasons for their diagnosis. Usually, clinical observation—the collecting of pathological signs—is not finished, yet the diagnosis is already made. Moreover, socioeconomic forces make it much less costly and far less complex (for the hospital unit and insurance companies) to prescribe medication and send the mentally ill patient back home than to meet and listen to him or her on a weekly basis for an extended period of time.[30]

It is precisely this temporal stake—the loss of time, the need for time, and the institutional depreciation of time—that is being played out in *24 Hour Psycho*. Video has appropriated the pathology of the independent yet tired, responsible yet numbed viewing subject. It anticipates and creates a depressed and perceptually dysfunctional viewer, but only inasmuch as this depressing image brings the contemporary subject into the realm of slow temporality, of the nothing-to-see, of quasi-illegibility; it is a projection that incites projection. Progressively, a new film constructs itself, formed by the interaction of the video images and the spectator's mental images or imaginary productions, made of memories, reoriented expectations, daydreams, fantasies, and hallucinations, so as to fill in the blanks, as it were, and proceed with the process of narration. It is a process not of interpretation (the disappearance of that model unfolds in front of our eyes) but of temporalization and with it, potentially, mental regeneration. The image is a mechanism of potential rementalization through the appropriation of time. It explores the frame, which is clearly delineated in its suspended isolation in space, as a circumscribed space that incites imaginary projection. As Anne Friedberg has pointed out, it is through the frame (as it emerged from the perspectivist construction) that our experience is transposed into the domain of representation; it is through the frame (as structuralist theoreticians of cinema such as Jean-Louis Baudry and Christian Metz have observed) that the screen becomes a site of projection and fascination in which psychic space is deployed in physical space.[31]

The critical value of the installation thus lies in its devaluation of Hitchcock's cinema of attraction and related revaluation of mute and slow-motion imagery, which turn *Psycho* into a matrix of time and projection, a screen that both materializes the symptom of impoverished perception and, through this materialization, transforms the symptom into a device to—and here I appropriate the title of an exhibition organized by the Palm Beach Institute of Contemporary Art in 2000—"make time."[32] It does so within a culture that, for Douglas Gordon, has "sacrificed time in order to gain speed."[33] Perceptual deficiency

must be seen as critical insofar as it reinforces slowness, the slow passage of time, the time and distance to think, and the quasi-nothingness that counters the absence of time of current bio- and psychotherapies of depression.

As bell hooks has argued, "[A]rt is necessarily a terrain of defamiliarization; it may take what we see/know and make us look at it in a new way."[34] This heuristic of aesthetics is precisely what Gordon's *24 Hour Psycho* is about. The installation privileges not so much the what of looking as the how and even the whether of looking in new ways. In his *Performing Live: Aesthetic Alternatives for the Ends of Art* (2000), Richard Shusterman has argued that, in light of Anglo-American philosophy's gradual dismissal of the aesthetic experience (as articulated in the work of John Dewey, Monroe Beardsley, Hans-Georg Gadamer, Nelson Goodman, and Arthur Danto), the task of revaluing the sensory and affective dimensions of aesthetics has become primordial. The dismissal of aesthetics has been elaborated on the grounds that it assumes that the work of art can be immediately experienced in all its fullness. In opposition to the illusionistic access to pure presence, Gadamer, for example, insists on the imperative to consider the experience of art as an act of understanding, one that is achieved through the interpretative activity of the viewer. According to this hermeneutical approach, notes Shusterman, "aesthetic experience requires more than mere phenomenological immediacy to achieve its full meaning, . . . so interpretation is generally needed to enhance our experience. Moreover, prior assumptions and habits of perception . . . are necessary for the shaping of appropriate responses that are experienced as immediate."[35] The same logic of radical "anestheticization of aesthetics" is at play in the work of Arthur Danto and Nelson Goodman, in which sensorial experience is subsumed by semantic theories of artistic symbolization and interpretation.[36] Opposed to the growing "hermeneuticization" of the art experience, which cannot accept any mode of understanding other than the one provided by linguistic interpretation (defined as the "uncovering of hidden meanings" that will disclose the work "as a well-related whole"), Shusterman affirms, "Our age is even more hermeneutic than it is postmodern, and the only meaningful question to be raised at this stage is whether there is ever a time when we refrain from interpreting":[37]

> It is simply a mistake to think all interpretation is governed by the depth metaphor of uncovering hidden layers or kernels of meaning. Interpretation is also practiced and theorized in terms of formal structure with the aim not so much of exposing hidden meanings but of connecting unconcealed features and surfaces so as to see and present the work as a well-related whole. . . . What I wish to contest is the view that, logically and necessarily, we are always interpreting whenever we meaningfully experience or understand anything, the view expressed in Gadamer's dictum that "all understanding is interpretation."[38]

Shusterman has been a key figure in the disclosure of art history's and philosophy's reliance on interpretative models that reject the sensorial experience of the artwork, on the basis that interpretation is what allows the viewer to select, structure, and produce a text on what he or she experiences—a definition that refutes prereflexive and nonlinguistic

understandings of art. The problematic consequences of this tradition are double: it de-values sensory-aesthetic appreciation *(aisthesis)* and undermines popular art as providing gratifications, sensations, and experiences that are spurious, fraudulent, ephemeral, entertaining, even passively consumerist (that is, not genuine).[39] In its valorization of slow time, illegibility, and the projective screen, Douglas Gordon's *24 Hour Psycho* reinstitutes the productivity of sensation, together with prereflexive and nonlinguistic understandings of the image. It moves away from the visual experience of psychoanalytical or hermeneutical interpretation. The incitement here is not really to decipher what is "behind" the symptom but to use the image as a time screen through which the viewer can experience the vicissitudes of perception and memory so as to reinvigorate them from within their impoverishment.

The Symptom Debate

In her study on the historical development of melancholia, Jennifer Radden notes that the passage from melancholia to depression was concomitant with the shift from the understanding of the melancholy symptom as felt experience to the depressive symptom as observable sign. Whereas melancholia was understood as a set of symptoms corresponding to the patient's description of inner states, depression is a disease whose symptoms consist of outwardly observable features of behavior or bodily condition.[40] Melancholia was a subjective mood, understood as such in a period when psychiatric and philosophical interpretations emphasized the experience, agency, and unconscious of the mentally ill. In contrast, depression, a pathology of lethargy, is detected through the recording of a series of biobehavioral signs, including insomnia and weight loss, fatigue, and psychomotor retardation or agitation. In their comparative study of psychodynamics and *DSM* psychiatry, psychiatrists Jacques Gasser and Michael Stigler have established that the psychodynamic approach is based on a conception of the symptom as having an inexplicit (adaptive, communicative) meaning and a susceptibility to mutation and transformation. Priority is thus given not so much to the form as to the life of the symptom. This view contrasts sharply with the *DSM* diagnostic perspective, wherein the meaning of the symptom corresponds to the "outcome of a provable pathogenic chain."[41] In his own comparative examination of the differences between anthropology's and psychiatry's approaches to the symptom, social anthropologist Angel Martinez-Hernaez specifies that the former understands the symptom as a meaningful reality, whereas the latter reduces it to an organic dysfunction or abnormality.[42] In the *DSM* paradigm, writes Martinez-Hernaez, "symptoms are objectified as if they were physical signs that bespeak a natural, universal and abiographical reality." The content of symptoms ceases to relate to the patient's experience, instead becoming dependent on the professional's eye. In this process, the patient is relegated to a state of muteness:

> As in Kraepelin's project, the emphasis is on diseases and not on patients, reinforcing the idea that an individual "suffers from a disorder" rather than "is disturbed." The cataloguing of the disorders inhabiting the patient's body ("major depression,"

"alcohol abuse," "dependent personality disorder") reasserts the model of "suffering from," and weakens the links between the disease and the patient's "being." *The patient is thus converted into a mute space in which different pathological species coincide.* It is of little importance that an appendix included in DSM-IV provides a glossary of culture-bound syndromes and appears to stress the importance of cultural and social factors in the etiology, course and outcome of mental disorders. *The patients' voices have no place in the multiaxial system of neo-Kraepelinism.* This naturalist approach denies us access to large or small worlds of meaning, to the cultural categories and political-economic relations that a complaint may contain. Like Kraepelin's taxonomies, the new DSMs disregard the possible understanding of the patient's narrative in favor of a botany of mental illnesses.[43]

Perceived and converted by the contemporary observer (and not the patient) into a universal and observable sign, the symptom is diagnosed without any consideration of what medical anthropologist Arthur Kleinman designates the "meaning of the observations in a given social system." In other words, the diagnostic perspective fails to acknowledge that, in the context of psychiatry's current inability to identify the pathophysiological basis of mental illnesses such as depression, "observation is inseparable from interpretation."[44] Advocating the need to both listen to the illness narratives of the patient and to interpret them in accordance with the patient's social and cultural environment, Kleinman argues that symptoms should be perceived not as static things but as dynamic feedback processes involving both the patient's interpretation of self and observer, and the observer's interpretation of self and patient.[45]

The controversies about the *DSM* approach to mental illness reveal the important cleavage that separates psychodynamic and diagnostic understandings of the symptom, one that opposes interpretation to observation, hermeneutics to logical empiricism, time as psychic dynamism to the temporality of the moment, and active patient (capable of introspective and associative description) to passive body (enabling factual symptomatic description). As my critique of the diagnostic model makes clear, anthropologists and historians of science emphasize the need to reintroduce a psychodynamic model in which symptoms arise "from a complicated interplay between unconscious dynamics and processes of repression" and whose meaning is revealed only after sufferers engage "in intensive and extensive explorations of their most intimate thoughts and feelings with therapists in an effort to understand how their symptoms stemmed from their personal histories."[46] And yet, as I have noted earlier, psychoanalysis has been significantly marginalized in recent decades. Psychoanalytically derived therapies understand symptom formation, personality development, and psychological vulnerability as shaped by conflicts occurring in early childhood and during the life cycle of the individual. These underlying conflicts predominantly concern guilt, repressed or unacceptable desires or impulses, problems in child-parent relationships, and related problems of self-esteem, psychological cohesiveness, and emotional self-regulation.[47] Such aspects do not significantly come into play in depression, where guilt has been somewhat subsumed by

frustration, and conflict by cleavage. Although the efficacy or inefficacy of psycho-dynamic therapy has not been demonstrated (that is, has not been adequately studied in controlled trials), recent studies have tended to show its lack of effectiveness. Results from two meta-analyses suggest that, for the treatment of major depressive disorder, brief psychodynamic psychotherapy is "more effective than a waiting list control condition but probably less effective than other forms of psychotherapy."[48] These findings are limited; psychodynamic results are not easily quantifiable compared to cognitive therapy and interpersonal therapy, and Mitchell Wilson's examination of the transformations of American psychiatry has shown that the institution of the *DSM–III* and the concomitant overriding of the psychoanalytical paradigm did not occur because the categorical method was proved to be better than the dimensional approach.[49] Nevertheless, the findings corroborate the growing awareness in psychoanalysis that depression may not be related to repressed desire and underlying conflictual structures. In this regard, it is significant that when psychoanalysis does associate depression with conflicts, these conflicts are related not so much to loss, guilt, or self-reproach as to the need to protect oneself against loss (as per Triandafillidis and Fédida). From a more sociological perspective, it is also important to raise the fact that, in the mid-twentieth century, the psychoanalytical view of the individual as a being in constant conflict with prevalent social and cultural demands brought a special category of people—highly educated, wealthy, and predominantly white artists, writers, and intellectuals, and a significant proportion of the Jewish population—into psychoanalysis, people, as Allan Horwitz has pointed out, who "rejected conventional morality, especially conventional sexual morality, . . . [and] traditional cultural systems of belief and behavior," and who were attempting "to overcome a repressive society that stymied genuine expression of basic instincts, with rebellion against mainstream society."[50] As these individuals became more integrated, the notion of conflictual subjectivity correlatively became less relevant.

The marginalization of the psychoanalytical model, together with the acknowledgment of the inherence of depressiveness to contemporary subjectivity, raises the larger issue of art history, more specifically the imperative to question art history's indebtedness to psychoanalysis. At least for the last thirty years, since the emergence of what has been called New Art History—a discipline that has learned to widen its definition of art and to expand its interdisciplinary borrowings in its approach to art[51]—art history has been systematically drawing from psychoanalysis to attend to the neurotic dimensions of the subject and examine how they come into play in the constructs of subjectivity that art sets about. But, for reasons indicated earlier, this methodological reliance seems to be less and less convincing in the analysis of contemporary cultures. The major challenge in matters of depression is to devise approaches that are attentive to aesthetics as a possible source of regeneration of perception and memory acuity. If, as Fédida maintains, the medicalization of depression as a disease rests on a summary semiology of symptoms that are approached as "signals" so that they may then be constituted as "targets" for pharmaceutical interventions (which means that the purpose of symptoms is reduced to "the identification of a pathological alteration"[52]), then it is crucial to reinstitute the symptom

as a plastic state, a process, a potential site of deformation and alterity. Following a perspective in which not only bodies but also images function as symptoms (for Rondinone's and Post's screens do just that when they materialize in the electronic thickness of the image the depressive symptom of conservation of the living under its inanimate form), I argue that Gordon's installation—as well as Rosemarie Trockel's triptych, which I will examine presently—does endow the image with a plasticity, a de-formative and defamiliarizing process that turns the symptom not only into the manifestation of a disorder but, more importantly, into a screen that enacts the depressed's need for time. It provides time for the rementalization of a depressed viewer. The work of art historian Georges Didi-Huberman is significant in this regard, for it approaches the symptom not as a visible reality or as a mere representation—the site of form and *istoria* that can be seen, read, named, and known—but as an action analogous to dream's or hysteria's deformation of resemblance.[53] Like a dream, which occurs through operations of displacement (the figuring of something by the figuration of something else) and condensation (the conglomeration of different realities into a single unit), the symptom is what brings the artwork into the realm of nonknowledge and enigma, and what removes the viewer from his or her central position as a person of knowledge. Symptoms are intrusions, disparities, local catastrophes, and crisis events that look back at the viewer to reveal his or her own insufficiency and constitutive fallibility:

> A sovereign accident . . . is called, strictly speaking, a *symptom*: a word to be understood following all the semiotic extension and rigor provided by Freud. A symptom . . . will be for example the moment, the unpredictable and immediate *passage* of a body to the aberration of a crisis, of a hysterical convulsion, of an extravagance of all movement and attitude: sudden gestures have lost their "representationality," their code; members contort and tangle; the face exasperates and deforms itself; release and contraction absolutely mix; no "message," no "communication" can continue to emanate from such a body; in short, this body *does not resemble itself anymore*, or does not resemble anymore.[54]

Although Didi-Huberman's conception of the symptom relies on a psychoanalytical understanding of the gaze and dream processes, his understanding has the merit of setting up the image as a site that shatters both the visible (the order of represented aspects) and the legible (the order of the mechanisms of signification).[55] The symptom worries (critiques) the image from the inside. In so doing, it modifies the position of the subject of knowledge by introducing the "risk of non-knowledge."[56] This phenomenology of the visible conceives the image as a dream only inasmuch as it builds itself through a logic of rupture, contact, infection, collision, and deformation of different images—a logic that challenges, in short, the notion of resemblance. For Didi-Huberman, the image as dream solicits the viewer to interpret. I would like to see how it can operate merely as a matrix—a screen that makes time—to open up the possibility of dream or projection. Gordon's *24 Hour Psycho* does exactly that: it explores the image as a symptom, introducing perceptual and mnemonic dysfunctions into the retransmission of *Psycho*, so as to

put resemblance into crisis. His is an aesthetics of deformation and disfiguration of filmic representation, but it incites the viewer not so much to interpret the image, to reveal the hidden meaning behind the signs or to "hermeneuticize" the symptom, as to receive the image as a screen whose only purpose is to allot time to a depressed viewer so that he or she may regain mental acuity. Following psychiatrist Serge Tisseron's expression, the image is "liberated from meaning."[57] Not that meaning cannot and will not emerge; rather, meaning ceases to be intrinsic to the image, becoming increasingly extrinsic. It is more pragmatic than interpretative. Its effect is more important than its content.

Distracted Attention

If indeed the contemporary depressed subject is perceptually impoverished, as the work of Rondinone, Post, and Gordon discloses, it is imperative to raise the question of productivity-within-insufficiency. Can there be a productive look within depressed subjectivity, within the aesthetics of depression? If in the affirmative, what could this look be? It is these questions that inhabit a triptych installation of German artist Rosemarie Trockel (b. 1952) produced for the 1999 Venice Biennial, an installation composed of three video projections entitled *Eye, Sleepingpill,* and *Kinderspielplatz.* The *Eye* section, which consists of a large screen projection of a human eye, proposes from the start an insufficient vision whose activity of recognition has been replaced by an activity of somnolent (drowsy, sleepy) attention. But, as I hope to show, the installation produces insufficiency, a form of weakening of perceptual sharpness, both as a loss and as a state that might engender new cognitive possibilities. The strength of the installation resides in the questions it constantly raises: What does it mean, today, to recognize? What does it mean to see? What happens to the subject, in terms of identity, critical understanding of the world, and empowerment, when his or her power of recognition drifts away to be replaced by an attention deprived of its functions of identification and differentiation? I suggest that Trockel's installation was produced as an attempt to understand cultural modalities of contemporary vision. It is one of the key artworks at the turn of the twenty-first century to address the imperative to rethink visual perception (both its sensorimotoricity and its potential for criticality, excitability, and sensuality) in light of the social changes affecting subjectivity. Its heuristic is to think about perception in relation to the insufficiency of the contemporary subject.

Eye plays a central role in the whole display of the installation. Located between the two other components of the triptych, it welcomes the public at the entrance of the pavilion, occupying a room through which the viewer must go to pass from one projection to the other. When the viewer enters the room, he or she immediately faces the large screen projecting an eye that occupies the entire field of the image. Projected in black and white and in slow motion, larger than life-size, the eye is imposing, yet, though it actively looks, it doesn't look at the space in front of it. Made out of the gradual superimposition of seven left female eyes, it is an organ that progressively yet subtly modifies itself throughout the projection. It moves in saccades (from right to left and from left to

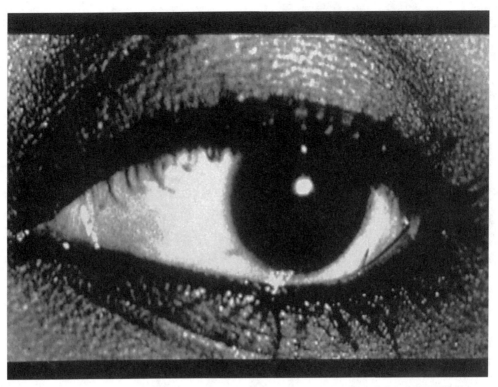

Figure 57. Rosemarie Trockel, *Eye*, 1999. Video still. Copyright Rosemarie Trockel and VG Bild-Kunst, Germany. Courtesy of Barbara Gladstone.

right) with an occasional blinking of the eyelid. Yet it fails to anchor itself into a fixed position. It is also devoid of stable identity markers, for gender, race, and agency persist in their ambiguity. This uncertainty derives from the recording modalities of image: the combined use of black and white, close-up, absence of sound, and slow motion disengages the eye from its environment, cutting off biographical, sexual, geographical, and cultural information. Although it is in fact female, its gender is never completely secured by the projection. A dark seeing organ projected in black and white in a dark room and circumscribed by an ambivalent shadow (is it natural or artificial, makeup or skin?), the eye is, moreover, ambiguous in terms of racial identity. Is the subject white or black? The installation does not answer this question.[58] Furthermore, as the emphasis is put on the continuous, reiterated motion of the eye, the actual agency of the eye is put into question. In fact, two incompatible readings of agency come about. If the viewer focuses on the ocular movements, they appear to be controlled and activated by the image technology; the eye becomes a passive mass whose motion is manipulated by different technological procedures—the slow motion, the close-up, and the framing—for the sake of scientific observation. Yet this lack of ocular agency is never confirmed, for when the viewer looks at the eye in relation to the outside, imagining the rest of the face or situating it in the room's environment, the eye gains in agency as it gains in subjectivity.

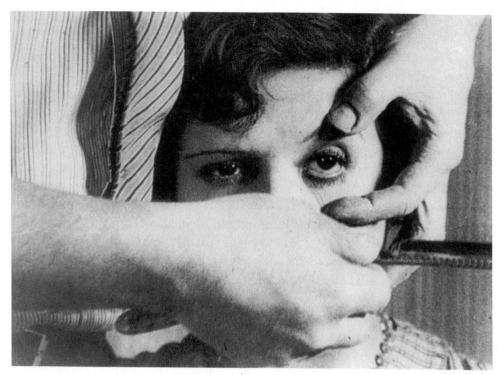

Figure 58. Luis Buñuel and Salvador Dalí, *Un chien andalou*, 1928. Black-and-white silent film, 16 minutes.

The eye's ambivalence mostly relies on its isolation in the frame, but it also arises from the technique of morphing, which blends the different eyes together as though they were one. In contrast to the montage aesthetics so characteristic of the avant-garde between the 1920s and 1950s—notably Dada, surrealist, and constructivist literature, art, and cinema—and the resurgence of deconstructivist art of the 1980s, the different silhouettes and boundaries of the eyes are erased to form a coherent whole. In this, *Eye* adopts what Lev Manovich has called the antimontage tendency of current Hollywood cinema, one in which "*the problem is no longer how to generate convincing individual images but how to blend them together.* Consequently, what is important now is what happens on the edges where different images are joined. The borders where different realities come together [are] the new arena where the Potemkins of our era try to outdo one another."[59] Whereas electronic keying and digital compositing make it possible "to join seamlessly" distinct images together, montage's critical effect lies specifically in the semantic clashing of signs (words, images, and sounds) that cannot merge into a single reality.[60] Luis Buñuel and Salvador Dalí's *Un chien andalou* (1928), for example, brings an eye and a sharp knife together into a single frame so as to prevent any form of perceptual resolution: the presence of the knife next to the eye questions the viewer's taken-for-granted reliance on vision to apprehend the world—his or her sense of mastery through the very act of looking—while also disclosing unconscious fears of castration, formlessness, and death. I suggest that

Trockel's *Eye* strategically partakes of the dissolution of this critical language in digital technology. For, as it adopts morphing's aesthetic of continuity, the video foregrounds the erasure of identity that derives from a technique whose main purpose is to smoothly blend edges and borders as though they were a unique reality.

Eye, in constant dissolution and regeneration, unable to fix itself in a single point in time or space, and endowed with ambiguous identity markers, fails to fix the spectator's own identity. It looks but does not see *me*, not enough to recognize the viewer's presence or to assess his or her selfhood in unitary and exclusive terms: disengaged, it sees without seeing something or someone, unable to confirm and indifferent to the presence of the spectator in front of the image. This could also be said of the viewer, who sees the eye yet cannot conclude on its identity. The recognition of the self through the other is not operative. Identification is faltering, valorizing insufficient identities. Such a display confirms Ehrenberg's conclusion that the contemporary subject is dominated by a feeling of insufficiency, one that expresses itself not in terms of duty ("what do I have to do?") but in terms of capacity ("am I able to do it?"). In a society founded on individualistic independence and self-realization, the self is always on the threshold of being inadequately itself, leading to chronic problems of identity insecurity and the substantial increase of diagnosed cases of depression in the last thirty years. Trockel's installation should be read as a staging of contemporary insufficiency. But, as the following sections will demonstrate, it explores this inadequacy so as to turn it into a radical renewal of perception. In this process, depressive symptoms (notably the difficulty in falling or staying asleep, too much sleep, or the lack of sleep) are significantly valued and attended to.

Absorption

One of *Eye*'s most noticeable characteristics is its monocularity. The projection inscribes *in* the image the viewpoint inherited from the Renaissance system of perspective. When the viewer faces the image, not only is he or she not recognized as a self, but also he or she sees the viewpoint as a vanishing point. *Eye* both signals the persistency of the tradition of perspective and shows us that once the viewpoint is absorbed, the viewer anticipates and waits for a recognition that simply cannot occur. To better evaluate the meaning of such a deceived anticipation—what it says about contemporary vision and how it may underlie new models of vision—it is useful to briefly specify the perspective tradition through which this deception articulates itself.

I refer here to the studies of Hubert Damish, Martin Jay, and Norman Bryson on the positioning of the viewer in the system of linear perspective as it was theorized in Leon Battista Alberti's treatise *De pictura* (1435) and subsequently in the writings of Piero della Francesca, Uccello, Dürer, Bosse, and others. In this tradition, a painting is defined as a specular surface relating two symmetrical visual pyramids: one developing from the picture plane into the painting, with its apex corresponding to the vanishing point; and the other emerging from the picture plane outside the painting, with its apex corresponding to the viewpoint, a position that the viewer's eye must occupy if he or she is to

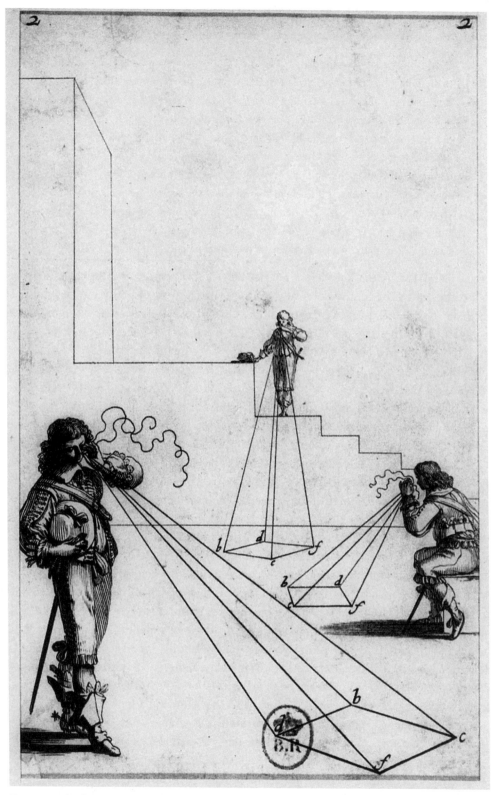

Figure 59. Abraham Bosse, *Les perspecteurs*, print from *Maniere universelle de M. Desargues pour traiter la perspective*, 1648. Bibliothèque Nationale de France.

see the scene as the painter initially saw it. Intellectual historian Martin Jay summarizes quite well the disembodied, centered, and distanced nature of such a construction:

> If the beholder was now the privileged center of perspectival vision, it is important to underline that his *viewpoint* was just that: a monocular, unblinking fixed eye (or more precisely, abstract point) rather than the two active, stereoscopic eyes of embodied actual vision, which give us the experience of depth perception. This assumption led to a visual practice in which living bodies of both the painter and the viewer were bracketed, at least tendentially, in favor of an eternalized eye above temporal duration. . . . No longer did the painter seem as emotionally involved with the space he depicted; no longer was the beholder absorbed in the canvas. The reduction of vision to the Medusan gaze (or often the male gaze contemplating the female nude) and the loss of its potential for movement in the temporal glance was now ratified, at least according to the logic—if not always the actual practice—of perspectival art.[61]

Even if we accept that the viewer, in an Albertian formulation, is recognized in his or her corporeality (the centric ray relates the eye to the vanishing point, but because it is axial, the position of the viewer is not confined to a specific point in space[62]), monocular perspective has the effect of transforming the eye into a theoretical infinitesimal point and the viewer into an object. Art theorist Norman Bryson has convincingly shown how the vanishing point is precisely a geometric point, an objectified unit, visible and measurable, a mirror of the spectator's viewpoint that allows the viewer to see himself or herself as such: "[Albertian space] solidifies a form which will provide the viewing subject with the first of its 'objective' identities."[63] In the sixteenth and seventeenth centuries, proto-Cartesian and Cartesian pictorial systems, which adopted the camera obscura as a theoretical model of vision, increasingly reduced the viewer to a transcending viewpoint that denies both the sensorial dimension of vision and the subject's mobility in space.

In Trockel's installation, the monocular viewpoint adopted by the viewing subject of the perspectival system is now on the other side of the mirror: it is now *in* the tableau. With this reversal, the film projection merges the viewpoint and the vanishing point. No longer is the viewing subject bracketed "in favor of an eternalized eye above temporal duration." On the contrary, it has been absorbed within the screen. But if this is so, it is under the action of technology: it is the camera that ingests and reingests the viewer it seeks to preserve. The camera has been endowed with a subjectivity that supports a phantasm of absorption, of losing one's sense of self—one's identity—by technological ingestion. The distancing effect of perspective has been abolished to reinstate Freud's definition of cannibalistic identification, in which the subject constitutes itself by ingesting the other whom he or she both loves and hates (this is the fundamental ambivalence of identification) so as to compensate for the other's loss.[64] So a question emerges: in a context where the viewpoint has been absorbed by the camera—a hypothesis that refers directly to the present development of immersion and surveillance technologies—and perspectival distancing has expired, how can visual perception be productive? More importantly, does Trockel's Venetian projection propose such a productivity?

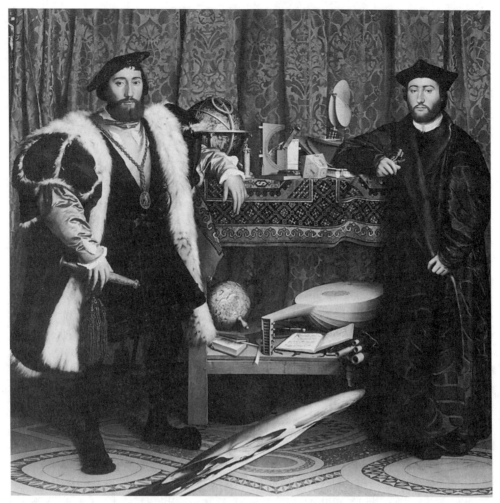

Figure 60. Hans Holbein the Younger, *Jean de Dinteville and Georges de Selve (The Ambassadors)*, 1533. Oil on wood, 207 × 209.5 cm. Copyright National Gallery, London.

In many aspects, *Eye* confirms the Lacanian definition of the gaze formulated in *The Four Fundamental Concepts of Psycho-analysis* (1964), which positions the viewing subject (Lacan speaks more specifically of the viewer looking at Holbein's *The Ambassadors* of 1533) not outside but inside the image, as though the tableau extended itself to include the spectator. In his analysis of vision, Lacan introduces a chiasma between the seeing eye and the unseeable gaze, one that has been strongly emphasized by Kaja Silverman's reading of Lacanian visuality. *The Ambassadors* represents this state obliquely, via the anamorphic representation of a skull that the two ambassadors do not see but that nevertheless abolishes their sovereignty, as it also does for the spectator. The subject sees only inasmuch as he or she is part of the spectacle of the world; he or she is constituted by the gaze, which is the manifestation of the symbolic in the field of vision.[65] "[I]n the scopic field," writes Lacan, "the gaze is outside, I am gazed upon, that is I am in the tableau. . . .

What fundamentally determines me in the visible is the gaze which is outside. It is through the gaze that I enter light, and it is from the gaze that I receive its effect."[66] The gaze (in this case the skull) is "the first and foremost point of nothingness which marks a crack in the field of reduction of the subject."[67] As Georges Didi-Huberman has superbly demonstrated, the gaze is an act of *évidement* (a voiding) that shatters the *evidence* of the visible, an impossible image that reminds the viewer of his or her mortality, of the ineluctable, albeit eventual, loss of the body: "Such would thus be the modality of the visible when its insistence becomes ineluctable: a working of the *symptom* in which what we see is supported by (and returned to) a *work of loss*. A working of the symptom which affects the visible in general and our own viewing body in particular. Ineluctable like an illness. Ineluctable like a definitive closure of our eyelids."[68]

But in Trockel's installation, does the blinking eyelid bring the viewer back to the ineluctable? Does it reinstate the Lacanian chiasma between the viewing subject and the gaze? To say it bluntly, no. And why is this? Because there is no viewing subject to gaze at or to absorb: he or she has already been absorbed, the camera has already cannibalized the viewer's eye in the image—not only the viewpoint but also, virtually speaking, the eye(s) before the film. For Lacan, the experience of the chiasma was a means to acknowledge the otherness of self and to distance the subject from primary narcissistic identification with the image, such as the one at play in the infant's attempt to achieve a coherent and unified sense of selfhood in the mirror stage. Yet, in *Eye*, because the monocular viewpoint is now in the image, the self and the other, the eye and the gaze, have collapsed into one, to affirm the sovereignty not of the human subject but of the camera. This forces us to conclude that it is technology and not the viewing subject that is now exposed to the condition of infinite desire; that subjectivity or agency is on the side of technology and not the side of the already-absorbed and self-absorbed human eye; and that the perspectival distancing between viewpoint and vanishing point has collapsed. Yet to reduce Trockel's installation to this collapse would entail a denial of other important aspects of the work that attempt to rethink the agency of the viewing subject. I argue that the Venetian installation rethinks vision from within this absorption. In so doing, it takes technological absorption not as a necessary point of arrival but as a point of departure—a factual reality from which to propose productive modes of viewing. The point of departure is the loss of distance between subjectivity and technology, the inability to focus, fatigue, and the waning of conflict. In short, it is insufficiency or . . . depression.

Absorption and Theatricality Revisited

The eye in Trockel's installation raises questions about the agency of vision precisely because of the installation's three main features; ingested by the camera, its identity is fundamentally ambiguous, and its constant saccadic motion prevents it from focusing on anything specific. The eye is absorbed, but does it see? If it sees, what is seeing without focus and attention, without an object to look at? If it sees, who sees? If someone is seeing, who is this someone? Let us not forget, furthermore, that, as a response to *Eye*'s inability to

recognize the beholder and its constant saccadic motion, the viewer is incited to leave the central projection and move on to the lateral projections of the installation. In Trockel's Venetian installation, *Eye* is framed by two other video projections, *Kinderspielplatz* and *Sleepingpill,* that together bring forward the contemporary world of distraction and release: childhood, entertainment, performance, consumerism, and noise, on the one hand; and a public sanctuary for sleepers, silence, slowness, and the physiological need to sleep and dream, on the other hand. In this, the installation articulates and rethinks one of the important dialectics of modern art, the dialectic of absorption and distraction. As I hope to show, Trockel's installation integrates this dialectic so as to posit the inseparability of absorption and distraction, and to rethink the productivity of vision by considering the deficiencies and disorders that presently shape perception. In so doing, the work provides a critical reassessment of art historian Michael Fried's theorization of this dialectic in his study of modern art.

In *Absorption and Theatricality: Painting and Beholder in the Age of Diderot* (1980), a study of eighteenth-century French painting, Fried postulates that the period opened by Jean-Baptiste-Siméon Chardin and closed more or less by Jacques-Louis David was one of pictorial absorption.[69] Absorption is about the modern subject's simultaneous ability and difficulty in cutting off his or her mind from the outside world so as to fully engage himself or herself in a specific activity. According to Fried, not only was absorption the prevailing subject matter of mid-eighteenth-century painting, but it also came to represent what was expected of the beholder. Chardin's genre paintings, notably *Un philosophe occupé de sa lecture* (Salon of 1753), *Le dessinateur* (Salon of 1759), and *The Soap Bubble* (ca. 1733); Joseph-Marie Vien's *Ermite endormi* (Salon of 1753); Jean-Baptiste Greuze's sentimental narratives; the pictorial universes of Carle and Louis-Michel Van Loo; and Jean-Honoré Fragonard—all these works propose a form of absorption that involves both conscious attention and unconsciousness. The figures are so utterly engaged in their activities that they are oblivious to "everything other than the specific objects of their absorption."[70] This explains why a critic from the *Journal encyclopédique* interpreted Greuze's *La tricoteuse endormie,* in the Salon of 1759—a girl who has just fallen asleep while knitting—as a successful representation of absorptive condition: "Elle a laissé échapper son ouvrage de sa main & il pourra tomber à terre si la jeune fille ne se réveille." It also explains why another critic celebrated Greuze's representation of a little girl leaning on and crushing flowers in *Une jeune fille qui pleure son oiseau mort* (Salon of 1765) as a successful depiction of self-abandonment "nearly to the point of extinction of consciousness."[71] Fried's major insight lies in his postulation that the Enlightenment produced a form of absorption that is inseparable from distraction: in all the works he describes, with the exception of Chardin's, painting struggles to render absorption. Fried observes that with Greuze, "extraordinary measures" such as sentimentalism, moralism, invention of narrative-dramatic structures, even exploitation of sexuality were required "in order to persuade contemporary audiences of the absorption of a figure or group of figures in the world of the painting, and that consequently the everyday as such was in an important sense lost to pictorial representation around that time."[72]

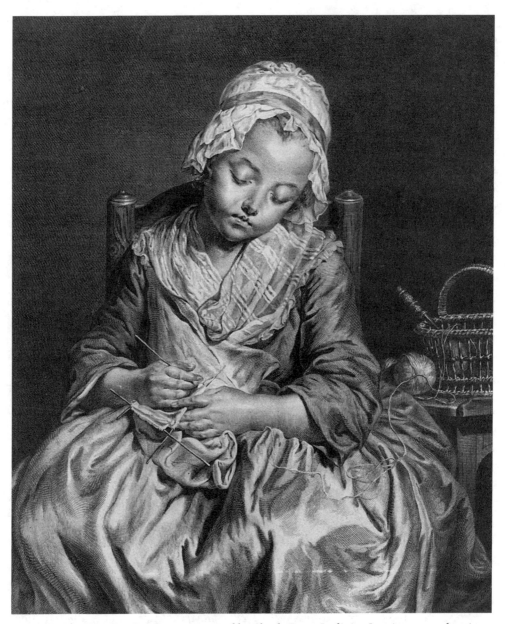

Figure 61. After Jean-Baptiste Greuze, engraved by Claude Donat Jardinier, *La tricoteuse endormie*, 1759. Bibliothèque Nationale de France.

Fried does not engage the social, cultural, and economic factors that intensified the growth of distraction—such as the development of modern capitalism, the beginnings of urbanization, the rise of the bourgeoisie, the development of consumerism, the gradual affirmation of women's rights and consequential modification of definitions of gender and sexuality, the burgeoning of mass-attended cultural events—yet he does point out how persuasion of absorption led to the paradoxical need to emphasize the closure of painting

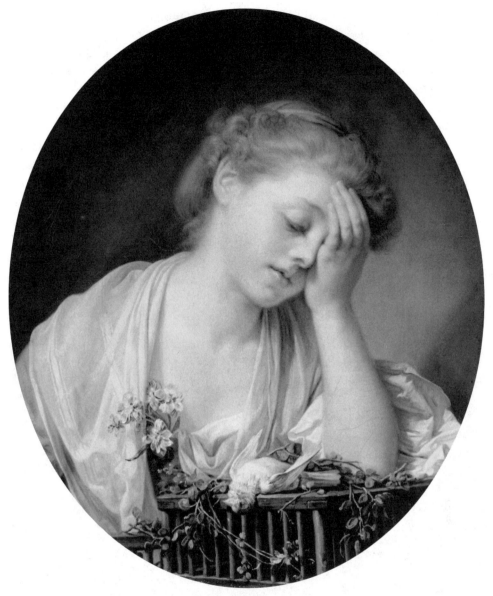

Figure 62. Jean-Baptiste Greuze, *Une jeune fille qui pleure son oiseau mort,* Salon of 1765. Oil on canvas, 52 × 45.6 cm. National Gallery of Scotland, Edinburgh.

vis-à-vis the beholder. The increased need to persuade, a need made manifest not only in Greuze's exploitation of sentimental, sexualized, or moralistic dramatic structures but also in the critical revalorization of history painting and its representation of significant action and strong passions, was a need to persuade the beholder to engage (as the figures in the paintings were doing) in absorptive activities. Yet this persuasion meant that the presence of the beholder was not simply ignored but obliterated by the painting. The successful rendering of absorption *in* the painting functioned as a mirror of the absorptive

state of the beholder *before* the finished work. Through this process, eighteenth-century painting produced a new object—the tableau—and a new beholder—a new subject "whose innermost nature would consist precisely in the conviction of his absence from the scene of representation."[73] *Absorption and Theatricality* is a description of the beginnings of the modernist closure of art into its own world. Suffice it to say that Fried sees the tableau as a means to "*de-theatricalize beholding* and so to make it once again a mode of access to truth and conviction."[74] In other words, Fried supports an extremely narrow view of art: any artwork that fails to support the modernist project of self-referentiality fails *tout court*. And yet absorption is *the* operation at play in Trockel's Venetian installation. The *Eye* projection is absorptive not in the sense that it is self-referential (the images, on the contrary, lead the viewer toward the two lateral projections) but in that it institutes a viewer "whose innermost nature would consist precisely in the conviction of his absence from the scene of representation."[75] In contrast to early modern art, the agent of absorption is the camera, not the human subject in or before the painting. *Eye* is absorptive in the sense that the camera has absorbed the subject's eye and that this absorption produces and is made possible by a distracted, depressed eye that has lost its ability to focus, to identify, and to recognize. The situation brings forward this impossible ques-

Figure 63. Rosemarie Trockel, *Kinderspielplatz*, 1999. Video still. Copyright Rosemarie Trockel and VG Bild-Kunst, Germany. Courtesy of Barbara Gladstone.

tion: how does one see—even more so, how can one see oneself—if one cannot perceive? The Venetian installation as a whole is an attempt to address this question.

The two lateral projections contextualize *Eye*; they also set into play the dialectic of absorption and distraction that structures the whole. *Kinderspielplatz* is a slow-motion video projection of a public playground filmed between sunrise and sunset. It stages go-kart-riding for children as the central activity around which other leisure activities unfold. In this delimited space, which should be seen as a microrepresentation of society as a society of entertainment, children and adults play yet at the same time learn the social rules of coexistence between self and others. Actors include joggers, walkers, picnickers, demonstrators, lovers, photographers, passersby with cellular phones, and a multiplicity of different players, including children riding go-karts, skateboarders, Rollerbladers, Ping-Pong and ball players, jugglers, and a guitar player. The sound track plays a major role in this representation of the world-as-playground. Recording has been orchestrated so as to intensify specific sounds, such as the sweeping of the ground, the steps of a group of children, the rolling of a skateboard, and the music of the guitar player, which multiply throughout the day, dying out only toward sunset. This multiplicity

Figure 64. Rosemarie Trockel, *Kinderspielplatz*, 1999. Video still. Copyright Rosemarie Trockel and VG Bild-Kunst, Germany. Courtesy of Barbara Gladstone.

of sound becomes gradually a form of aggression, of pollution, as the sounds intensify and diversify into a cacophony unnoticed by the players yet increasingly perceptible by the observer. The coexistence of heterogeneous sounds—steps, skateboards, church bells, tape-recorded pop music, the click of a photo camera, horns, guitar playing, the barking of a dog, the movement of the go-karts, voices—defines community life as a matter of entertainment and sound pollution. It also manifests the fact that leisure is about work. *Kinderspielplatz* enacts economist Charles Goldfinger's insight that Western contemporary societies are increasingly defining themselves through the growing dissolution of the division between work and nonwork, as they adopt entrepreneurial norms of autonomy, performance, flexibility, responsibility, and initiative.[76]

As a dialectic counterpart, *Sleepingpill* is concerned with the clinical observation of a transportable public dormitory filled with mattresses spread out on the floor and large plastic bags used to suspend sleepers from the ceiling in a vertical position. Filmed in slow motion and supported by a sound track that filters the local sounds into background noise, *Sleepingpill* represents the gestures and activities of the subjects in a temporality and sonority of slowness and remoteness that together emphasize the state of sleep and

Figure 65. Rosemarie Trockel, *Sleepingpill,* 1999. Video still. Copyright Rosemarie Trockel and VG Bild-Kunst, Germany. Courtesy of Barbara Gladstone.

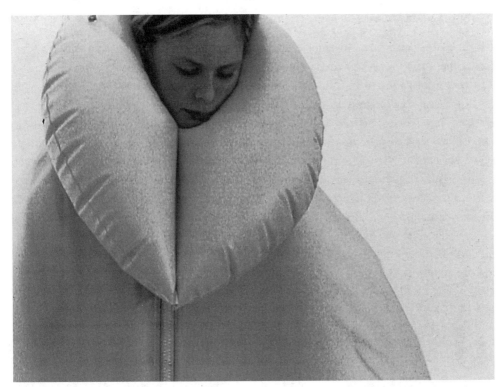

Figure 66. Rosemarie Trockel, *Sleepingpill,* 1999. Video still. Copyright Rosemarie Trockel and VG Bild-Kunst, Germany. Courtesy of Barbara Gladstone.

drowsiness. Some individuals are sleeping; others (a female cyclist, three young men, an elderly woman with a young girl) gradually enter the room. The shelter allows the co-existence of action and sleep. Shadows of men and women are regularly projected on the walls of the dormitory, indicating that this is a public sanctuary located in a public space, a shelter for passersby in need of sleep.

The distraction that Fried is so pressed to relegate outside the viewing experience of the painting (in contrast to the inside of the work ensured by an absorption that obliterates the presence of the beholder) is now on the fringes of the absorbed and absorbing *Eye,* contextualizing the eye but also attempting to care for it and to reempower it differently. This means that distraction, what Fried has also designated as theatricality (art's reliance on the beholder's experience), has become a condition of possibility of art. Indeed, if the viewer is absorbed, unrecognized, and unable to focus, art's answer to distraction cannot be self-referentiality. The challenge is not how to persuade the viewer to engage in absorption but how to make seeing possible. Fried's modernist beholder is stillborn—attracted yet ignored, absorbed yet denied, recognized yet unrecognized. Trockel stages this disengagement—rescues it, as it were—to think about the conditions of possibility of contemporary vision.

The Sheltering Effect of Distance

For the 1997 documenta, Rosemarie Trockel produced a "live" installation with Carsten Höller that announces the Venetian intervention in many ways and helps one understand Trockel's valorization of a vision that could bypass the act of recognition. In *A House for Pigs and People* (1997), human visitors and real-life animals were invited to share a space but were nevertheless separated by a thick one-way glass that allowed human observation only. Because of the one-way transparency of the partition, the pigs could not see, smell, or hear the visitors, and the viewers could contemplate but could not touch or act upon the pigs. The house was therefore—and I believe this to be one of the important features of the work—both a prison (the pigs were captive animals already fed and raised for market purposes) and a shelter. For the duration of the exhibition at least, the pigs were protected from the humans they couldn't perceive and from their own destiny as processed meat for human consumption. The shelter effect is crucial for understanding the Venetian installation, whose *Sleepingpill* is also a shelter project, in this case a shelter for passersby in need of sleep. In both cases, sheltering is made possible by a display that blocks off intersubjectivity. As Richard Shusterman rightly observes, *A House for Pigs and People* prevented any "communicative meeting of the eyes," and "identification" was constantly "frustrated."[77] This privileging of distance became explicit in Trockel and Höller's statement about the work, which insisted on the value of looking at the animals from the other side of the one-way looking glass: "Watching pigs alive must remind the gaze that it is always life which is at stake. That one should look at a distance. With caution. With respect. And with the thoughtfulness which might create room for one's own survival. In all its vulnerability."[78] The positioning of the spectators as distanced viewers observing from the outside is seen as a prerogative for the preservation of animals.

Two years later, in her triptych for the German pavilion of the Venice Biennial, Trockel proposed a shelter for humans made fragile. To do so, she favored the act of observation and discouraged the "communicative meeting of the eyes." Indeed, the disengaged eye of *Eye* sees (scans, blinks), but it does not look out. Reciprocity (as has been the case with all of the artworks we have thus far examined) is denied. The viewer might search for recognition, but the mutable, ambiguous, and unfocused eye will not confirm the spectator's body. The display articulates a major break with the intersubjectivity that art historian Amelia Jones has convincingly identified as being the main characteristic of body art. Adopting Merleau-Ponty's conception of the self/other as embodied, reciprocal, and contingent, Jones has shown how body artists of the 1960s and 1970s established a relationship between the self and the other as enabling "the circulation of desire among subjects of making and viewing," which marks "the contingency of . . . meanings and values on the interpretive relation."[79] This intersubjectivity entailed the acknowledgment that one is never fully present to oneself; one always needs the other to form one's subjectivity. It also articulated a relationship of mutual recognition and interdependency between the artist and the viewer. In contrast to body art's search for intercorporeality, Trockel's installation encourages the more distancing act of observation, not only in *Eye*

(which prevents empathy and exchange) but also in the two other film projections of the installation. *Sleepingpill* shows a public shelter for sleepers, yet this place is, paradoxically, completely lit. The high intensity of the light transforms the sanctuary into a clinic for the quasi-scientific observation of sleeping activities. If the lighting display must be understood as emphasizing the surveillance function of contemporary technology, it nevertheless cannot be reduced to this operation alone. Trockel paradoxically uses surveillance technology (film, video, one-way glass) to provide shelter for the vulnerable, a sheltering effect made possible by the distance that surveillance or scientific observation institutes between the viewer and the object. On the opposite side of the installation, *Kinderspielplatz* concentrates on the daily activities occurring in a public playground. Again the spectator is looking not just at a representation but at a space under observation as he or she hears the voice of the cameraperson filming the scene and witnesses the focusing process that occurs throughout the projection to mark the different sequences of the film. This is the laboratory aspect of the installation.

The positioning of the viewer as an observer has to be understood in the context of Trockel's reiterated preoccupation with the reality of the *pattern*, an interest manifested literally in her industrially produced "knitting pictures," made out of repetitions of

Figure 67. Rosemarie Trockel, *Napoli*, 1994. Video still. Copyright Rosemarie Trockel and VG Bild-Kunst, Germany. Courtesy of Barbara Gladstone.

singular commercial motifs that create overall two-dimensional patterns of logos (such as the Woolmark, the hammer and sickle, the swastika, the sailboat and castle, and the Playboy bunny). Yet, for Trockel, a pattern is not just a logo or an industrial textile motif; it is, more generally speaking, as she states in a 1987 interview with Jutta Koether, a "model to be copied"—a prototype, a stereotype, a norm, a behavioral pattern.[80] This understanding is at its most explicit in *Napoli* (1994), a videotape of hundreds of birds flying in the sky as a group, forming a structure maintained by the self-positioning of each bird. Each bird's behavior is a pattern followed for the sake of the orderly functioning of the collective. The pattern, more precisely, corresponds—and I am adopting here Judith Butler's performative conception of subjectivity—to the set of norms that a subject must copy, imitate, and repeat so as to constitute himself or herself as a social subject.[81] Trockel's work is a sociological attempt to observe social agents and the patterns they must follow to inscribe themselves in society. Yet this observation is a simultaneous look from the outside and through technology, a distancing to protect the observed from observation and a desire to transform patterns into subversive strategies.

So how can the eye in Trockel's installation be productive if it can't assert and secure the viewer's identity, if it cannot focus and see something or someone? Is this vision deficient, completely submitted to the gaze? The saccadic movements of *Eye*; the inability of the image to fulfill its identity function in terms of fixation, coherence, and unification; the viewer's inability to find self-recognition through the image; the filmed public dormitory of *Sleepingpill*; the sequences of *Kinderspielplatz* representing children riding go-karts in an amusement park full of people and noise—the whole of the installation deals with the dialectic of absorption and distraction. By imagining a shelter where passersby may stop and rest for a while at any time of the day—a prototype that could be installed anywhere within the city—Trockel's installation thinks vision and identity in relationship to the growing field of investigation in cognitive science and neurobiology dedicated to the study of attentional and sleep disorders.[82] The installation must also be situated in the larger context of epidemiological studies on insomnia indicating that "about one person in three often has difficulty falling or staying asleep, or wakes up unrefreshed. One in ten suffers from significant insomnia."[83] The study of sleep disorders such as insomnia, fatal family insomnia, obstructive sleep apnea, sleep inertia, narcolepsy, and circadian rhythm disorders (disorders of sleep schedules) is still in its infancy, yet scientific publications show a growing interest in the areas of sleep-wakefulness mechanisms, "high-risk" hours for accidents caused by driver sleepiness (said to be between 3:00 and 6:00 a.m. and 3:00 and 6:00 p.m.), the prevalence and incidence of sleepiness in shift work (estimated to affect 75 percent of the total population working on night shifts), changes of sleep patterns over the life span, and the hygiene and pharmacology of sleep.[84] There is some consensus to the effect that, as Peretz Lavie explains, "sleep is an accurate barometer of the subject's mental condition, responding rapidly to situations of tension and anxiety, sometimes even before any other bodily system does so," depression being *the* mental illness in which sleep is significantly affected.[85] As a counterpart to the busy *Kinderspielplatz,* and as a lateral extension of the unfocused, generic, saccadic

Eye, Sleepingpill is a nonpharmaceutical device through which one may rethink vision in relation to the deficiencies of attention, learning, perception, and memory that sleep disorders may entail.

Attentional and Sleep Disorders

In Trockel's installation, attention is deficient only from a cognitivist perspective: the eye is without anchor and is unable to fix a targeted object. However, I contend that *Eye* proposes a form of perception that can be characterized as attentive even though it fails to recognize and see something or someone. This is not to say that cognitive science is wrong in its conclusions about attentive perception but to point out that the cognitive model is one that equates much too easily distortion, dysfunction, and impairment.[86] Other models of attentive perception do exist, especially if one considers phenomena that are less measurable and predictable, such as mental imagery. The installation should be seen as partaking of feminist psychoanalyst and philosopher Luce Irigaray's "nothing to see," an anti-oculocentric model of perception theorized in her *Speculum de l'autre femme* (1974).[87] The productivity of Irigaray's "nothing to be seen" or "nothing to see" lies in the fact that it is both a critique of phallocentric metaphysics and a philosophical project to rethink vision. As it discloses how psychoanalytical discourse has reinforced a way of seeing that excludes different categories of being from the realm of subjectivity on the basis of invisibility (the interiority of female genitalia versus the exteriority of male genitalia), it proposes a vision that inscribes difference within the symbolic order. Rather than reducing the seemingly formless to mere nothingness, the nothing-to-see would correspond to an act of looking that transforms itself as it fails to see "something," so as to be altered by the invisible, the illegible, and the unrecognized. If woman's sex is the nothing-to-see of patriarchal oculocentrism, to "see nothing" is a symptom of a different libidinal economy.

Eye proposes a model of attentive vision (the eye is in motion, it seeks) that does not have a fixed, differentiated object: it has been relieved of its function of targeting outside objects. The ocular movements of the blinking and scanning eye are therefore redefining visual perception by integrating drowsiness and sleepiness in the process of attention. In this redefinition, Trockel relies on another model of attention, a model that comes into play in what neurobiology calls "paradoxical sleep." Michel Jouvet, one of the main theoreticians of paradoxical sleep, has shown how this specific form of sleep occurs when we dream and how it is characterized by muscular atonia and rapid eye movements that are directed toward inside visual stimuli, even if the brain continues to be in contact with the outside world.[88] By representing an eye in constant scanning, oblivious of the outside viewer, Trockel explores the similitude between awakening and paradoxical sleep (both are said to be attentive activities)[89] to propose a model of vision in which the eye sees without seeing *something,* a way of looking that simultaneously concerns a relationship to a stimulus (the eye moves in saccades, it seeks and blinks) and suspends identification of the stimulus in terms of fixedness and differentiation.

At this stage, it is important to point out that the projection is punctuated with subliminal images (whose duration approximates a half second) hardly visible to the human eye. These subliminal images are also fleeting dream images for the disengaged eye of *Eye*. It is difficult to say exactly how many of these images appear, for most, if not all, of them are not seen by the viewer. Too short, too random, too rare, too sudden and unpredictable, these still images exist at the threshold of perceptibility. The fleeting images, which emerge after an eyeblink, belong to the surrealist world of dreams. They stage a woman in different contexts: leaning against a vertical surface with her eyes shut; sitting down and looking in front of her; lying with her eyes shut and mouth open to be fed; and lying on her back, legs crossed, one hand on her stomach, the other holding a luminous object resembling a large keyhole. The point here, however, is not to engage in a cryptic interpretation of these images (they are, after all, barely visible) but to acknowledge that a quasi-perceptibility is at play to redefine and regenerate attentive vision in a social context of increased distraction and the correlate need for sleep. Out of necessity—how could this be otherwise for the distracted, depression-prone contemporary subject?— these images will only randomly be seen by the viewers of the installation. It is, however, in this randomness that lies Trockel's radical redefinition of attentive perception in terms of drowsiness, dream, and unfocused vision: to see "nothing," *as* but also *for* the fatigued. This model subverts cognitive science's reiterated objective to measure, predict, and control supposed failures of attention. Insufficiency is not necessarily a failure.

In 1991 and 1995, the National Sleep Foundation commissioned surveys from the Gallup organization to assess the frequency and nature of sleep problems in the United States. The two reports confirmed that between one-third and one-half of the American adult population experiences at least occasional sleep problems and that 9–12 percent have regular or frequent problems with insomnia. The 1995 survey also found that adults with significant sleep problems reported a lower general physical health rating. About four out of ten adults reported daytime napping, and 12 percent reported dozing off during daytime activities.[90] It is safe to conclude that sleeping has become a problem or a need for a significant portion of the population. A number of studies have shown the recurrence of sleep-abnormality patterns in cases of depression, and the *DSM* has recognized this recurrence as a symptom of major depressive disorder. Three sleep-pattern disturbances have been well documented in depressed individuals: sleep-continuity problems (difficulty falling or staying asleep and early waking up, present in about 80 percent of patients suffering from major depression), decreased slow-wave (delta) sleep (most apparent in melancholic depressions), and alterations in the nature and timing of rapid eye movement (REM) sleep (approximately 50 percent of depressed patients have shortened REM latencies).[91] The most obvious question emerging from such an assessment is, what is the relationship between sleep, perception, and depression? This is still under debate, in that science doesn't know precisely yet what sleep and dreams are for. There is consensus, however, on the fact that the brain requires sleep to function. A study by Steven Poceta and Merrill Mitler attests that "we sleep to reverse the negative effects of extended periods of wakefulness on the body and brain and to restore the metabolic capability

of neurons."[92] Within this debate, many theories have been brought forward to explain the function of sleep, including the adaptive theory, the energy-conservation theory, the restorative theory, and the programming-reprogramming theory.[93] More significant to Trockel's installation, recent neurobiological and cognitivist studies have concluded that one of the main functions of sleep is to prepare the energy conditions necessary for the irruption of dreams,[94] and paradoxical sleep is perceived by many as playing a significant role in the process of memorization: we dream to allow better access to stored memories and to forget those which are false or useless—a form of unlearning to favor learning.[95] For Rodolfo Llinas and Denis Paré, "REM sleep can be considered as a modified attentive state in which attention is turned away from the sensory input, toward memories."[96] More recent research, from the Weizmann Institute (Rehovot, Israel), has found that REM sleep plays a significant role in the consolidation of *procedural memory,* which is needed for any daily task "that requires repetition and practice."[97]

As seen earlier, Walter Benjamin, one of the important thinkers of modern distraction, posited that distraction resulted from the subject's need to protect his or her consciousness against the shocks of modern life. Mass entertainment's role was precisely to anesthetize perception and memory. Anesthesia surely impoverished—and still impoverishes—mental faculties (a fact made manifest in Post's photo and video work), but it also parried the aggressions of modern life. From an architectural point of view, as Anthony Vidler has recently pointed out, Benjamin related the distracted state of the subject to the decline of Renaissance perspective in modern architecture and urbanism, notably the erosion of the visual connection between foreground and background, along with the distance separating the center from the periphery, the inside of the city from its outside.[98] With this loss of connection, deriving from an interaction of architectural and urbanistic factors such as the mingling of large-scale urban constructions with traditional architecture, the contamination of space by advertisement, and the modern city's baroque "dissolution" of forms and boundaries in its call for "unlimited space and the elusive magic of light,"[99] it was the very space for criticism that was affected. "Criticism," wrote Benjamin, ". . . was at home in a world where perspectives and prospects counted and where it was still possible to take a standpoint. Now things press too closely on human society. . . . [T]he advertisement . . . abolishes the space where contemplation moved and all but hits us between the eyes with things as a car, growing to gigantic proportions, careens at us out of a film screen."[100] And yet, for Benjamin, the answer to the numbing effects of distraction lay in distraction. In his "Work of Art in the Age of Mechanical Reproduction" (1936), he argued that the distracted subject could be compared to the absentminded passerby who knows architecture through habit. Hence, although distraction was a numbing process whose main effect was to shrink apperception, this did not necessarily mean that the distracted subject was doomed to the loss of critical faculties. Indeed, for Benjamin, in its habitual use of architecture or viewing of film, the public was an absentminded "examiner."[101] This renewed possibility of criticism-through-distraction was tied to Benjamin's understanding of film as an aesthetics of montage whose assembling of heterogeneous images could shock and thus penetrate the spectator

as the surgeon's knife penetrates the body of the patient. Although Trockel's Venice Biennial trilogy does not rely on the belief in the revolutionary powers of filmic reproductive technology, it does propose a similar homeopathic mode of curing (entertaining) distraction through (weary) distraction. The need for sleep is both a symptom of depressed fatigue and a means to regenerate the subject, for it is through sleep that the subject may dream and, in this very state of distracted absentmindedness, regenerate its learning and memory faculties—that is, rementalize itself.

In post-1970s Western societies, argues Ehrenberg, entrepreneurial norms of performative independence have become *the* norms of socialization. This means that the subject is increasingly prone to depressive states that result from the individual's inability to meet the neoliberal demand for speed, flexibility, responsibility, motivation, communication, and initiative. It also means that the subject is more and more compelled to define and redefine itself *by itself* and to choose its life as though any identity were possible, depression being the inability to follow this perpetual quest for the reinvention of self in a culture in which "no moral law, no tradition shows from the outside who we have to be and how to conduct ourselves."[102] Today's subject is confronted with not so much an illness of fault (as in Freud's model of subjectivity) as a pathology of insufficiency. By thinking vision through the dialectic of absorption and distraction, Trockel's work is an acknowledgment of how perception has to be rethought in light of the insufficiency of the contemporary subject. If depressive disorders, through time and sleep deficiencies, impair memory and learning—as recent research tends to confirm—it becomes crucial to find ways to assess and regenerate perception.[103] My hypothesis is that the Venetian installation proposes a model of perception that finds its productivity not in acts of recognition and identification but in dreamlike attention. Not only is its eye endowed with ambiguous identity markers, but it is also absorbed by the gaze of the camera, it fails to recognize the viewer's presence in front of the image, it struggles between sleep and distraction, and it is haunted by quasi-imperceptible dream images. All these aesthetic choices, all these ocular operations, are about the need to restore perception by going with contemporary fallibility instead of attempting to suspend it. The regeneration of perception is engendered by a screen that is explored as a weary matrix that generates dream more than as a locus of dream to be interpreted. The urgency, in a period of depressed subjectivity, is not to give meaning to the dream image but to make rementalization possible. As an image, the symptom has regained in plasticity and temporality. Explored as this refiguration, it revalues some of the most remarkable necessities of the depressed: time and sleep.

Chapter 5

THE CRITIQUE OF THE DEMENTALIZATION OF THE SUBJECT

> Curiously enough, I love my depression. I don't love experiencing
> my depression, but I love the depression itself. I love who I am in
> the wake of it. . . . The opposite of depression is not happiness but
> vitality, and my life, as I write this, is vital, even when sad. I may
> wake up sometime next year without my mind again; it is not likely
> to stick around all the time. Meanwhile, however, I have discovered
> what I would have to call a soul, a part of myself I could never have
> imagined until one day, seven years ago, when hell came to pay me
> a surprise visit. It's a precious discovery. Almost every day I feel
> momentary flashes of hopelessness and wonder every time whether
> I am slipping. . . . I hate those feelings, but I know that they have
> driven me to look deeper at life, to find and cling to reasons for living.
> —*Andrew Solomon,* The Noonday Demon: An Atlas of Depression

The *Diagnostic and Statistical Manual of Mental Disorders,* now in its revised fourth edition (*DSM–IV–TR,* 2000), is a system of classification of mental disorders that uses diagnostic criteria to identify mental disorders through the observation of clinical signs.[1] It classifies so as to be able to diagnose, even though the multiplicity and vagueness of its criteria in no way guarantee the efficiency of the resulting typology. Its alleged descriptive and atheoretical form of classification—one that does not apparently promote a particular theory, so as to be compatible with different recognized perspectives on mental disorders—has primarily been devised to allow diagnostic reliability, a compensation for the fact that the etiology (the specific causes) of many mental conditions remains unknown and highly debated. The *DSM* classifies depression as a unipolar mood disorder[2] under the clinical term "depressive disorders," which is itself subdivided into three categories: "major depressive disorder" (which may be either single-episode or recurrent), "dysthymic disorder," and "depressive disorder not otherwise specified" (which includes, among others, premenstrual dysphoric disorder, minor depressive disorder, recurrent brief depressive disorder, and the postpsychotic depressive disorder of

schizophrenia). A listing in the *DSM* specifies a set of symptoms that must be present for a specific time length to justify an official diagnosis of depression. The requirement is both quantitative and time-related. In the case of major depressive disorder, for instance, five (or more) of the listed symptoms must have been present during a single two-week period, with one of the symptoms being either "depressed mood most of the day, nearly every day, as indicated by either subjective report (e.g., feels sad or empty) or made by others (e.g., appears tearful)" or "markedly diminished interest or pleasure in all, or almost all, activities most of the day, nearly every day (as indicated by either subjective account or observation made by others)."[3] When the full criteria for major depressive disorder are fulfilled, the professional is asked to nuance the diagnosis with one or more of the following specifications: mild, moderate, severe (either without psychotic features or with psychotic features), chronic, with catatonic features, with melancholic features, with atypical features, or with postpartum onset.

To understand the philosophical, institutional, and methodological implications of the diagnostic perspective, one must move slightly back in time to the moment when the American Psychiatric Association published the 1980 edition of the manual, the *DSM–III*, a publication that established the primacy of the diagnostic approach, along with the categorical system of classification of mental affections. The *DSM–III* inaugurated what has been called the "remedicalization of psychiatry," that is, the psychiatric return to descriptive diagnosis and the marginalization of the clinically based psychodynamic (psychoanalytically derived) model, which had come to characterize American psychiatry since the end of World War II.[4]

In his study on the contemporary developments of psychiatry, Mitchell Wilson has shown how, in the 1970s, psychiatry underwent a major disciplinary redefinition to respond to psychiatrists' and antipsychiatrists' critique of psychodynamics, especially regarding the treatment of more severe psychiatric illnesses. During this period, psychiatrists increasingly disagreed—in a disagreement highly supported by biologically oriented psychiatrists advocating the efficacy of medication for the treatment of certain mental disorders—with the primary presumptions of the psychodynamic discourse as it had been theorized by Karl Menninger, notably the following: the dimensional consideration of mental illness along a continuum of severity, from neurosis to psychosis, and the correlated disregard of mental disorders as discrete pathological entities (that is, the psychoanalytical view that there is no clear demarcation between the ill and the well); the understanding of psychiatry as a scientific discipline whose main task is to explain the psychological meanings *behind* the symptoms; and the belief that disorders are a manifestation of psychic conflicts evolving in constraining environments.[5] These psychodynamic presumptions meant that there was no way to document the rates and profiles of people afflicted with mental illness and that diagnosis was an unimportant, unreliable, and unprovable affair. Psychiatrists' complaints were reinforced by the antipsychiatry movement, which also attacked the psychodynamic orientation of psychiatry, although for other reasons. Antipsychiatry denounced psychiatry's mythologization of mental illness, arguing that, if there is no identifiable psychopathology of mental disorder, then

mental disorder is an arbitrary construction that serves only to maintain the subjecting power of scientists over patients.

The publication of the *DSM–III*, written by a committee of experts chaired by Robert Spitzer, was an attempt to solve these ongoing attacks against the discipline. The mandate of the committee was to find a model and a language that could enhance diagnostic reliability and establish psychiatry as a positivist science based on the respect of strict standards of evidence. Redesigning the manual thus meant reaching the following objectives: to simplify the diagnostic process through the establishment of easily observable symptoms; to adopt clear categories that would differentiate mental disorders from one another; to devise a common language that could facilitate communication between psychiatrists and other mental health professionals; to be as atheoretical as possible so as to enable consensus; and to keep clinical inference to a minimum. To meet all these objectives, psychiatry was redefined as a descriptive diagnostic system based on the observation of symptoms, favoring what Wilson calls "the *publicly visible* over what was privately inferred."[6] The final, official version discredited as much as possible the key psychoanalytical notion of "neurosis" (as an illness of psychic conflict) by putting the label "neurotic disorder" in parentheses—next to the classified disorders—and by excluding it as an etiological concept. The notion was completely erased with the publication of the fourth edition *(DSM–IV)* in 1994. Although this shift was motivated by legitimate reasons—the need for dependable diagnoses, the imperative to acknowledge the shortcomings of psychoanalysis, and the impulse to conduct further research on the actual biology of mental disorders—Wilson points out what was lost in this process: psychiatry became a discipline shaped by a mixture of neurobiological and behavioral-cognitive perspectives with no real interest in issues of causes and treatment (areas in which consensus is impossible) or personal histories of patients. As indicated in chapter 4, the shift from psychodynamics to diagnostic psychiatry has meant the loss of the concept of the unconscious, or depth of mind; the shrinking of the sense of time (the consideration of the "unfolding of life over time" has been replaced by the short, five- to forty-five-minute interview); and a marginalization of key aspects of clinical cases, including conflict, transference, family dynamics, and social factors, for the sake of scrupulous descriptions of symptoms.[7] The advent of the *DSM–III* has led to what psychoanalyst Pierre-Henri Castel has called the "dementalization" of the subject,[8] a term that highlights the banalization of the psychic dimensions of subjectivity in contemporary sciences of depression—not only psychiatry but also neurobiology, psychopharmacology, and behavioral, cognitive, and interpersonal psychotherapies. This is to say that the subjective experience of mental illness, the mental processes of depression (such as illness-induced or illness-inductive thinking and perception), and psychic life—the realm of desire, dream, and phantasm, the subjective sense of loss and time, and the world of conscience and conflict—are increasingly devalued in the scientific appreciation of depressive disorders.

It is precisely here, in this interstice between psychodynamics and diagnostic psychiatry, that art enters the depression debate. In its complexification of that very interstice lies art's original contribution to the scientific discussion around depressive disorders. In all

the artworks thus far examined, the aesthetic enactment of depression has set into play a rementalization of the subject. As it performs the different rules of disengagement of depression—the depressed withdrawal into the self, the radical movement of protection of the self from the other, the subject's signaling (through reduced nonverbal communication) to "keep my distance," the depressive sense of isolation, the rupture of communicational intersubjectivity, and perceptual insufficiency—contemporary art has this specificity: the subject it represents, performs, or interpellates is historicized, recognized, and sometimes even valorized in its depressive symptoms to the point where its subjectivity is defined in these very terms. Ugo Rondinone's articulation of a hiatus between depression and melancholy sets up the condition of possibility of a depressed creativity. In its deployment of site-specific laboratories, the performance production of Vanessa Beecroft stages and restages the female subject as a subjectivity shaped by depressive symptoms while exposing how depression itself, as a discursive formation, relies on the conception of the woman's body as "not whole" to define depression as a deficiency; continuously, the denied cognitivist viewer is exposed to the models' coping experience. Liza May Post's and Rondinone's image-screens are the interfaces that materialize the Beecroft's performers' disengagement from the other, what Pierre Fédida has called the protective symptom of "conservation of the living under its *inanimate* form."[9] These image-screens are surfaces that literally enact the depressed rupture of intersubjective communication: they engage the viewer in an experience of disengagement. Finally, the matrix devised by the installation work of Douglas Gordon and Rosemarie Trockel is fundamentally an attempt to reactivate perception through a revalorization of the depressed need for time and sleep.

But what does it mean exactly to aesthetically rementalize the dementalized? How can diagnostic psychiatry be said to have elaborated the dementalization of the subject in the first place? So as to situate art's contribution to the depression debate, this section will examine the process of psychiatric dementalization. The importance of such a process cannot be overestimated. Indeed, in light of the growing intertwining of depression and subjectivity, the ways in which psychiatry has remedicalized its gaze have a considerable impact both on the destiny of the contemporary subject and on the fate of art, which has tended to uphold and defend the very mental features currently banalized in the predominant sciences of depression. Dementalization, as I hope to make clear in this chapter, occurs at the confluence of three crucial operations: the biologization of depression, the institution of the antidepressant paradigm, and the marginalization of psychodynamic therapy. It is in this confluence that the paradigm of depression takes form, and it is in relation to this confluence that art is forced to redefine itself—that art, I contend, *is* redefining itself.

The Biologization of Depression

Attempts to identify biological markers for depressive disorders have generally failed.[10] To date, there is still little evidence for a type of depression that would occur independently of stress precipitants.[11] This is not to say, however, that biological features do not

play a role in the development of depression. Genetic studies (known as linkage studies, which aim to track down whether a psychiatric diagnosis runs in families with an established marker gene) have determined that there are patterns of family transmission of depression.[12] Yet such patterns cannot be attributed solely to genetic factors, because psychological and environmental variables are also likely to come into play in the transmission of depression. Molecular-genetics research pertaining to the identification of particular depression genes is still inconclusive, not only because of the high heterogeneity of the disorder but also because, in cases of depressions that obviously arise from psychological and environmental factors, disorders represent phenocopies that cannot be distinguished from genetically based disorders.[13] Recently a team at the University of Pittsburgh discovered a mutation in a gene known as CREB1, which could play a major role in the development of some severe forms of depression in women.[14] Yet understanding how the mutation has this effect remains difficult, given that the protein acts not in isolation but in interaction with a set of other genes and, possibly, different estrogen receptors. At this writing, in 2005, it is still the case, then, that a mood gene has not yet been identified or localized, supporting the current predominant hypothesis that depression is a complex trait "that may involve the interaction of several mood genes as well as a variety of environmental factors."[15] Increasingly attentive to the interactional nature of depression, research following a diathesis-stress approach has proposed a gene-environment interaction model according to which "a genetic predisposition interacts with an environment stressor to produce a depressive reaction."[16] Diathesis specifically refers to a predisposition for disorders presumed to have the same origin notwithstanding their different manifestations. The 1995 Virginia diathesis-stress twin study by Kendler and colleagues, for example, suggests that genetic factors influence the risk of depression in part by "lowering the sensitivity of individuals to the impact of stressful events."[17] A 1988 study by P. McGuffin, R. Katz, and P. E. Bebbington also showed that both depression and stressful life events were more likely to be present in the families of depressed probands. This led to the suggestion that individuals may themselves create high-risk environments by engaging in behaviors that cause stressful life events usually associated with depression onset. An alternative to this gene-environment interaction model is the genotype-environment correlation model, in which genetic predispositions are said to correlate with environmental factors. Genetic influence on depression may thus be said to contribute to the tendency to experience stressful life events, in a relationship that is "not an interaction of independent factors but a correlation between factors."[18] In short, at present, genetic family studies cannot rule out environmental factors in the transmission of depression, but the ways in which these factors intervene are still difficult to assess.

In contrast to the previous belief (in the 1960s and 1970s) that depression was either reactive—triggered by stressful life events and best handled by psychotherapy—or, more rarely, endogenous—biological in origin (the result of a spontaneous neurological imbalance or a genetic predisposition) and best treated with pharmacotherapy—the consensus today is that this descriptive dichotomy is not meaningful and that depression should be

seen to be both reactive and endogenous. This means that, although one type of depression has biological features, these features are likely to have been triggered by life events and that, although another type of depression may have no significant biological features and is clearly related to psychosocial difficulties, it will often respond to pharmacotherapy.[19] It is clear, however, that depression is a mental illness with corporeal ramifications. Many symptoms of depression, such as sleep disturbance, weight loss or gain, fatigue, lack of energy, and psychomotor retardation or agitation, are physical. Deeper in the physiology of the body, the apparent success of antidepressants reveals that depression reacts to the antinervous action of these drugs. Biochemical changes in the brain, notably a dysregulation of neurotransmitters (the chemical messengers by which neurons communicate and link the functions and regions of different parts of the brain[20]), have been found to occur in states of depression and are what antidepressant medications act upon, even though research, as I will discuss, has not been able to prove that depression is caused by a deficit or excess of specific neurotransmitters. In addition, recent research devoted to brain abnormalities in depressed patients has recorded dysfunctions of the brain during depressive episodes. Neuroimaging and electrophysiological (EEG) recording have provided some evidence of structural abnormalities in the frontal regions of the brains, particularly the left frontal and the right posterior regions of the frontal lobes (which control the intellectual functions of planning and judgment and act as a major regulatory component of the limbic system, responsible for emotion and drive), of depressed individuals.[21] Other corporeal dysregulations, such as altered central and sympathetic activity, hypersecretion of cortisol (a key hormone in the sympathetic nervous system, consistently found to be synthesized by the hypothalamus when a person is under stress), and hypersecretion of various cytokines (which affect the peripheral immune system), are also said to characterize the depressed patient.[22] Yet, to date, there is no clear evidence demonstrating that frontal-lobe dysfunctions are a primary etiological factor in cases of depression.

In an attempt to integrate evidence of sex-related differences in depression rates, it has been hypothesized, furthermore, that female hormones and reproductive biology play a significant role in the onset and development of depression in women. Again, evidence of this connection is weak. Research conducted by anthropologist Carol Worthman, for instance, reveals that a direct causal relation between female hormones and women's depression cannot be maintained in light of current knowledge about hormonal action. For hormones to be proved as key factors for the onset of depression, evidence would have to indicate how their action relied on a series of other biological processes: "Hormones do not directly cause specific biological or behavioral effects. Rather, hormonal action is mediated through an array of other factors. These include: circulating binding proteins, metabolic enzymes, cellular receptors, nuclear binding sites, competing molecules, and presence of cofactors."[23] This being said, however, although empirical findings fail to support biological explanations for depression in women, menstruation, pregnancy, childbirth, and menopause are nonetheless often underscored both by specialists and patients as probable explanations of moods of distress.[24] As psychologist Janet Stoppard has observed, medical treatment reinforces the "assumption that the female body is potentially

disordered and dysfunctional" and may eventually justify the exclusion of women from high-paid, responsible jobs and positions of power in society.[25] This, in turn, feeds pharmaceutical developments of psychotropic drugs as a primary form of medical treatment, as has been the case for premenstrual dysphoric disorder (or premenstrual syndrome, PMS), whose integration as a subtype of depressive disorders has led to an increase in the development and promotion of medications aimed at PMS sufferers.[26] Despite the lack of convincing evidence, the biological hypothesis has meant that female hormones and reproductive biology are increasingly understood as a potential cause of disease, notably depressive disorders.[27]

This tendency to biologize depression, one that rejects the likelihood that biological factors simply reflect consequences of depressive symptoms or that they are correlates of some other, unknown factors, is not specific to women-centered research. Indeed, the biological-causal hypothesis of depression is being more and more seriously explored in the stride of genetic-research developments, the blooming of the antidepressant industry, and the invention of brain-imaging technologies. What biologically oriented psychiatry implies as it deals with issues of genetic predisposition, efficacy of antidepressant medication, brain physiology, and reproductive systems is that biology is the underlying cause of depression. Such is today the predominant discourse in the field of scientific investigations of depressive disorders, a predominance that becomes obvious when we examine the evolution of compilations of·scientific research on depression. The late 1970s and 1980s produced major sociocultural publications on depression; I am thinking here, for example, of George W. Brown and Tirril Harris's *Social Origins of Depression* (1978); Arthur Kleinman and Byron Good's edited *Culture and Depression* (1985); Kleinman's *Social Origins of Distress and Disease* (1986); and Dana Crowley Jack's *Silencing the Self: Women and Depression* (1991). During the 1980s and early 1990s, books like Alfred Dean's edited *Depression in Multidisciplinary Perspective* (1985) and C. Douglas McCann and Norman S. Endler's edited *Depression: New Directions in Theory, Research, and Practice* (1990) included two chapters out of ten, for the former, and six chapters out of sixteen, for the latter, dealing with the biology of depression. In contrast, the mid- to late 1990s and early years of the new millennium have witnessed a significant marginalization of social approaches and a corollary blooming of biologically oriented studies: to name a few, Peter Kramer, *Listening to Prozac* (1993); David Healy, *The Antidepressant Era* (1997); Katharine J. Palmer's edited *Drug Treatment Issues in Depression* (2000); and Dieter Ebert and Klaus P. Ebmeier's edited *New Models for Depression* (1998), which includes one chapter on the psychology of depression whereas the remaining text investigates different biological perspectives.[28] The increased biologization of depression research fits harmoniously with the *DSM*'s categorical-diagnostic approach to mental disorder. The diagnostic methodology—according to which the mental health specialist diagnoses depression on the basis of observable symptoms present for an extended period of time—grounds depression as a medical condition: a patient either has or does not have depression, in the same way that a patient has or does not have cancer or multiple sclerosis. In its attention to observable symptoms to the detriment of the patient's

personal life story and sociocultural context, the diagnostic perspective approaches mental disorder like a brain disease, subjected to what sociologist Allan Horwitz calls the "laws of cause and effect rather than cultural frameworks of motives, actions, meanings, and responsibilities that are applied to social objects."[29]

This is to say that a brain/mind, biology/psychosociology divide structures contemporary research on depression, much as it structures contemporary research on the brain. Reviewing Joseph LeDoux's *Synaptic Self: How Our Brains Become Who We Are* (2002), a book about the determining role of synapses on the psychological states of cognition, emotion, and motivation, philosopher Jerry Fodor has insightfully described the considerable cleavage existing today between cognitive science (a science of the mind) and cognitive neuroscience (a science of the brain). The conjunction of slow progress in cognitive-scientific mind studies and neuroscientific overspecialization has meant that brain-science research examining the connection between brain and mind lacks "a serious cognitive psychology to build a model of the brain on."[30] This shortfall is most obvious in LeDoux's understanding that individual neurons and their synaptic connections are the units in which neural computations occur, a hypothesis that relies on the now-obsolete associationist-psychological perspective, according to which the cognitive mind is primarily associative. The associationist view, which assumes that mind activity results from a reflexive connection between a stimulus and a response, has been overrun by computational-oriented cognitive science, which asserts the need to study and explain not the transmission per se but the "what" that transmission lines connect—that is, the nature of the computations that intervene between connections.[31] Hence, although we can presume that many psychological states depend on synapses, it is more problematic to agree with LeDoux's argument that "[y]ou are your synapses. They are who you are."[32] Much the same can be said about the current field of study on depressive disorders. This is most evident in the biological approaches, which either isolate the body from its social environment or implicitly give precedence to the physiological body over both mind and environment. In these cases, the body is endowed with such autonomy that it becomes the sole active subject *and* object of the pathology. Human subjectivity is relegated to the brain, which is detached from mind, psyche, and culture.

To better understand this biological reductionism, it is useful here to briefly discuss two recent publications that imply that depression is caused by brain malfunctioning. Ebert and Ebmeier's *New Models for Depression* perfectly exemplifies a compilation whose central methodology is to isolate biological models from psychological and social perspectives. The book examines a variety of biological issues related to depression, including the identification of brain regions implicated in emotional behavior (for example, the amygdala, the hypothalamus, and the mesocorticolimbic dopaminergic system); the examination of the role of the medial prefrontal cortex in the pathogenesis of clinical depression; the devising of neuroanatomical models of mood dysregulation in the understanding of the multiple etiologies of clinical depression; the study of the neurological symptoms of depression; the evaluation of the role of cortisol secretion in the onset of depression; the investigation of sleep deprivation as an effective antidepressant therapy; and reports

on imaging technologies for the examination of brain function and structure, such as transcranial magnetic stimulation (TMS), single photon emission computed tomography (SPECT), positron-emission tomography (PET), and functional magnetic resonance imaging (fMRI). Each of these studies deals with depression as a set of biological symptoms that not only exist within the individual but also cohere around the individual's body. The biologization of depression lies precisely in this operation, which consists in discarding the environmental dimension while concomitantly focusing on the biological components of depression as though this is what such a "medical condition" is about. Biologization becomes manifest in statements that imply that the depressed person is merely a vehicle for a somatic illness for which he or she should not be held responsible (at any level), such as the following statement made by one of the contributors to *New Models for Depression*: "[T]he new functional imaging tools . . . are now further destigmatizing the primary mood disorders by revealing abnormal regional brain function despite generally normal structure."[33] To put it differently, the biological perspective tends to localize the causes of depression in dysfunctions of the brain and consequently to discourage any attempt of relating these dysfunctions to the individual's actions or social environment, thereby excluding the *acting, thinking,* and *feeling* individual from the treatment process. Destigmatization of depression occurs through the biologization of mental illness, but in turn biologization completely dementalizes the subject.

In another relatively recent publication exploring a biological perspective on depression, *A Mood Apart: Depression, Mania, and Other Afflictions of the Self* (1997), psychiatrist Peter Whybrow starts his study with an interesting description of the subjective experience of depression, emphatically describing the feelings of sadness, hopelessness, and withdrawal that shape the depressive experience. Biological statements, however, gradually and securely displace the site of depression from the emotional self to the emotional brain:

> Depression and manic depression are thus very special diseases of the brain; they are afflictions of the private person—of the emotional self. It is not easy to recognize or accept their intruding presence, for in disturbing the neurobiological systems they regulate the *emotional* brain, they distort the *person*ality.
>
> . . . The changing behavior we call emotion reflects a homeostatic system of brain activity that has been shaped by evolution to increase successful adaptation, especially in complicated social groups. We rely on this system of emotional intuition for basic survival.[34]

Whybrow concludes, "What may have started as an appropriate response to a tragic moment extends into some sort of behavioral cancer, a malignant mood that invades and distorts the very nature of the self."[35] Depression is thus biological in two ways: metaphorically, it is a form of bacterial or viral infection, the result of an uncontrollable and infectious microorganic invasion that acts to deform the self and distort cognitive-behavioral functioning; and, literally, it is a dysfunction of the brain, which means that it is in fact the brain that acts as a virus as it turns against the self and threatens the self's

integrity.[36] The conjunction of these two characteristics explains why depression is designated here as a "behavioral cancer." Similarly to LeDoux's approach to brain-science research, Whybrow's conceptualization privileges brain over mind. Whereas cognitive science describes the depressed as an individual whose systematic patterns of negative and dysfunctional thinking have come to distort the perception of reality, Whybrow speaks of distorted perception as occurring in—and not by—a being whose thinking activity has become irrelevant. Dementalization is this process by which the subject of depression ceases to be a moral, emotional, mindful, social, and psychological individual and becomes the brain itself.[37] Depression is more specifically equated with failures of the cervix: the limbic system, which generates and even dictates emotional behavior, is dysfunctional, hormones are in a state of imbalance, and "the principal brain centers participating in the limbic alliance: the thalamus, hypothalamus, hippocampus, amygdala and the great limbic lobe" are impaired.[38]

This is not to say that Whybrow ignores the larger environmental context of the depressed; rather, the manifold dysfunctions of the brain bring about depression, even when they are related to stressful life events. In the biological turn, it is the brain that fails to respond adequately to stress, notably for individuals with a strong family history of depression, as can be seen, according to Whybrow, in seasonal affective disorder, where a markedly seasonal climate disrupts the brain's capacity for predictive adjustment and homeostasis (internal balance).[39] This type of research must be understood as a continuation of the seminal Post study (1992), which suggested that repeated episodes of depression might alter the brain's sensitivity to stress at the cellular level so as to produce an organism that would react at such low levels of stress as to have virtually "autonomous" episodes.[40] The underlying hypothesis here is that a child exposed early in life to chronic stress experiences unusually prolonged reactions that can eventually damage the homeostatic neuroendocrine processes and lead to the sensitization of critical limbic regions in the brain. With time, the individual becomes predisposed to depressive reactions when stressors occur. To date, however, as psychologist Constance Hammen has indicated, there is little research on humans "that directly supports such transactional models."[41] Furthermore, this type of hypothesis operates a displacement of agency from mind to brain that not only presumes simplistically that the brain can function autonomously but also suspends the environmental factors that are otherwise proved to be essential for the sensitization of critical limbic sites in the brain.

"To be ill not from the self but from the brain"—this is what Pierre-Henri Castel has called the somatic turn of depression.[42] It is not that specialists such as Whybrow deny the role of stressful life events in the triggering of depression but that the agency conferred to the brain ultimately disqualifies these events, or the mind's interpretation of these events, as significant markers of mental disorders. It is the brain that thinks, feels, predicts, adjusts, and balances bodily systems, and it is the brain that—in the case of depression—fails to think, feel, predict, adjust, and balance bodily systems adequately. The cerebrum becomes a potential enemy from within, the latent virus that may turn against the self without any warning and without any possibility of control. A similar view is at play in

the following description of depression, formulated by psychiatrist Sheldon Preskorn, for whom symptoms have become the cause rather than the result of depression, and stressful life events the result rather than the cause of depressive states:

> The clinician may unfortunately conclude that the depressive symptoms are understandable results of the patient's life situation and/or recent stressors. While that connection may seem obvious given cultural beliefs, it is often wrong. Major depression may be the *cause* of the life problems rather than being the result of them. After all, this illness can adversely affect work performance, motivation, and social skills. . . . Having a "reason" for major depression does not alter its course, reduce its severity and consequences, nor change its responsiveness to treatment. Nonetheless, clinicians may not treat major depression if they perceive that the patient "has a reason for being depressed." However, they would never think of not treating a myocardial infarction or lung carcinoma because the patient has a "reason" for having the illness, such as being overweight or being a smoker, respectively.[43]

The Antidepressant Paradigm

As psychiatrist Joseph Glenmullen has pointed out, psychopharmacology—biological psychiatry—is largely responsible for the understanding of mental disorder as a biological disease.[44] This is so not only because the relative success of antidepressants raises the strong possibility that their target (neurotransmitters) is the source of the pathology but also because the pharmacological industry can only gain from such assumptions. The increased popularity of antidepressants both as therapeutic technology and as a means to specify the causes of depression has meant that psychodynamic therapy's requirement to attend to the psychic life of the depressed is now a marginal affair and that the body has become a testing ground for diagnosis and optimal medication. In the 1990s, antidepressants were among the most prescribed drugs in the United States. The use of a new generation of antidepressants, called SSRIs—selective serotonin reuptake inhibitors, such as Prozac (introduced in 1987), Zoloft, Paxil, and Luvox (all introduced in the 1990s)—which have been found to be safer and easier to use than previous antidepressants, doubled in 1993 and since then has redoubled, with sales estimated to be approaching $6 billion annually.[45] These figures may sound impressive, but, despite the fact that more people than ever are treated with antidepressants, it has been found that many patients who could benefit from pharmacotherapy are never diagnosed (the diagnosis of major depressive disorder is made in fewer than half of primary-care patients who meet the criteria for diagnosis) and that those who are diagnosed are often treated suboptimally.[46] This means that the market for antidepressants could be potentially much larger than it actually is. As historian Philippe Pignarre has argued, in a view largely corroborated by the increase of sales figures, it is impossible today to separate depression from antidepressants: each time an antidepressant is perfected, the social type of

"the depressed" is being (re)defined, and gradually a new social group of people—a new attachment—is created and needs to be stabilized.[47] The very future of such groups is disrupted by the launching of new drugs, which ceaselessly transform previous attachments into new ones. To test new molecules is to test new social types and to ensure the continual growth of the market.

In the last three decades or so, psychopharmacology has made hypothetical suggestions as to what might be the underlying biological cause of depression (for example, serotonin imbalance) following the presumption that a disease is modeled on the medication that treats it. Hence, for instance, when a medication is said to elevate serotonin (a monoamine neurotransmitter present in the mammalian brain), it is presumed that patients helped by that medication must have serotonin deficiency. Tricyclic antidepressants such as imipramines, for example, were found to block the synaptic reuptake of monoamines into the presynaptic neurons.[48] Based on this drug effect, Joseph J. Schildkraut postulated in 1965 that depression resulted from insufficiencies of the monoamine neurotransmitters (especially norepinephrine and serotonin).[49] Tricyclic antidepressants were made more widely available as a result. But research in this area is far from conclusive. According to Brian Leonard and David Healy's study on the differential effects of antidepressants, although it has been accepted for more than thirty years "that a relative deficit in noradrenaline, serotonin and possible dopamine in the limbic (emotional) regions of the brain is primarily responsible for the symptoms of depression," direct evidence "for a primary deficit in such neurotransmitters in depression is limited."[50] The monoamine hypothesis of depression, in particular, which postulates that mood changes result from a hypoactivity (an insufficiency) of the main monoamine neurotransmitters in the emotional areas of the brain, is "a gross oversimplification" of the situation, "because it has been shown that many other transmitters are changed in the brains of depressed patients, in addition to the three monoamines that have received most attention."[51] Because of major difficulties with the monoamine hypothesis, recent research has focused on different types of neurotransmitter receptors that may be dysfunctional in the brain of the depressed patient. Antidepressants were first found to regulate downward beta-adrenergic receptors, yet this hypothesis also went out of fashion with the development of SSRIs in the 1980s and 1990s.[52] More recent research has suggested that depression can be attributed to a decreased synthesis of serotonin in the brain and that SSRIs have been found to enhance release of serotonin—more specifically, to normalize central serotonergic neurotransmission (malfunctional in depression) by producing adaptive changes in the somatodendritic 5IIT (1A-) (inhibitory) receptors and the postsynaptic 5IIT (2A-) receptors. But whether serotonin is the primary cause of depression or acts indirectly to modulate the activity of other neurotransmitters "is currently unclear."[53]

Thus, at present, neurological causality of depression has not been proved, and if such a causality exists, its complexity is so important that reducing depression to a mere neurotransmitter causality is hardly conceivable. As historian of psychiatry Healy has observed, "[T]he question of sorting out the biology of nervous transmission has become incredibly complex" because of the discovery of an outstanding number of neurotransmitters (about

one hundred), each of which has a variety of receptor types associated with it. This means that, "[f]ar ... from providing answers to the questions of how antidepressants work or to the question of what is actually wrong in the nervous systems of people who are depressed, the biological investigations involved have played a different role. In essence, they have provided biological justification for the new approaches that were taken up by psychiatry during the 1970s and 1980s. They have provided artistic verisimilitude by allowing psychiatrists, who talked about biology, to appear scientific."[54] To put it another way, depression is a complex illness that cannot be defined as a disorder of one specific neurotransmitter or receptor but involves a variety of compromised physiological systems, and whose treatment, therefore, probably requires nonspecific treatments.[55] The complexity and nonspecificity of these downstream disturbances are not yet clearly understood.

If antidepressants cannot reveal the biological nature of depression, then how efficient are they? More importantly for the question of dementalization, how do they reinforce the body/mind split? Notwithstanding the present difficulty in ensuring the optimal use of antidepressants and despite the presence of significant side effects, SSRIs are less toxic and easier to handle than drugs from previous generations. Considered to be optimal medications "in terms of the patient's acceptance of side effects, safety, and quantity and quality of clinical trial data,"[56] they do not have the tricyclics' more impairing side effects, such as weight gain, drowsiness, and an increased risk of cardiac arrest.[57] This means that there has been a significant improvement in the area of psychiatric medication since the mid-1980s. The improvement has been decisive for the biomedicalization of depression. Yet a growing concern for the efficacy and side effects of antidepressants is palpable in recent literature on depression. This preoccupation is timely, in the sense that it could really arise only after the new generation of SSRI antidepressants had been prescribed to a sufficiently large portion of the population and for a sufficient length of time. To appreciate their efficacy, it is important to emphasize that antidepressants cannot be said to eliminate symptoms of depression, although they can be effective in the treatment of the disorder. The work of Jules Angst and colleagues has summarized the nature of antidepressant actions in the following terms: "The therapeutic qualities of antidepressants do not lie in the suppression of symptoms but rather are related to their ability to elicit and maintain certain conditions which allow recovery in a sub-group of patients who would otherwise remain non-responsive."[58]

RCT (randomized, placebo-controlled, double-blind trial) results have shown that the more severe the depression, the greater the likelihood of response to pharmacotherapy than to placebo (a superiority that shows efficacy but says nothing about how good a specific compound is, compared to others) and that the milder the depression, the lower the likelihood of benefits from pharmacotherapy.[59] It has, furthermore, been observed that patients with melancholic depression and patients hospitalized for depression "do not respond well to at least some of the SSRIs."[60] In the case of milder forms of depressive disorders, treatment with antidepressants may even be impairing. This is why the American Psychiatric Association strongly recommends the use of antidepressant medication only during the acute and continuation phases of a depressive episode: whereas

medication "may be provided" in the case of mild major depressive disorder, it "should be provided" for moderate to severe major depressive disorder; and when medication has been prescribed as an initial primary treatment, patients "should be maintained on these agents to prevent relapse" during the 16–20 weeks following remission.[61] In cases of mild depression, SSRIs can precipitate cardiovascular or convulsive disorders, can trigger akathisia (agitation), and can increase nervousness leading possibly to suicidal ideation, together with the risk of making patients worse by labeling them as depressed.[62] Fluoxetine hydrochloride (Prozac) has been shown generally to make depressed people less likely to commit suicide than other SSRIs, but it is suspected of causing some people who might otherwise not have committed suicide to be more likely to do so.[63] In cases of major depressive disorder with comorbid anxiety or panic disorder, tricyclic anti-depressants and SSRIs "may initially worsen rather than alleviate an anxiety and panic symptoms."[64] Side effects of tricyclic antidepressants include cardiovascular effects (including tachycardia or orthostatic hypotension leading to dizziness, falls, or fractures), sexual dysfunction, dry mouth, impaired ability to focus at close range, urinary hesitation, sedation, weight gain, and mild myoclonus, and SSRIs may cause gastrointestinal effects (including nausea, vomiting, diarrhea, heartburn, and reflux), "may precipitate or exacerbate restlessness, agitation, and sleep disturbance" (anxiety, panic attacks, and insomnia), and usually lead to "loss of erectile or ejaculatory function in men and loss of libido and anorgasmia in both sexes."[65] Recent studies also reveal that SSRIs may have the following neurological side effects: migraine and tension headaches, parkinsonism (symptoms similar to those seen in Parkinson's disease), akathisia, dystonia, muscle spasms, and tardive dyskinesia (tics), all of which "represent abnormalities in the involuntary motor system."[66] These side effects may emerge while the patient is under medication or as the patient withdraws from medication, and they do not necessarily fully disappear after stopping medication. In other words, neurological damage may be irreversible.

The fact that antidepressants have not yet fulfilled expectations of efficacy and security has major implications for the understanding of the shaping of contemporary subjectivity, for it suggests that the efficacy of antidepressants might lie elsewhere—notably, in the redesigning of the self. In 1993, *Listening to Prozac* caused alarm by suggesting that SSRIs not only allowed patients to recover from mood disorders but transformed the modern sense of self.[67] Observing how effective mood-altering drugs such as Prozac were on compulsive and rejection-sensitive people, psychiatrist Peter Kramer argued that they could transform a patient's personality from a depressive to a hyperthymic type, providing to the patient crucial entrepreneurial qualities such as a heightened sense of responsibility, vigilance, initiative, flexibility, resilience, assertiveness, hedonic capacity, and mental agility.[68] Announcing Ehrenberg's 1998 study on the inherent relationship between contemporary subjectivity, performative norms of socialization, and depressive counterparts, Kramer contended that the management model of the productive individual is exactly what Prozac reinforces:

The operational definition of wellness must be in relation to the demands and goals of our society, here and now. Once we have seen the joy on patients' faces, we can only be grateful for the availability of more powerful and specific medication. But the awareness that what we are altering is a personal style that might have succeeded in a different, and not especially distant, culture may make us wonder whether we are using medication in the service of conformity to societal values. Indeed, experience with medication may make us aware of how exigent our culture is in its behavioral demands.[69]

Concluding that "Prozac highlights our culture's preference for certain personality types. Vivacious women's attractiveness to men, the contemporary scorn of fastidiousness . . . , the business advantage conferred by mental quickness—all these examples point to a consistent social prejudice," Kramer's study underlined, in short, that antidepressants' efficacy lies both in their relative ability to facilitate recovery and in their power to pharmaceutically design performative identities.[70] Yet the growing awareness that antidepressants' healing capacity not only is lower than and different from what was anticipated but also is accompanied by dangerous side effects transforms the patient into a pharmaceutical battleground, a situation that is intensified when the efficacy of a medication is unclear or when diagnosis is uncertain. The psychopharmacological presumption that a disease is modeled on the medication that treats it has led some mental health researchers and clinicians to define depression as "what is cured by antidepressants," although some SSRIs, proved to be "broad-spectrum antidepressants," are known to be effective for the treatment of other conditions, such as several anxiety disorders, obsessive-compulsive disorder, bulimia nervosa, chronic fatigue syndrome, migraine prophylaxis, and premature ejaculation.[71] This logic, according to which a psychiatric condition is identified by the medication used to treat it, has important consequences in the case of depression. Not only are antidepressants beneficial in the treatment of other psychiatric and nonpsychiatric conditions but also, as indicated earlier, depressive symptoms are at play in more than one disease, and many symptoms are necessary (yet not sufficient) for the diagnosis of specific diseases. So when psychiatrists rely on medication to establish a definitive diagnosis, this may entail a series of drug explorations. If a patient fails to respond to an initially prescribed antidepressant, his or her diagnosis will then be questioned and another mood stabilizer will be prescribed. In such cases of medication testing, as anthropologist Tanya Luhrmann has observed, the patient's body becomes the matter of experience for a psychiatrist in search of the right diagnosis. The practice of diagnosis *post factum* is even more problematic than in the rest of medicine if we consider the triple fact that antidepressants are often ineffective (in some cases, depression doesn't respond at all to any medication), that they act differently on different patients, and that most patients are on more than one medication.[72] Recent publications on the use of antidepressants in the treatment of depression, such as Katharine Palmer's *Drug Treatment Issues in Depression*, focus on the need to optimize antidepressant therapy in light of findings that reveal an international suboptimal use of antidepressants due

to inappropriate delays in the initiation of treatment, use of inadequate antidepressant doses, lack of understanding of the phases of pharmacotherapeutic treatment (acute, continuation, and maintenance), lack of knowledge as to the mechanism of substituting one antidepressant for another, and premature discontinuation of treatment. Bluntly speaking, pharmacotherapy entails, more often than not, a narrowing down of the subject to a body whose corporeality is both marked and emphasized by the constant testing and adjustment of medication. Dementalization unfolds in this narrowing down.

The Marginalization of Psychodynamic Therapy

One of the main effects of the antidepressant revolution is the increased marginalization of psychodynamic therapy, even though it has been established—both in individual studies and meta-analyses—that, for patients with severe or recurrent major depressive disorder, "the combination of psychotherapy (including interpersonal therapy, cognitive behavioral therapy, behavior therapy, or brief dynamic therapy) and pharmacotherapy" is superior "to treatment with a single modality."[73] I suggest in this section that the marginalization of the talking cure, as a necessary correlate to the biologization of depression and the institution of the antidepressant paradigm, is one of the key factors of the dementalization of the depressed. The denial of or reduced attention to the patient's standpoint, life story, and interpretation devaluates the psychic dimensions of identity loss, dream lapse, and deterioration of sense of time experienced by the subject and therefore discourages any view that depression is also somewhat a view of the world. Also negated is the patient's own account of his or her relationship to the health institutions that frame the diagnosis and treatment of depression. Highly critical of this denial, sociologist David Karp argues more precisely:

> The essential problem with nearly all studies of depression is that we hear the voices of a battalion of mental health experts (doctors, nurses, social workers, sociologists, psychologists, therapists) and never the voices of depressed people themselves. We do not hear what depression feels like, what it means to receive an "official" diagnosis, or what depressed individuals think of therapeutic experts. Nor do we learn the meanings that patients attach to taking psychotropic medications, whether they accept illness metaphors in assessing their condition, how they establish coping mechanisms, how they understand depression to affect their intimate relationships, or how depression influences their occupational strategies and career aspirations.[74]

The low number of publications written by individuals living with depression may be partly explained by the fear of stigmatization. But it must conjointly be seen as deriving substantially from the current devaluation of the psychodynamic model. Psychiatry's healthy criticism of psychoanalysis—highlighting the inability of psychoanalysis to provide convincing proof of its healing effects—has surprisingly led to its complete disregard, with the consequence of discouraging the patient's access to meaning. It favors the "how"

of disease instead of the "why" of illness. For Luhrmann, the marginalization of psycho-dynamic therapy—a term that encompasses a variety of psychotherapeutic interventions sharing the psychoanalytical understanding of symptom formation, personality development, and psychological vulnerability as being shaped by conflicts emerging in early childhood and developing during the life cycle of the individual[75]—has been gradual over the years but has now become a fait accompli because of managed care's adaptation to the perfecting of antidepressants:

> The real crisis for psychodynamic psychiatry has been not the new psychiatric science but managed care and the health care revolution of the 1990s. More specifically, it is not just managed care but managed care in the context of ideological tension that is turning psychodynamic psychiatry into a ghost. It is harder to think about psychotherapy, about a patient's psychodynamics, about a patient as a kind of person to whom those thoughts are relevant because what must be done in the hospital belongs squarely in the domain of the new psychiatric science, and that way of thinking has been imagined as the denial and disproof of the psycho-therapeutic endeavor.[76]

It is not that psychiatrists refuse the psychotherapeutic model; rather, the current predominance of the diagnostic model and psychotherapy's dependence on patients' insurance companies disclose a form of disinvestment in talking cures. Managed care involves the increasing agency of insurance companies in medical treatment; the constant negotiations between psychiatrists and health insurance companies to seek permission to admit a patient and to treat her or him following a predefined and preagreed plan; the ongoing requirement to administrate admission interviews; and the need to compensate for shortage of staff. Thus, managed care discourages the type of care provided by longer-term psychodynamics, which involves investing time in the building of a relationship and the psychoanalytically derived, slow uncovering of repressed mental contents, which cannot be elicited—and I follow Ernest Gellner's description—"by any more direct approach" and whose "extraction and recognition by the patient" are necessary for any "significant and beneficial therapeutic consequences."[77] Psychopharmacology, which aims to alleviate symptoms as immediately as possible, fits the time-is-money and antidepressant-as-proof-of-disease setting of managed care. The consequent consolidation of psychopharmacological treatment of depressive disorders is manifest in the recent assessment of the state of scientific research on depression in *L'actualité médicale*. In his introductory remarks, Dr. Georges Costan defines depression as "a deficiency of chemical mediators (neurotransmitters) responsible for the transmission of nervous influx, notably serotonin (5-hydroxy–5 tryptamine; 5-HT) and noradrenaline (= norepinephrine; NA or NE)."[78] Considered a biochemical imbalance, depression can really be treated only with medication. Although Costan does stipulate that three main forms of therapies are now available for the treatment of depression (antidepressants, psychotherapy, and diverse methods of electric stimulation of the brain), he observes that, "in the majority of cases, antidepressants remain the privileged approach in the treatment of depression."[79]

The prescription of drugs is thus replacing the psychotherapeutic talk-and-listen process and the lengthier exploration of metaphor in the description of human emotions, culminating in what Luhrmann has designated the victory of medication over relationships: "When medications take the place of relationships, not only do patients suffer the side effects of aggressive medication, but they lose the healing power of the relationship."[80]

Disapproving psychiatry's disinvestment from psychodynamic therapy, feminist psychologists have been arguing for the need to support therapies that listen to the patient's standpoint and that make room for personal accounts of subjective experience, elements largely ignored in mainstream scientific methodology. In current psychotherapy, subjective reports may still be included, but these may also distort the patient's standpoint. From a feminist perspective, acknowledging the patient's standpoint—making women's experiences the center of investigation—brings about not only possibilities for developing emancipating ways of understanding depression but also new resources for patients struggling with both depression and mental health professionals. Highly critical of the standardized self-report questionnaires or checklists (such as the Beck Depression Inventory) made available to mental health professionals to help them collect information about a patient's episodes, Stoppard has pointed out that when the patient is asked to report his or her subjective experience by answering a questionnaire, the account is somewhat flawed by the very fact that it must fit the questionnaire's content and wording, both of which have been conceived not by patients but by specialists in the field. Experiences that cannot meet the scope of the questions are seen as irrelevant and remain unexplored. The underlying objective of these questionnaires is not to register the patient's story but to evaluate the patient's statements according to statistical procedures for item analysis and scale construction, that is, to objectify experience in relation to predetermined definitions of personality traits, attributional styles, cognitive types, and conceptions of normality versus abnormality.[81] This is to say not that objective measurement is an obstacle to the care of the depressed (on the contrary, pattern data can be extremely useful for the understanding of mental disorders) but that it reduces experiential knowledge to a typology of coping styles. In contrast, talking cures are psychotherapeutic processes that validate the patient's attempts to make sense of his or her experiences (be they stereotypical or alternative, biological or social views), a means to better understand depression through the establishment of a dialogue between personal, popular, and specialized definitions of depression.[82]

As Stoppard has pointed out, the problem of devaluation of personal accounts is especially problematic for women, who are diagnosed with depression at least twice as often as men: "Although women may draw connections between their lives and their depressive experiences, understanding based on experiential (or subjective) knowledge is likely to be discounted by experts as anecdotal, or reinterpreted as signs of a woman's mental illness or psychopathology."[83] Even when treated according to the precepts of the current recognized (that is, proved-to-be-efficient) psychotherapies—behavioral, cognitive, and interpersonal therapies—the depressed person is further dementalized by approaches that systematically define patients as maladaptive coping machines to be *corrected* with

problem-solving strategies. These psychotherapies tend to marginalize the interpretative strategies of psychodynamics, with the following consequences: the search for the reasons for or causes of depression is banalized, the experience of the depressed devalued, and the patient's interpretation of illness rendered irrelevant. In light of this reduction, two key questions are left unanswered and need to be brought back to the fore: How is the production of knowledge on depression shaped by predefined sociocultural categories of femininity? To what degree are subjective reports taken into account in the diagnosis of depression? The point here is to say not that the positivist approach in psychiatry is wrong but that it is crucial to be aware that knowledge claims are always partial, contingent, and contextual.[84]

Psychiatrist Joseph Glenmullen has recently argued that the marginalization of the talking cure is implied in the *DSM*'s diagnostic approach. The *DSM*'s criteria checklist specifies biopsychological conditions as physical and cognitive-behavioral symptoms, and not as manifestations of psychical states. It encourages a logic of diagnosis and medication and discourages de facto "any attempt to help patients understand themselves and to effect real change."[85] The *DSM*'s "observation of symptoms" approach was especially devised to counter the considerable role of subjective judgment in the diagnosis of mental illnesses. Hence, to ensure diagnostic reliability, psychiatry's impulse has been to reduce as much as possible the high reliance on doctor-patient relationships and the related sociocultural context in the diagnosis of depression. This sense of context is lost in the *DSM*'s concept of mental disorder as "a behavioral, psychological, or biological dysfunction in the individual."[86] The underlying premise here is that the diagnosis of depression can and should be established independently of the complex particularities of the subject to which it has been attributed. In the words of psychiatrists Jacques Gasser and Michael Stigler, "it is the diagnosis which is the identity of the patient, making other forms of identity superfluous."[87] This logic can take place only in concomitance with or as a reinforcement of the biological perception of the patient as a mindless, unintentional body, as someone who should be held responsible neither for the emergence of the disorder nor for its development and cure. As Luhrmann rightly points out, whereas psychiatry privileged the life of the mind from the 1950s through the 1970s, it is now the mindless body that has come to the fore:

> We still think that the body is something unintentional, something given, something for which any individual is not responsible. That is why we are so interested in metabolic set points, inborn temperaments, learning disabilities, and the genetic roots of attention deficit disorder. If something is in the body, an individual cannot be blamed; the body is always morally innocent. If something is in the mind, however, it can be controlled and mastered, and a person who fails to do so is morally at fault. . . . If a child gets poor grades because of a learning disability, she should not be punished for not studying but should be given special help, the way we help those with other special physical needs. If I am lazy because I was born that way, I don't need to be guilty and embarrassed by the slope of my career. Biology is the

great moral loophole of our age. This is not to say that I think this to be entirely inappropriate. As a good American, I believe that it is wrong to hold people responsible for something they cannot control. Nevertheless, a moral vision that treats the body as choiceless and nonresponsible and the mind as choice-making and responsible has significant consequences for a view of mental illness precariously perched between the two.[88]

Why is the overall marginalization of psychotherapy so problematic? The answer to this critical question is not difficult: studies have consistently revealed that patients "do less well off without psychotherapy. They do less well, are readmitted [to hospitals] more quickly, diagnosed more inaccurately, and medicated more randomly."[89] RCTs have also shown that placebos can be expected to work for the majority of primary-care depressions.[90] This has led Healy to postulate that "[t]he large placebo response to almost all psychiatric treatments means that responses are heavily shaped by factors such as the quality of the interaction between physician and patient, the circumstances in which help is sought, and other nonspecific factors . . . , elements of the therapeutic encounter [that] cannot be subject to randomized control procedures or made a matter of guidelines."[91] In the 1980s, the National Institute of Mental Health (NIMH) funded a large-scale study with the objective of comparing psycho- and pharmacotherapy. It was demonstrated that both forms of therapy had comparable results in the short-term treatment of depression.[92] Similar results have been reached studying subsequent studies, such as one conducted by a group of researchers headed by Steven Hollon from the University of Minnesota, which postulated in the October 1992 issue of *Archives of General Psychiatry* that "no differences in overall responses were observed" in patients with psychotherapy versus pharmacotherapy, and that "combining cognitive therapy with pharmacotherapy did not markedly improve response over that observed for either modality alone."[93] However, the absence of psychotherapy seems to be detrimental in the long run, meaning that psychotherapy does seem to reduce the chances of relapse in depression. Indeed, when patients in the NIMH study were examined two years later, 50 percent of patients treated with drugs had become depressed again, whereas only 35 percent of those treated with psychotherapy had relapsed. As for the Minnesota study, within two years, 50 percent of patients treated with drugs had relapsed, whereas only 18 percent of those treated with psychotherapy had relapsed.[94] A more recent study from the University of Texas Southwestern Medical Center has shown that "8 months of A-CT [acute-phase cognitive therapy] significantly reduces relapse and recurrence in the highest-risk patients with recurrent MDD [major depressive disorder]."[95] This has led Glenmullen to conclude that pharmacotherapy may reverse the physical symptoms of depression by helping restore "a patient's ability to function" but that it cannot be seen as a cure for "the fundamental, underlying problem" of depression.[96]

The institution of psychiatry thus has its own inherent disorder, which Luhrmann has identified as the split between, "on the one hand, diagnosis and psycho-pharmacology, which are usually the dominant focus of inpatient psychiatry, and, on the other, psycho-

dynamic psychotherapy, which tends to be taught as an outpatient specialization distinct from the skills of hospital psychiatry."[97] Examining the American university and hospital training of psychiatrists, she observes that although young psychiatrists learn both biomedical and psychotherapeutic ways to identify, comprehend, and respond to mental illness, and although they are expected to excel equally in drug therapy and talk therapy, the two models are far from being integrated in practice. This lack of integration derives not only from differences in ideology—the two models oppose each other on the fundamental question of how suffering works—but also from socioeconomic forces that make it much more economic and far less complex (for the hospital unit and insurance companies) to prescribe medication and send patients back home than to meet and listen to them on a weekly basis for an extended period of time. As for psychiatrists who do manage to integrate the two approaches, it is clear that "from the outset" they carry two "different models of the person, different models of causation, and different expectations of how a person might change over time."[98] Although the American Psychiatric Association believes that the integration of psychotherapy and biomedical psychiatry is necessary for the recovery of mental patients, the split between them is actually leading to the prevalence of the biomedical model and the corollary decline of psychotherapy.

The dementalization of the subject in contemporary sciences of depression is inextricably tied to the remedicalization of psychiatry inaugurated by the *DSM–III* and its implementation of a diagnostic approach whose main modus operandi is to assemble visible symptoms into syndromes that in turn must correspond to prefixed categories of depressive disorders, according to a disease-centered apprehension of mental disorder. In his historical study of modern psychiatry, David Healy has especially emphasized how much "[t]he premium put on categorical models of disease rather than dimensional models radically changed the face of psychiatry" and how "[t]he exemplar of a categorical disease state was the bacterial infection."[99] The prevalence of this bacterial perspective essentially means that the complexities of normality and abnormality are not being examined, that the voice of the patient—his or her personal story, his or her interpretation of the meaning of, reasons for, and causes of depression, and his or her dealings with the health institutions—is being judged as irrelevant and is not being heard, and that the psychic reality behind the symptoms and the larger sociocultural context of the patient's environment are not being addressed. Dementalization is further cultivated by the biologization of depression, which naturally comes about once mental disorder is understood as located within the decontextualized depressed individual. This biological perspective has become extremely problematic not because of its attention to the corporeal dimensions of depressive disorders (these are an inherent part of depression) but because of its adoption of a disease model that shrinks the depressed to a mindless body and equates subjectivity with brain activity. The blooming of the antidepressant industry is fed by and reinforces such a model through the pharmaceutical numbing of the mind. By promising rapid recovery and facilitating personality changes that fit the prerequisites of the entrepreneurial subject, this industry also sustains the late-twentieth- and

early-twenty-first-century social norms of performative independence based on general-ized individual initiative (personified by the model of the entrepreneur) and pluralism of values (exemplified by the dictum "It's my choice"). In light of psychiatry's deprecia-tion of mental life, it is hard to measure how much the understanding of depression as a form of mental impoverishment—a disorder shaped by the reduced ability to dream and fantasize, to relate intersubjectively, and to remember, project, and concentrate—can be attributed to the diagnostic perspective that frames that understanding. In matters of depressive disorder, science is mimicking the process it seeks to cure; it both reveals and produces an affection whose main "negative" trait is an astonishing impoverishment of the self, one that is read, lived, and discursively amplified in terms of failed autonomy and lost creativity.

The key point here is that the notion of disease as pathology has overrun that of illness as experience. In other words, the "how" (of a particular disease) has absorbed the "why" (of a particular illness: "why this?" "why me?" "why now?") that was at the foreground of the psychoanalytical integration of personal narratives into therapy.[100] Although biomedi-cal research has certainly been and still is essential for the understanding and treatment of mental suffering (there is no mental disorder without biology), the antidepressant para-digm has increasingly negated psychodynamic therapy's competence in acknowledging and valorizing the patient's experience, responsibility and voice,[101] and thinking and psy-chic processes, as well as his or her socioenvironmental context. From a psychodynamic perspective, as Luhrmann has convincingly observed, illness is considered to be not exter-nal to the subject but part of subjectivity, and the therapist's task is to "empathize with the unique life course of that person: his hopes, his losses, his mistakes, his frailties, his cour-age, and his strength." What the psychotherapist sees, but what is usually denied in bio-logical, psychopharmacological, and cognitivist approaches that seek to cure a disease or correct a deficient coping style, is "the complexity of a particular life: how a specific person dreamed, feared, yearned, avoided, chose."[102] The subject as constituted in and through loss (the loss of the loved object, the loss of the self in the other, the loss of the self through constraint and prohibition, the loss of time) is pushed to the periphery to make place for a maladapted lost subject. Scientific dementalization, then, is a foundational debasement of the melancholy attachment to loss, of the psychodynamic belief in the benefits of loss as it shapes the self, structures time, and infiltrates sleep.

When contemporary art enacts depression, it occupies the interstice created by the distance that has come to separate the withering discipline of psychoanalysis and the prevailing field of diagnostic psychiatry. Still attached to the creativity traditionally as-sociated with melancholic insight, it opposes the cognitivist view of depression as a flaw of adaptation and creativity by focusing on the subjective experience of the performer and of the viewer. In this process, it has nevertheless abandoned the modern belief in emancipation and subversion; it has ceased to assume the power of dreams and has left the conflicted subject behind to stage the individual's search "to only be oneself" in so-cieties where "neither moral law nor tradition shows from the outside who we have to be and how we must conduct ourselves."[103] More importantly—and this is its true legacy—it

performs the manifold rules of disengagement of depressed subjectivity: the withdrawal into the self, self-absorption, the protection of the self from the possible loss of the other, the media's distancing, suspension, or delaying of the other, the "conservation of the living under its *inanimate* form," the rupture of communicational intersubjectivity, the deployment of perceptual insufficiency. Artistic melancholia—and I follow Sarah Kofman here—lay in its resistance to reproductive mimesis and the correlated belief in the necessity not to bridge the gap between imitation and imitated, not to pass over lack or loss.[104] Contemporary art's enacting of depression can also be said to have adopted an antipharmaceutical stance. Refusing the numbing, protective, and reanchoring effects of pharmaceuticals, its main modus operandi is not to pass over communicational rupture but in fact to expose and investigate it. Attentive to communicational loss, it melancholizes depression so that loss is not reduced to a deficiency.

Contemporary art thus performs and discloses the intertwining of depression and subjectivity, but only to expose its disengagement logic. This, I argue, is where a process of rementalization takes place, for it is by enacting disengagement that the (still-incomplete) shift from the melancholic to the depressive paradigm is disclosed, that depressive disorders are understood in the larger social context of neoliberalism, and that the image is radically rethought not in order to correct but in order to materialize, enounce, repeat, reactivate, bring to the fore, display, and explore the mental, affective, and corporeal symptoms of depression. As they devise the image as an image-screen, the artworks examined here engage the viewer in the experience of disengagement. As they investigate the image as a screen matrix whose main function is to produce time and weariness for the one who looks, they even reinvent the image through the enactment of depressive symptoms (waiting immobilization and insomnia), so as to reactivate the perception of the depressed viewer while still embracing perceptual insufficiency. This trajectory has given us an occasion to understand that contemporary art's research on the image, the body, visuality, and matter or form is involved in the thinking, making, and unmaking of a historical subject. It has led us closer not only to the specificity of art but also to its relationship with science.

Notes

Introduction

1. On Cadieux's *La voie lactée,* see Julie Lavigne, *"La voix lactée* de Geneviève Cadieux: Une voix féministe de l'intime," *Globe: Revue internationale d'études québécoises* 3, no. 1 (2000): 83–102; and, more generally about language, voice, and speech in Cadieux's work, Johanne Lamoureux, *Seeing in Tongues: A Narrative of Language and Visual Arts in Quebec = Le bout de la langue: Les arts visuels et la langue au Québec* (Vancouver, BC: Morris and Helen Belkin Art Gallery, 1995), 37–38, 45–46.

2. Klaus Biesenbach, *Loop* (New York: P.S.1, 2001–2), 20.

3. Alain Ehrenberg and Anne M. Lovell, "Pourquoi avons-nous besoin d'une réflexion sur la psychiatrie?" in *La maladie mentale en mutation: Psychiatrie et société,* ed. Alain Ehrenberg and Anne M. Lovell (Paris: Éditions Odile Jacob, 2001), 13–14.

4. National Institute of Mental Health, *The Invisible Disease: Depression* (Bethesda, MD: National Institute of Mental Health, 2003), http://www.nimh.nih.gov/publicat/invisible.cfm; and World Health Organization, *The World Health Report, 2001—Mental Health: New Understanding, New Hope* (Geneva: World Health Organization, 2001).

5. The rate disparity is said to reflect the nonstandardization of definitions of depression and epidemiological methodologies as well as social and cultural differences in the actual experience of mental illness. For statistics, see Kenneth B. Wells et al., *Caring for Depression* (Cambridge: Harvard University Press, 1996), 30–31; Michael Thase, "Relapse and Recurrence of Depression: An Updated Practical Approach for Prevention," in *Drug Treatment Issues in Depression,* ed. Katherine J. Palmer (Auckland, NZ: Adis International, 2000), 35–36; and Caroline Carney Doebbeling, "Epidemiology, Risk Factors, and Prevention," in *Depression,* ed. James L. Levenson (Philadelphia : American College of Physicians, 2000), 23–27. On rate disparity, see Philippe Pignarre, "Comment passer de la 'dépression' à la société?" in *La dépression est-elle passée de mode?* ed. Pierre Fédida and Dominique Lecourt (Paris: Presses Universitaires de France, 2000), 37. Also see Doebbeling (26–27) for a comparative view of the results from the two major studies conducted to determine the lifetime prevalence of major depressive disorders in the American population, the Epidemiological Catchment Area study (ECA, 1994) and the National Comorbidity Survey (NCS, 1998). The figures are markedly different: 4.4 percent for the ECA and 17.1 percent for the NCS. Also see Li-Shiun Chen et al., "Empirical Examination of Current Depression Categories in a Population-Based Study: Symptoms, Course, and Risk Factors," *American Journal of Psychiatry* 157, no. 4 (April 2000): 574, 578–79, which nuances these figures by considering the

heterogeneity of depression. The study reports that the lifetime prevalence of major depressive disorder is 5.4 percent; however, the lifetime prevalence of depressive syndrome (a subthreshold entity defined by the statement "have had a period of 2 weeks or longer when several [three or more] depressive symptoms occur together including dysphoria or anhedonia") is 12 percent, meaning that more people are impaired by minor depression than major depression disorder.

6. David Healy, "The Antidepressant Drama," in *Treatment of Depression: Bridging the 21st Century,* ed. Myrna M. Weissman (Washington, DC: American Psychiatric Press, 2001), 26.

7. Janet M. Stoppard, *Understanding Depression: Feminist Social Constructionist Approaches* (New York: Routledge, 2000), 4–5.

8. Ibid., 6.

9. On this specific question, see Edouard Zarifian, "De la mélancolie au malheur de vivre," *Magazine littéraire* 411 (July–August 2002): 25.

10. For a brief examination of the analogy between depression and neurasthenia, see comments by the neurologist Déréjine, quoted in Alain Ehrenberg, "Des troubles du désir au malaise identitaire," *Magazine littéraire* 411 (July–August 2002): 23.

11. Alain Ehrenberg, *La fatigue d'être soi: Dépression et société* (Paris: Éditions Odile Jacob, 1998), 9 (my translation).

12. Judith Butler, *Gender Trouble: Feminism and the Subversion of Identity* (New York: Routledge, 1990), 140 (my emphasis).

13. Kitty Scott, "Ken Lum Works with Photography," in *Ken Lum Works with Photography = Ken Lum le travail de l'image,* ed. Kitty Scott and Martha Hanna (Ottawa: National Gallery of Canada, 2002), 12.

14. See especially Ehrenberg, *La fatigue d'être soi.*

15. See ibid. and Ehrenberg, "Des troubles du désir," 24.

16. Alain Renaut, *The Era of the Individual: A Contribution to the History of Subjectivity,* trans. M. B. DeBevoise and Franklin Philip (Princeton: Princeton University Press, 1997), 21. Originally published as *L'ère de l'individu: Contribution à une histoire de la subjectivité* (Paris: Gallimard, 1989).

17. Étienne Balibar, "Subjection and Subjectivation," in *Supposing the Subject,* ed. Joan Copjec (New York: Verso, 1994), 8.

18. This is Jean-Luc Nancy's definition of *identity.* See Jean-Luc Nancy, *The Birth to Presence,* trans. Brian Holmes (Stanford: Stanford University Press, 1993), 10. For a brilliant elaboration on the role of identification in identity processes using Nancy's definition of identity, see Diana Fuss, *Identification Papers* (New York: Routledge, 1995).

19. Peter Bürger, *Theory of the Avant-Garde,* trans. Michael Shaw (Minneapolis: University of Minnesota Press, 1984). For a critical assessment of Bürger's hypothesis, see Hal Foster, "What's Neo about the Neo-Avant-Garde?" *October* 70 (Fall 1994), reprinted in *The Duchamp Effect,* ed. Martha Buskirk and Mignon Nixon (Cambridge: MIT Press, 1996), 5–32.

20. Elisabeth Roudinesco, *Pourquoi la psychanalyse?* (Paris: Flammarion, 1999), 28 (all quotations my translation).

21. Following Kuhn's definition of the term, the paradigm is the frame of thought, set of representations, or model specific to a period from which reflections are built. Every scientific revolution translates itself by a paradigmatic shift. See Thomas S. Kuhn, *The Structure of Scientific Revolutions* (Chicago: University of Chicago Press, 1962).

22. Roudinesco, *Pourquoi la psychanalyse?* 28–31.

23. Jean-Marie Schaeffer, *L'art de l'âge moderne: L'esthétique et la philosophie de l'art du VIIIe siècle à nos jours* (Paris: Gallimard, 1992).

24. Rose-Marie Arbour, *L'art qui nous est contemporain* (Montreal: Artextes, 2000), 82 (my translation).

25. Pierre Fédida, *Des bienfaits de la dépression: Éloge de la psychothérapie* (Paris: Éditions Odile Jacob, 2001), 14 (my translation).

26. Adam Jaworski and Nikolas Coupland, "Introduction: Perspectives on Discourse Analysis," in *The Discourse Reader,* ed. Adam Jaworski and Nikolas Coupland (New York: Routledge, 1999), 3.

27. On the way discourse affects subjectivity and identity formation, see Colleen Heenan, "Feminist Therapy and Its Discontents," in *Psychology Discourse Practice: From Regulation to Resistance,* by Erica Burman et al. (London: Taylor & Francis, 1996), 61.

28. Deborah Schiffrin, *Approaches to Discourse* (Oxford, UK: Blackwell, 1994), 408.

29. J. C. Wakefield, quoted in Allan V. Horwitz, *Creating Mental Illness* (Chicago: University of Chicago Press, 2002), 12.

30. Ibid., 11.

31. Pierre-Henri Castel, "La dépression est-elle encore une affection de l'esprit?" in Fédida and Lecourt, *La dépression?* 54–70.

32. Michel Foucault, *The Archaeology of Knowledge,* trans. A. M. Sheridan Smith (New York: Harper Colophon, 1972), 115.

33. On this topic, see notably Roy Porter, *Madness: A Brief History* (Oxford: Oxford University Press, 2002); and Louis A. Sass, *Madness and Modernism: Insanity in the Light of Modern Art, Literature, and Thought* (New York: BasicBooks, 1992). On surrealism's conception of madness as a revolutionary force, see J. H. Matthews, *Surrealism, Insanity, and Poetry* (Syracuse: Syracuse University Press, 1982). On the subversiveness of madness, see Gilles Deleuze and Félix Guattari, *Anti-Oedipus: Capitalism and Schizophrenia,* trans. Robert Hurley, Mark Seem, and Helen R. Lane (New York: Viking, 1977); and Elaine Showalter, *The Female Malady: Women, Madness, and English Culture, 1830–1980* (New York: Pantheon, 1985). On the stereotypical association of madness and art, see Sander L. Gilman, *Difference and Pathology: Stereotypes of Sexuality, Race, and Madness* (Ithaca: Cornell University Press, 1985).

34. This expression is from Pierre Fédida, who sees depression as a protective reply against loss, a means to conserve the self through protection. See Fédida, *Des bienfaits de la dépression,* 16. More on this in the following chapters.

1. The Withering of Melancholia

1. For an overview of the persistence of the concept of "sadness without a cause," see Stanley W. Jackson, *Melancholia and Depression: From Hippocratic Times to Modern Times* (New Haven: Yale University Press, 1986), 315–17; Aristotle, *Problemata,* section on melancholia reprinted in Raymond Klibansky, Erwin Panofsky, and Fritz Saxl, *Saturn and Melancholy: Studies on Natural Philosophy, Religion, and Art* (London: Nelson, 1964), 18–29; Celsus, *De medicina,* trans. W. G. Spencer, Loeb Classical Library (Cambridge: Harvard University Press, 1953–61), 1:301, quoted in Jackson, *Melancholia and Depression,* 315.

2. Emil Kraepelin, *Lehrbuch der Psychiatrie* (New York: Macmillan, 1902), 284, quoted in Jackson, *Melancholia and Depression,* 316.

3. Sigmund Freud, "Mourning and Melancholia," in *Essential Papers on Depression,* ed. James C. Coyne (New York: New York University Press, 1986), 50.

4. Clément Rosset, quoted in Didier Raymond, "Clément Rosset: Dans l'œil du cyclone," *Magazine littéraire* 411 (July–August 2002): 19 (my translation).

5. William Styron, *Darkness Visible: A Memoir of Madness* (New York: Vintage, 1990), 38.

6. Pierre Fédida, *Des bienfaits de la dépression: Éloge de la psychothérapie* (Paris: Éditions Odile Jacob, 2001), 14 (my translation).

7. Janet M. Stoppard, *Understanding Depression: Feminist Social Constructionist Approaches* (New York: Routledge, 2000), 4–5.

8. Hubertus Tellenbach, *Melancholy: History of the Problem, Endogeneity, Typology, Pathogenesis, Clinical Considerations,* trans. Erling Eng (Pittsburgh: Duquesne University Press, 1980), 73: "Not in all, yet in many cases, one hears how guiltiness *from way back* is constantly recollected, that its weight cannot be lightened by any contrition, confession, penitence, or grace" (93).

9. Ibid., 97.

10. Ibid., 76.

11. Douglas Crimp, "The Melancholia of AIDS: Interview with Douglas Crimp," by Tina Takemoto, *Art Journal* 62, no. 4 (Winter 2003): 89.

12. See especially Alexandra Triandafillidis, *La dépression et son inquiétante familiarité* (Paris: Éditions Universitaires, 1991).

13. On this specific point, see François Lelord, "De la culpabilisation à la frustration," *Magazine littéraire* 411 (July–August 2002): 31.

14. For two insightful examinations of the Western development of the notion of melancholia, see Jackson, *Melancholia and Depression,* and Jennifer Radden, ed., *The Nature of Melancholy: From Aristotle to Kristeva* (New York: Oxford University Press, 2000). The following section relies substantially on both books and, more notably, on Radden's conclusions.

15. Robert Burton, *The Anatomy of Melancholy* (1621), ed. Holbrook Jackson, New York Review Books Classics (New York: New York Review of Books, 2001), 386–87.

16. Francesco Bonami, "Ugo Rondinone: 'Grounding,'" *Parkett* 52 (1998): 105.

17. Fédida, *Des bienfaits de la dépression,* 16.

18. Georges Costan, "La dépression se porte de mieux en mieux," *L'actualité médicale,* September 18, 2002, 33 (my translation).

19. Jackson, *Melancholia and Depression,* 99.

20. For descriptions of the Walcheturm installation, see mainly Daniel Kurjakovic, "Anywhere Out of the World! Le concept psychologique d'installation d'Ugo Rondinone," in *"Heyday": Ugo Rondinone* (Geneva: Centre d'Art Contemporain and Museum für Gegenwartskunst, 1996), n.p.; as well as Christophe Chérix, "Ugo Rondinone," trans. Christopher Martin, *Flash Art* 28, no. 183 (Summer 1995): 136–37; Johanna Hofleitner, "Ugo Rondinone," trans. Bibi Kamm, *Art and Text* 53 (January 1996): 85; Bonami, 108–9; Laura Hoptman, "Against Nature," *Parkett* 52 (1998): 133–34; and Hans Rudolf Reust, "Ugo Rondinone," trans. David Jacobson, *Artforum International* 34, no. 2 (October 1995): 109–10.

21. Bonami, "Ugo Rondinone," 108.

22. Jean-Étienne-Dominique Esquirol, *Mental Maladies: A Treatise on Insanity,* trans. E. K. Hunt (Philadelphia: Lea & Blanchard, 1845), 203, quoted in Jackson, *Melancholia and Depression,* 152.

23. Kurjakovic, "Anywhere Out of the World!"; Bonami, "Ugo Rondinone," 108.

24. Bonami, "Ugo Rondinone," 109.

25. Reust, "Ugo Rondinone," 109–10.

26. Hoptman, "Against Nature," 133–34.

27. René Ebtinger, *Ancolies: Approches psychanalytiques, phénoménologiques et esthétiques des mélancolies* (Strasbourg, France: Éditions Arcanes, Apertura, 1999), 250 (my translation).

28. Kevin Williams, *Understanding Media Theory* (London: Arnold, 2003), 63.

29. See Craig Owens, "The Allegorical Impulse: Toward a Theory of Postmodernism," in *Art after Modernism: Rethinking Representation,* ed. Brian Wallis, Documentary Sources in Contemporary Art 1 (New York: New Museum of Contemporary Art; Boston: Godine, 1984), originally published in *October* 12 (Spring 1980): 67–80, and 13 (Summer 1980): 59–80.

30. Douglas Crimp, "Pictures," in *Pictures* (New York: Artists Space, 1977), 3.

31. Douglas Crimp, "Pictures," in Wallis, *Art after Modernism,* 175, originally published in *October* 8 (Spring 1979): 75–88.

32. Ibid., 179–80.

33. Ibid., 181.

34. Ibid., 177.

35. Leo Steinberg, "Other Criteria," in *Other Criteria: Confrontations with Twentieth-Century Art* (New York: Oxford University Press, 1972), 82, 84.

36. Anne Rorimer, "Photography—Language—Context: Prelude to the 1980s," in *A Forest of Signs: Art in the Crisis of Representation,* ed. Catherine Gudis (Los Angeles: Museum of Contemporary Art; Cambridge, MA: MIT Press, 1989), 153.

37. Owens, "Allegorical Impulse," 204.

38. The expression is from Ann Goldstein, "Baim—Williams," in Gudis, *A Forest of Signs,* 30.

39. Owens, "Allegorical Impulse," 229.

40. Ibid. Owens quotes Crimp, "Pictures," in *Pictures,* 26.

41. Owens, "Allegorical Impulse," 233.

42. See n. 34.

43. On Rondinone's relation to the tradition of the *Wandermaler,* see Paolo Colombo, "Une autobiographie de la contradiction," trans. Françoise Senger, in *"Heyday".* On the technical details of the transfer from sketch to ink paintings, see notably Elizabeth Janus, "Ugo Rondinone," *Artforum International* 37, no. 3 (November 1998): 102–3.

44. Hoptman, "Against Nature," 134.

45. On the persistence of this double reading between copy and authenticity, see Jan Verwoert, "Pictures Came and Broke my Heart," *Parkett* 52 (1998): 126.

46. Ibid.

47. On the destabilization of identity in Rondinone's work, see Beatrix Ruf, "The Web That Has a Weaver," trans. Margret Powell-Joss, in *Ugo Rondinone: Guided by Voices* (Glarus, Switzerland: Kunsthaus Glarus; Leipzig, Germany: Galerie für Zeitgenössische Kunst Leipzig, 1999): "[S]table identity is increasingly replaced by transitory, ever renewable and newly realizable relationships among the increasingly undefinable, multiple and complex elements of the reality of modern, global living. In the description of these relationships, the position of the individual, or the formulation of a historical concept, is no longer clearly definable but increasingly in permanent flux" (1).

48. Stuart Hall, "Old and New Identities, Old and New Ethnicities," in *Culture, Globalization, and the World-System: Contemporary Conditions for the Representation of Identity,* ed. Anthony D. King (Binghamton: Department of Art and Art History, State University of New York at Binghamton, 1991), 44–45.

49. Donna J. Haraway, "A Cyborg Manifesto," in *Simians, Cyborgs, and Women: The Reinvention of Nature* (New York: Routledge, 1991), 150, 163–64; and Judith Butler, *Gender Trouble: Feminism and the Subversion of Identity* (New York: Routledge, 1991), 136, 140.

50. Freud, "Mourning and Melancholia," 49–50.

51. Karl Abraham, "Notes on the Psycho-analytical Investigation and Treatment of Manic-Depressive Insanity and Allied Conditions" (1911), in Coyne, *Essential Papers on Depression*, 31–47.

52. On these distinctions, also see Ebtinger, *Ancolies*, 25–26.

53. On this specific point, see Giorgio Agamben, *Stanzas: Word and Phantasm in Western Culture*, trans. Ronald L. Martinez (Minneapolis: University of Minnesota Press, 1993), 20–21, 25.

54. Jacques Hassoun, *La cruauté mélancolique* (1995; repr., Paris: Flammarion, 1997): "Car faire advenir dans la mélancolie *l'objet* comme 'perdu' suppose que c'est en tant que non-perdu (donc 'non advenu') qu'il se présente chez le mélancolique comme une cause de souffrance et de deuil impossible à accomplir auquel le sujet est soumis" (44). As Hassoun observes, this means that the melancholic subject experiences in fact the "absence of the lost object" (72). This view also supports Charity Scribner's reading of melancholia in comparison to nostalgia. Scribner stipulates that if the nostalgic "affixes himself to the object's loss, then the melancholic, in contradistinction, focuses on the lack that always inhered in the primordial lost object. The melancholic does not strive to recapture the lost object but, rather, aims at the lack that already resides within it." Charity Scribner, "Left Melancholy," in *Loss: The Politics of Mourning*, ed. David L. Eng and David Kazanjian (Berkeley and Los Angeles: University of California Press, 2003), 308–9.

55. On this specific point, see Jackson, *Melancholia and Depression*, 224–25.

56. Julia Kristeva, *Black Sun: Depression and Melancholia*, trans. Leon S. Roudiez (New York: Columbia University Press, 1989), 5. For the original French version, see *Soleil noir: Dépression et mélancolie* (Paris: Éditions Gallimard, 1987).

57. Verwoert, "Pictures Came," 127.

58. Kristeva, *Black Sun*, 12.

59. Max Pensky, *Melancholy Dialectics: Walter Benjamin and the Play of Mourning* (Amherst: University of Massachusetts Press, 1993), 2.

60. Ibid., 122–23. As Pensky observes, in melancholy allegory, "[t]he object fragmented and rescued from the abyss is rescued *as* hieroglyph, as rune, and is thus revivified as dead, empty, redeemed only as a meaningless image, in order to receive an assigned allegorical meaning. Image emblems pile up; they become material for allegorical construction, which seeks to make a coherent picture from them. This piling up of redeemed but now empty fragments shatters the mythic context of wholeness and completeness in which the fragments were initially presented. But so liberated, they become enigmatic and in this way point even more urgently to the crisis of meaning, the image world of natural history. The fragments become pieces of a mysterious puzzle waiting to be solved" (121).

61. Owens, "Allegorical Impulse," 206. For Walter Benjamin, see the concluding chapter of *The Origin of German Tragic Drama*, trans. John Osborne (London: New Left Books, 1977), especially 183–84: "If the object becomes allegorical under the gaze of melancholy, if melancholy causes life to flow out of it and it remains dead, but eternally secure, then it is exposed to the allegorist, it is unconditionally in his power. That is to say it is now quite incapable of emanating any meaning or significance of its own; such significance as it has, it acquires from the allegorist. He places within it, and stands behind it: not in a psychological but in an ontological sense." For Benjamin's

thoughts on melancholy in Baudelaire, see his *Charles Baudelaire: A Lyric Poet in the Era of High Capitalism,* trans. Harry Zohn (London: New Left Books, 1973).

62. Benjamin Buchloh, "Allegorical Procedures: Appropriation and Montage in Contemporary Art," *Artforum International* 30, no. 1 (September 1982): 52–53.

63. Owens, "Allegorical Impulse," 235.

64. For Benjamin's condemnation of leftist melancholia, see Walter Benjamin, "Linke Melancholie: Zum Erich Kästner's neuem Gedichtbuch" (1931), in *Gesammelte Schriften,* ed. Rolf Tiedemann and Hermann Schweppenhäuser (Frankfurt: Suhrkamp Verlag, 1972–89), 3:279–83. For his theoretical investigation of melancholia as a critical way of seeing, see notably Benjamin, *Origin of German Tragic Drama.*

65. Leon Battista Alberti, *On Painting* (1435–36), trans. John R. Spencer, rev. ed. (New Haven: Yale University Press, 1966), 78. On the specific figure of the commentator, or *abnomiteur,* see Spencer's introduction to Alberti, 26; and René Payant, *Vedute: Pièces détachées sur l'art, 1976–1987* (Laval, QC: Éditions Trois, 1987), 155.

66. For a description of *Sleep,* see especially Ruf, "Web That Has a Weaver," 4–5; and Jan Avgikos, "The Land of Happy," trans. Margret Powell-Joss, in *Ugo Rondinone: Guided by Voices,* 10–11.

67. Avgikos, "Land of Happy," 11.

68. For this section, I rely mostly on Klibansky, Panofsky, and Saxl, *Saturn and Melancholy*; Tellenbach, *Melancholy*; Jackson, *Melancholia and Depression*; Pensky, *Melancholy Dialectics*; and Radden, *Nature of Melancholy.*

69. Hippocrates' *Nature of Man* (fifth century BC) is posited as establishing the black bile as one of the four natural humors. It also formulated the humoral theory, which would persist at least until the eighteenth century along with its fundamental assumption that the black bile was the essential bodily ingredient in the pathogenesis of melancholia. See Jackson, *Melancholia and Depression,* 7–8. Also see Pensky, *Melancholy Dialectics,* 23.

70. See Jackson, *Melancholia and Depression,* 31.

71. Aristotle, *Problemata* 30.1.54; text reproduced in Klibansky, Panofsky, and Saxl, *Saturn and Melancholy,* 18. In Jackson's quotation of the same passage, "melancholics" is replaced by "of an atrabilious temperament" (*Melancholia and Depression,* 31).

72. Klibansky, Panofsky, and Saxl, *Saturn and Melancholy,* 17.

73. Aristotle, *Problemata* 30.1.54, in ibid., 24.

74. See ibid., 25: "[T]he melancholy temperament, just as it produces illnesses with a variety of symptoms, is itself variable, for like water it is sometimes cold and sometimes hot. Therefore if it so happens that something alarming is announced at a time when the admixture is rather cold, then it makes a man cowardly;—for it has prepared a way for the fear, and fear makes one cold, as is shown by the fact that those who are frightened tremble.—If however the mixture is rather warm, fear reduces it to a moderate temperature and so he is self-possessed and unmoved."

75. I am paraphrasing here psychiatrist Hubertus Tellenbach, who stipulates that "Aristotle ties together the elements of melancholy and genius." Tellenbach, *Melancholy,* 11.

76. Aristotle, *Problemata* 30.1.54, in Klibansky, Panofsky, and Saxl, *Saturn and Melancholy,* 23.

77. Agamben, *Stanzas,* 12.

78. Klibansky, Panofsky, and Saxl, *Saturn and Melancholy,* 79.

79. Tellenbach, *Melancholy,* 15–16.

80. Agamben, *Stanzas,* 12.

81. Marsilio Ficino, quoted in Klibansky, Panofsky, and Saxl, *Saturn and Melancholy,* 259–60.

82. Klibansky, Panofsky, and Saxl, *Saturn and Melancholy*, 265–66.

83. Ibid., 271.

84. Ibid., 246–47.

85. Ibid., 284.

86. Ibid., 303–4.

87. Ibid., 304.

88. Erwin Panofsky and Fritz Saxl, *Dürer's "Melencolia I": Eine quellen- und typengeschicht-liche Untersuchung*, Studien der Bibliothek Warburg 2 (Leipzig, Germany: Teubner, 1923). For an examination of heroic melancholia and its elaboration in Warburg's and Panofsky's studies on Dürer's *Melencolia I*, see Pensky, *Melancholy Dialectics*, 97–107. More on this later in this chapter.

89. Klibansky, Panofsky, and Saxl, *Saturn and Melancholy*, 316.

90. Ibid., 317–18.

91. Ibid., 317.

92. Ibid., 340.

93. Ibid., 345.

94. Ibid., 346–47.

95. As Agamben points out, this is the traditional art historical interpretation, one that he fundamentally questions. See *Stanzas*, 26.

96. Klibansky, Panofsky, and Saxl, *Saturn and Melancholy*, 349.

97. In their historical overview of the emergence and development of the association of art and melancholia, Rudolf and Margot Wittkower observe that pseudo-Aristotle's famous statement that "all extraordinary men distinguished in philosophy, politics, poetry and the arts are evidently melancholic" does not imply that the genius is mad or mentally ill. According to the Aristotelian reformulation of Hippocratic humoral theory, *Homo melancholicus* depended on a particular balance of humors—one that could either characterize the person of distinction or, if the balance was not right, articulate a shift into mental illness. As the Wittkowers maintain, the melancholic is a precarious being, for "if the black bile is not properly tempered (by yellow bile, phlegm, and blood), it may produce depression, epilepsy, palsy, lethargy, and what we would nowadays call anxiety complexes." See Rudolf Wittkower and Margot Wittkower, *Born under Saturn: The Character and Conduct of Artists; A Documented History from Antiquity to the French Revolution* (London: Shenval, 1963), 102.

98. Klibansky, Panofsky, and Saxl, *Saturn and Melancholy*, 255–56, 263, 266–67.

99. See n. 83.

100. Pensky, *Melancholy Dialectics*, 104.

101. Ibid., 105. This dialectic becomes manifest in Benjamin's statement that melancholy—in the great baroque playwrights, who depicted a religiously shattered world, but also in Baudelaire's allegories and Proust's reminiscences—"betrays the world for the sake of knowledge. But in its tenacious self-absorption it embraces dead objects in its contemplation, in order to rescue them." See Benjamin, *Origin of German Tragic Drama*, 157.

102. See Agamben, *Stanzas*, 24–25.

103. Romano Alberti, *Trattato della nobiltà della pittura* (1585), trans. and quoted in Agamben, *Stanzas*, 25.

104. Agamben, *Stanzas*, 25.

105. Sarah Kofman, *Mélancolie dans l'art* (Paris: Éditions Galilée, 1985), 11–12, 15 (all quotations my translation).

106. Ibid., 20.

107. Ibid., 21–22.

108. Ibid., 40.

109. Ibid., 60.

110. Agamben, *Stanzas,* 26. This interpretation is supported by the *putto* (winged cherub) in Dürer's engraving, identified as "Practice" by Klibansky, Panofsky, and Saxl but reidentified by Agamben as *erotes: spiritus phantasticus,* "the magic vehicle of love." The figure of love is essential here, for if we resituate melancholy (as Agamben does) in the light of the medieval and Renaissance theory of the *spiritus phantasticus,* the syndrome is returned to the context of the theory of love, "as the phantasm was, at once, the object and vehicle of the act of falling in love, and love itself a form of *solicitudo melancholica* (melancholy diligence)" (27 n. 6). The note also includes Agamben's reinterpretation of the bat, which in Dürer's work is represented holding the scroll with the inscription "Melencolia I."

111. Ibid., 26.

112. Bonami, "Ugo Rondinone," 108.

113. On Rondinone's clowns, see notably Éric Troncy, "Ugo Rondinone: Where Do We Go, Ugo? Clown and Out with Ugo Rondinone," *Art Press* 227 (September 1997): 32–37; Rein Wolfs, "Clown and World," in *"Heyday,"*; Ruf, "Web That Has a Weaver," 1–2; Jan Winkelmann, "The Happy Clown: Aspects of Ugo Rondinone's Work between Slow Motion and Authenticity," 14–18; Hoptman, "Against Nature," 136; Philippe Régnier, "Les clowns tristes atteignent leurs cibles: Ugo Rondinone au Consortium à Dijon," *Le journal des arts* 33 (February 1997): 12; Pierre-André Lienhard, "Ugo Rondinone: A Great Joker Facing the Universe," XXIII Bienal Internacional de São Paulo, 1996, http://www.uol.com.br/23bienal/paises/ipch.htm; and Pierre-André Lienhard, "Portraits of the Artist as a Clown: From Flight to Immobility," in *Ugo Rondinone: No How On; Kunsthalle Wien, June 28–September 22, 2002,* ed. Gerald Matt (Cologne, Germany: König, 2002), n.p.

114. On the 1996 initial version, see Janus, "Ugo Rondinone": "In 1996, at Zurich's Museum für Gegenwartskunst, [Rondinone] created an installation bringing together live actors, sound, painting, and video and took the figure of the clown as its centre-piece. At the show's opening, several paunchy, middle-aged men made up as clowns lounged lazily on the floor of one of the museum's galleries, moving only to change position or to yawn. Fits of hysterical laughter could be heard from hidden speakers activated by sensors whenever a visitor entered. For the rest of the exhibition's run, the clowns were replaced by their videotaped likeness on monitors set up precisely where each clown sat. . . . If the ensemble's initial effect was carnivalesque, with time, a creeping sense of unanswered expectations, boredom, and emptiness took over. This was due partly to the fact that the clowns never performed (they barely moved) and partly to their pathetic appearance. Rondinone's buffoon is a tragic everyman caught between the banality of his own life and his job of making us forget the banality of ours" (102).

115. Catherine Millet, "On a changé la Biennale de Sao Paulo," trans. L.-S. Torgoff, *Art Press* 220 (January 1997): 78.

116. Lienhard, "Portraits of the Artist as a Clown," 20.

117. See n. 6.

118. See n. 17.

119. On the "image" transformation of the posing sitter, see Roland Barthes, *Camera Lucida: Reflections on Photography,* trans. Richard Howard (New York: Hill & Wang, 1981), 10.

120. Craig Owens, "Posing," in *Beyond Recognition: Representation, Power, and Culture,* ed.

Scott Bryson, Barbara Kruger, Lynne Tillman, and Jane Weinstock (Berkeley and Los Angeles: University of California Press, 1992), 210.

121. In the white clown projection, a sentence uttered by a woman and recorded on tape, extracted from Wim Wenders's *Paris, Texas* (1984)—a film that is significantly about a man's wandering search for his loved one—is played approximately every three minutes: "Yep! I know that feeling." For the sake of clarity (my emphasis in this section is on the quasi-immobility of the clown in Rondinone's installation), I will not be addressing the film quotations that abound in Rondinone's video works. Suffice it to say here that his visual and aural quotations of films by Wenders and Antonioni, in particular, work to consolidate a melancholy state. But in this specific projection and in many video installations produced between 2000 and 2002, the modalities of reproduction of the quotations elaborate the passage from melancholy to depression. Here, the repetition of the sentence, its near intelligibility, and the fact that it has obviously been recorded and uttered by someone other than the clown act together to dementalize the subject, consolidating its depressiveness.

122. Barthes, *Camera Lucida*.

123. Fédida, *Des bienfaits de la dépression*, 219.

124. Ibid., 46.

125. Triandafillidis, *La dépression et son inquiétante familiarité*, 145–49 (my translation).

126. For descriptions of Bruce Nauman's *Clown Torture*, see J. E. R., "Bruce Nauman," in "Modern and Contemporary Art: The Lannan Collection at the Art Institute of Chicago," special issue, *Museum Studies* 25, no. 1 (1999): 62–63; and "Bruce Nauman," in "Art in the Twenty-First Century," 2003, PBS, http://www.pbs.org/art21/artists/nauman/card2.html.

127. Peter Schjeldahl, "The Trouble with Nauman," *Art in America* 82, no. 4 (April 1994): 85. This article provides an insightful critical reading of Nauman's production at large.

128. Richard Dorment, "Bruce Nauman: Words Are All We Have," review, http://www.theartnewspaper.com/artcritic/level1/reviewarchive/1998/jul_22_1998_main.html.

129. Ugo Rondinone, interviewed in Régnier, "Les clowns tristes atteignent leurs cibles," 12 (my translation).

130. Jean Starobinski, *Portrait de l'artiste en saltimbanque* (Geneva: Éditions d'Art Albert Skira, 1970), 9 (all quotations my translation).

131. Ibid., 86–88.

132. Ibid., 94–95.

133. Ibid.

2. The Laboratory of Deficiency

1. Melanie Klein, *Contributions to Psycho-analysis, 1921–1945*, International Psycho-analytical Library 34 (London: Hogarth, 1948), 312.

2. Ibid., 290. Also see Stanley W. Jackson, *Melancholia and Depression: From Hippocratic Times to Modern Times* (New Haven: Yale University Press, 1986), 230–33.

3. Melanie Klein, *Love, Guilt, and Reparation and Other Works* (1940; repr., London: Hogarth, 1975). For an insightful description of the Kleinian depressive position, see Alexandra Triandafillidis, *La dépression et son inquiétante familiarité* (Paris: Éditions Universitaires, 1991), 53–57.

4. Melanie Klein, "The Depressive Position," in *The Nature of Melancholy: From Aristotle to Kristeva,* ed. Jennifer Radden (Oxford: Oxford University Press, 2000), 298.

5. Pierre Fédida, *Des bienfaits de la dépression: Éloge de la psychothérapie* (Paris: Éditions Odile Jacob, 2001), 16 (all quotations my translation).

6. Ibid., 15.

7. Judith Butler, *Gender Trouble: Feminism and the Subversion of Identity* (New York: Routledge, 1991), 66–67.

8. Jean-Luc Nancy, *The Birth to Presence*, trans. Brian Holmes (Stanford: Stanford University Press, 1993), 10.

9. Warren Kidd, *Culture and Identity*, Skills-Based Sociology (Basingstoke, UK: Palgrave Macmillan, 2001), 25.

10. Julia Kristeva, *Powers of Horror: An Essay on Abjection*, trans. Leon S. Roudiez (New York: Columbia University Press, 1982).

11. On the loss of self in depression, see notably Dana Crowley Jack, *Silencing the Self: Women and Depression* (Cambridge: Harvard University Press, 1991); David A. Karp, *Speaking of Sadness: Depression, Disconnection, and the Meanings of Illness* (New York: Oxford University Press, 1996); Janet M. Stoppard, *Understanding Depression: Feminist Social Constructionist Approaches* (London: Routledge, 2000); and Fédida, *Des bienfaits de la dépression.*

12. Vanessa Beecroft, quoted in Michelle Falkenstein, "What's So Good about Being Bad? The Art World's Angry Young Women," *ARTnews* 98, no. 10 (November 1999): 159.

13. Vanessa Beecroft, quoted in Dodie Kazanjian, "The Body Artist," *Vogue,* April 2001, 406.

14. Beecroft has produced a few all-male performances. To date, however, they have been marginal in Beecroft's work, and they integrate homogeneity through the military. Her first all-male performance was presented in 1999. Entitled *VB39,* it brought together United States Navy SEALs from the Naval Special Warfare Command in San Diego. The SEALs were invited to stand at attention in the Farris Galleries at the San Diego Museum of Contemporary Art, dressed in their immaculate summer whites. The military theme was reused in *VB42 Intrepid—The Silent Service* (2000), involving the Intrepid Sea, Air, and Space Museum, housed on an aircraft-carrier museum berthed at a Hudson River pier, in which she staged a group of navy men and women standing at attention. For a critical reading of *VB39,* see Norman Bryson, "US NAVY SEALS," *Parkett* 56 (1999): 78–79. For a brief review of *VB42,* see Edward Leffingwell, "Vanessa Beecroft aboard the USS Intrepid," *Art in America* 88, no. 10 (October 2000): 168. Although *VB39* raised interesting issues with regard to the possibility of masculinizing the female role of to-be-looked-at-ness, I will be focusing here on Beecroft's female performances.

15. Elizabeth Janus, "Openings: Vanessa Beecroft," *Artforum International* 33, no. 9 (May 1995): 92.

16. Beecroft herself states that "nothing happens" in her performances; quoted in Barbara S. Polla, "Young Artists' Performances in the Nineties: Acts and Signs," *Semiotica* 122, nos. 3–4 (1998): 340.

17. On these typical instructions, see Keith Seward, "Classic Cruelty," *Parkett* 56 (1999): 100.

18. Jan Avgikos, "Let the Picture Do the Talking," *Parkett* 56 (1999): 106.

19. Janus, "Openings," 92.

20. Clarisse Hahn, "Vanessa Beecroft," *Art Press* 221 (February 1997): 69.

21. The inextricability of Beecroft's performances and her anorexic-bulimic disorder have been confirmed in a recent interview. See Judith Thurman, "The Wolf at the Door: Vanessa Beecroft's Provocative Art Is Inextricably Tied to Her Obsession with Food," *New Yorker,* March 17, 2003, 84–123.

22. Ibid., 114.

23. For a short description of *VB52*, see Adriana Polveroni, "Beecroft, un banchetto tra rinascimento e surrealismo," *La repubblica,* October 7, 2003, http://www.repubblica.it/2003/sezioni/spettacoli_e_cultura/beecroft/beecroft/beecroft.html.

24. Ann Elgood, curatorial associate at the New Museum of Contemporary Art in New York, quoted in Falkenstein, "What's So Good about Being Bad?" 159.

25. Wayne Koestenbaum, "Bikini Brief," *Artforum International* 36, no. 10 (Summer 1998): 24. *Interior Scroll* was initially presented in 1975, at the "Women Here and Now" festival in East Hampton, Long Island.

26. See, for example, Kazanjian, "Body Artist," 273–377, 406.

27. Laura Mulvey, "Visual Pleasure and Narrative Cinema," *Screen* 6 (Fall 1975): 6–18, reprinted in *Art after Modernism: Rethinking Representation,* ed. Brian Wallis (New York: New Museum of Contemporary Art; Boston: Godine, 1984), 361–73.

28. Avgikos, "Let the Picture Do the Talking," 108.

29. Elizabeth Janus, "Vanessa Beecroft," *ARTnews* 98, no. 6 (June 1999): 144.

30. Kazanjian, "Body Artist," 373.

31. Cherry Smyth, "Vanessa Beecroft," *Art Monthly* 240 (October 2000): 34.

32. Claire Bishop, "Vanessa Beecroft VB43," *Make: The Magazine of Women's Art* 88 (June–August 2000): 31–32.

33. Avgikos, "Let the Picture Do the Talking," 108.

34. Michel Foucault, "Nietzsche, Genealogy, History," in *The Foucault Reader,* ed. Paul Rabinow (New York: Pantheon, 1984), 88.

35. Avgikos, "Let the Picture Do the Talking," 108–9.

36. On this, see especially Susan Bordo, "The Body and the Reproduction of Femininity," in *Writing on the Body: Female Embodiment and Feminist Theory,* ed. Kate Conboy, Nadia Medina, and Sarah Stanbury (New York: Columbia University Press, 1997), 90–110; and Susan Bordo, *Unbearable Weight: Feminism, Western Culture, and the Body* (Berkeley and Los Angeles: University of California Press, 1993).

37. Gaby Wood, "Call Me a Feminist," *Observer,* September 16, 2001, review section.

38. Heather Cassils, in an interview by the author, Montreal, June 13, 2002.

39. Clover Leary, from a written interview by the author, May 10, 2002.

40. American Psychiatric Association, *Diagnostic and Statistical Manual of Mental Disorders,* 4th ed. (Washington, DC: American Psychiatric Association).

41. Jonathan Crary, *Techniques of the Observer: On Vision and Modernity in the Nineteenth Century* (Cambridge: MIT Press, 1991), 6.

42. On the notion of identification with death, see Triandafillidis, *La dépression et son inquiétante familiarité.*

43. On the controversy between the dimensional versus the categorical, see Paul Gilbert, *Depression: The Evolution of Powerlessness* (New York: Guilford, 1992), 23.

44. James C. Coyne, "Ambiguity and Controversy: An Introduction," in *Essential Papers on Depression,* ed. James C. Coyne (New York: New York University Press, 1986), 4.

45. See Stoppard, *Understanding Depression,* 8.

46. Armand W. Loranger, "Categorical Approaches to Assessment and Diagnosis of Personality Disorders," in *Personality and Psychopathology,* ed. C. Robert Cloninger (Washington, DC: American Psychiatric Press, 1999), 203.

47. Ibid.

48. Lee Anna Clark, "Dimensional Approaches to Personality Disorder Assessment and Diagnosis," in Cloninger, *Personality and Psychopathology*, 221.

49. Ibid.

50. Li-Shiun Chen et al., "Empirical Examination of Current Depression Categories in a Population-Based Study: Symptoms, Course, and Risk Factors," *American Journal of Psychiatry* 157, no. 4 (April 2000): 573–74; and Martin B. Keller et al., "Results of the DSM–IV Mood Disorders Field Trial," *American Journal of Psychiatry* 152, no. 6 (June 1995): 843–49.

51. Chen et al., "Empirical Examination," 574.

52. Stoppard, *Understanding Depression*, 35.

53. James C. Coyne, "Self-Reported Distress: Analog or Ersatz Depression?" *Psychological Bulletin* 116 (1994): 29–45.

54. Chen et al., "Empirical Examination," 574, 579.

55. Constance Hammen, *Depression* (Hove, UK: Psychology Press, 1997), 21.

56. Ibid. Also see W. E. Broadhead et al., "Depression, Disability Days, and Days Lost from Work in a Prospective Epidemiologic Survey," *Journal of the American Medical Association* 264 (1990): 2524–28.

57. See Dan G. Blazer et al., "The Prevalence and Distribution of Major Depression in a National Community Sample: The National Comorbidity Survey," *American Journal of Psychiatry* 151, no. 7 (July 1994): 979–86; and Hammen, *Depression*, 19, 44.

58. National Institute of Mental Health, *The Invisible Disease: Depression* (Bethesda, MD: National Institutes of Health, August 2003), Medem, http://www.medem.com/search/article_display.cfm?path=n:&mstr.

59. Tanya M. Luhrmann, *Of Two Minds: The Growing Disorder in American Psychiatry* (New York: Knopf, 2001), 48.

60. Murray B. Stein et al., "Social Anxiety Disorder and the Risk of Depression," *Archives of General Psychiatry* 58, no. 3 (March 2001): 251–56; Aartjan T. F. Beekman et al., "Anxiety and Depression in Later Life: Co-occurrence and Communality of Risk Factors," *American Journal of Psychiatry* 157, no. 1 (January 2000): 89–95; Mark Zimmerman, Wilson McDermut, and Jill L. Mattia, "Frequency of Anxiety Disorders in Psychiatric Outpatients with Major Depressive Disorder," *American Journal of Psychiatry* 157, no. 8 (August 2000): 1337–40; and Lee Anna Clark and David Watson, "Theoretical and Empirical Issues in Differentiating Depression from Anxiety," in *Psychological Aspects of Depression*, ed. Joseph Becker and Arthur Kleinman (Hillsdale, NJ: Erlbaum, 1991), 39–65.

61. See, for example, George W. Brown and Tirril Harris, *Social Origins of Depression: A Study of Psychiatric Disorder in Women* (London: Tavistock, 1978), who raise the question of the difference between clinical depression and disturbance of mood: "The answer is that there is no general agreement. In practice psychiatrists have given the name depression to a wide variety of clusters of symptoms" (23).

62. Hammen, *Depression*, 25.

63. Richard West, *Depression* (London: Office of Health Economics, 1992), 3.

64. David Healy, *The Antidepressant Era* (Cambridge: Harvard University Press, 1997), 178.

65. Coyne, "Ambiguity and Controversy," 1–2.

66. Fédida, *Des bienfaits de la dépression*, 209–10. Fédida speaks more specifically of the *"à-peine-notion"* of depression.

67. For statistics, see West, *Depression,* 3; Kenneth B. Wells et al., *Caring for Depression* (Cambridge: Harvard University Press, 1996), 30–31; Michael Thase, "Relapse and Recurrence of Depression: An Updated Practical Approach for Prevention," in *Drug Treatment Issues in Depression,* ed. Katherine J. Palmer (Auckland, NZ: Adis International, 2000), 35–36; Caroline Carney Doebbeling, "Epidemiology, Risk Factors, and Prevention," in *Depression,* ed. James L. Levenson (Philadelphia: American College of Physicians, 2000), 23–27; David Healy, "The Antidepressant Drama," in *Treatment of Depression: Bridging the 21st Century,* ed. Myrna M. Weissman (Washington, DC: American Psychiatric Press, 2001), 26; and T. Bedirhan Üstün, "The Worldwide Burden of Depression in the 21st Century," in Weissman, *Treatment of Depression,* 43. The Global Burden of Disease study was conducted in 1996 by the World Health Organization and the World Bank. Findings were published in Christopher J. L. Murray and Alan D. Lopez, *The Global Burden of Disease: A Comprehensive Assessment of Mortality and Disability from Diseases, Injuries, and Risk Factors in 1990 and Projected to 2020* (Cambridge: Harvard School of Public Health on behalf of the World Health Organization and the World Bank, 1996).

68. Üstün, "Worldwide Burden of Depression," 39–40.

69. Allan V. Horwitz, *Creating Mental Illness* (Chicago: University of Chicago Press, 2002).

70. For two insightful examinations of the Western development of the notion of melancholia, see Jackson, *Melancholia and Depression*; and Jennifer Radden, "From Melancholic States to Clinical Depression," introduction to Radden, *Nature of Melancholy,* 3–54. The following section relies substantially on both works and, more notably, on Radden's conclusions.

71. Radden, "From Melancholic States," 48–49.

72. Ibid., 40–41.

73. Jean-Étienne-Dominique Esquirol, *Mental Maladies: A Treatise on Insanity,* trans. E. K. Hunt (Philadelphia: Mathew Carey, 1845), quoted in both ibid., 42; and Jackson, *Melancholia and Depression,* 153.

74. Emil Kraepelin, quoted in Radden, "From Melancholic States," 42.

75. Radden, "From Melancholic States," 43. Also see Francis G. Gosling, *Before Freud: Neurasthenia and the American Medical Community, 1870–1910* (Urbana: University of Illinois Press, 1987).

76. These statistics are based on Darrel A. Regier et al., "The De facto Mental and Addictive Disorders Service System: Epidemiologic Catchment Area Prospective 1-year Prevalence Rates of Disorders and Services," *Archives of General Psychiatry* 50, no. 2 (1993): 85–94.

77. This study is cited in Jean A. Hamilton and Margaret Jensvold, "Sex and Gender as Critical Variables in Feminist Psychopharmacology Research and Pharmacology," *Women and Therapy,* 16 (1995): 11.

78. Alain Ehrenberg, *La fatigue d'être soi: Dépression et société* (Paris: Éditions Odile Jacob, 1998).

79. Stoppard, *Understanding Depression,* 92.

80. Ibid., 93–97.

81. See, for example, Anne E. Figert, *Women and the Ownership of PMS: The Structuring of a Psychiatric Disorder* (New York: Aldine de Gruyter, 1996), on how the categorization of "premenstrual dysphoric disorder" as a psychiatric disorder has led to an increase in the development of medication for PMS sufferers.

82. Stoppard, *Understanding Depression,* 92. Stoppard's inscription of identification failure in processes of contemporary subjectivity partially relies on Judith Butler's performative view

of subjectivity, which posits that the subject is constituted rather than constituting (power being what both "acts on" and "enacts" the subject into being) and that identity can come into being only through failed (melancholic) identifications with social norms. See especially Judith Butler, *The Psychic Life of Power: Theories in Subjection* (Stanford: Stanford University Press, 1997), 13.

83. Stoppard, *Understanding Depression,* 107–8.

84. Ibid., 108.

85. Ibid., 209.

86. Ibid.

87. Fédida, *Des bienfaits de la dépression,* 209.

88. Charles DeBattista, David L. Smith, and Alan F. Schatzberg, "Psychopharmacology," in Levenson, *Depression,* 97–103. On the predominance of the disease model in psychiatric practice, see Luhrmann, *Of Two Minds.*

89. Healy, "Antidepressant Drama," 17, 19, 21. On the impact of the disease model, also see Murray and Lopez, *Global Burden of Disease.*

90. Bordo, "Body and the Reproduction of Femininity," 93.

91. Ibid., 95–96.

92. Susan Bordo, "Reading the Slender Body," in *Unbearable Weight,* 198.

93. Ibid., 201–3.

94. Ibid., 198; and Bordo, "Body and the Reproduction of Femininity," 99.

95. Bordo, "Body and the Reproduction of Femininity," 91.

96. Foucault, "Nietzsche, Genealogy, History," 83.

97. Lynda Nead, *The Female Nude: Art, Obscenity, and Sexuality* (London: Routledge, 1992), especially chap. 1.

98. Margrit Shildrick, *Leaky Bodies and Boundaries: Feminism, Postmodernism, and (Bio)Ethics* (London: Routledge, 1997), 31–41.

99. See n. 12.

100. Beecroft, quoted in Kazanjian, "Body Artist," 376.

101. Beecroft, quoted in Falkenstein, "What's So Good about Being Bad?" 159.

102. See n. 12.

103. Koestenbaum, "Bikini Brief," 23–24.

104. Peter Schjeldahl, quoted in Kazanjian, "Body Artist," 373.

105. See n. 39.

106. Michel Foucault, "Sexuality and Solitude," in *On Signs,* ed. Marshall Blonsky (Baltimore: The Johns Hopkins University Press, 1985), 367. On this point, also see Shildrick, *Leaky Bodies and Boundaries,* 54–55.

107. These are some of the attitudes suggested by Vanessa Beecroft in a handout given to the models for *VB46.*

108. Smyth, "Vanessa Beecroft," 240.

109. Hahn, "Vanessa Beecroft," 69.

110. Cassils, interview.

111. Pier Luigi Tazzi, "Parades," *Parkett* 56 (1999): 95.

112. Janus, "Openings," 92.

113. For a useful overview of the cognitive approach to depression, see Norman B. Schmidt, Kristen L. Schmidt, and Jeffery E. Young, "Schematic and Interpersonal Conceptualizations of Depression: An Integration," in *The Interactional Nature of Depression: Advances in Interpersonal*

Approaches, ed. Thomas E. Joiner and James C. Coyne (Washington, DC: American Psychological Association, 1999), 127–48.

114. Robert E. Becker and Richard G. Heimberg, "Cognitive-Behavorial Treatments for Depression: A Review of Controlled Clinical Research," in *Depression in Multidisciplinary Perspective,* ed. Alfred Dean (New York: Brunner/Mazel, 1985), 217.

115. Martin E. P. Seligman, *Helplessness: On Depression, Development, and Death* (New York: Freeman, 1975). For a general discussion about helplessness and hopelessness theories, see Schmidt, Schmidt, and Young, "Schematic and Interpersonal Conceptualizations of Depression."

116. Lyn Y. Abramson, Martin E. P. Seligman, and John D. Teasdale, "Learned Helplessness in Humans: Critique and Reformulation," in Coyne, *Essential Papers on Depression,* 260.

117. On Beck's theory of depression, see Aaron T. Beck, *Depression: Causes and Treatment* (Philadelphia: University of Pennsylvania Press, 1967).

118. Aaron Beck, quoted in Becker and Heimberg, "Cognitive-Behavorial Treatments for Depression," 218.

119. American Psychiatric Association, *Practice Guideline for the Treatment of Patients with Major Depressive Disorder,* 2nd ed. (Washington, DC: American Psychiatric Association, 2000), 32.

120. Coyne, "Self-Reported Distress." See also Stoppard, *Understanding Depression,* 44.

121. Stoppard, *Understanding Depression,* 44; and Lisa A. Spielman and John A. Bargh, "Does the Depressive Self-Schema Really Exist?" in *Depression: New Directions in Theory, Research, and Practice,* ed. Douglas McCann and Norman S. Endler (Toronto: Wall Editions, 1990), 119.

122. Nicholas A. Kuiper, L. Joan Olinger, and Rod A. Martin, "Are Cognitive Approaches to Depression Useful?" in McCann and Endler, *Depression,* 56.

123. See Aaron T. Beck, "Beyond Belief: A Theory of Modes, Personality, and Psychopathology," and David A. Clark and Robert A. Steer, "Empirical Status of the Cognitive Model of Anxiety and Depression," in *Frontiers of Cognitive Therapy,* ed. Paul M. Salkovskis (New York: Guilford, 1996), 1–25 and 75–96, respectively.

124. Clark and Steer, "Empirical Status of the Cognitive Model," 81.

125. Beck, "Beyond Belief"; and Robert A. Steer, *Manual for the Revised Beck Depression Inventory* (San Antonio, TX: Psychological Corporation, 1987).

126. Kuiper, Olinger, and Martin, "Are Cognitive Approaches to Depression Useful?" 68.

127. Tom Pyszczynski and Jeff Greenberg, *Hanging On and Letting Go: Understanding the Onset, Progression, and Remission of Depression* (New York: Springer-Verlag, 1992), 8.

128. Ibid., 9.

129. Ibid., 59.

130. James P. McCullough, *Treatment for Chronic Depression: Cognitive Behavioral Analysis System of Psychotherapy (CBASP)* (New York: Guilford, 2000), 14–15.

131. American Psychiatric Association, *Practice Guideline,* 33.

132. Charles J. Holahan, Rudolph H. Moos, and Liza A. Bonin, "Social Context and Depression: An Integrative Stress and Coping Framework," in Joiner and Coyne, *Interactional Nature of Depression,* 41.

133. As noted earlier, in his examination of the creation of mental illness, sociologist Allan Horwitz has extended the emphasis on coping styles by proposing that nonpsychotic forms of depression should not be diagnosed as mental illnesses, as they predominantly are now, when they are adequate responses to stressful life events and that only depressions occurring without apparent cause should be considered a disease. To put it differently, only coping styles that are

maladaptive, such as disproportionate sadness or fatigue following the rupture of a relationship, should be classified as indicative of a mental disorder. Although Horwitz leaves open the question as to what constitutes an appropriate versus an inappropriate coping style, he maintains that appropriateness is not a natural value but a culturally defined notion. Following the work of J. C. Wakefield, he defines mental disorders as "internal dysfunctions that a particular culture defines as inappropriate." See Horwitz, *Creating Mental Illness,* 12.

134. Gilbert, *Depression,* 405–6.

135. Jaqueline B. Persons, Joan Davidson, and Michael A. Tompkins, *Essential Components of Cognitive-Behavior Therapy for Depression* (Washington, DC: American Psychological Association, 2001), 33.

136. McCullough, *Treatment for Chronic Depression,* 240.

137. Jon McKenzie, *Perform or Else: From Discipline to Performance* (London: Routledge, 2001), 6.

138. *Leadership and Motivation: Essays of Douglas MacGregor,* ed. Warren G. Bennis and Edgar H. Schein, with the collaboration of Caroline MacGregor (Cambridge: MIT Press, 1966), 15, 19.

139. McKenzie, *Perform or Else,* 56.

140. Ehrenberg, *La fatigue d'être soi,* 10; and Alain Ehrenberg, "Des troubles du désir au malaise identitaire," *Magazine littéraire* 411 (July–August 2002): 24 (all quotations my translation). Slavoj Žižek, in *The Ticklish Subject: The Absent Centre of Political Ontology* (London: Verso, 1999), speaks similarly about the decline of Oedipus: "So when, today, one speaks of the decline of paternal authority, it is *this* father, the father of the uncompromising 'No!', who is effectively in retreat; in the absence of his prohibitory 'No!', new forms of the phantasmatic harmony between the symbolic order and *jouissance* can thrive again" (322).

141. Ehrenberg, "Des troubles du désir," 26.

142. Ibid.

143. Ehrenberg, *La fatigue d'être soi,* 14.

3. Image-Screens, or The Aesthetic Strategy of Disengagement

1. Jean-Marie Schaeffer, *Adieu à l'esthétique* (Paris: Presses Universitaires de France, 2000), 17 (all quotations my translation).

2. Ibid., 45.

3. Ibid., 26. In the same line of thought, see Gérard Genette, "La clé de Sancho," *Poétique* 101 (1995): "[C]e n'est pas l'objet qui rend la relation esthétique, mais la relation qui rend l'objet esthétique" (16).

4. See Nelson Goodman, *Languages of Art* (Oxford: Oxford University Press, 1968), and *Ways of Worldmaking* (Indianapolis: Hackett, 1978); and Arthur Danto, *The Transfiguration of the Commonplace* (Cambridge: Harvard University Press, 1981), and *The Philosophical Disenfranchisement of Art* (New York: Columbia University Press, 1986).

5. Richard Shusterman, *Performing Live: Aesthetic Alternatives for the Ends of Art* (Ithaca: Cornell University Press, 2000), 30.

6. Schaeffer, *Adieu à l'esthétique,* 49.

7. Jean-Marie Schaeffer, *Les célibataires de l'art: Pour une esthétique sans mythes* (Paris: Gallimard, 1996), 178. On the aesthetic relation as a form of attention, see 16–17.

8. Schaeffer, *Adieu à l'esthétique*, 22–30.

9. Pierre Fédida, *Des bienfaits de la dépression: Éloge de la psychothérapie* (Paris: Éditions Odile Jacob, 2001), 16 (all quotations my translation).

10. Ibid., 206.

11. James P. McCullough, *Treatment for Chronic Depression: Cognitive Behavioral Analysis System of Psychotherapy (CBASP)* (New York: Guilford, 2000), 4, 7.

12. Michael Fried, "Art and Objecthood," in *Minimal Art: A Critical Anthology*, ed. Gregory Battcock (New York: Dutton, 1968), 125–28.

13. Kate Bush, "Considering What Is More: The Art of Liza May Post," in *Liza May Post: Biennale di Venezia, 2001* (Amsterdam: Mondriaan Foundation; Eindhoven: Stedelijk Van Abbemuseum; Rotterdam: NAi, 2001), 50. See also p. 45 for a discussion of the photograph.

14. Homi Bhabha, "Of Mimicry and Man: The Ambivalence of Colonial Discourse," *October* 28 (Spring 1984): 126, 130.

15. On this precise point, see Adam Phillips, "In Preparation," in *Liza May Post*: "They [the figures] are not characters, because they will not let us imagine their lives" (71).

16. Ibid.

17. Laura Mulvey, "Visual Pleasure and Narrative Cinema," *Screen* 6 (Fall 1975): 6–18, reprinted in *Art after Modernism: Rethinking Representation*, ed. Brian Wallis (New York: New Museum of Contemporary Art; Boston: Godine, 1984), 361–73.

18. For an insightful analysis of Lorna Simpson's work, see especially bell hooks, *Art on My Mind: Visual Politics* (New York: New Press, 1995), 94–98.

19. David Joselit, *Infinite Regress: Marcel Duchamp, 1910–1941* (Cambridge: MIT Press, 1998).

20. Timothy J. Clark, "Preliminaries to a Possible Treatment of 'Olympia' in 1865," *Screen* 21, no. 1 (Spring 1980): 18–41.

21. Rosalind Krauss, "The Motivation of the Sign," in *Picasso and Braque: A Symposium*, ed. Lynn Zelevansky (New York: Museum of Modern Art, 1992), 262.

22. See Susan Buck-Morss, *The Dialectics of Seeing: Walter Benjamin and the Arcades Project* (Cambridge: MIT Press, 1995).

23. Liza May Post, quoted in Phillips, "In Preparation," 71.

24. Alexandra Triandafillidis, *La dépression et son inquiétante familiarité* (Paris: Éditions Universitaires, 1991), 64 (all quotations my translation).

25. Ibid., 66.

26. Melanie Klein, "The Psychogenesis of Manic-Depressive States," in *The Selected Melanie Klein*, ed. Juliet Mitchell (New York: Free Press, 1987), 119.

27. Triandafillidis, *La dépression et son inquiétante familiarité*, 145.

28. Bush, "Considering What Is More," 54.

29. See Michel Foucault, *Discipline and Punish: The Birth of the Prison*, trans. Alan Sheridan (New York: Vintage, 1977), notably the section "Panopticism," 195–228.

30. For a brief yet excellent description of Lefebvre's spatial triad, see Andy Merrifield, "Henri Lefebvre: A Socialist in Space," in *Thinking Space*, ed. Mike Crang and Nigel Thrift (London: Routledge, 2000), 173–75.

31. Edward S. Casey, *The Fate of Place: A Philosophical History* (Berkeley and Los Angeles: University of California Press, 1997), 204.

32. Maurice Merleau-Ponty, *Phenomenology of Perception*, trans. Colin Smith (New York: Humanities Press, 1962), 250.

33. Casey, *Fate of Place*, 210.

34. Schaeffer, *Adieu à l'esthétique*: "The aesthetic dimension is a relational property and not a property of the object" (17).

35. George W. Brown and Tirril Harris, *Social Origins of Depression: A Study of Psychiatric Disorder in Women* (London: Tavistock, 1978), 103.

36. Ibid., 179. As for psychological factors, Brown and Harris insist on the role of low self-esteem in the onset of depression, self-esteem being defined as "one's ability to control the world and thus to repair damage, a confidence that in the end alternative sources of value will become available." The individual's commitment to a given identity or clusters of identities also contributes to depression: the more one's identity is assumed, the greater the crisis when a life-event "deprives her of an essential part of it" (235–36).

37. Avshalom Caspi and Glen H. Elder Jr., quoted in Thomas Joiner, James C. Coyne, and Janice Blalock, "On the Interpersonal Nature of Depression: Overview and Synthesis," in *The Interactional Nature of Depression: Advances in Interpersonal Approaches,* ed. Thomas Joiner and James C. Coyne (Washington, DC: American Psychological Association, 1999), 12.

38. Constance Hammen, "The Emergence of an Interpersonal Approach to Depression," in Joiner and Coyne, *Interactional Nature of Depression,* 22.

39. Joiner, Coyne, and Blalock, "On the Interpersonal Nature of Depression," 13.

40. Joseph Becker and Karen Schmaling, "Interpersonal Aspects of Depression from Psychodynamic and Attachment Perspectives," in *Psychological Aspects of Depression,* ed. Joseph Becker and Arthur Kleinman (Hillsdale, NJ: Erlbaum, 1990), 131–68.

41. David A. Karp, *Speaking of Sadness: Depression, Disconnection, and the Meanings of Illness* (New York: Oxford University Press, 1996), 16.

42. Ibid., 166, 181. In contemporary societies where the neoliberal paradigm enforces the blooming of the independent (entrepreneurial) subject, even the depressed must be held "responsible" for his or her mental affection. Although the neurobiological perspective on depression has somewhat countered this tendency by focusing on the dysfunctionality of the mindless body (and therefore conveying full responsibility to biology), psychology usually situates the problem in the individual's coping style. Robin Allwood rightly observes that "if we repeatedly experience being depressed, we will not only be unhappy, but we can blame ourselves, our weak personality, our lack of willpower, etc. What is intended as an empowering philosophy [responsibility] can potentially make one more of a victim." Robin Allwood, "'I Have Depression, Don't I?': Discourses of Help and Self-Help Books," in *Psychology Discourse Practice: From Regulation to Resistance,* ed. Erica Burman et al. (London: Taylor & Francis, 1996), 19–20. As Rosalind Coward has similarly pointed out, "We live in a society which believes the individual is responsible for his or her actions and indeed that the individual is ultimately responsible for whatever happens to her in society, whether she succeeds or fails." Rosalind Coward, *The Whole Truth: The Myth of Alternative Health* (London: Faber & Faber, 1989), 199, quoted in Allwood, 19. Reinforcing the disconnectedness of the person experiencing depression, the neoliberal tradition that shapes the majority of self-help books on depression "posits the notion of a 'natural' or 'true' self within each of us and so 'leads directly and inevitably to the idea of *personal* solutions and *individual* liberation,'" a focus on personal responsibility that obscures the requirement for wider social change. Allwood, 20, quoting S. Scott and T. Payne, "Underneath We're All Lovable," *Trouble and Strife* 3 (Summer 1984): 22 (Allwood's emphasis).

43. Clément Rosset, quoted in Didier Raymond, "Clément Rosset: Dans l'œil du cyclone," *Magazine littéraire* 411 (July–August 2002): 21 (my translation).

44. Pierre Marie, "Le symptôme du monde contemporain," *Magazine littéraire* 411 (July–August 2002): 29.

45. Émile Durkheim, *Suicide: A Study in Sociology* (1897), trans. John A. Spaulding and George Simpson (New York: Free Press, 1966).

46. Dana Crowley Jack, *Silencing the Self: Women and Depression* (Cambridge: Harvard University Press, 1991), 16.

47. Silvano Arieti and Jules Bemporad, *Severe and Mild Depression: The Psychotherapeutic Approach* (New York: Basic Books, 1978), 163; and Paul Chodoff, "The Depressive Personality," *Archives of General Psychiatry* 27 (1972): 670.

48. On the self-in-relation model, see Carol Gilligan, *In a Different Voice: Psychological Theory and Women's Development* (Cambridge: Harvard University Press, 1982); Nancy Chodorow, *The Reproduction of Mothering: Psychoanalysis and the Sociology of Gender* (Berkeley and Los Angeles: University of California Press, 1978); and Nancy Chodorow, *Feminism and Psychoanalytic Theory* (New Haven: Yale University Press, 1989).

49. Jack, *Silencing the Self,* 16.

50. Ibid., 27–28.

51. Fédida, *Des bienfaits de la dépression,* 206.

52. Ibid., 216–18.

53. Ibid., 203–4.

54. Ibid., 206. According to Fédida, the model also fails to consider the fact that the transfer is, like the symptom and the dream, a psychic formation with an autoerotic dimension that cannot be conveyed by an interpersonal communication.

55. Jenny France, "Depression and Other Mood Disorders," in *Communication and Mental Illness: Theoretical and Practical Approaches,* ed. Jenny France and Sarah Kramer (London: Kingsley, 2001), 113–14.

56. Zvia Breznitz and Tracy Sherman, "Speech Patterning of Natural Discourse of Well and Depressed Mothers and Their Young Children," *Child Development* 58, no. 2 (1987): 395–400. Also see ibid., 76.

57. France, "Depression and Other Mood Disorders," 75.

58. Kaja Silverman, *The Threshold of the Visible World* (New York: Routledge, 1996), 197, 233.

59. Martin Lister et al., *New Media: A Critical Introduction* (London: Routledge, 2002), 125.

60. Margaret Morse, *Virtualities: Television, Media Art, and Cyberculture* (Bloomington: Indiana University Press, 1998), 181.

61. Lister et al., *New Media,* 125.

62. Ibid., 133.

63. Ibid.

64. Lev Manovich, *The Language of New Media* (Cambridge: MIT Press, 2001), 90.

65. Ibid., 91–92.

66. Anne Friedberg, *Window Shopping: Cinema and the Postmodern* (Berkeley and Los Angeles: University of California Press, 1993), 28.

67. Manovich, *Language of New Media,* 115, 113.

68. On the new media screen as an image-interface and image-instrument, see ibid.: "The image becomes interactive, that is, it now functions as an interface between a user and a computer or other devices. The user employs an *image-interface* to control a computer, asking it to zoom into the image or display another one, start a software application, connect to the Internet, and so

on. The user employs *image-instruments* to directly affect reality—move a robotic arm in a remote location, fire a missile, change the speed of a car and set the temperature, and so on. To evoke a term often used in film theory, new media move us from identification to action. What kinds of actions can be performed via an image, how easily they can be accomplished, their range—all these play a part in the user's assessment of the reality effect of the image" (183).

69. Anne Friedberg, "The Virtual Window," in *Rethinking Media Change: The Aesthetics of Transition,* ed. David Thorburn and Henry Jenkins (Cambridge: MIT Press, 2003), 346.

70. Lister et al., *New Media,* 134.

71. Oliver Grau, *Virtual Art: From Illusion to Immersion* (Cambridge: MIT Press, 2003), 251.

72. On this topic, see ibid., 206; Yvonne Spielmann, "The Vasulkas: Convergence of Video and Computer" (paper presented at the conference "La nouvelle sphère intermédiatique V: Histoire et géographie d'un concept; L'intermédialité entre les savoirs," Cinquième colloque international du Centre de recherche sur l'intermédialité, Montreal, QC, October 1, 2003); and Christine Ross, "The Corpus in Video," *Parachute* 70 (April–June 1993): 14–21.

73. Lister et al., *New Media,* 135.

74. Grau, *Virtual Art,* 202.

75. Anthony Vidler, *Warped Space: Art, Architecture, and Anxiety in Modern Culture* (Cambridge: MIT Press, 2000), 243. This observation supports Hubert Damisch's view on the persistence of perspective in contemporary times. See Hubert Damisch, *The Origin of Perspective,* trans. John Goodman (Cambridge: MIT Press, 1994): "Without any doubt, our period is much more massively 'informed' by the perspective paradigm, thanks to photography, film, and now video, than was the 15th century, which could boast of very few 'correct' perspective constructions" (28).

76. Vidler, *Warped Space,* 245.

77. Ibid., 8.

78. Ibid., 253–54.

79. Ibid., 10. On Vidler's examination of Benjamin's analysis of modern space, see particularly 82–85.

80. See especially Paul Virilio, *L'espace critique* (Paris: Christian Bourgois Editeur, 1984): "Devant cette dérégulation des apparences, l'orientation du point de vue est moins celle de l'angulation des surfaces et des superficies de la géométrie non-euclidienne que celle de l'incidence (topologique et iconologique) de l'absence de délai des transmissions et des retransmissions d'images télévisées. Ici, la grandeur primitive du vecteur vitesse reprend son office dans la redéfinition de l'espace sensible: la *profondeur de temps* (de la téléologie opto-électronique) supplante l'ancienne *profondeur de champ* de la topologie. Le point de fuite, centre omniprésent de l'ancienne visée perspective, cède la place à l'instantanéité télévisée d'une observation prospective" (37).

81. For a detailed description of her *House* project, see Rachel Whiteread, *House,* ed. James Lingwood (London: Phaidon, 1995).

82. Nicolas Bourriaud, *Esthétique relationnelle* (Dijon: Presses du réel, 1998). *L'esthétique relationnelle* has been the object of two special issues of *Parachute,* nos. 100 and 101 (October–December 2000 and January–March 2001, respectively).

83. Rosa Martinez, "Cityscape on New Feminism," *Flash Art* 33, no. 214 (October 2000): 56.

84. Bourriaud, *Esthétique relationnelle,* 14 (all quotations my translation).

85. Ibid., 15. See more specifically this passage: "L'essence de la pratique artistique résiderait ainsi dans l'invention de relations entre des sujets: chaque œuvre d'art particulière serait la

proposition d'habiter un monde en commun, et le travail de chaque artiste, un faisceau de rapports avec le monde, qui générerait d'autres rapports, et ainsi de suite, à l'infini" (22).

86. Bruce Barber, "Sentences on Littoral Art" (1988), reproduced in "Squatting on Shifting Grounds: An Interview with Bruce Barber and Katherine Grant," by Marc J. Léger, *Afterimage* 29, no. 1 (July–August 2001): 11.

87. On the notion of avant-garde as provocation (antagonism, agonism, and activism), see Renato Poggioli, *The Theory of the Avant-Garde,* trans. Gerald Fitzgerald (Cambridge: Harvard University Press, Belknap Press, 1968).

88. Barber, "Sentences on Littoral Art," 11. Documentation of two littoral art projects, the Banff and Piotrkow projects, can be found at http://www.banffcentre.ca/wpg/nmsc/squat/collaborators.htm and http://www.wizya.net/bruce.htm, respectively. More recent littoral interventions have taken the form of squatting projects involving the invitation of homeless writers to squat in specifically designed gallery squats for a period of time so as to write and communicate with other writers and the larger public. During the summer of 1999, for example, Barber invited Katherine Grant, an itinerant from Calgary, Alberta, to become a "squat(wri)ter" at the Banff Centre's Walter Phillips Gallery for a period of eight weeks. Using advertisements in local newspapers and distributing handbills to homeless people on the street, Barber met Grant, a woman in her late forties or early fifties who lived in an old car. A self-taught writer (who had, however, taken one continuing education course in writing), she had not yet published any of her work. During the residency, the gallery space was transformed into living quarters and was linked to an Internet Web site through which virtual visitors could access information on littoral art, on the residency, and on housing rights, and could chat with the squatter. Spectators were also invited onto the premises. Some of them were disturbed by the display of a "homeless," whereas others chose to talk with the resident. As Katherine Grant explains, "[M]y purpose in being there was to be a voice for the poor, ill and elderly, not the lawless. Many visitors left the squat saying they had a totally changed view of the situation and wanted to make a difference where they could." During her residency, she published one piece locally and received invitations to publish others. She did some writing on her life story, learned video making, made friends with other members of the Banff Centre community, and invited people "to sign the walls of the interior of her bedroom, which many did, leaving messages of support and friendship, drawings and poems that were subsequently documented in video."

89. On Habermas, see notably William Outhwaite, *Habermas: A Critical Introduction* (Cambridge, UK: Polity, 1994).

90. Jenny France, "Disorders of Communication and Mental Illness," in France and Kramer, *Communication and Mental Illness,* 15.

91. Jurgen Ruesch, "Values, Communication, and Culture," in *Communication: The Social Matrix of Psychiatry,* ed. Jurgen Ruesch and Gregory Bateson (London: Norton, 1987), 3–20.

92. Paul Ardenne, *L'art dans son moment politique: Écrits de circonstance* (Brussels: La Lettre Volée, 1999), 12, 229–30.

93. Ibid., 244–45.

94. On the relational dimension of aesthetics, see Schaeffer, *Adieu à l'esthétique*: "Mais on voit bien que ce qui est en cause ce n'est pas une propriété interne des choses (ni *a fortiori* une détermination d'essence de l'art), mais une propriété relationnelle, puisque l'épiphanie se constitue toujours dans et à travers la rencontre entre un objet et un individu. Autrement dit . . . : la dimension esthétique est une propriété relationnelle et non pas une propriété d'objet" (16–17).

4. Nothing to See?

1. Pierre Fédida, *Des bienfaits de la dépression: Éloge de la psychothérapie* (Paris: Éditions Odile Jacob, 2001), 203. On the question of reliability, see Mitchell Wilson, "DSM-III and the Transformation of American Psychiatry: A History," *American Journal of Psychiatry* 150, no. 3 (March 1993): 407–8.

2. Jean Laplanche and J.-B. Pontalis, *Vocabulaire de la psychanalyse,* 11th ed. (Paris: Presses Universitaires de France, 1992), 267 (my translation).

3. Wilson, "DSM-III," 407.

4. Ibid., 408.

5. Ernest Gellner, *The Psychoanalytic Movement: The Cunning of Unreason* (1985; repr., Evanston, IL: Northwestern University Press, 1996), 7.

6. Edmond Couchot, *La technologie dans l'art: De la photographie à la réalité virtuelle* (Nîmes: Éditions Jacqueline Chambon, 1998), 223.

7. Douglas Gordon, "Attraction-répulsion," interview by Stéphanie Moisdon-Trembley, originally published in *Blocknotes* in 1996, reprinted in Douglas Gordon, *Déjà-vu: Questions and Answers,* vol. 1, *1992–1996* (Paris: Musée d'art moderne de la ville de Paris, 2000), 122.

8. Douglas Gordon, " . . . In Conversation: Jan Debbaut and Douglas Gordon," in *Douglas Gordon: Kidnapping* (Eindhoven, Neth.: Stedelijk Van Abbemuseum, 1998), 34, 42.

9. Douglas Gordon, "Voir c'est croire," interview by Marie de Brugerolle (1995), reprinted in Gordon, *Déjà-vu,* 97.

10. Douglas Gordon, "(P)ars pro toto," interview by Hans-Ulrich Obrist (1996), reprinted in Gordon, *Déjà-vu,* 171.

11. Jonathan Crary, *Suspensions of Perception: Attention, Spectacle, and Modern Culture* (Cambridge: MIT Press, 1999).

12. Kimron Shapiro and Kathleen Terry, "The Attentional Blink: The Eyes Have It (but So Does the Brain)," in *Visual Attention,* ed. Richard D. Wright (New York: Oxford University Press, 1998), 306.

13. Harold E. Pashler, *The Psychology of Attention* (Cambridge: MIT Press, 1998), 2.

14. Harold E. Pashler, "Attention and Visual Perception: Analyzing Divided Attention," in *Visual Cognition: An Invitation to Cognitive Science,* ed. Stephen M. Kosslyn and Daniel N. Osherson (Cambridge: MIT Press, 1995), 71–100.

15. See, respectively, Arien Mack and Irvin Rock, *Inattentional Blindness* (Cambridge: MIT Press, 1998); Jeremy M. Wolfe, "Inattentional Amnesia," in *Fleeting Memories: Cognition of Brief Stimuli,* ed. Veronika Coltheart (Cambridge: MIT Press, 1999), 75; Shapiro and Terry, "Attentional Blink," 324–25; and Nancy Kanwisher, Carol Yin, and Ewa Wojciulik, "Repetition Blindness for Pictures: Evidence for the Rapid Computation of Abstract Visual Descriptions," in Coltheart, *Fleeting Memories,* 119.

16. On this specific point, see Elizabeth Roudinesco, *Pourquoi la psychanalyse?* (Paris: Flammarion/Fayard, 1999), 93–124.

17. Slavoj Žižek, *The Ticklish Subject: The Absent Centre of Political Ontology* (London: Verso, 1999), 315. Žižek concludes, "So when, today, one speaks of the decline of paternal authority, it is *this* father, the father of the uncompromising 'No!,' who is effectively in retreat; in the absence of his prohibitory 'No!,' new forms of the phantasmatic harmony between the symbolic order and *jouissance* can thrive again" (322).

18. On the loss of the paternal figure in *Psycho*, see Slavoj Žižek, *Looking Awry: An Introduction*

to Jacques Lacan through Popular Culture (Cambridge: MIT Press, 1992). On psychosis specifically, see p. 74.

19. Linda Williams, "Discipline and Distraction: *Psycho,* Visual Culture, and Postmodern Cinema," in *"Culture" and the Problem of the Disciplines,* ed. John Carlos Rowe (New York: Columbia University Press, 1998), 102–3. Also see Carol Clover, *Men, Women, and Chain Saws: Gender in the Modern Horror Film* (Princeton: Princeton University Press, 1992), 21–64. The struggle with Oedipus is confirmed by Robert Corber's recent reading of Hitchcock's films as oedipal narratives that never truly lead the male spectator to a fixed, stable heterosexual subject position. Because most of his filmic narratives rely on processes of identification between the male viewer and the hero, they are constantly threatened by the reemergence of homosexual object choices that are perhaps forbidden by symbolic prohibition but never completely relinquished. Hitchcock's cinema, most notably *Vertigo,* enacts "polymorphous sexualities" that disrupt the formation of a fixed heterosexual identity. See Robert J. Corber, "Hitchcock's Washington: Spectatorship, Ideology, and the 'Homosexual Menace' in *Strangers on a Train,*" in *Hitchcock's America,* ed. Jonathan Freedman and Richard H. Millington (New York: Oxford University Press, 1999), 99–121.

20. See, for example, Raymond Bellour, "Psychosis, Neurosis, Perversion," in *A Hitchcock Reader,* ed. Marshall Deutelbaum and Leland Poague (Ames: Iowa State University Press, 1986), 311–31.

21. Alfred Hitchcock, quoted in François Truffaut, *Hitchcock,* rev. ed. (New York: Simon & Schuster, Touchstone, 1985), 282–83.

22. Williams, "Discipline and Distraction," 93. On the way the cinema of attractions articulates a loss of distance vis-à-vis the image, see Martin Jay, "Diving into the Wreck: Aesthetic Spectatorship at the End of the Millennium" (paper presented in the Department of Comparative Literature, University of Montreal, May 25, 2000).

23. Tom Gunning, "The Cinema of Attractions: Early Film, Its Spectator, and the Avant-Garde," in *Early Cinema: Space, Frame, Narrative,* ed. Thomas Elsaesser and Adam Barker (London: British Film Institute, 1990), 57–59.

24. Tom Gunning, "An Aesthetic of Astonishment: Early Film and the (In)Credulous Spectator," in *Viewing Positions: Ways of Seeing Film,* ed. Linda Williams (New Brunswick: Rutgers University Press, 1995), 119–21.

25. Alain Ehrenberg, *La fatigue d'être soi: Depression et société* (Paris: Éditions Odile Jacob, 1998), 250 (all quotations my translation).

26. Fédida, *Des bienfaits de la dépression,* 11. On this point, see notably p. 19: "Car c'est une seule et même chose que de négliger les temps par lesquels s'exprime le patient déprimé et de priver celui-ci de la capacité psychique de redécouvrir en parlant la ressource des modulations rythmiques temporelles" (all quotations my translation).

27. Tanya M. Luhrmann, *Of Two Minds: The Growing Disorder in American Psychiatry* (New York: Knopf, 2001), 42.

28. Jacques Gasser and Michael Stigler, "Diagnostic et clinique psychiatrique au temps du DSM," in *La maladie mentale en mutation: Psychiatrie et société,* ed. Alain Ehrenberg and Anne M. Lovell (Paris: Éditions Odile Jacob, 2001), 231.

29. Luhrmann, *Of Two Minds,* 42.

30. Ibid., 7.

31. Anne Friedberg, "The Virtual Window," in *Rethinking Media Change: The Aesthetics of Transition*, ed. David Thorburn and Henry Jenkins (Cambridge: MIT Press, 2003), 344.

32. Making Time: Considering Time as a Material in Contemporary Video and Film (exhibition), Palm Beach Institute of Contemporary Art, Lake Worth, FL, March 5–May 28, 2000.

33. Douglas Gordon, "Six Questions to Douglas Gordon," interview by Christine Van Assche (1996), reprinted in Gordon, *Déjà-vu*, 134.

34. bell hooks, *Art on My Mind: Visual Politics* (New York: New Press, 1995), 4.

35. Richard Shusterman, *Performing Live: Aesthetic Alternatives for the Ends of Art* (Ithaca: Cornell University Press, 2000), 20.

36. Ibid., 31.

37. Ibid., 115.

38. Ibid., 119–20.

39. Ibid., 37.

40. Jennifer Radden, "From Melancholic States to Clinical Depression," introduction to *The Nature of Melancholy: From Aristotle to Kristeva*, ed. Jennifer Radden (New York: Oxford University Press, 2000), 48.

41. Gasser and Stigler, "Diagnostic et clinique psychiatrique," 229–45.

42. Angel Martinez-Hernaez, *What's Behind the Symptom? On Psychiatric Observation and Anthropological Understanding*, trans. Susan M. DiGiacomo and John Bates (Amsterdam: Harwood Academic Publishers, 2000), 4.

43. Ibid., 77 (my emphasis).

44. Arthur Kleinman, *Rethinking Psychiatry: From Cultural Category to Personal Experience* (New York: Free Press; London: Collier Macmillan, 1988), 12.

45. Arthur Kleinman, *Patients and Healers in the Context of Culture* (Berkeley and Los Angeles: University of California Press, 1980), 75. Gasser and Stigler, "Diagnostic et clinique psychiatrique," also emphasize that symptoms are transformed into signs by the patient and the doctor, which means symptoms can never be reduced to autonomous visibilities: "[T]he observer is part of the observation: the search for signs does not result from the simple meeting between a person who suffers from psychic disorder by producing symptoms and another person mentally healthy producing knowledge who . . . decrypts objectively the signs he sees, regroups them logically, infers a diagnostic and then concludes on a specific therapy" (230–31; my translation).

46. Allan V. Horwitz, *Creating Mental Illness* (Chicago: University of Chicago Press, 2002), 43–44.

47. American Psychiatric Association, *Practice Guideline for the Treatment of Patients with Major Depressive Disorder*, 2nd ed. (Washington, DC: American Psychiatric Association, 2000), 34.

48. Ibid.

49. Wilson, "DSM-III," 399–400. The reasons for the institution of the *DSM–III* are argued to be more of a corporative nature—the need to reconsolidate psychiatry—than to the result of a proven methodological rationale. As Allan Horwitz succinctly points out, "The triumph of a categorical system was not based on evidence that diagnoses were more adequate scientific classifications than dynamic or other alternatives. The developers of this new system did not make empirical comparisons between categorical diagnoses and other possible frameworks. The new system instead imposed a categorical system of diagnoses on phenomena that had previously been considered dimensional. Diagnostic categories emerged in order to raise the prestige of psychiatry, to guarantee reimbursement from third parties, to allow medications to be marketed,

and to protect the interests of mental health researchers and professionals." See Horwitz, *Creating Mental Illness,* 81–82.

50. Horwitz, *Creating Mental Illness,* 48. See also 48–50.

51. For a good compilation of texts dealing with the New Art History, see A. L. Rees and Frances Borzello, *The New Art History* (London: Camden, 1986). As summarized by the authors in their introduction, "[T]he new art history is a capacious and convenient title that sums up the impact of feminist, Marxist, structuralist, psychoanalytic, and social-political ideas of a discipline notorious for its conservative taste in art and its orthodoxy in research" (2).

52. Fédida, *Des bienfaits de la dépression,* 215.

53. Georges Didi-Huberman, *Devant l'image: Question posée aux fins d'une histoire de l'art* (Paris: Les Éditions de Minuit, 1990), 9–10 (all quotations my translation).

54. Ibid., 306.

55. Ibid., 175.

56. Ibid., 172.

57. Serge Tisseron, *Le bonheur dans l'image,* Collection les empêcheurs de penser en rond (Paris: Les Éditions du Seuil, 1996), 7–14.

58. I thank Mieke Bal for pointing out to me this persisting ambiguity.

59. Lev Manovich, *The Language of New Media* (Cambridge: MIT Press, 2001), 155.

60. Ibid., 155–58.

61. Martin Jay, *Downcast Eyes: The Denigration of Vision in Twentieth-Century French Thought* (Berkeley and Los Angeles: University of California Press, 1993), 54–56.

62. Norman Bryson, *Vision and Painting: The Logic of the Gaze* (New Haven: Yale University Press, 1983), 106.

63. Ibid., 106–7.

64. Sigmund Freud, *Group Psychology and the Analysis of the Ego* (1921), in *The Standard Edition of the Complete Psychological Works of Sigmund Freud,* ed. and trans. James Strachey (London: Hogarth, 1955), 18:105. Freud defines cannibalistic identification in the following terms: "Identification, in fact, is ambivalent from the very first; it can turn into an expression of tenderness as easily as into a wish for someone's removal. It behaves like a derivative of the first, *oral* phase of the organization of the libido, in which the object that we long for and prize is assimilated by eating and is in that way annihilated as such. The cannibal, as we know, has remained at this standpoint; he has a devouring affection for his enemies and only devours people of whom he is fond" (105).

65. See Kaja Silverman, *The Threshold of the Visible World* (New York: Routledge, 1996), 167. For an insightful discussion of Lacan's division between the eye and the gaze, also see Jay, *Downcast Eyes,* 346–58.

66. Jacques Lacan, *Les quatre concepts fondamentaux de la psychanalyse* (1964) (Paris: Éditions du Seuil, 1973), 121 (all quotations my translation).

67. Ibid., 96: "[L]e point de néantisation premier où se marque, dans le champ de la réduction du sujet, une cassure."

68. Georges Didi-Huberman, "Ce que nous voyons, ce qui nous regarde," *Les Cahiers du Musée national d'art moderne* 37 (Fall 1991): 34–35 (my translation).

69. Michael Fried, *Absorption and Theatricality: Painting and Beholder in the Age of Diderot* (Berkeley and Los Angeles: University of California Press, 1980), 45.

70. Ibid., 31.

71. Quoted in ibid., 61.

72. Fried, *Absorption and Theatricality*, 61.

73. Ibid., 104, 130–31.

74. Ibid., 104.

75. Ibid.

76. Charles Goldfinger, *Travail et hors-travail: Vers une société fluide* (Paris: Éditions Odile Jacob, 1998).

77. Richard Shusterman, "A House Divided," in *A House for Pigs and People,* ed. Carsten Höller and Rosemarie Trockel (Cologne: Walther König, 1997), 34.

78. Carsten Höller and Rosemarie Trockel, "In the Next Millennium Everything Will Be Better: Then We Can Let the Pigs Watch Us; Notes on *Haus für Schweine und Menschen,*" in Höller and Trockel, *House for Pigs and People,* 4.

79. Amelia Jones, *Body Art/Performing the Subject* (Minneapolis: University of Minnesota Press, 1998), 52, 36.

80. "Rosemarie Trockel," interview by Jutta Koether, *Flash Art* 134 (May 1987): 41.

81. Judith Butler, *Gender Trouble: Feminism and the Subversion of Identity* (New York: Routledge, 1991).

82. Pashler, "Attention and Visual Perception."

83. "And So to Bed," *Economist,* December 21, 2002, 113.

84. See, for example, Timothy Monk, ed., *Sleep, Sleepiness, and Performance* (New York: Wiley, 1991); Mark R. Pressman and William C. Orr, *Understanding Sleep: The Evaluation and Treatment of Sleep Disorders* (Washington, DC: American Psychological Association, 1997); and J. Steven Poceta and Merrill M. Mitler, eds., *Sleep Disorders: Diagnosis and Treatment* (Totowa, NJ: Humana, 1998).

85. Peretz Lavie, *The Enchanted World of Sleep,* trans. Anthony Berris (New Haven: Yale University Press, 1996), 105, 186.

86. For a thorough critique of the cognitive model, see Paul Gilbert, *Depression: The Evolution of Powerlessness* (New York: Guilford, 1992), chap. 13.

87. Luce Irigaray, *Speculum de l'autre femme* (Paris: Les Éditions de Minuit, 1974). For the English translation, see *Speculum of the Other Woman,* trans. Gillian C. Gill (Ithaca, NY: Cornell University Press, 1985), 47–48: "*The gaze is at stake from the outset.* Don't forget, in fact, what 'castration,' or the knowledge of castration, owes to the gaze, at least for Freud. The gaze has always been involved. Now the little girl, the woman, supposedly has *nothing* you can see. She exposes, exhibits the possibility of *a nothing to see.* . . . This is the odd, the uncanny thing, as far as the eye can see, this nothing around which lingers in horror, now and forever, an overcathexis of the eye. . . . This nothing, which actually cannot well be mastered in the twinkling of an eye, might equally have acted as an inducement to perform castration upon an age-old oculocentrism. It might have been interpreted as the intervention of a difference, of a deferent, as a challenge to an imaginary whose functions are often improperly regulated in terms of sight. Or yet again as the 'symptom,' the 'signifier,' of the possibility of an *other* libidinal economy. . . . Woman's castration is defined as her having nothing you can see, as her *having* nothing. In her having nothing penile, in seeing that she has No Thing. Nothing *like* man. That is to say, *no sex/organ* that can be seen in a *form* capable of founding its reality, reproducing its truth. *Nothing to be seen is equivalent to having no thing. No being* and *no truth.*"

88. Michel Jouvet, *Le sommeil et le rêve* (Paris: Éditions Odile Jacob, 1998), 93–96.

89. This similitude has been postulated by Rodolfo R. Llinas and Denis Paré, "Of Dreaming and Wakefulness," *Neuroscience* 44, no. 3 (1991): 521–35.

90. See S. J. Enna and Joseph T. Coyle, *Pharmacological Management of Neurological and Psychiatric Disorders* (New York: McGraw-Hill, 1998), 215–16.

91. See Constance Hammen, *Depression* (Hove, UK: Psychology Press, 1997), 68–71.

92. Poceta and Mitler, *Sleep Disorders,* 20.

93. Ibid., 30–31.

94. Jouvet, *Le sommeil et le rêve,* 137; and Lavie, *Enchanted World of Sleep,* 140.

95. Jouvet, *Le sommeil et le rêve,* 160–64.

96. Llinas and Paré, "Of Dreaming and Wakefulness," 523.

97. See Christina Gorman, "Why We Sleep," *Time,* December 2004, 46–56.

98. Anthony Vidler, *Warped Space* (Cambridge: MIT Press, 2000), 85–86.

99. Walter Benjamin, *Ursprung des deutschen Trauerspiels* (1928), quoted in ibid., 94.

100. Walter Benjamin, *One-Way Street, and Other Writings,* trans. Edmund Jephcott and Kingsley Shorter (London: Verso, 1979), 89.

101. Walter Benjamin, "The Work of Art in the Age of Mechanical Reproduction" (1936), in *Illuminations,* ed. Hannah Arendt, trans. Harry Zohn (New York: Harcourt, Brace & World, 1968), 241.

102. Ehrenberg, *La fatigue d'être soi,* 14–17.

103. On the way depression affects memory, learning, and perception, see C. Douglas McCann and Norman S. Endler, eds., *Depression: New Directions in Theory, Research, and Practice* (Toronto: Wall, 1990); and Gilbert, *Depression.*

5. The Critique of the Dementalization of the Subject

1. American Psychiatric Association, *Diagnostic and Statistical Manual of Mental Disorders,* 4th ed., text revision (Washington, DC: American Psychiatric Association, 2000); Jacques Gasser and Michael Stigler, "Diagnostic et clinique psychiatrique au temps du DSM," in *La maladie mentale en mutation: Psychiatrie et société,* ed. Alain Ehrenberg and Anne M. Lovell (Paris: Éditions Odile Jacob, 2001), 232, 234.

2. As opposed to bipolar disorders (also called manic-depressive disorders), which include depressive phases followed by manic episodes.

3. American Psychiatric Association, *Diagnostic and Statistical Manual of Mental Disorders,* 4th ed., text revision, 168.

4. American Psychiatric Association, *Diagnostic and Statistical Manual of Mental Disorders,* 3rd ed. (Washington, DC: American Psychiatric Association, 1980); Mitchell Wilson, "DSM-III and the Transformation of American Psychiatry: A History," *American Journal of Psychiatry* 150, no. 3 (March 1993): 399–400.

5. Ibid., 400–402.

6. Ibid., 408.

7. Ibid.

8. Pierre-Henri Castel, "La dépression est-elle encore une affection de l'esprit?" in *La dépression est-elle passée de mode?* ed. Pierre Fédida and Dominique Lecourt (Paris: Presses Universitaires de France, 2000), 54–70.

9. Pierre Fédida, *Des bienfaits de la dépression: Éloge de la psychothérapie* (Paris: Éditions Odile Jacob, 2001), 16 (my translation).

10. See Colin A. Ross and Alvin Pam, *Pseudoscience in Biological Psychiatry: Blaming the Body* (New York: Wiley, 1995).

11. Constance Hammen, "Stress and Depression: Research Findings on the Validity of an Endogenous Subtype of Depression," *Directions in Psychiatry* 15 (1995): 1–8.

12. Joseph Glenmullen, *Prozac Backlash: Overcoming the Dangers of Prozac, Paxil, and Other Antidepressants with Safe, Effective Alternatives* (New York: Simon & Schuster, Touchstone, 2000), 198.

13. Constance Hammen, *Depression* (Hove, UK: Psychology Press, 1997), 62–63.

14. Peter Farley, "Condemned to a Life of Depression?" *New Scientist,* July 18, 2003, 20.

15. Samuel H. Barondes, *Mood Genes: Hunting for Origins of Mania and Depression* (New York: Freeman, 1998), 121–25.

16. Hammen, *Depression,* 63.

17. Cited in ibid.

18. P. McGuffin, R. Katz, J. Aldrich, and P. Bebbington, "The Camberwell Collaborative Depression Study: II. Investigation of Family Members," *British Journal of Psychiatry* 152 (1988): 766–74; and P. McGuffin, R. Katz, and P. Bebbington, "The Camberwell Collaborative Depression Study: III. Depression and Adversity in the Relatives of Depressed Probands," *British Journal of Psychiatry* 152 (1988): 775–82.

19. Brian E. Leonard and David Healy, *Differential Effects of Antidepressants* (London: Martin Dunitz, 1999), 3; and Caroline Carney Doebbeling, "Epidemiology, Risk Factors, and Prevention," in *Depression,* ed. James L. Levenson (Philadelphia: American College of Physicians, 2000), 24.

20. Hammen, *Depression,* 64.

21. Ibid., 71–72.

22. Leonard and Healy, *Differential Effects of Antidepressants,* 30, 69.

23. Carol M. Worthman, "Hormones, Sex, and Gender," *Annual Review of Anthropology* 24 (1995): 595.

24. Janet M. Stoppard, *Understanding Depression: Feminist Social Constructionist Approaches* (New York: Routledge, 2000), 99.

25. Ibid., 100.

26. Anne E. Figert, *Women and the Ownership of PMS: The Structuring of a Psychiatric Disorder* (Hawthorne, NY: Aldine de Gruyter, 1996); and Margaret M. Lock, *Encounters with Aging: Mythologies of Menopause in Japan and North America* (Berkeley and Los Angeles: University of California Press, 1993).

27. Stoppard, *Understanding Depression,* 97.

28. George W. Brown and Tirril Harris, *Social Origins of Depression: A Study of Psychiatric Disorder in Women* (London: Tavistock, 1978); Arthur Kleinman and Byron Good, eds., *Culture and Depression: Studies in the Anthropology and Cross-Cultural Psychiatry of Affect and Disorder* (Berkeley and Los Angeles: University of California Press, 1985); Arthur Kleinman, *Social Origins of Distress and Disease: Depression, Neurasthenia, and Pain in Modern China* (New Haven: Yale University Press, 1986); Dana Crowley Jack, *Silencing the Self: Women and Depression* (Cambridge: Harvard University Press, 1991); Alfred Dean, ed., *Depression in Multidisciplinary Perspective* (New York: Brunner/Mazel, 1985); C. Douglas McCann and Norman S. Endler, eds., *Depression: New Directions in Theory, Research, and Practice* (Toronto: Wall Editions, 1990); Peter Kramer, *Listening to Prozac: A Psychiatrist Explores Antidepressant Drugs and the Remaking of the Self* (New York: Penguin, 1993); David Healy, *The Antidepressant Era* (Cambridge: Harvard University Press, 1997); Katharine J. Palmer, ed., *Drug Treatment Issues in Depression* (Auckland,

NZ: Adis International, 2000); and Dieter Ebert and Klaus P. Ebmeier, eds., *New Models for Depression* (Basel, Switzerland: Karger, 1998).

29. Allan V. Horwitz, *Creating Mental Illness* (Chicago: University of Chicago Press, 2002), 5.

30. Jerry Fodor, "Making the Connection: Axioms from Axons; Why We Need to Think Harder about Thinking," review of *Synaptic Self: How Our Brains Become Who We Are,* by Joseph LeDoux, *Times Literary Supplement,* May 17, 2002, 3.

31. Ibid., 4.

32. LeDoux, *Synaptic Self,* quoted in ibid.

33. Mark S. George et al., "Transcranial Magnetic Stimulation: A New Method for Investigating the Neuroanatomy of Depression," in Ebert and Ebmeier, *New Models for Depression,* 95.

34. Peter C. Whybrow, *A Mood Apart: Depression, Mania and Other Afflictions of the Self* (New York: BasicBooks, 1997), 8.

35. Ibid., 15.

36. Ibid., 14–15.

37. Ibid., 70–80.

38. Ibid., 133.

39. Ibid., 157.

40. Robert M. Post, "Transduction of Psychosocial Stress into the Neurobiology of Recurrent Affective Disorder," *American Journal of Psychiatry* 149 (1992): 999–1010.

41. Hammen, *Depression,* 77.

42. Castel, "La dépression," 54–56.

43. Sheldon H. Preskorn, "How to Establish the Diagnosis in the Primary-Care Setting," chap. 3 in *Outpatient Management of Depression,* 2nd ed. (Caddo, OK: Professional Communications, 1999), http://www.preskorn.com/books/omd_s3.html.

44. Glenmullen, *Prozac Backlash,* 193.

45. Charles DeBattista, David L. Smith, and Alan F. Schatzberg, "Psychopharmacology," in Levensen, *Depression,* 97–103.

46. Ibid., 97.

47. Philippe Pignarre, "Comment passer de la 'dépression' à la société?" in Fédida and Lecourt, *La dépression,* 46.

48. E. T. McNeal and Peter Cimbolic, "Antidepressants and Biochemical Theories of Depression," *Psychological Bulletin* 99 (1986): 361–74.

49. Joseph J. Schildkraut, "The Catecholamine Hypothesis of Affective Disorders: A Review of Supporting Evidence," *American Journal of Psychiatry* 122 (1965): 509–22.

50. Leonard and Healy, *Differential Effects of Antidepressants,* 25.

51. Ibid., 26.

52. Healy, *Antidepressant Era,* 161–62.

53. Leonard and Healy, *Differential Effects of Antidepressants,* 57, 59.

54. Healy, *Antidepressant Era,* 164.

55. Ibid., 169.

56. American Psychiatric Association, *Practice Guideline for the Treatment of Patients with Major Depressive Disorder,* 2nd ed. (Washington, DC: American Psychiatric Association, 2000), 4 n. b.

57. Tanya M. Luhrmann, *Of Two Minds: The Growing Disorder in American Psychiatry* (New York: Knopf, 2001), 236.

58. Jules Angst et al., quoted in Leonard and Healy, *Differential Effects of Antidepressants,* 4.

59. Leonard and Healy, *Differential Effects of Antidepressants,* 4.

60. David Healy, "The Antidepressant Drama," in *Treatment of Depression: Bridging the 21st Century,* ed. Myrna M. Weissman (Washington, DC: American Psychiatric Press, 2001), 16.

61. American Psychiatric Association, *Practice Guideline,* 2–6.

62. Ibid., 4; David Cohen and Suzanne Cailloux-Cohen, *Guide critique des médicaments de l'âme* (Montreal: Éditions de l'Homme, 1995); and Glenmullen, *Prozac Backlash.*

63. Healy, *Antidepressant Era,* 136.

64. American Psychiatric Association, *Practice Guideline,* 15.

65. Ibid., 25–27. Also see DeBattista, Smith, and Schatzberg, "Psychopharmacology," 103–4; and Glenmullen, *Prozac Backlash,* 72.

66. Glenmullen, *Prozac Backlash,* 34.

67. Kramer, *Listening to Prozac,* 11–13.

68. Ibid., 35, 103, 249.

69. Ibid., 41.

70. Ibid., 270.

71. Supporting the view that depression is "what is cured by antidepressants," see, for example, the preface of Jean-Pierre Olié, Marie-France Poirier, and Henri Lôo in their edited *Les maladies dépressives* (Paris: Flammarion, 1997). On the broad-spectrum effect of SSRIs, see DeBattista, Smith, and Schatzberg, "Psychopharmacology," 103; Leonard and Healy, *Differential Effects of Antidepressants,* chap. 7; and Glenmullen, *Prozac Backlash,* 106–34.

72. Luhrmann, *Of Two Minds,* 49–50.

73. American Psychiatric Association, *Practice Guideline,* 35.

74. David A. Karp, *Speaking of Sadness: Depression, Disconnection, and the Meanings of Illness* (New York: Oxford University Press, 1996), 10–12.

75. See the definition of *psychodynamic therapy* in American Psychiatric Association, *Practice Guideline,* 33–34.

76. Luhrmann, *Of Two Minds,* 238.

77. Ernest Gellner, *The Psychoanalytic Movement: The Cunning of Unreason* (Evanston, IL: Northwestern University Press, 1993), 7.

78. Georges Costan, "La dépression se porte de mieux en mieux," *L'actualité médicale,* September 18, 2002, 29 (all quotations my translation).

79. Ibid., 33. Methods of electric stimulation include, among others, transcranial magnetic stimulation, electroconvulsive therapy, and stimulation of the vagus nerve.

80. Luhrmann, *Of Two Minds,* 259.

81. For an extended discussion on questionnaires and the measurement of subjective experience, see Stoppard, *Understanding Depression,* 18–20.

82. See ibid., 37; Karen Henwood and Nick Pidgeon, "Remaking the Link: Qualitative Research and Feminist Standpoint Theory," *Feminism and Psychology* 5 (1995): 7–30; Paula Nicolson, "Feminism and Psychology," in *Rethinking Psychology,* ed. Jonathan A. Smith, Rom Harré, and Luk Van Langenhove (London: Sage, 1995), 122–42; Sandra Harding, *The Science Question in Feminism* (Ithaca: Cornell University Press, 1986); D. J. Gammel and Janet M. Stoppard, "Women's Experiences of Treatment of Depression: Medicalization or Empowerment?" *Canadian Psychology* 40 (1996): 112–28; and R. Schreiber, "(Re)defining My Self: Women's Process of Recovery from Depression," *Qualitative Health Research* 6 (1996): 469–91.

83. Stoppard, *Understanding Depression,* 39.

84. For a discussion, see ibid., 15–16; and Harding, *Science Question in Feminism.*

85. Glenmullen, *Prozac Backlash,* 194.

86. American Psychiatric Association, *Practice Guideline,* xxi–xxii, 199; also Stoppard, *Understanding Depression,* 31.

87. Gasser and Stigler, "Diagnostic et clinique psychiatrique," 230–31 (my translation).

88. Luhrmann, *Of Two Minds,* 8.

89. Ibid., 262.

90. Healy, *Antidepressant Era,* 102–3.

91. Ibid., 109.

92. Cited in Glenmullen, *Prozac Backlash,* 237.

93. Glenmullen, *Prozac Backlash,* 237.

94. Ibid., 268.

95. Robin B. Jarrett et al., "Is There a Role for Continuation Phase Cognitive Therapy for Depressed Outpatients?" *Journal of Consulting and Clinical Psychology* 66, no. 6 (December 1998): 1036–40.

96. Glenmullen, *Prozac Backlash,* 271.

97. Luhrmann, *Of Two Minds,* 7.

98. Ibid.

99. Healy, "Antidepressant Drama," 21.

100. Healy, *Antidepressant Era,* 109.

101. For the analyst Hans Loewald, the pressing need today is precisely to reinstate a culture of responsibility in which the subject takes "responsibility for his own history, the history that has been lived and the history in the making." See Hans Loewald, *Psychoanalysis and the History of the Individual* (New Haven: Yale University Press, 1978), 11.

102. Luhrmann, *Of Two Minds,* 276.

103. Alain Ehrenberg, *La fatigue d'être soi: Dépression et société* (Paris: Éditions Odile Jacob, 1998), 14 (my translation).

104. Sarah Kofman, *Mélancolie dans l'art* (Paris: Éditions Galilée, 1985), 60–68.

Index

Christine Ross is associate professor in the Department of Art History and Communication Studies at McGill University. She is the author of *Images de surface: L'art vidéo reconsidéré*.